THE ARTS OF CHINA

Michael Sullivan

THE ARTS OF CHINA

Revised Edition

University of California Press

Berkeley · Los Angeles · London

University of California Press
Berkeley and Los Angeles, California

University of California Press, Ltd.
London, England

Library of Congress Catalog Card Number: 76-44639
Printed in the United States of America
Designed by Dave Pauly

Contents

to Khoan

Foreword
to Revised Edition

Once more, I would like to express my special thanks to Allen and Carmen Christensen, whose continued generous support for our work has helped to make this new, more fully illustrated edition possible. I should like also to record my appreciation to the collectors and museum directors who have allowed me to reproduce additional works from their collections, and to thank reviewers for their comments on the earlier edition, my students for their help, and Patrick and Darle Maveety for preparing a new set of maps.

MICHAEL SULLIVAN

Oxford
September 1976

Foreword
to the 1979 Reprint

The publishers, in reprinting the 1977 edition of this book, have kindly allowed me to make some necessary corrections, and to take account of the official adoption by the Chinese Government of the Chinese phonetic alphabet, *pinyin*, which presents problems to Western readers familiar with the Wade-Giles system. To avoid cluttering the text with the two readings, old and new, my wife Khoan has revised the Index, inserting the *pinyin* romanisation after the Wade-Giles.

We have also been able to include, as supplementary illustrations, a small number of important bronzes and jades from recent excavations that have significantly enlarged our knowledge of the extent and richness of Shang and Chou culture.

I would like once again to express my appreciation of the support that Allen and Carmen Christensen continue to give to our work.

MICHAEL SULLIVAN

Stanford
April, 1979

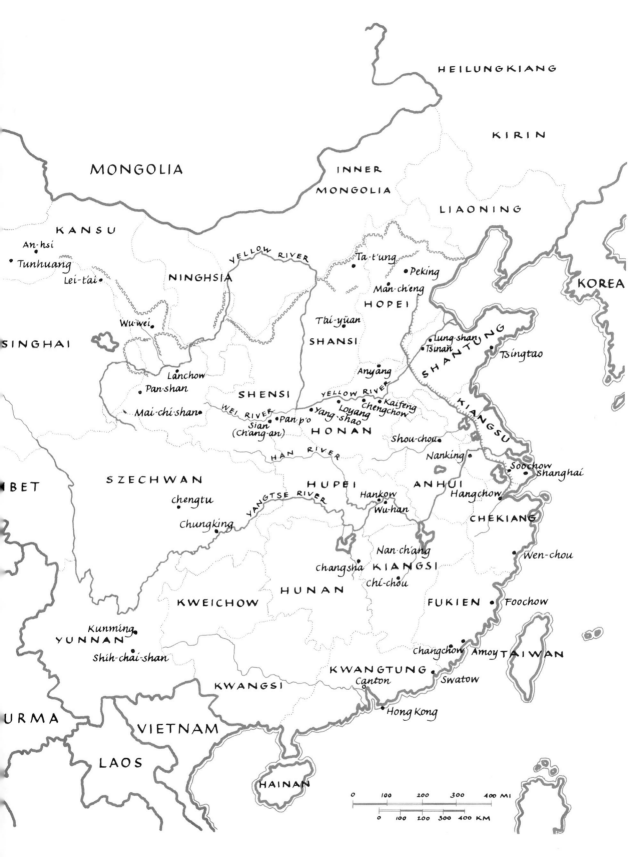

MAP 1 Modern China.

Chronological Table

SHANG			*c.* 1550–*c.* 1030 B.C.
CHOU	Western Chou	*c.* 1030–711	*c.* 1030–256
	Eastern Chou	770–256	
	'Spring and Autumn' period	722–481	
	Warring States period	480–222	
CH'IN			221–207
HAN	Former (Western) Han	202 B.C.–A.D. 9	202 B.C.–A.D. 220
	Hsin	9–23	
	Later (Eastern) Han	25–221	
THREE KINGDOMS	Shu (Han)	221–263	221–265
	Wei	220–265	
	Wu	222–280	
SOUTHERN (Six Dynasties)	Chin	265–316	
	Eastern Chin	317–420	
	Liu Sung	420–479	
	Southern Ch'i	479–502	
	Liang	502–557	
and	Ch'en	557–587	265–581
NORTHERN DYNASTIES	Northern Wei (T'o-pa)	386–535	
	Eastern Wei (T'o-pa)	534–543	
	Western Wei (T'o-pa)	535–554	
	Northern Ch'i	550–577	
	Northern Chou (Hsien-pi)	557–581	
SUI			581–618
T'ANG			618–906
FIVE DYNASTIES	Later Liang	907–922	907–960
	Later T'ang (Turkic)	923–936	
	Later Chin (Turkic)	936–948	
	Later Han (Turkic)	946–950	
	Later Chou	951–960	
	Liao (Khitan Tartars)	907–1125	
	Hsi-hsia (Tangut Tibetan)	990–1227	
SUNG	Northern Sung	960–1126	960–1279
	Southern Sung	1127–1279	
	Chin (Jurchen Tartars)	1115–1234	
YÜAN (Mongols)			1260–1368
MING			1368–1644
CH'ING (Manchus)			1644–1912
REPUBLIC			1912–

Reign Periods of the Ming and Ch'ing Dynasties

MING 1368–1644

Hung-wu	1368–1398
Chien-wen	1399–1402
Yung-lo	1403–1424
Hung-hsi	1425
Hsüan-te	1426–1435
Cheng-t'ung	1436–1449
Ching-t'ai	1450–1457
T'ien-shun	1457–1464
Ch'eng-hua	1465–1487
Hung-chih	1488–1505
Cheng-te	1506–1521
Chia-ching	1522–1566
Lung-ch'ing	1567–1572
Wan-li	1573–1620
T'ai-ch'ang	1620
T'ien-ch'i	1621–1627
Ch'ung-chen	1628–1644

CH'ING 1644–1912

Shun-chih	1644–1661
K'ang-hsi	1662–1722
Yung-cheng	1723–1735
Ch'ien-lung	1736–1796
Chia-ch'ing	1796–1821
Tao-kuang	1821–1850
Hsien-feng	1851–1861
T'ung-chih	1862–1873
Kuang-hsü	1874–1908
Hsüan-t'ung	1909–1912

NOTE

The earliest exactly known date in Chinese history is 841 B.C. According to calculations made by a number of scholars on the basis of probable reign lengths, the date of the founding of the Shang Dynasty has been put between 1766 and 1523 B.C, that of the Chou conquest between 1122 and 1018 B.C.

1

Before the Dawn of History

In the years that have passed since 1949, China has undergone a revolution—not only political, but social, cultural and moral—more profound, perhaps, than any other nation has ever experienced in a comparable period. We would be justified in thinking that in the process of creating a new culture she has utterly rejected the old. Yet—and this is the remarkable thing—the Chinese have been able, while repudiating the social system and the class attitudes that produced the old culture, to cherish and study it as never before. This they have achieved by obeying Chairman Mao's exhortation to "make the past serve the present." China's heritage is the deep reservoir from which she draws cultural sustenance today, a source of national pride, to be not merely preserved but made use of and developed along new lines. She sees archaeology, conservation and the study of her artistic traditions, not as luxuries, but as an essential part of the reconstruction of her culture.

Nor have the old legends and folklore been forgotten. The Chinese have a powerful sense of history, and time-honoured fables such as that of the foolish old man who removed the mountain in front of his house (because it blocked his view) are used today to inspire people to achieve the impossible. One of these legends, not quite so popular today perhaps, concerns the origins of the world.[1] In far-off times, it runs, the universe was an enormous egg. One day the egg split open; its upper half became the sky, its lower half the earth, and from it emerged P'an Ku, primordial man. Every day he grew ten feet taller, the sky ten feet higher, the earth ten feet thicker. After eighteen thousand years P'an Ku died. His head split and became the sun and moon, while his blood filled the rivers and seas. His hair became the forests and meadows, his perspiration the rain, his breath the wind, his voice the thunder—and his fleas our ancestors.

A people's legends of its origins generally give a clue as to what they think most important. This one is no exception, for it expresses an age-old Chinese viewpoint—namely, that man is not the culminating achievement of the creation, but a relatively insignificant part in the scheme of things; hardly more than an afterthought, in

LEGENDARY
BEGINNINGS

fact. By comparison with the beauty and splendour of the world itself, the mountains and valleys, the clouds and waterfalls, the trees and flowers, which are the visible manifestations of the workings of the *Tao*, he counts for very little. In no other civilisation did the forms and patterns of nature, and man's humble response to it, play so big a part. We can, moreover, trace the germs of this attitude—now emphatically repudiated by the new society—back into the remote past, when in North China nature was a kinder master than she is now. Half a million years ago, in the time of Peking man, that region was comparatively warm and wet; elephants and rhinoceroses roamed a more luxuriant countryside than the barren hills and windswept plains of recent times. Within this till lately inhospitable area, forming the modern provinces of Honan, Hopei, Shensi and Shansi, was born a uniquely Chinese feeling of oneness with nature which, in course of time, was to find its highest expression in philosophy, poetry and painting. This sense of communion was not merely philosophical and artistic; it had a practical value as well. For the farmer's prosperity, and hence that of society as a whole, depended upon his knowing the seasons and attuning himself to the 'will of heaven', as he called it. Agriculture in course of time became a ritual over which the emperor himself presided, and when at the spring sowing he ceremonially ploughed the first furrow, not only did he hope to ensure a good harvest thereby, but his office was itself further ennobled by this act of homage to the forces of nature.

This sense of 'attunement' is fundamental in Chinese thinking. Man must attune himself not only to nature but also to his fellow men, in ever-widening circles starting from his family and friends. Thus, his highest ideal has always in the past been to discover the order of things and to act in accordance with it. As in the following pages the history of Chinese art unfolds, we will find that its characteristic and unique beauty lies in the fact that it is an expression of this very sense of attunement. Is that one reason why Westerners, often with no other interest in Chinese civilisation, collect and admire Chinese art with such enthusiasm? Do they sense, perhaps, that the forms which the Chinese artist and craftsman have created are *natural* forms—forms which seem to have evolved inevitably by the movement of the maker's hand, as an intuitive response to a natural rhythm? Chinese art does not demand of us, as does Indian art, the effort to bridge what often seems an unbridgeable gulf between extremes of physical form and metaphysical content; nor will we find in it that preoccupation with formal and intellectual considerations which so often makes Western art difficult for the Asian mind to accept. The forms of Chinese art are beautiful because they are in the widest and deepest sense harmonious, and we can appreciate them because we too feel their rhythms all around us in nature and instinctively respond to them. These rhythms, moreover, this sense of inner life expressed in line and contour, are present in Chinese art from its earliest beginnings.

Every lover of Chinese art today is familiar with the magnificent painted pottery of the Neolithic period, and we are apt to forget that little more than fifty years ago this stage in the evolution of Chinese civilisation, and all that went before it, was completely unknown. It was not until 1921 that positive evidence was found that China had actually passed through a Stone Age at all. In that year the Swedish geologist J. Gunnar Andersson and his Chinese assistants made two discoveries of immense importance. The first was at Chou-k'ou-tien, southwest of Peking, where deep in a cleft in the hillside Andersson picked up a number of flint tools, indicating that it had been occupied by very early man. He himself did not excavate, but his find led to further excavations and to the eventual discovery by Dr. P'ei Wen-chung of fossil bones which, with the exception of late Java man, *Pithecanthropus erectus*, were the oldest human remains yet discovered. The bones were those of a hominid, *Sinanthropus pekinensis*, who lived in the middle Pleistocene period, about half a million years ago, according to Andersson, although it has recently been suggested that *Sinanthropus* may be far older than that. The remains in the deep cleft, fifty metres thick, represent many thousands of years of occupation. Peking man had tools of quartz, flint and limestone, made either from pebbles chipped to shape or from flakes struck off a large pebble. He was a cannibal who broke open the bones of his victims to suck out the marrow; he had fire, ate grain and probably knew some very primitive form of speech. In 1964, in deposits on an open hillside in Lan-t'ien County, Shensi, palaeontologists discovered the cranium of a hominid believed, from related fossil remains, to be at least 100,000 years older than Peking man, and so roughly the same age as early Java man, *Pithecanthropus robustus*.

Gradually, in the late Pleistocene, the evolution of early man in China gathered pace. In recent years, remains of *Homo sapiens* have been found in many areas. 'Upper Cave Man' at Chou-k'ou-tien (c. 25,000 B.C.) had a wider range of stone tools than his ancestors, he probably wore hides sewn together, and his wife adorned herself with stone beads, drilled and painted with hematite, the earliest known intentional decoration in the history of Chinese civilisation. Finely fashioned microliths (very small stone implements) have been found in many desert sites in Ning-hsia and the Ordos region, different types of blades and flakes being fashioned for different purposes. Further south, in the region of northern Honan that was to become the last seat of the Shang Dynasty, thousands of microliths were discovered in a habitation site in 1960; other rich remains have been found far to the southwest, in Szechwan, Yunnan and Kweichow. Although as yet the dating of these scattered sites and their relationship to each other are by no means clear, their distribution suggests that the Upper Palaeolithic culture, shading imperceptibly into the Mesolithic, was spread very widely across ancient China.

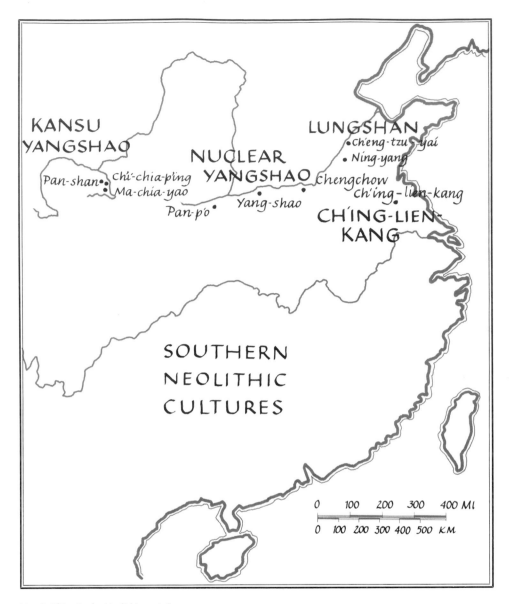

MAP 2 China in the Neolithic period.

NEOLITHIC CULTURE The people of the Mesolithic era were hunters and fishermen. The 'Neolithic Revolution' took place when the ancestors of the Chinese race settled down, began to build villages and to learn the arts of farming, horticulture and pottery making. It is not yet known when this momentous development took place in China, but sites on the Shensi-Szechwan border containing coarse cord-impressed grey pottery are thought to be as old as the sixth millennium B.C. Comparisons of this crude ware with the cord-marked pottery of South China and Southeast Asia suggest the existence of a primitive Neolithic culture over a wide area, out of which the mature Yang-shao culture with its magnificent painted pottery seems to have sprung with dramatic and as yet unexplained suddenness.

16

The first definite evidence of the existence of a Neolithic culture in China was found in 1921 by Andersson and his assistants, who located at Yang-shao-ts'un in Honan an extensive deposit of Neolithic tools and beautiful red pottery painted with designs in black. Before long more sites had been discovered in Honan. In 1923 Andersson went to Kansu to trace the connecting links which he suspected existed between this painted pottery and that of the Near East, and there he found more than fifty prehistoric sites representing a gradual development from about the third millennium B.C. to the Late Chou. Some of the features of this Neolithic culture are common to all early civilisations and belong to a culture-complex that extends from the Nile Valley to Mesopotamia, from the Indus Valley to the Tarim Basin, and is linked to China by the 'Corridor of the Steppes,' a natural migration route.

For many years we had to visualise Chinese Neolithic culture in terms of the rather poor sites found by Andersson—notably the single grave at Pan-shan in Kansu and the extensive but imprecise deposits at Yang-shao in Honan. This picture was dramatically revised in 1953 by the discovery of a group of Neolithic villages at Pan-p'o, east of Sian in Shensi on the right bank of the Chan River. The villages cover two and half acres; four separate layers of houses have been found in a cultural deposit three metres thick, repre-

1 Pan-p'o-ts'un, Shensi. Part of the Neolithic village after excavation; now a museum.

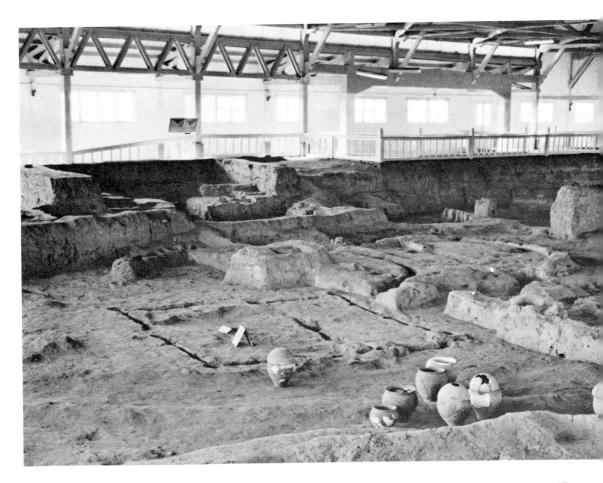

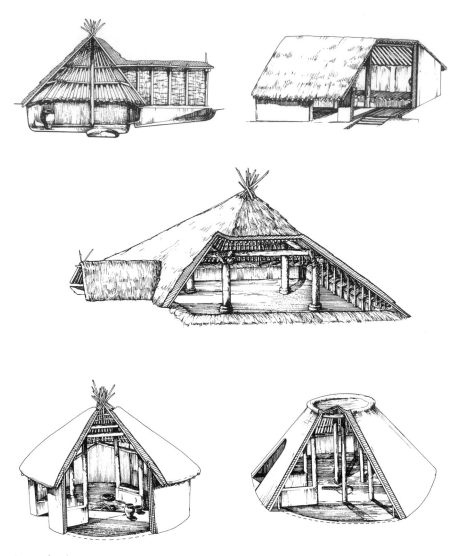

2 Pan-p'o-ts'un, Shensi. Neolithic houses, reconstructed. After Kwang-chih Chang.

senting many centuries of occupation spanning the fifth millennium B.C. The earliest inhabitants lived in round wattle-and-daub huts with reed roofs and plaster floors and an oven in the centre, the design perhaps copied from an earlier tent or yurt. Their descendants built rectangular, round, or square houses with a framework of wooden planking, sunk a metre below ground level and approached by a flight of steps. The roof of one particularly large building over twelve metres long was supported on three rows of posts. In the village were found no less than six pottery kilns, of two types: a simple pocket-shaped pit with a perforated floor, and a cylindrical tunnel with forced draft, leading to a beehive-shaped chamber. In these kilns the Pan-p'o potters made both a coarse grey or red pottery and a fine red ware burnished and then painted in black with geometric designs and occasionally with fishes and human faces. They seem not to have known the potter's wheel, but

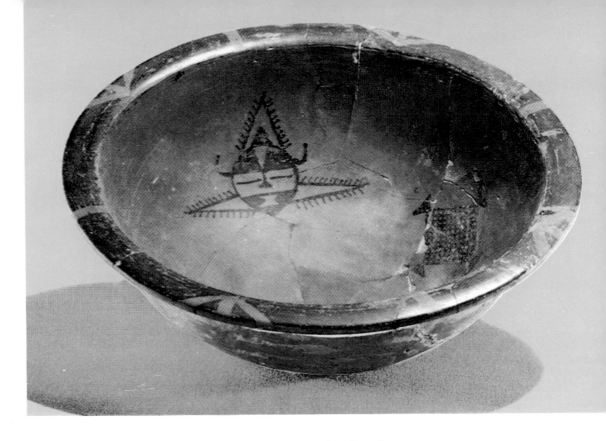

made their vessels by coiling long strips of clay. From clay they also made spindle whorls and even hairpins, but the finer objects such as needles, fishhooks, spoons, and arrowheads were made of bone. Part of the village of Pan-p'o has been roofed over and preserved as a museum of Chinese Neolithic culture.

3 Bowl. Pottery decorated with masks and nets(?) in black slip. Excavated at Pan-p'o-ts'un, Shensi. Early Yang-shao culture, Neolithic period.

The painted pottery found first by Andersson, and later in many other sites in Honan and Kansu, has not been matched in quality and beauty by any Neolithic wares discovered since. It consists chiefly of mortuary urns, wide and deep bowls and tall vases, often with loop-handles set low on the body. Though the walls are thin, the forms are robust, their generous contours beautifully enhanced by the decoration in black pigment which was clearly executed with a crude form of brush. Some of the designs are geometric, consisting of parallel bands or lozenges containing concentric squares, crosses, or diamonds. The lower half of the body is always left undecorated; perhaps it may have been set in the sandy ground to prevent it overturning. Many vessels are adorned with sweeping wavelike bands which gather into a kind of whirlpool; others make use of the stylised figures of men, frogs, fishes, and birds. Shards found at Ma-chia-yao in Kansu (c. 2500 B.C.) reveal a quite sophisticated brush technique, in one case depicting plants each of whose leaves ends in a sharp point with a flick of the brush—the same technique that was to be used by the Sung artist, three thousand years later, in painting bamboo. The naturalistic motifs however are rare, and the majority are decorated with geometric or stylised patterns whose significance is still a mystery.

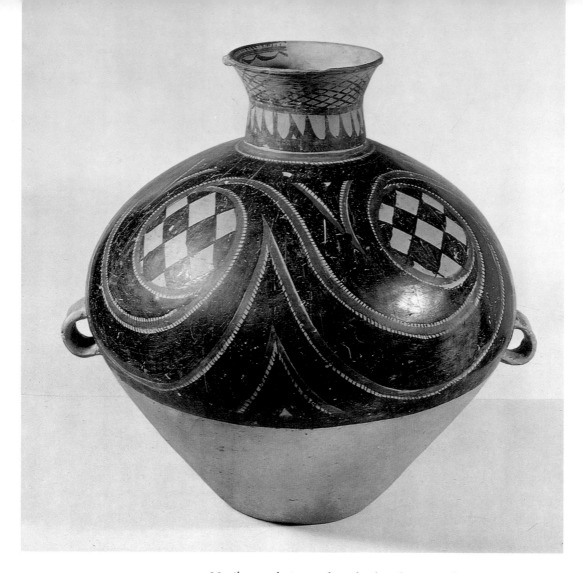

4 Funerary urn. Pottery decorated with red and black slip. Excavated at Pan-shan, Kansu. Yang-shao culture, Neolithic period.

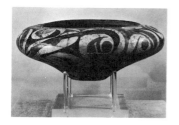

5 Bowl. Pottery decorated with scrolled ornament in red and white slip. Excavated in P'ei-hsien, Kiangsu. Ch'ing-lien-kang culture, late Neolithic period.

Until recently it was thought that the painted pottery Yang-shao culture was more or less directly superseded by a totally different culture centered on Shantung, and represented by the burnished black pottery of Lung-shan. But under the impact of a succession of new discoveries, this rather simple picture has given way to a more complex and interesting one. First of all, the beautiful painted pottery from Ma-chia-yao and Pan-shan in Kansu (c. 2400 B.C.) is now known from carbon 14 analysis to be as much as two thousand years later in date than the painted pottery of the Yang-shao village of Pan-p'o, which has yielded a date as early as 4865 B.C. ± 110 years.[2] This seems to suggest a centrifugal movement of the nuclear Yang-shao outward from the Central Plain (Chung-yüan) and to disprove the old theory that the Chinese painted pottery was the product of a great eastward movement, if not of peoples, then of an essentially Western Asiatic culture. That there may have been some crossfertilisation with Western Asia is possible, particularly in the later Neolithic period, but in their lively, uplifted forms and still more in the dynamic linear movement of their brush decoration, the Chinese painted vases reveal qualities that are uniquely Chinese.

The view that China developed her early civilisation more or less independently was reinforced by the discovery in 1959 of the first evidence of a late Neolithic culture in southeast China, at Ch'ing-lien-kang in northern Kiangsu. Intensive excavations in Kiangsu have revealed hundreds of sites, some of which are contemporary (by carbon 14 dating) with the Miao-ti-ko phase of the Honan Yang-shao—about 3900–2700 B.C.—that is, slightly later than Pan-p'o, but earlier than Pan-shan. In earlier editions of this book, following Dr. Chang Kwang-chih, I called this southeastern culture "Lungshanoid" because it seemed at first to be transitional between the Honan Yang-shao and the Black Pottery Culture of Shantung.[3] But while it has links with Yang-shao, its painted pottery, as illustrated by the elegant bowl on page 20, has distinctive characteristics, notably the liberal use of a white pigment in addition to red and black, which gives it a rather cheerful air. Some of the stone tools and implements of the Ch'ing-lien-kang culture are also quite different from those of North China, belonging rather to a family of artifacts that stretches right down the eastern coastal part of China to the south and southwest, and into Southeast Asia.

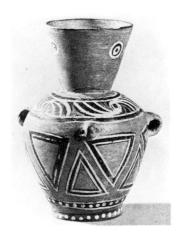

6 Jar. Pottery decorated with black and white slip. Excavated in Ning-yang-hsien, Shantung. Lung-shan culture, late Neolithic period.

As we move northwards from Kiangsu and later in time, we pass through Ta-wen-k'ou in the Ning-yang district of southern Shantung. The pottery found there includes both the black Lung-shan ware and a small quantity of red ware painted with geometric motifs in black and white slip. The 'Ta-wen-k'ou culture', if indeed it deserves so grand a name, appears to be earlier than the classic Lung-shan, and perhaps illustrates, so far as the northeast is concerned, the last stages of the decline of an ancient Neolithic tradition of brush painting that was not to be revived again in Chinese ceramic decoration until the Han Dynasty.

Still farther to the north, and later in time, we come to the 'classic' Black Pottery culture first discovered by Dr. Wu Chin-ting in 1928 at Lung-shan (Ch'eng-tzu-yai) in Shantung, and now dated by carbon 14 analysis to around 2000–1500 B.C. Most famous among the Lung-shan wares is a delicate pottery made of dark grey clay burnished black and of incredible fragility, being sometimes as little as half a millimetre thick. The shapes are elegant, while the decoration, consisting chiefly of raised bands, grooves and milled rings, gives it a somewhat metallic, machine-made look. It must have been extremely difficult to make, let alone use, for in the succeeding Bronze Age the tradition died out completely. Recent discoveries at Wei-fang in Shantung reveal that the Black Pottery culture also produced a white pottery of remarkable vigour and originality, illustrated here by the extraordinary pitcher, called a *k'uei*, which seems to imitate a vessel made of hides bound with thongs.

7 Stemcup. Black pottery. Excavated at Wei-fang, Shantung. Lung-shan culture, late Neolithic period.

While the painted and black wares are certainly the most spectacular, they represent only a small fraction of all the utensils produced by the Chinese Neolithic potter. There was much plain red ware and even more coarse grey ware representing an all-pervading continuation of the earliest ceramic tradition in China. To the art lover, these grey wares are often of interest more for their legacy than any intrinsic merit they may possess. For later we will

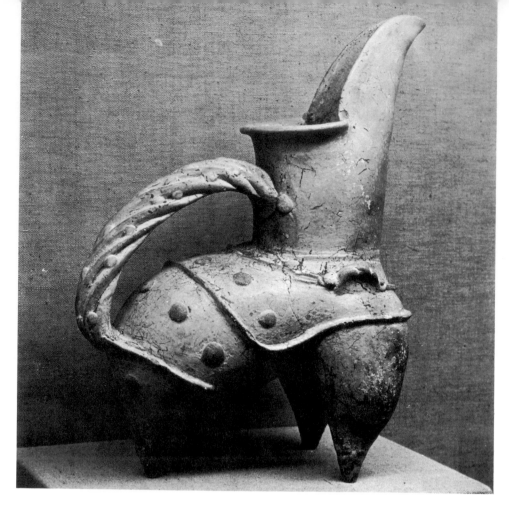

8 Pitcher. Greyish-white pottery. Excavated at Wei-fang, Shantung. Lung-shan culture, late Neolithic period.

find some of these shapes, notably the *ting* and *li* tripods, and the *hsien* steamer (a pot with perforated base standing on a *li*), adopted in the Bronze Age as ritual vessels used in the ancestral sacrifices of the Shang Dynasty; while the technique of impressing designs in the wet clay, which later developed, particularly in eastern China, into a sophisticated language of stamped motifs, also played its part in the decoration of the bronzes.

As we move westward again from Shantung into Honan, we find black Lung-shan pottery in strata overlying the earlier Yang-shao and representing a still later stage in the development of the Neolithic culture of the Chung-yüan. In some of the latest black pottery sites, such as Ch'i-chia-p'ing in Kansu, dated by carbon 14 to around 2000–1750 B.C., simple artifacts of pure copper begin to appear, heralding the dawn of the great Bronze Age culture that will be described in Chapter 2.

Though often beautifully made and finished, most of the stone implements of late Neolithic times were utilitarian objects such as hoes, scrapers and axes, one of the latter being the ancestor of the *ko*-type dagger axe of the Shang Dynasty (p. 38). The finest of these implements were made of polished jade, a stone which, because of its hardness, fine texture and purity of colour was

destined to become an object of special veneration in Chinese cultural history. Among Neolithic jades are bracelets (*huan*), penannular rings (*chüeh*), and half-rings (*huang*), a flat disc with a hole in the centre (*pi*) and a ring or short tube squared on the outside (*tsung*). In later historic times these shapes acquired a ritual or ceremonial function, the *pi* and *tsung*, or example, symbolising respectively heaven and earth; but there is no means at present of knowing whether they already had this, or indeed any, symbolic meaning in the late Stone Age.

Into this short chapter we have compressed more than half a million years of human history in China. Although the picture is enormously oversimplified, it shows that before the dawn of recorded history there had already emerged many of those characteristics which we consider essentially Chinese: a highly organised social life centred on agriculture and bound together by ritual, high standards of craftsmanship, the flexible brush as an instrument of artistic expression, the ceremonial use of jade, and a preoccupation with man's fate after death. This primitive culture lingered on in South and West China long after the coming of bronze had opened a new and incomparably richer chapter in Chinese history.

9 *Hsien* steamer. Excavated at Chengchow, Honan. Second millennium B.C.

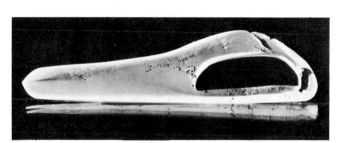

10 Scraper or dagger. Polished stone. Excavated in Pi-hsien, Kiangsu. Late Neolithic period.

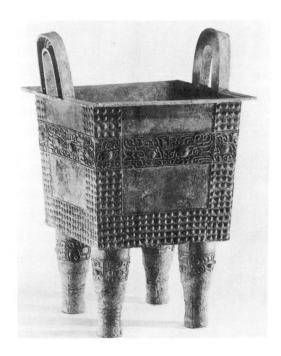

Supp. 1 Ritual vessel, *ting*, with animal mask and nipple design. Bronze; ht. 100 cm. Excavated in 1974 at Chengchow (see page 27). The exceptional size and fine workmanship of this vessel show that Middle Shang culture, before the capital moved to Anyang, was much more advanced than had formerly been thought.

2

The Shang Dynasty

For centuries, farmers living in the village of Hsiao-t'un near Anyang in Honan have been picking up peculiar bones which they found lying in the fields after rain or while they were ploughing. Some were polished and shone like glass; most had rows of oval notches in their backs and T-shaped cracks; a few had marks on them that looked like primitive writing. The farmers would take these bones to apothecaries in Anyang and neighbouring towns, who often ground off the marks before selling them as 'dragon bones', a potent ingredient in restoratives. In 1899 some of the inscribed bones fell into the hands of the noted scholar and collector Liu Ngo, who recognised the writing as an older form of the archaic script already known on the ritual bronzes of the Chou Dynasty. Soon, other scholars, notably Lo Chen-yü and Wang Kuo-wei, took up the study of what were, in fact, fragments of the archives of the royal house of Shang, the actual existence of which had hitherto not been proved, though Chinese historians had never doubted it.

The bones were traced to Anyang. The farmers began to dig deeper, and before long there began to appear on the antique market in Peking and Shanghai magnificent bronze vessels, jades and other objects, whose exact place of origin was kept secret. For nearly thirty years the farmers and dealers' agents, working at night or during the idle winter months, continued their indiscriminate pillaging of Shang tombs. Finally, in 1928, the Chinese National Research Institute (Academia Sinica) began at Anyang an important series of excavations which were to provide the first definite archaeological evidence that the Shang Dynasty had actually existed and was not, as some Western writers had come to suspect, a pious fabrication of the backward-looking Chinese. By 1935 more than three hundred graves had been discovered, ten of which, of enormous size, were undoubtedly royal tombs.

These discoveries posed more problems than they solved. Who were the Shang people and where did they come from? How was it that their earliest remains revealed a culture of such sophistication, particularly in their bronze techniques? If the Shang had existed,

then perhaps remains would be found of the even earlier Hsia Dynasty.

The Chinese traditionally believe that they are descended from Huang Ti, the Yellow Emperor, who lived for a hundred years. He succeeded Fu Hsi, who first drew the magical diagram *pa kua* (the "eight trigrams") from which the art of writing is descended. Shen Nung, the Divine Farmer, invented agriculture and discovered the use of medicinal herbs. Then came Yao and the filial Shun, the ideal rulers, and finally Yü the Great, who founded the Hsia Dynasty. In these legendary figures the Chinese personified all that they held most sacred: agriculture, good government, filial piety and the art of writing. Now it is believed that all these personages were invented or took on these rôles at a much later date. Yü, Yao and Shun appeared first in late Chou literature. Huang Ti was probably invented by the Taoists. As for the Hsia, although the character appears on the Shang oracle bones, it is never used there to refer to the dynasty, which may simply have been invented by the Chou people to legitimatise their conquest of the Shang, whom they chose to consider as usurpers. Before the rise of Shang there were, as we saw in Chapter 1, many primitive communities, and one of those conquered by the first Shang ruler may have been called Hsia. Such communities form a connecting link between the late Neolithic and the full flowering of the Bronze Age.

As early Chinese culture coalesced, it came to incorporate elements characteristic of several distinct regions. The people of North China practised shamanism and elaborate burial rites; some authorities believe that they were originally matriarchal; they had timber houses partly sunk in the ground, and ate dry grains such as wheat and barley. By the second millennium B.C. they were being influenced by the northwestern 'proto-Turkic' peoples, who bridged the huge empty spaces between them and the cultures of central and western Asia, and who brought to China itself a patriarchal nomadism, horses and horse-sacrifice, the worship of the heavenly bodies, tumulus graves and the use of earthen drums. At a somewhat later stage, and especially in the Chou period, North China felt the impact of the Yüeh group of peoples from the southeast and south, whose ethnic links were as much with Southeast Asia and Oceania as with China proper. They lived by the sea and on the rivers, had longboats and fought naval battles, worshipped the forces of the rain and rivers in serpents and crocodiles ('dragons'), used bronze drums, tattooed themselves, perhaps lived in longhouses, cultivated wet rice and decorated their pottery with stamped designs.

Until 1950 our knowledge of Shang culture was derived almost wholly from the remains of the Shang capital at Anyang, founded by King P'an-keng around 1400 B.C. and finally conquered by the armies of the Chou in the second half of the eleventh century B.C. At Anyang the bronze culture was at its height; the metalworkers were producing sacrificial vessels of a quality that has been equalled

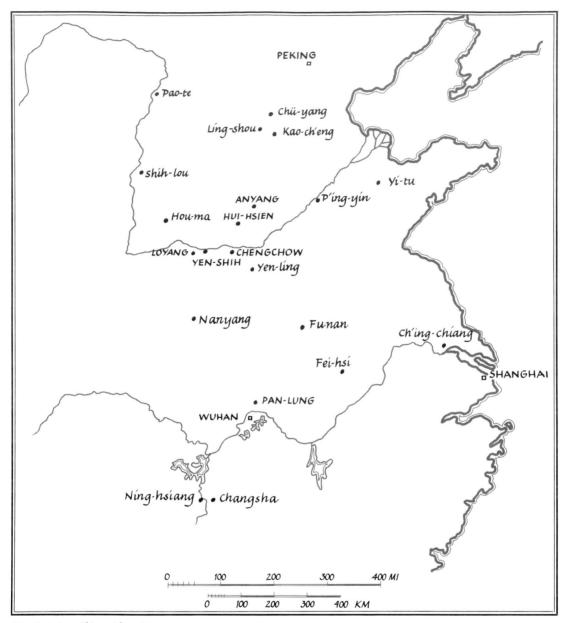

Map 3 Ancient China with major
Shang Dynasty sites.

nowhere in the world—the culmination, clearly, of centuries of development. The oracle bones gave the names of eighteen kings before P'an-keng and, according to tradition, the Shang had moved their capital five times before finally settling at Anyang. If traces of these earlier capitals could be found, the gap between the late Neolithic and the mature bronze culture of Anyang might be closed.

When the new régime came to power in 1949, there was some fear that the authorities would have no time or funds for archaeological excavation and that the pioneer work of the Academia Sinica would be forgotten. But the opposite was the case. Popular education and the fostering of pride in China's cultural heritage have combined to arouse the interest and cooperation of the poorest peasant, while the work of the Institute of Archaeology of the Chinese Academy of Sciences, the universities and various regional organisations is rapidly altering the whole archaeological picture. One result of this activity has been that it is now known that Shang culture and its influence spread far beyond the Anyang region, reaching up into northern Hopei and Shansi, southwards into the central Yangtse Valley, and southeastwards into Anhui, Chekiang and Kiangsu. It now seems that the dawn of the historical Shang Dynasty broke not at Anyang but in the Yen-shih district of Honan, lying between Loyang and Chengchow. Bronze Age finds in this region have been dated by corrected carbon 14 analysis to 1870 B.C. ±95 years. One site, Kao-yai, is clearly stratified: Yang-shao—Lung-shan—early Bronze Age; another, much richer, is Erh-li-t'ou on the Lo River nearby. Here have been found the remains of a bronze foundry, a bronze bell, turquoise, jade and shell ornaments, and new pottery shapes such as the *chia*, *ku* and *chüeh* (shortly to appear in bronze), some of which bear incised markings which may be a primitive form of script. It has been suggested that Erh-li-t'ou was the site of Po, capital of the first Shang monarch T'ang Wang.

The next big step in the development of Shang culture is represented by the remarkably rich finds in and around Chengchow. The lowest strata are typical Lung-shan, with no bronze, but the next stages, Lower and Upper Erh-li-kang, show a dramatic change. Remains of a city wall more than a mile square and sixty feet across at the base have been uncovered, together with what were probably sacrificial halls, houses, bronze foundries, pottery kilns and a bone workshop. Large graves were furnished with ritual bronze vessels, jade and ivory, while the pottery includes both glazed wares and the fine white ware first found at Anyang. All the evidence points to Chengchow having been the site of a great city, very probably Ao, capital of the tenth Shang ruler Chung-ting. The decline in quality of the remains in the last Shang phase at Chengchow, represented by the People's Park site to the northwest of the city, suggests that by then the capital had already been moved to Anyang.

In the autumn of 1974, archaeologists working at P'an-lung, north of the great industrial city of Wuhan on the Yangtse, unearthed the remains of a large building and a richly furnished tomb of the Middle Shang–Chengchow period. At the time of writing it is not yet known whether this supposed palace was the seat of a Shang feudal chief or district governor, or of an independent ruler, but the presence of so important a Shang site so far to the south has led to much speculation as to just how far the influence of Shang culture extended. There seems no doubt, however, that Shang

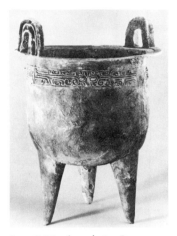

Supp. 2 Ritual vessel, *ting*, Bronze; ht. 48 cm. Excavated in 1974 from the site of a palace at P'an-lung, in Huang-p'i-hsien, Hupei. The palace, tombs and bronzes from the P'an-lung excavations provide important evidence of the southward extension of Shang culture in the period around 1400–1300 B.C.

civilisation reached its peak at Anyang, a region which the Chou people called 'Yin'. Half a century of periodic excavation there has given us a detailed picture of the city and of its social and economic life. Chinese historians today, following orthodox Marxist doctrine, describe Shang and Chou as pre-feudal slave societies, and indeed the contents of the royal tombs at Anyang alone are enough to show that, under the Shang, slaves were many and brutally treated. But it seems that elements of feudalism were already present, for the inscriptions on the oracle bones indicate that successful generals, sons and even wives of the Shang rulers were enfeoffed, while small neighbouring 'states' paid regular tribute. Prominent among the officials was the *chen-jen* who, as a scribe, composed and probably wrote the inscriptions on the oracle bones, and, as a diviner, interpreted the cracks which appeared in them when a hot metal rod was applied to one of the holes bored into the back. These inscriptions were generally engraved, though a few were written with brush and ink. About three thousand characters have been identified, rather less than half of which have been deciphered; they were written in vertical columns, moving either to the left or to the right, apparently according to the dictates of symmetry. In the early stages at Chengchow the oracle bones were mainly scapulae of pig, ox or sheep; in the final phase at Anyang tortoise shells were used almost exclusively, fastened together with thongs passed through holes at each end, as is shown in the pictograph for a book, *ts'e*: 卌. The inscriptions on the bones are either declarations of fact or of the ruler's intentions, or questions about the future which could be answered with a simple yes or no. They relate chiefly to agriculture, war and hunting, the weather, journeys and the all-important sacrifices by means of which the ruler attuned himself to the will of heaven. They reveal that the Shang people had some knowledge of astronomy, knew precisely the length of the year, had invented the intercalary month and divided the day into periods. Their religious belief centred in a supreme deity (Ti) who controlled the rain, wind and human affairs, and in lesser deities of the heavenly bodies, of the soil, of rivers, mountains and special places (the *genius loci*). Special respect was paid to the ancestral spirits, who lived with Ti and could affect the destinies of men for good or ill, but whose benevolent concern in the affairs of their descendants could be ensured by elaborate sacrificial rites.

The Shang people built chiefly in wood and tamped earth. Remains have been found of several large buildings; one of them, over ninety feet long, was raised on a high plinth, its presumably

11 Reconstruction of a house at Hsiao-t'un, Anyang. Late Shang Dynasty. After Shih Chang-ju and Kwang-chih Chang.

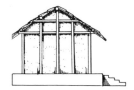

thatched roof supported on rows of wooden pillars, of which the stone socles remain. Another was laid out axially with steps in the centre of the south side, and but for its roof would not have looked so very different from any large building in North China today. Some of the more important buildings were adorned with formalised animal heads carved in stone, and their beams were painted with designs similar to those on the ritual bronzes. The most popular method of construction—presumably because it was cheap and provided good protection against the piercing cold of the North China winter—was the *pan-chu* ("plank building") technique, in which the earth was tamped between vertical boards with a pole: the smaller the diameter of the pole, the stronger the wall. Chou texts relate that the common people lived in 'burrows and nests'. The 'nests' may refer to little huts raised, as in Southeast Asia, several feet above the ground. The 'burrows' were either caves in the loess terraces, still inhabited today by millions of North China peasants, or dwellings sunk below the surface of the ground, a custom inherited from Neolithic times. Many of these dwelling pits have been found at Anyang. They had plaster floors and walls, while as in Neolithic times, rows of timber posts supported a thatched roof, probably with a hole in the centre through which the smoke from the central hearth escaped. Often a deep storage pit was sunk in the floor of the house. We can imagine ancient Anyang as a cluster of these lowly dwellings, with here and there a large timber building raised on a platform, the whole city surrounded by a mud wall with gates at intervals surmounted by watchtowers.

The most spectacular of Shang remains, however, are not the buildings but the tombs. The Chinese belief that the spirit of the departed must be provided with all he possessed (or, indeed, would

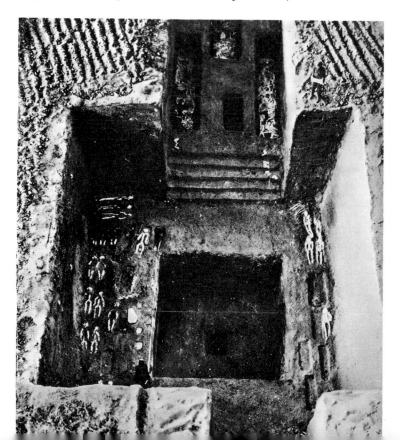

12 Replica of excavated tomb at Wu-kuan-ts'un, Anyang. Late Shang Dynasty.

29

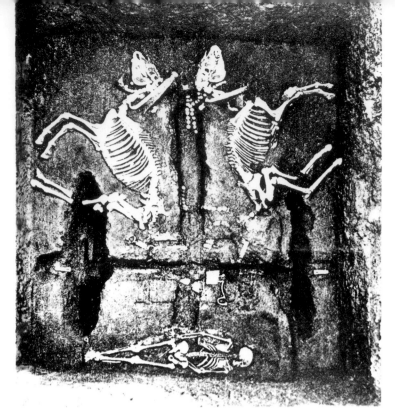

13 Carriage burial, showing bronze fittings in place. Anyang. Late Shang Dynasty.

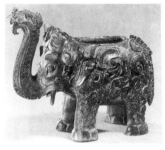

Supp. 3 Ritual vessel, *ts'un*, in the shape of an elephant. Bronze; ht. 22.8 cm. This richly-ornamented wine vessel of the Late Shang period was discovered in 1975 southeast of Changsha in Hunan, during tree-planting on the Li-ling Commune. Although an isolated find, it helps to confirm the evidence of the spread of high bronze culture into south China before the end of the Shang Dynasty.

have liked to possess) in his earthly life led to immolation and human sacrifice on a gigantic scale. Later the more frightful practises were abandoned, but until the Ming Dynasty the custom persisted of placing in the tomb pottery models not only of furniture, farms and houses, but also of servants, guards and domestic animals. At the same time, the corpse was decked out with the richest clothing, jewellery and jades that his family or the state could afford. Collectors are even known to have been buried with their favourite paintings. However much one may deplore this custom, it has ensured the preservation of many beautiful things that would otherwise have been irretrievably lost.

The Shang tombs throw a lurid light upon early Chinese civilisation. Some of them were of enormous size and furnished with bronze vessels, jade objects and pottery. One royal personage, apparently an animal lover, had his pets, including an elephant, buried near him in separate graves. The tomb excavated at Wu-kuan-ts'un contained the remains of a canopy of painted leather, woodbark and bamboo; in the approaching ramps and main chamber lay the complete skeletons of no less than twenty-two men (one beneath the tomb chamber) and twenty-four women; while the skulls of a further fifty men were buried in adjacent pits. In some cases the bodies show no signs of violence—the result, perhaps of voluntary self-immolation by relations or retainers of the dead man—while in others, decapitation suggests the victims may have been slaves, criminals or prisoners of war. Elsewhere at Anyang, light carriages with their horses and driver were buried in specially prepared pits, with channels dug out for

the wheels. The wood has of course perished, but impressions in the earth have made it possible to reconstruct the carriage itself, and thus to determine the position and function of many of its beautiful bronze fittings. Mass immolation was not practised officially by the Chou, though it appears to have been revived from time to time, on a more modest scale, by later rulers.

One of the biggest surprises at Anyang was the discovery of Shang marble sculpture in the round, a notable example of which is the head of an ox illustrated here. Previously, nothing of the sort earlier than the Han Dynasty was known, and even today only a handful of Chou stone carvings have been unearthed and those so small as hardly to deserve the name of sculpture. Other figures include tigers, buffaloes, birds, tortoises and a kneeling captive (or sacrificial victim) with his hands tied behind his back. A few of the larger pieces have slots in the back suggesting that they might have been part of the structure and decoration of a building, perhaps a sacrificial hall; for there is a close similarity in style between many of these figures and those depicted on the ritual bronzes. They are carved foursquare out of the block, rigidly frontal, and have something of the formality and compactness of Egyptian art. Their impressiveness (although none are more than a metre or so in maximum dimension) derives from their solid, monumental feeling of weight and from the engraved geometric and zoomorphic designs which play over their surface, rather than from the tension over the skin itself which enlivens Egyptian sculpture.

Ceramics formed the backbone of early Chinese art, indispensable, ubiquitous, reflecting the needs and tastes of the highest and the lowest, lending its forms and decoration to the metalworker and, less often, borrowing from him. In the Shang, the crudest is a grey earthenware, cord-marked, incised or decorated with repeated stamped motifs ranging from squares and coils, the ancestor of the 'thunder pattern' (*lei-wen*), to simple versions of the zoomorphic masks which appear on the bronzes. Pottery decorated by stamping or carving geometric designs in the wet clay has been found in a number of Neolithic sites in the southeast, notably in Fukien (Kuang-tse) and Kwangsi (Ch'ing-chiang). In South China, this technique persisted into the Han Dynasty and was carried thence to Southeast Asia—if, indeed, it had not originated there. It is very seldom found in the Neolithic pottery of North China, and its appearance on vessels at Chengchow and Anyang suggests that by the Shang Dynasty the culture of the southern peoples was already beginning to make its influence felt.

The beautiful white Shang pottery is unique in the history of Chinese ceramics. So fine is it that it has been taken for porcelain, but it is in fact a very brittle ware made from almost pure kaolin, finished on the wheel, and fired at about 1000° C. Many writers have remarked how closely its decoration echoes that of the bronzes, but there is no proof that this style in fact originated in bronze. As we have seen, Southeast China had already evolved a

SHANG POTTERY

14 Ox-head. Marble. Excavated at Hou-chia-chuang, Anyang. Late Shang Dynasty.

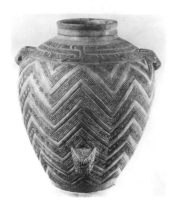

technique for stamping designs in the wet clay, which in turn influenced bronze design; the white stoneware urn in the Freer Gallery illustrated here is indeed very close in design and decoration to a bronze vessel in the Hellström collection. The Chengchow finds suggest that some of the motifs decorating both the white ware and the bronzes originated in the earlier stamped grey pottery; the techniques and designs used in woodcarving suggest another possible source. Some of the grey and buff ware found in Shang sites in Honan and Hupeh is glazed. While in some cases the glaze was produced accidentally when wood ash fell on the heated pottery in the kiln, in others it is a true felspathic glaze, generally reddish-brown or greenish-yellow, applied very thinly and evenly to both inner and outer surfaces of the vessels. These Shang glazed wares, which are being excavated in ever-increasing quantities, are the remote ancestors of the renowned celadons of later dynasties.

15 Urn. Carved white pottery. From Anyang. Late Shang Dynasty.

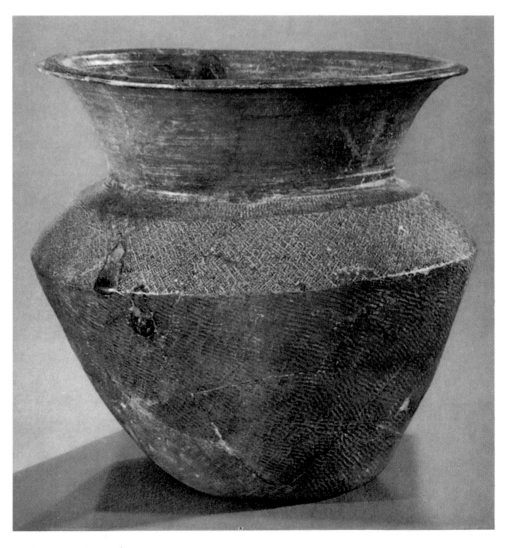

16 *Tsun* vase. Proto-porcelain decorated with impressed design under yellowish-brown felspathic glaze. Excavated at Chengchow, Honan. Middle Shang period.

According to tradition, when the great emperor Yü of the Hsia divided the empire, he ordered nine *ting* tripods to be cast in metal, brought as tribute from each of the nine provinces, and decorated with representations of the remarkable things characteristic of each region. These tripods were credited with magical powers; they could ward off noxious influences, for example, and cook food without fire. From dynasty to dynasty they were handed down as the palladia of empire, but at the end of the Chou they were lost. The unsuccessful efforts of the first Ch'in emperor, Shih-huang-ti, to recover one of them from a riverbed are mocked in several delightfully humorous Han reliefs, though one of the Han emperors tried to accomplish the same thing by means of sacrifices with no better success. But so strong was the tradition of the nine tripods that as late as the T'ang Dynasty the 'empress' Wu caused a set to be cast in order to bolster up her own dubious claim to the throne.

Long before any archaeological evidence of the Shang Dynasty had been unearthed, the ritual bronzes bore witness to the power and vitality of this remote epoch in Chinese history. Bronze vessels have been treasured by Chinese connoisseurs for centuries: that great collector and savant, the Sung emperor Hui-tsung (1101–1125), is even said to have sent agents to the Anyang region to search out specimens for his collection. These vessels, which, as Hansford aptly observed, formed a kind of 'communion plate', were made for the offerings of food and wine to ancestral spirits which formed the core of the sacrificial rites performed by the ruler and the aristocracy. Some of them bear very short inscriptions, generally consisting of two or three characters forming a clan name. Often this inscription is enclosed within a square device known as the *ya-hsing*, from its resemblance to the character *ya*. A number of theories as to its meaning have been advanced. The recent discovery at Anyang of bronze seals leaving an impression of precisely this shape suggests that it was in some way connected with the clan name.

17 *Ya-hsing.*

18 Sectional clay moulds for bronze-casting. After Shih Chang-ju and Kwang-chih Chang.

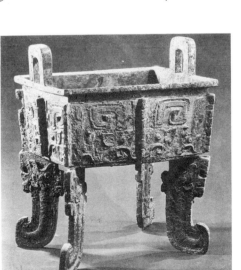

Supp. 4 Ritual vessel, *fang* (square) *ting*. Bronze; ht. 42.5 cm. Excavated at Anyang in 1976 from the tomb of Fu Hao, consort of King Wu-ting of the Shang Dynasty (early 12th century B.C.). Richly furnished and undisturbed, this is the first Shang tomb to be identified, through its bronze inscriptions, with a particular ruler. The thin curved legs of this vessel have hitherto been thought to be more characteristic of the early Chou period.

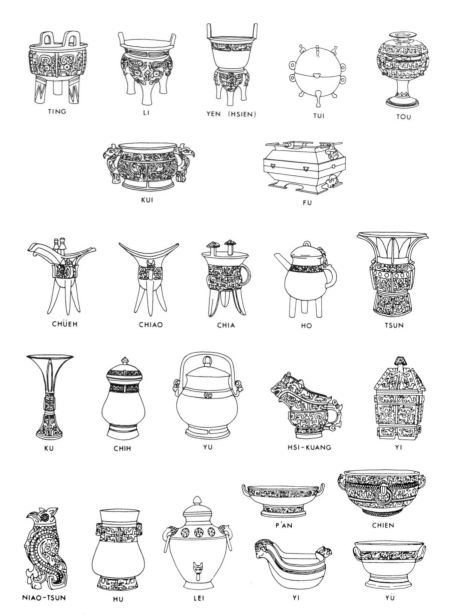

| TING | LI | YEN (HSIEN) | TUI | TOU |

| KUI | FU |

| CHÜEH | CHIAO | CHIA | HO | TSUN |

| KU | CHIH | YU | HSI-KUANG | YI |

| NIAO-TSUN | HU | LEI | P'AN | CHIEN | YI | YÜ |

19 Major types of Shang and Chou bronze vessels. After Kwang-chih Chang.

Chemical analysis shows that the bronze vessels were composed of 5–30 per cent tin, 2–3 per cent lead, the rest (apart from impurities) being copper. In course of time many of them have acquired a beautiful patina, much valued by connoisseurs, which ranges from malachite green and kingfisher blue to yellow or even red, according to the composition of the metal and the conditions under which the vessel was buried. Forgers have gone to enormous trouble to imitate these effects, and Yetts records the case of one family of which each generation buried fakes in specially treated soil, to be dug up and sold by the next generation but one. It was long thought that the Shang and Chou bronzes were made by the *cire-perdue* method; for how, it was argued, could such exquisite detail have been modelled except in wax? However, while the

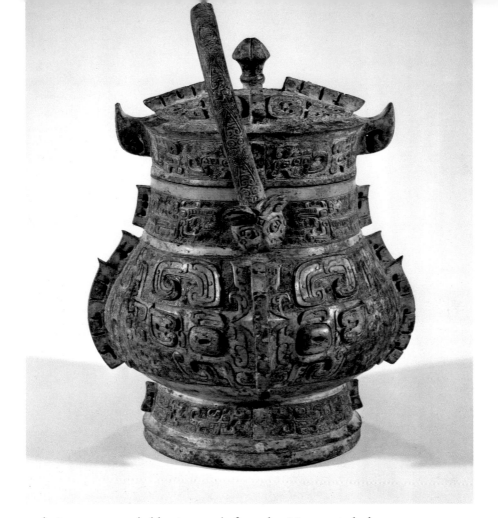

20 Ritual vessel, *yu*. Bronze. Late Shang Dynasty.

technique was probably in use before the Han period, large numbers of outer and inner clay moulds and crucibles have been found at Anyang and Chengchow, and there is now no question that the vessels were cast in sectional moulds assembled round a solid central core and that legs and handles were cast separately and soldered on. Many vessels still show ridges or rough places where two mould sections were imperfectly joined.

There are at least thirty main types of ritual vessels, which range in size from a few inches in height to a gigantic *ting* unearthed at Anyang in 1939 which was cast by a Shang king in memory of his mother; it is over four feet high and weighs 800 kilograms. They can most simply be grouped according to their use in the sacrifices. For cooking food (of which the essence only was extracted by the spirits, the participants later eating what they left behind), the chief vessels were the hollow-legged *li* tripod and the *hsien* steamer. Both of these types, as we have seen, were common in Neolithic pottery and may then already have had a more-than-utilitarian function in some primitive rite. The *ting*, which has three or four straight legs, is a variant of the *li*, and like it generally has fairly large handles or 'ears' to enable it to be lifted off the fire. Vessels made for serving food included the two-handled *kuei* and the *yü* (basin). Among

35

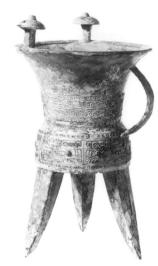

21 Ritual vessel, *chia*. Bronze. Phase I, Middle Shang period.

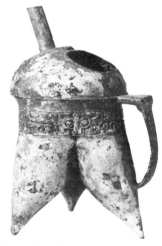

22 Ritual vessel, *li-ho*. Bronze. Phase II, Middle Shang period.

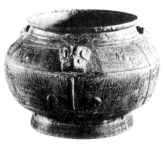

23 Ritual vessel, *p'ou*. Bronze. Phase III, Shang Dynasty, early Anyang period.

those for fluids (chiefly wine) were the *hu* (a vase or jar with a cover), the *yu* (similar, but with a swing or chain handle and sometimes fitted with a spout), the *chih* (a cup with a bulbous body and spreading lip), the *ho* (kettle), the tall and elegant trumpet-mouthed *ku* for pouring libations, and its fatter variant, the *tsun* (both derived from pottery prototypes), the *chia* and the *chio* for pouring and probably also for heating wine, and the *kuang*, for mixing wine, shaped like a gravy boat, generally with a cover and provided with a ladle. Other vessels such as the *i* and *p'an* were presumably made for ritual ablutions.

During the fifteen hundred years that bronze-casting was a major art form in China, the art went through a series of changes in style, reflecting ever greater sophistication in technique and decoration, which make it possible to date vessels within a century or less. In 1953, Professor Max Loehr proposed five phases for the Shang which have since been largely confirmed by excavation: Shang I, vessels with thin relief decoration, simple forms and a light, airy effect. Shang II, decoration in carved ribbon relief and forms that tend to be harsh and heavy. Shang III, dense fluent curvilinear designs. (In fact, II and III are not always distinguishable and may have been contemporaneous.) Shang IV, main motifs and spiral background first become separated, though in the same plane. Shang V, motifs rise in bold relief and background spirals may disappear altogether. Phases I, II and III have been found at Chengchow (see p. 32); Phases IV and V evolved after the move to Anyang.

The bronzes first published from Chengchow were, as one would expect, simpler and cruder versions of the magnificent vessels of the Anyang period, thinly cast in poor-quality alloy. But recent excavations have revealed vessels of rather higher quality, notably two very large and robustly modelled *ting* decorated with bands of bosses and *t'ao-t'ieh* masks in thread relief, that suggest that bronze technology at Chengchow was more advanced than was once thought. But with new discoveries being made almost daily, it is too soon to say just how far the bronze art had progressed before the move to Anyang.

At Anyang, the bronze art is fully mature, the reflection of a stable and prosperous society. In the perfection of their craftsmanship and the immense power of their form and decoration, the Shang bronzes must rank as one of the great artistic triumphs of early civilisation. The zoomorphic motifs which adorn them and give them their intense vitality may seem to be innumerable, but are for the most part variations and combinations of the same few elements—notably the tiger, water buffalo, elephant, hare, deer, owl, parrot, fish, cicada and possibly the silkworm. Occasionally, in a frieze around an otherwise plain vessel, these creatures may be represented naturalistically, but far more often they are so stylised as to be barely recognisable; their bodies dissolve, their limbs break down or take on a life of their own, sprouting other creatures. The *k'uei* dragon, for example, may appear with gaping jaws, with a beak, with a trunk, wings or horns, or he may form the eyebrow of

that most impressive and mysterious of all mythical creatures, the *t'ao-t'ieh*.

This formidable mask, which often appears to be split open on either side of a flange and laid out flat on the belly of the vessel, is the dominating element in the decoration of Shang bronzes. Sung antiquarians named it *t'ao-t'ieh* in deference to a passage in a third-century B.C. text, the *Lü Shih Ch'un-ch'iu*, which runs, "On the *ting* of the Chou there is applied the *t'ao-t'ieh*: having a head but no body he ate people, but before he had swallowed them, harm came to his body." Thus, by the end of Chou, the *t'ao-t'ieh* was considered as a monster; later it came to be called 'the glutton', and was interpreted as a warning against overeating. Modern scholars have claimed that it represents a tiger or a bull; sometimes it has the characteristics of the one, sometimes of the other. Mizuno has drawn attention to a passage in the *Ch'un-ch'iu Tso-chuan* describing the *t'ao-t'ieh* as one of the four devils driven away by the emperor Shun, and subsequently made defenders of the land from evil spirits.[1] Like the grotesque characters in the Tibetan 'devil dance', the more terrifying the *t'ao-t'ieh*, the greater his protective power.

Two examples will show how effectively the various elements can be combined and integrated with the shape of the vessel itself. The lid of the *kuang* shown on this page terminates in a tiger's head at one end and an owl's at the other; the tiger's legs can clearly be seen on the front of the vessel, the owl's wing at the back. Between them a serpent coils up onto the lid, ending in a dragon's head at the crown of the dorsal flange. The main decoration of the magnificent *chia* in Kansas City (Fig. 25) consists of *t'ao-t'ieh* masks divided down the centre by a low flange and standing out against a background of spirals, called *lei-wen* by Chinese antiquarians from their supposed resemblance to the archaic form of the character *lei* ("thunder"). However, like the endless spirals painted on the Yang-shao pottery, their meaning, if any, is lost. The *t'ao-t'ieh* has large 'eyebrows' or horns; a frieze of long-tailed birds fills the upper zone, while under the lip is a continuous band of 'rising blades' containing the formalised bodies of the cicada, a common symbol of regeneration in Chinese art. The vessel is crowned with a squatting heraldic beast and two large knobs for lifting it off the fire with tongs, while the tapering legs are decorated with a complex system of antithetical *k'uei* dragons.

Several distinct bronze styles appear to have existed simultaneously.[2] Some vessels are plain, some richly ornamented, while some confine the decoration to a band below the lip; the *kuei* may have *t'ao-t'ieh* on its body, or vertical fluting like a Georgian teapot, while its handles, like those on many Shang bronzes, are vigorously modelled in the form of elephants, bulls, tigers or more fabulous composite creatures. That this mastery of the craft was not confined to Anyang is shown by the magnificent *tsun* illustrated here which was excavated in 1957 at Funan in Anhui. At first it was thought that it could not have been made locally but must have

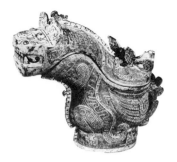

24 Ritual vessel, *kuang*. Bronze. Phase IV, Late Shang period.

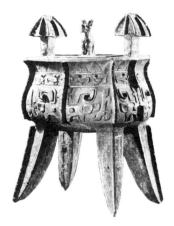

25 Ritual vessel, *chia*. Bronze. Phase V, Late Shang period.

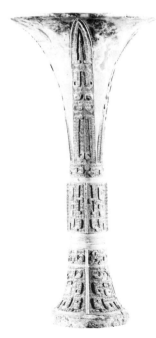

26 Ritual vessel, *ku*. Bronze. Phase V, Late Shang period.

37

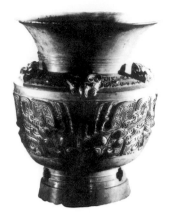

27 Ritual vessel, *tsun*. Bronze. Excavated at Funan, Anhui. Late Shang period.

been imported from Anyang. But now we realise that Shang culture reached far beyond the Central Plain and that this richly conceived vessel, whose decoration is more flowing and 'plastic' than that of the typical late Anyang bronzes, must represent a vigorous local tradition far to the southeast. Occasionally, the effect is too bizarre and extravagant to be altogether pleasing, but in the finest vessels the main decorative elements play over the surface like a dominant theme in music against a subtle 'ground bass' of *lei-wen*; indeed, to pursue the analogy further, these motifs seem to interpenetrate one another like the parts in a fugue, and at the same time to pulsate with a powerful rhythm. Already in the sweeping decoration of the Yang-shao painted pottery we saw a hint of that uniquely Chinese faculty of conveying formal energy through the medium of dynamic linear rhythms; here in the bronzes that faculty is even more powerfully evident, while many centuries later it will find its supreme expression in the language of the brush.

The bronze weapons used by the Shang people show several aspects of this many-faceted culture. Most purely Chinese was a form of dagger-axe known as the *ko*, with pointed blade and a tang which was passed through a hole in the shaft and lashed to it, or, more rarely, shaped like a collar to fit round the shaft. The *ko*

28 Dagger-axe, *ko*. Bronze with jade blade. From Anyang. Late Shang period.

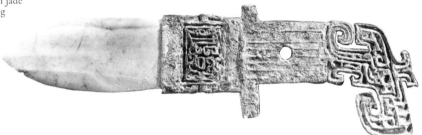

29 Axe, *ch'i*. Bronze. From Yi-tu, Shantung.

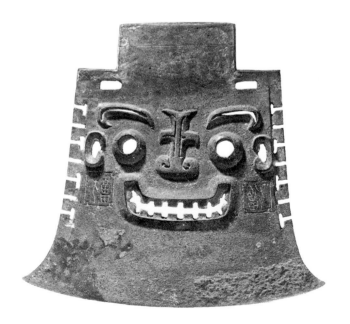

probably originates in a Neolithic weapon and seems to have had a ritual significance, for some of the most beautiful Shang specimens have blades of jade, while the handle is often inlaid with a mosaic of turquoise. The *ch'i* axe, which also originated in a stone tool, has a broad, curving blade like that of a mediaeval executioner's axe, while its flanged tang is generally decorated with *t'ao-t'ieh* and other motifs. A fine example of a *ch'i* axe, excavated in 1976 at Yi-tu in Shantung, is illustrated here. On either side of the terrifying mask is a cartouche of *ya-hsing* shape, containing the figure of a man offering wine on an altar from a vessel with a ladle. Less exclusively Chinese are the bronze daggers and knives, simple forms of which have been found at Chengchow. At Anyang they become more elaborate, the handle often terminating in a ring or in the head of a horse, ram, deer or elk. These have their counterpart in the 'animal style' of the Ordos·Desert, Inner Mongolia and southern Siberia.

The problem as to whether China or central Asia was the source of this style has long been debated. Much turns upon the date of the South Siberian sites such as Karasuk where it also appears, and until this is established the question of priority cannot be finally settled. It seems that an animal style existed simultaneously in western Asia (Luristan third phase), Siberia (Karasuk) and China (Anyang) roughly between 1500 and 1000 B.C., and that China drew upon this style from her western neighbours and at the same time contributed from her own increasingly rich repertoire of animal forms. Elements of the animal style appear also in the bronze fittings made for furniture, weapons and chariots. Recent excavations at Anyang have made it possible to reconstruct the Shang chariot and to assign to their correct place such objects as hubcaps, jingles, pole ends, awning-fittings and the V-shaped sheaths for horses' yokes.

The origin of the decoration on the bronzes represents a difficult problem. The most striking element in it is the profusion of animal motifs, not one of which appears in Chinese Neolithic art. The Shang people had cultural affinities with the steppe and forest folk of Siberia and, more remotely, with the peoples of Alaska, British Columbia and Central America. The similarities between certain Shang designs and those, for example, in the art of the West Coast Indians of North America are too close to be accidental. Li Chi has suggested that the richly decorated, square-sectioned bronze vessels with straight sides are a translation into metal of a northern woodcarving art, and Carl Hentze has amassed a considerable amount of evidence for the stylistic similarity between the décor of these bronzes and the art of the northern nomadic peoples. On the other hand, the art of carving formalised animal masks on wood or gourd is native to Southeast Asia and the Archipelago, and still practised today. Also surviving in Southeast Asia till modern times is the technique of stamping designs in the wet clay, which may have contributed the repeated circles, spirals and volutes to bronze ornament. Clearly the sources of the decorative language of the Shang bronzes are more numerous and complex than was once supposed.

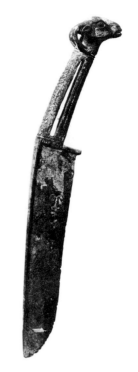

30 Knife with ibex head. Bronze. From Anyang. Late Shang period.

Whatever the origins of this language, we must not think of it as confined solely to the sacrificial bronzes. Could we but transport ourselves to the home of some rich Anyang nobleman we would see *t'ao-t'ieh* and beaked dragons, cicadas and tigers, painted on the beams of his house and applied to hangings of leather and matting about his rooms, and, very probably, woven into his silk robes. That this is likely we know from the contents of the tombs, and it tends to reinforce the view that these motifs are not tied to the form or function of any individual bronze vessel, but belong to the whole repertoire—part decorative, part magical—of Shang art.

JADE

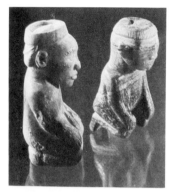

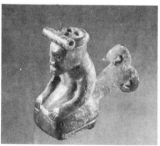

Supp. 5 Kneeling figures of servants or slaves. Stone and jade; ht. 7–9 cm. Among over 500 jades in the tomb of Fu Hao (see Supp. Illus. 4), these figurines are particularly interesting for their details of costume and head-dress. The figure below may have been fastened to a wooden staff.

Already in certain Neolithic sites we have encountered jade, selected, it appears, for objects of more than purely utilitarian purpose by virtue of its hardness, strength and purity. In the Shang Dynasty, the craft of jade carving progresses a further step forward, and we must briefly consider the sources of this stone, the technique of carving it and the unique place it occupies in early Chinese culture. Although early Chinese texts speak of jade from several places in China, for many centuries the chief source has been the riverbeds of the Khotan region in central Asia, and Western scholars came to the conclusion that jade did not exist in its true state in China proper. Recent discoveries, however, seem to lend some support to the ancient texts, for a jadeitic stone used today by Peking jadesmiths has been traced to Nanyang in Honan. However, the true jade (*chen yü*) prized throughout history by the Chinese is nephrite, a crystalline stone as hard as steel and of peculiar toughness. In theory it is pure white, but even small amounts of impurities will produce a wide range of colours from green and blue to brown, red, grey, yellow and even black. In the eighteenth century, Chinese jade carvers discovered in Burma a source of another mineral, jadeite, whose brilliant apple and emerald greens have made it deservedly popular for jewellery both in China and abroad. Because of its unique qualities, jade has since ancient times been regarded by the Chinese with special reverence. In his great dictionary the *Shuo-wen Chieh-tzu* the Han scholar Hsü Shen described it in words now well known to every student of Chinese art: "Jade is the fairest of stones. It is endowed with five virtues. Charity is typified by its lustre, bright yet warm; rectitude by its translucency, revealing the colour and markings within; wisdom by the purity and penetrating quality of its note when the stone is struck; courage, in that it may be broken, but cannot be bent; equity, in that it has sharp angles, which yet injure none."[3] While this definition applies essentially to true jade, the word *yü* may include not only nephrite and jadeite, but other fine stones such as serpentine, tremolite, hornblende and even marble.

The hardness and toughness of jade makes it very difficult to carve. To work it one must use an abrasive. Hansford has demonstrated that it is possible, given time, to drill a hole in a slab of jade using only a bamboo bow drill and builder's sand. It has recently been suggested that metal tools were already employed at Anyang,

and there is evidence that the Shang lapidary may also have used a drill-point harder than modern carborundum. Some small pieces carved in the round have been found in Shang sites, but the vast majority consist of weapons, ritual and decorative objects carved from thin slabs seldom more than half an inch thick. The jades from Chengchow include long, beautifully shaped knives and axe blades (*ko*), circles, sections of discs, a figure of a tortoise, flat plaques in the shape of birds and other creatures pierced at each end for use as clothing ornaments or pendants.

The finds at Anyang have been incomparably richer in beauty, workmanship and range of types than those at Chengchow, and recent discoveries make it likely that the great numbers of jade objects labelled 'probably from Anyang' which have reached Western collections as a result of the indiscriminate digging of the recent past must have come from that site. The excavations at the Anyang village of Ta-ssu-k'ung-ts'un in 1953, for example, yielded plaques carved in the shape of birds, fishes, silkworms and tigers; *pi*, *tsung*, *yüan* and other ritual objects; beads, knife handles and *ko* axes. The most impressive recent find at Anyang was a huge sonorous stone found lying on the floor of the grave pit at Wu-kuan-ts'un; cut from a thin slab of marble eighty-four centimetres long and pierced for suspension, it is decorated on one side with a design of a tiger executed in thread relief.

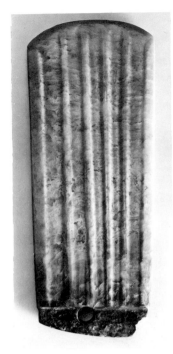

31 Axe-blade. Jade. From Anyang. Late Shang period.

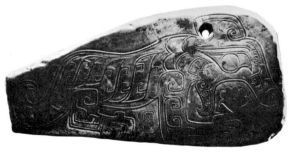

32 Chime carved with tiger design. Stone. From tomb at Wu-kuan-ts'un, Anyang. Late Shang period.

Not all carving was done in such intractable materials as jade and marble. Some of the most beautiful of all Shang designs were carved in bone and ivory. Elephants roamed north China in prehistoric times and probably were still to be found north of the Yangtse in the Shang Dynasty. We know that at least one Shang emperor kept one as a pet, possibly sent as tribute from Yüeh, while a plentiful supply of ivory could be had from China's southern neighbours. On plaques of ivory and bone a few inches square, made presumably as ornaments for chariots, furniture or boxes, were carved *t'ao-t'ieh* and other designs of extraordinary intricacy and beauty, sometimes inlaid with turquoise. Like the bronzes, these bone and ivory carvings show striking similarities with the art of the West Coast Indians of North America. For years scholars have toyed with the fascinating possibilities that these similarities have opened up, but as yet no archaeological connecting links have been found to account for them.

33 Carved bone handle. Excavated at Anyang.

41

3
The Chou Dynasty

During the last years of the decline of Shang, the vassal state of Chou on her western frontier had grown so powerful that its ruler Wen was virtually in control of two-thirds of the Shang territories. Finally, in about 1050 or 1030 B.C., Wen's son Wu, the Martial King, captured Anyang, and the last Shang ruler committed suicide. Under Wu's young successor, Ch'eng Wang, a powerful regent known to history as the Duke of Chou (Chou Kung) consolidated the empire, set up feudal states and parcelled out the Shang domains among other vassals, though he took care to permit the descendants of Shang to rule in the little state of Sung so that they could keep up the hereditary sacrifices to their ancestral spirits. Chou Kung was chief architect of a dynasty which was to have the longest rule in China's history, and even though its later centuries were clouded by incessant civil wars in which the royal house was crushed and finally engulfed, the Chou Dynasty gave to China some of her most characteristic and enduring institutions.

There was no abrupt break with Shang traditions; rather were many of them developed and perfected. Feudalism, court ritual and ancestor worship became more elaborate and effective instruments in welding the state together, so effective indeed that from the time of confusion at the end of the dynasty many conservatives, Confucius among them, came to look back upon the reigns of Wen, Wu and Duke Chou as a golden age. Religious life was still centred in worship of Shang Ti, though the concept of 'heaven' (*T'ien*) now began to appear and eventually replace the cruder notions embodied in Shang Ti. Bronze inscriptions and early texts indicate the beginnings of a moral code centred in adherence to the will of heaven and in respect for *te* ("virtue"), both of which would become fundamental in the teachings of Confucius. The Chou court became the focus of an elaborate ritual in which music, art, poetry and pageantry all combined under the direction of the 'master of ceremonies' (*pin-hsiang*) to give moral and aesthetic dignity to the concept of the state. The king held audiences at dawn and dusk (a custom that survived until 1912); orders for the day were written on bamboo slips, read out by the court historian and then handed

out to officials for execution. From the time of Mu Wang (947–928) onwards it became the custom to preserve these orders by casting them on the bronze ritual vessels. These inscriptions, which became longer as time went on, are one of the main sources for the study of early Chou history, the other chief documents being the *Book of Songs* (*Shih-ching*) an anthology of ancient court odes, ballads and love songs said to have been compiled by Confucius, and the authentic chapters of the *Classic of History* (*Shu-ching*) which tell of the fall of Shang and the early years of the Chou. These documents bear witness to that sense of history which is one of the most striking features of Chinese civilisation, and, as a corollary, to the almost sacred place held in Chinese life by the written word.

The first phase of Chou history ended in 771 B.C. with the death of Yu Wang and the shift of the capital eastwards from Shensi to Loyang. By this time the feudal states were growing more and more powerful, and P'ing Wang, the first ruler of Eastern Chou, was helped to power by two of them—Chin and Cheng. Before long the Chou state was declining still further, till eventually it became a mere shadow of its former self, kept artificially alive by the powerful states that surrounded it solely in order to maintain the prestige of the royal house, from which the 'mandate of heaven' had not yet been withdrawn. The period from 722 to 481 is often known as the *Ch'un-ch'iu* ("spring and autumn") because the events of the greater part of it are recorded in the *Spring and Autumn Annals* of the state of Lu, while for the rest we have the stories in another classic, the *Tso-chuan*. The feudal chiefs spent their time, it appears, in making aggressive and defensive alliances with other states, in keeping the northern barbarians at bay and in honouring the shrunken Chou, which survived, a pale shadow of its former glory, till its destruction in 256 B.C. at the hands of Ch'in.

At the moment, more is known about Shang architecture than about that of the early Chou, for which we have to rely largely upon the evidence of the written word. One of the chief sources for the study of Chou institutions is the *Chou-li*, a manual of ritual and government compiled, it is believed, in the Former Han Dynasty. Its authors, looking back through the mists of time to the remote golden age, present a somewhat idealised picture of Chou ritual and life; but the *Chou-li* is not without significance, for its descriptions were taken as canonical by later dynasts who strove always to follow the ancient institutions and forms as the *Chou-li* presented them. Writing of the ancient Chou city, the *Chou-li* says: "The architects who laid out a capital made it a square nine *li* [about three miles] on a side, each side having three gateways. Within the capital there were nine lengthwise and nine crosswise avenues, each nine chariot tracks wide. On the left was the ancestral temple, on the right the Altar of the Soil; in front lay the Court of State, at the rear the market-place."

Today, the work of the archaeologist has begun to fill out the picture of the Chou city given by the texts. At Chang-chia-p'o,

west of Sian, the first Chou capital, Feng, is in process of excavation, while nearby lie the remains of Hao, seat of twelve kings from Wu Wang to the end of Western Chou. The remains of over a score of Eastern Chou cities have been identified, the most important being Wang-ch'eng, capital of Eastern Chou itself, discovered in the early 1950s when the Chung-chou Road was constructed to connect Loyang with a new housing estate to the southwest. The capital of the state of Ch'i, in Lin-tzu-hsien, Shantung, was a mile from east to west and two and a half miles from north to south, surrounded by a wall of tamped earth over thirty feet high with the palace area in the southwest corner; the capital of the State of Yen, located in I-hsien, Hopei, was even larger. Almost all that remains of these cities above ground today are traces of walls and the thousands of roof tiles with stamped designs which litter the fields. But besides the cities themselves, tombs and buried hoards of bronzes have been found throughout the Chou realm.

ARCHITECTURE AND SCULPTURE

The Book of Songs contains several vivid descriptions of ancestral halls and palaces. Here is part of one of them, translated by Arthur Waley:

> To give continuance to foremothers and forefathers
> We build a house, many hundred cubits of wall;
> To south and east its doors.
> Here shall we live, here rest,
> Here laugh, here talk.
> We bind the frames, creak, creak;
> We hammer the mud, tap, tap,
> That it may be a place where wind and rain cannot enter,
> Nor birds and rats get in,
> But where our lord may dwell.
> As a halberd, even so plumed,
> As an arrow, even so sharp,
> As a bird, even so soaring,
> As wings, even so flying
> Are the halls to which our lord ascends.
> Well levelled is the courtyard,
> Firm are the pillars,
> Cheerful are the rooms by day,
> Softly gloaming by night,
> A place where our lord can be at peace.
> Below, the rush-mats; over them the bamboo-mats.
> Comfortably he sleeps,
> He sleeps and wakes
> And interprets his dreams.[1]

Such ballads give us a picture of large buildings with rammed earth walls standing on a high platform, of strong timber pillars supporting a roof whose eaves, though not yet curving, spread like wings, of floors covered with thick matting like the Japanese *tatami*, of warmth, light and comfort. While the most monumental buildings were the ancestral halls, the palaces and private houses were often large, and may well have had several successive court-

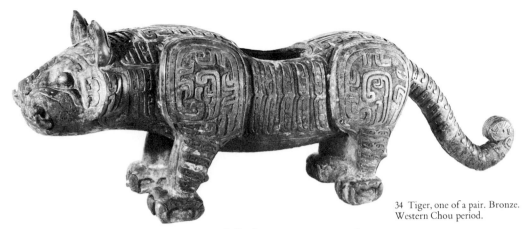

34 Tiger, one of a pair. Bronze. Western Chou period.

yards as they do today. Chou texts are full of warnings against those who build too extravagantly, and above all against the usurper of royal prerogatives. Confucius, for example, rebuked a contemporary who kept a tortoise (presumably for divination) in a pavilion adorned with the hill pattern on its capitals and the duckweed pattern on its kingposts, insignia reserved exclusively for the king. By comparison, the authors of these texts extol the simplicity of ancient times, when a virtuous ruler roofed his ancestral shrine with thatch, when King Ho-lu of Wu never "sat on double mats. His apartments were not lofty . . . his palaces had no belvederes, and his boats and carriages were plain."

The most conspicuous of Chou buildings, apart from palaces and ancestral halls, must have been the *Ming-t'ang* ("bright hall"), a ritual edifice of which detailed but conflicting accounts are given in early texts, and the towers (*t'ai*) constructed of timber on a high platform of rammed earth. Passages in the *Tso-chuan* show that the princes used them as fortresses, for feasting, or simply as lookouts. Perhaps they survived in the tall storage and lookout towers that were, till recently, a feature of villages and farms in South China.

Supp. 6 Ritual vessel, *lei*. Bronze; ht. 44.5 cm. This vessel is from a hoard of bronzes discovered in 1973 in K'e-tso-hsien, Liaoning, about 260 km. northeast of Peking. Believed to be connected with the early Chou feudal state of Yen, these vessels, which were probably not made locally, illustrate the degree that Chou civilisation had penetrated into the northeast by about the 10th century B.C.

No trace of the kind of decorative stone sculpture that adorned Shang interiors has yet been discovered in Chou sites. But the Chou craftsmen were certainly capable of modelling a figure in the round and endowing it with extraordinary vitality, even when, as in the famous pair of tigers in the Freer Gallery (one of which is shown here) its limbs and features are stylised. Indeed, here the rhythmic movement of the semi-abstract decoration over the surface gives these creatures a curious animation different from, but no less intense than, that which a more naturalistic treatment would have achieved. Although they have been tentatively dated as early as the tenth century B.C., the coarseness of the modelling and the overall 'baroque' decoration seem to herald the style of the middle Chou period.

In the earliest Western Chou ritual bronzes, the Shang tradition is carried on with little change, one of the more significant differences being in the inscriptions, which are no longer a simple record of

THE RITUAL BRONZES

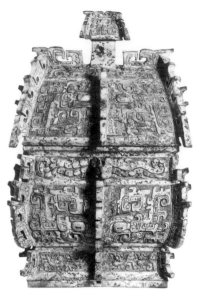

35 Ritual vessel, *fang*-(square)*i*. Bronze. Long dedicatory inscription of the court annalist Ling.

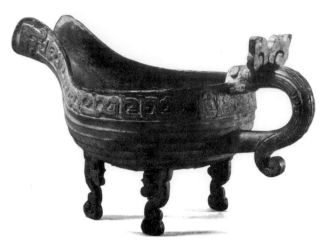

36 Ritual vessel, *yi*. Bronze. Late Western Chou period, about eighth century B.C.

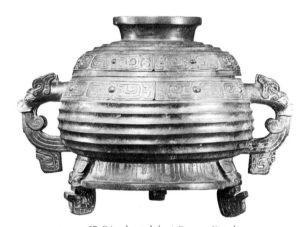

37 Ritual vessel, *kuei*. Bronze. Dated by inscription to 825 B.C. Western Chou period.

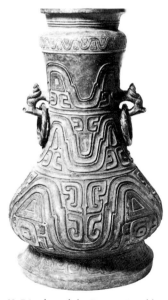

38 Ritual vessel, *hu*. Bronze. Dated by inscription to 862 or 853 B.C.: "It was in the 26th year, 10th moon, first quarter, on the day *chi-mao*, when Fan Chü Shang had this bridal *hu* cast as a bridal gift for his first child Meng Fei Kuai. May sons and grandsons forever treasure and use it."

ownership but become valuable historical documents, often setting out in some detail the circumstances in which that vessel was bestowed. A vessel of the reign of Ch'eng Wang (1024–1005), for instance, excavated in Tan-t'u, Kiangsu, had an inscription of 120 characters; that on a *ting* of the reign of his successor, K'ang Wang, runs to 291 characters. Later they became even longer. The typical short, early Chou inscription on a *kuei* in the Alfred Pillsbury Collection shows the function of the vessel quite clearly: "The King attacked Ch'i-yü and went out and attacked Nao-hei. When he came back, he made *liao*-sacrifice [burnt offering] in Tsung-chou and presented to me, Kuo Pao X, ten double strings of cowries. I presume in response to extol the King's grace, and so I have made my accomplished dead father's *kuei* vessel. May for a myriad years sons and grandsons forever treasure and use it."[2]

For perhaps a century after the Chou conquest, Shang bronze styles survived, particularly in the Loyang region of northern Honan, though increasingly modified by the taste of the Chou invaders from the west. By the end of the tenth century B.C. the *ku*, *chüeh*, *kuang*, *yu*, and square *i* had disappeared, along with such ubiquitous Shang motifs as the *t'ao-t'ieh*, cicada, 'rising blades', and long-tailed bird. The *ting* had become a wide, shallow bowl on three cabriole legs, and the *li*, when it appeared at all, had a curiously arched contour. The *p'an*, a wide flat dish, had become more common, while the *kuei* had two or, more rarely, four handles and stood on a square base, and the body was often decorated with horizontal fluting. Bronzes of this period generally show a certain exaggeration and coarseness of modelling, while shapes become increasingly slack and sagging. Flanges tend to be large and spiky, and new creatures make their appearance, among them the gaping monster with spiral tail and a bird with head turned back and frills of quill-like feathers along its body. By the ninth century B.C. birds and beasts are dissolving into a variety of vertical and horizontal scales and broad, flat meander patterns that cover the whole surface. The bronzes of late Western Chou, often called the middle Chou style (Yetts' "Second Phase," ninth and early eighth centuries), have none of the dynamic tension and unity of design that marks the vessels of late Shang and the first decades of the Chou.

The stylistic change was given a further impetus in the eighth and seventh centuries by foreign ideas and techniques brought back by the Chou kings from their northern campaigns, and by the rise of the feudal states, which were beginning to develop artistic styles of their own. The most striking new feature which the northern contact introduced is the art of interlacing animal forms into intricate patterns. This first appears in Chinese art in the bronzes excavated from seventh-century graves at Hsin-cheng and Shang-ts'un-ling in Honan. A more highly developed example is the *hu*, unearthed at Hsin-cheng in Honan and datable around 650 B.C., which is illustrated here. It stands on two tigers; two more tigers with huge horns and twisting bodies curl up the sides to form handles, while smaller tigers play at their feet. The body is covered with an overall pattern of flat, ropelike, interlaced dragons, the lid surrounded with flaring leaf-shaped flanges. Gone is the wonderfully integrated quality of the early bronzes, which achieved so perfect a fusion of form and decoration. Gone too is the coarse but imposing strength of the early middle Chou. These Hsin-cheng bronzes represent a restless period of transition before the flowering of the refined art of the Warring States.

Reliable archaeological evidence on the jade of the early and middle Chou is scanty, but constantly increasing with new finds. Before the Second World War, archaeologists working at Hsin-ts'un in Hsün-hsien (Honan) discovered a number of jade objects which were for the most part rather crude versions of Shang types,

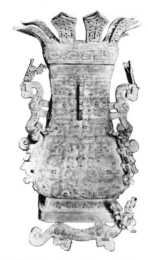

39 Ritual vessel, *hu*. Bronze. Early Eastern Chou period, about seventh century B.C.

JADE

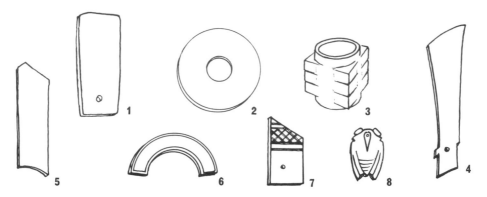

40 Ritual and funerary jades: 1. *kuei*; 2. *pi*; 3. *tsung*; 4. *ya-chang*; 5. *yen-kuei*; 6. *huang*; 7. *chang*; 8. *han*.

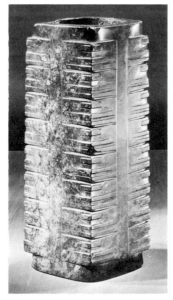

41 Ritual tube, *tsung*. Jade. Chou Dynasty.

with the relief carving often confined to shallow incisions on a flat surface. Since 1950, excavations of graves at Loyang and at P'u-tu-ts'un, near Sian, have tended to confirm the impression that there was a decline in the craft in the early Western Chou. But the Chou jades excavated under controlled conditions still represent a minute proportion of the total number; this, combined with the likelihood that the traditional forms must have persisted for long periods without change, and that when buried, jades may already have been treasured antiques, makes the dating of individual pieces extremely difficult.

There is less doubt, fortunately, about the meaning and function of the ritual and funerary jades. According to the *Chou-li* (and there is no reason to doubt its reliability) certain shapes were appropriate to particular ranks. The king in audience, for example, held a *chen-kuei*, a broad, flat, perforated sceptre; a duke held a *huan* (ridged sceptre); a prince a *hsin* (elongated sceptre); an earl a *kung* (curved sceptre); while the lower ranks of viscount and baron held *pi* discs decorated with the little bosses known as the 'grain pattern'. Proclamations were issued with jade objects to indicate the royal authority—as, for instance, the *ya-chang* (a long knife) for mobilising the imperial garrison, a *hu* (tiger) in two halves for transmitting military secrets, a *yen-kuei* (sceptre with concave butt) for protecting official envoys, and so on. Equally specific were the jades used to protect the body at burial, numbers of which have been found in their original positions in the grave. Generally, the corpse lay on his back (a change from Shang practice). On his chest was placed a *pi* disc, symbol of heaven; beneath his body a *tsung*, symbol of earth; to the east of the body was placed a *kuei* sceptre, to the west a tiger, to the north (at his feet) a *huang* (half circle), to the south a *chang* (a short stubby *kuei*); the seven orifices of the body were sealed with jade plugs, while a flat plaque, *han*, generally in the shape of a cicada, was placed in the mouth. Thus was the body protected from all harm without, and sealed lest any evil influences should escape from within.

48

An extreme instance of the belief in the preserving power of jade was the jade burial suit, long known from references in early literature, but never seen (except in fragments) until the accidental discovery of the tombs of a Han prince and princess at Man-ch'eng, Hopei, in 1968 (see p. 87). The corpses of Lui Sheng (died 113 B.C.) and of his wife Tou Wan were completely encased in head mask, jacket and trousers, each made of over two thousand thin jade plaques sewn together with gold thread. Each suit, it has been calculated, would have taken an expert jadesmith ten years to make.

In addition to mortuary jades, the early Chou lapidaries carved many kinds of pendants and ornaments, as in the Shang Dynasty, but as these were to be far more beautiful and refined in the late Chou period, we will defer discussion of them to Chapter 4.

(see p. 87).

CERAMICS

By comparison with the bronzes, the pottery of Western and early Eastern Chou is sober stuff. Many of the finest pieces are crude imitations of bronze vessels, though generally only the shape is copied, such bronzelike decoration as there is being confined to bulls' heads or *t'ao-t'ieh* masks attached to the sides. Although a few specimens of plain red ware have been found, most Western Chou pottery consists of a coarse grey ware, the most popular purely ceramic shape being a round-bottomed, wide-mouthed storage jar which is often cord-marked.

But recent discoveries show that in addition to this mass of unglazed wares a much more sophisticated ceramic art was beginning to develop. The Chinese language only distinguishes two types of ware: *t'ao* (pottery) and *tz'u* (which includes both stoneware and porcelain). Some of the Western Chou wares are certainly *tz'u*, if not what we would call porcelain, a particularly fine example being the glazed jar illustrated here, which was unearthed in 1972 from an early Western Chou burial at Pei-yao-ts'un in Honan. The important tomb of the reign of Mu Wang at P'u-tu-ts'un near Sian contained rather similar vessels decorated with horizontal grooves and covered with a thin bluish-green felspathic glaze quite different from the blackish or yellowish Shang glazes. Other glazed wares, dateable by bronze inscriptions to the eleventh and tenth centuries B.C., have been found in graves in Honan, Kiangsu and Anhui. They may all be considered as ancestors of the great family of celadons of later dynasties.

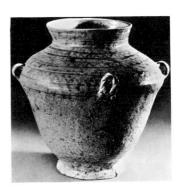

42 Jar. Stoneware covered with greenish-yellow celadon glaze. From a tomb at Pei-yao-ts'un, Loyang, Honan. Western Chou period.

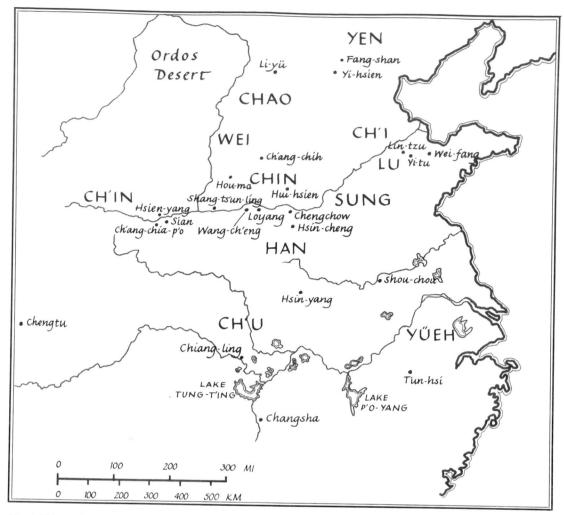

MAP 4 China in the Warring States
period.

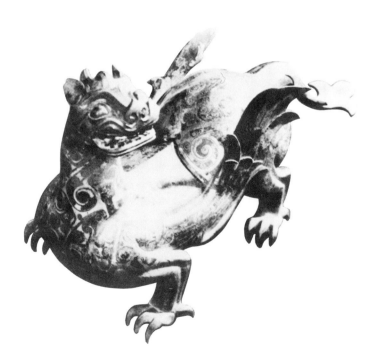

Supp. 7 Mythical winged animal.
Bronze, inlaid with silver. From a
royal tomb of the state of Chung-shan
near Shih-chia-chuang in Hopei.
Although the founders of the Chung-
shan state, which was destroyed
in 301 B.C., were originally a nomadic
people, the superbly refined decora-
tion and workmanship of this piece
are essentially Chinese.

50

4
The Period of the Warring States

A map of China in the sixth century B.C. would show a tiny and impotent state of Chou, somewhat like modern Canberra, surrounded by powerful principalities constantly forming and breaking alliances and attacking each other, condescending to consult the royal house only on matters of legitimacy and inheritance. In the north, Chin kept the desert hordes at bay until she was destroyed in 403 and parcelled out among the three states of Chao, Han and Wei: at one time these three states formed an alliance with Yen and Ch'i in the northeast against the power of the semi-barbarian Ch'in, now looming dangerously on the western horizon. The smaller states of Sung and Lu, which occupied the lower Yellow River Valley, were not militarily powerful—though they are famous in Chinese history as the home of the great philosophers. In the region of modern Kiangsu and Chekiang, Wu and Yüeh were emerging into the full light of Chinese culture, while a huge area of central China was under the domination of the southward-looking and only partly Sinicised state of Ch'u. Gradually Ch'u and Ch'in grew stronger. In 473, Wu fell to Yüeh, then Yüeh to Ch'u. Ch'in was even more successful. In 256 she obliterated the pathetic remnant of the great state of Chou; thirty-three years later she defeated her great rival Ch'u, simultaneously turning on the remaining states of Wei, Chao and Yen. In 221 B.C. she defeated Ch'i, and all China lay prostrate at her feet.

As often happens in history, these centuries of ever-increasing political chaos were accompanied by social and economic reform, intellectual ferment and great achievement in the arts. Iron tools and weapons were coming into use. Now for the first time private individuals could own land, and trade was developing, much aided by the invention of currency—bronze 'spade' money in central China, knife-shaped coins in the north and east. This was the age of the 'Hundred Schools', when roving philosophers known as *Shui-k'e* ("persuading guests") offered their council to any ruler who would listen to them. The most enlightened patronage was that offered by King Hsüan of Ch'i, who welcomed brilliant scholars and philosophers of every school to his Academy of the Chi Gate. But this was exceptional. Confucius, the greatest of them, was ill-used in the state

of Lu; for in those chaotic times few rulers saw any immediate advantage in the Sage's emphasis upon the moral and social virtues, upon *jen* ("human-heartedness") or upon the value of knowledge and self-cultivation. Wanting power at home and victory over their enemies abroad, they were often more attracted by the Machiavellian doctrines of Lord Shang and the Legalists, which were to find their ultimate justification in the rise of the totalitarian state of Ch'in.

Against the social commitment of Confucius and his follower Mencius on the one hand and the amoral doctrines of the Legalists on the other, the Taoists offered a third solution—a submission not to society or the state but to the universal principle, *Tao*. Lao Tzu taught that discipline and control only distort or repress one's natural instinct to flow with the stream of existence. In part, this was a reaction against the rigidity of the other schools, but it was also a way of escape from the hazards and uncertainties of the times into the world of the imagination. It was, in fact, through Taoism, with its intuitive awareness of things that cannot be measured or learned out of books, that the Chinese poets and painters were to rise to the highest imaginative flights. The state of Ch'u was the heart of this new liberating movement. The great mystical philosopher-poet Chuang Tzu (c. 350–275) belonged in fact to the neighbouring state of Sung, but, as Fung Yu-lan has observed, his thought is closer to that of Ch'u, while Ch'ü Yüan and Sung Yü, who in their rhapsodic poems known as *sao* poured out a flood of such passionate feeling, were both natives of Ch'u. It is perhaps no accident that not only the finest poetry of this period, but also the earliest surviving paintings on silk, should have been produced within its boundaries.[1]

During the early Warring States period, however, the Chung-yüan of southern Shensi and northern Honan was still the heart of Chinese civilisation, protected by the defensive walls which were being constructed at intervals along China's northern frontiers. The most ancient section of wall was built about 353 B.C. across modern Shensi, not only to keep the marauding nomads out, but equally to keep the Chinese in and to attempt to prevent that de-Sinicisation which in the Six Dynasties was to accompany the foreign occupation of large areas of North China.

Until recently, archaeologists had given much less attention to the remains of the Chou Dynasty than had been devoted to the Shang. Before the Second World War, only one important late Chou site had been scientifically excavated, at Hsin-cheng in Honan, where were found tombs containing bronzes that span the years from the baroque extravagances of middle Chou to the simpler forms and more intricate decoration of the early Warring States. At the same time, the local farmers living between Loyang and Chengchow had for some years been robbing tombs at Chin-ts'un. Bronzes believed to have come from these tombs range in style from late, and rather subdued, versions of the Hsin-cheng manner to magnificent examples of the mature style of the fourth and third centuries B.C.

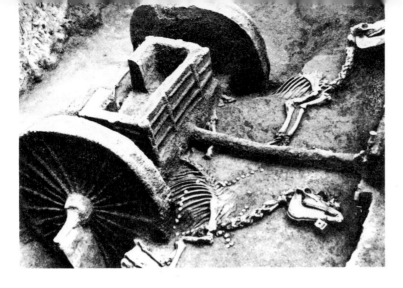

43 Chariot burial. Lui-li-ko, Hui-hsien, Honan. Warring States period.

Since 1950, however, controlled excavations have been carried out extensively in the region of Hui-hsien, which like Chin-ts'un lay within the state of Wei. At Lui-li-ko, just outside Hui-hsien, a pit was found containing nineteen chariots, with the horses buried separately—a late survival of the Shang custom. At Ku-wei-ts'un, tomb pits have been found containing magnificent bronzes inlaid with gold and silver, jades and other precious objects; while a tomb at Chao-ku-chen yielded a number of copper and bronze vessels one of which bears an engraved picture of a house—perhaps the earliest representation of architecture yet found in China. All these Hui-hsien sites may be dated in the late fourth or early third century B.C.

Excavations are also proceeding continuously at Loyang, the late Chou capital. Between 1950 and 1954 it was reported that over six hundred tombs of various periods had been opened there, yielding over ten thousand objects. It would be very surprising if all of them had received the attention of trained archaeologists, and, in fact, very few of them have yet been published. Just how widely late Chou culture was diffused is shown by recent important discoveries not only in central China but also in northern Shansi, Kwangtung, Anhui, Chekiang, Kiangsu and Szechwan. All reflect in varying degrees the artistic developments that were taking place in the Loyang-Hui-hsien region, although they also show, particularly in the finds from Southeast China, quite distinct local characteristics.

Already in the seventh century a change was beginning to become apparent in the bronze style. The huge extravagance of the middle Chou décor seems to have exhausted itself. Ungainly excrescences are shorn off, and the surface is smoothed away to produce an unbroken, almost severe silhouette. The decoration becomes even more strictly confined and is often sunk below the surface, or inlaid in gold or silver. Hints of archaism appear in the emphasis upon the *ting* tripod and in the discreet application of *t'ao-t'ieh* masks, which now make their reappearance as the clasps for ring-handles. But this stylistic revolution was not accomplished all at once. In vessels

CHANGES IN BRONZE STYLE

53

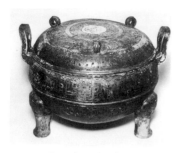

44 Ritual vessel, *ting*, with reversible cover, "Li-yü style." Bronze. Early Eastern Chou period, sixth to fifth century B.C.

45 Flask, *pien-hu*. Bronze inlaid with silver. Warring States period, late fourth to early third century B.C.

46 Ritual vessel, *ting*. Bronze inlaid with silver. Probably from Chin-ts'un, Loyang. Late Warring States period, fourth to third century B.C.

unearthed in 1923 far to the north at Li-yü in Shansi, and more recently in the much more prosperous and important area of Ch'ang-chih in central Shansi, the pattern of flat interlocking bands of dragons looks forward to the restless, intricate decoration of the mature late Warring States style; but in their robust forms, in the tiger masks which top their legs and the realistic birds and other creatures which adorn their lids, these vessels recall the vigour of an earlier age.

This 'decrescendo' from the coarse vigour of the middle Chou style continues in the later bronzes from Hsin-cheng and in the new style associated with Chin-ts'un and Li-yü. The typical broad, three-legged *ting* from Li-yü and Ch'ang-chih, for example, is decorated with bands of interlocked dragons separated by plaitlike fillets. There is a tendency to imitate other materials such as a leather water flask, the strapwork and texture of the animal's pelt being clearly suggested by what Karlgren called "teeming hooks," which may be seen filling the background on the top of the bell illustrated on p. 56. But on the most beautiful of these flasks, such as the *pien-hu* ("flat vessel") shown here, the symmetrical decoration consists of bars, angles and volutes inlaid in silver and probably derived from lacquer painting, that give the vessel a quite extraordinary liveliness and elegance. This vessel is typical of the finest inlaid bronzes unearthed from the later phases at Chin-ts'un. The simple shapes often recall pottery; except for the masks and ring-handles the surface is flat, giving full play to the inlaid decoration which is sometimes geometric, sometimes sweeps in great curves over the contour of the vessel. Gold had been used at Anyang, but now the goldsmith's art comes into its own, and in form, decoration and craftsmanship, the finest of the inlaid Warring States bronzes from the Loyang region are unsurpassed.

With the decline of the old ruling caste and the emergence of a wealthy upper middle class less schooled in the traditional rites, the metalworker's art was diverted, so to speak, from 'communion plate' to 'family plate'. A rich man would give his daughter inlaid

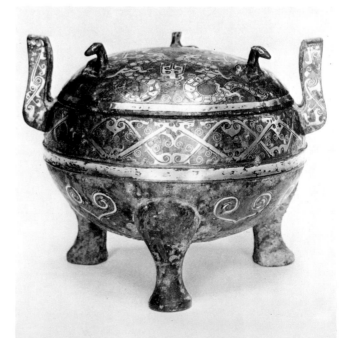

47 Striking the bells. From a rubbing of a third-century A.D. stone relief in the tomb at I-nan, Shantung, illustrated on p. 71.

48 Bell, *chung*. Bronze. Warring States period.

vessels as part of her dowry, while for himself he could adorn his furniture and carriages with bronze fittings inlaid with gold, silver and malachite, and when he died, take them with him into the next world. If anyone criticised him for his extravagance, he might well quote in self-defence this advice from the philosophical and economic treatise *Kuan Tzu*: "Lengthen the mourning period so as to occupy people's time, and elaborate the funeral so as to spend their money. . . . To have large pits for burial is to provide work for poor people; to have magnificent tombs is to provide work for artisans. To have inner and outer coffins is to encourage carpenters, and to have many pieces for the enshrouding is to encourage seamstresses."

The value of music as a moral force in society was recognised by Confucius as it was by his contemporary Pythagoras. Ballads were sung at the feudal courts not merely as entertainment but as admonition and example; the stately measure of the classical modes was an aid to right thinking and harmonious action, and it is not surprising that some of the finest of the bronzes of the Ch'un-ch'iu and late Chou should be the bells (*chung*) made in sets, either with a loop for suspension (*po*) from a wooden frame, or with a long handle. The rubbing from a relief in a third-century tomb in Shantung, illustrated here, shows how the performer struck these bells with a heavy wooden beam suspended from the ceiling. Bells of the *po* type decorated on the side with *t'ao-t'ieh* masks have recently been unearthed at Anyang together with handbells (*chih-chung*) and harness jingles. In the Western Chou period, *chung* bells became larger and more elaborate. Oval in section, the lower part was decorated with an animal mask or interlaced dragons; the upper part consisted of three bands of projecting knobs alternating with a dragon or *kuei* motif on either side of a vertical panel which often contained an inscription. In the Warring States these knobs were

55

49 Bell, *chung*. Bronze. Detail of decoration on top.

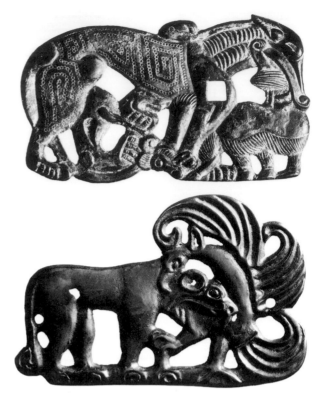

50 Harness plaques. Bronze.

flattened into serpent coils with feline heads, and the loop-handle was often beautifully modelled in the form of back-to-back creatures, real or fabulous. In the tombs at Chin-ts'un, nearly fifty bells were found from thirteen different sets, one of which, according to its inscriptions, was made for the Piao clan in 404 B.C.

While the aristocracy of metropolitan China were indulging in music, dancing and other delights in the comfort and security of their great houses, those in less fortunate areas were fighting a desperate battle against the savage tribes who harried the northern frontiers. Mounted on horseback and using the compound bow, the nomads were more than a match for the Chinese troops, who were finally forced to abandon the chariot and copy both their methods and their weapons of war. Their influence on the Chinese did not end with warfare. Their arts were few but vigorous. For centuries they and their western neighbours of the central Asiatic Steppe had been decorating their knives, daggers and harnesses with animal carvings—first in wood, and later in bronze cast for them, it is believed, by slaves and prisoners of war. This 'animal style' as it is called was totally unlike the abstract yet fanciful style of the Chinese bronzes. Sometimes the modelling is realistic, but more often it is formalised crudely and without the typical Chinese elegance of line. With barbaric vigour the nomads of the Ordos Desert and the wild regions to the north and west of it fashioned elk and reindeer, oxen and horses; they liked also to depict with

compact savagery a tiger or eagle leaping on the back of some terrified game beast—a scene they often witnessed, and the representation of which probably was intended to bring success to their own hunting expeditions. Hints of this animal style appeared, as we have seen, on some of the knives at Anyang. During the late Chou and Han, when the impact on China of the Hsien-yün, the Hsiung-nu and other northern tribes was at its height, its influence can be seen in the design of some of the inlaid bronzes, on which hunting scenes with fights with fierce beasts are modelled with a curiously un-Chinese angularity and harshness of form, although the shape of the vessel itself and its geometric decoration are purely Chinese.

The widest variety of animal designs is found on the bronze garment or belt hook. Many of these hooks indeed are purely Chinese in style, being carried out in the exquisite inlaid technique of Chin-ts'un and Shouchou. Court dancers wore them, as we know from the *Chao Hun*:

> Two rows of eight, in perfect time, perform a dance of Cheng;
> Their *hsi-pi* buckles of Chin workmanship glitter like bright suns.[2]

The beautiful specimen illustrated here is fashioned in gilt bronze, inlaid with a dragon in jade and multicoloured balls of glass. Some, representing the creatures of the Steppes singly or in mortal combat, are almost purely 'Ordos'. Yet others are in a mixed style: a garment hook recently excavated at Hui-hsien, for example, is decorated with three penannular jade rings in a setting formed of two intertwined dragons in silver overlaid with gold. The dragons are Chinese, but the sweeping angular planes in which they are modelled come from the northern Steppes.

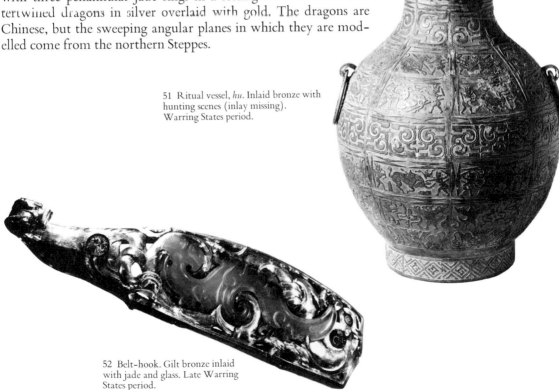

51 Ritual vessel, *hu*. Inlaid bronze with hunting scenes (inlay missing). Warring States period.

52 Belt-hook. Gilt bronze inlaid with jade and glass. Late Warring States period.

CERAMICS

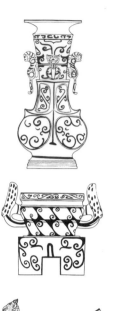

53 Miniature vessels. Pottery painted in red and black. Excavated at Ch'ang-p'ing. Late Warring States period.

No such barbarian influences appear in the pottery of North China at this time: the nomads indeed had little use for pottery and no facilities for making it. The grey tradition continues, but the coarse cord-marked wares of the early Chou are left behind. Shapes become more elegant, often imitating bronze—the most popular forms being the *tsun*, the three-legged *ting*, the tall covered *tou* ("stem-cup") and an egg-shaped, covered *tui* on three feet. Generally, they are heavy and plain, but some of those found at Chin-ts'un bear animals and hunting scenes stamped or incised with great verve in the wet clay before firing. Sometimes the potter even attempted to imitate the original metal by giving his vessel a lustrous black surface, or, more rarely, clothed it in tinfoil.

During the early 1940s, a group of miniature pottery vessels and figurines, said to have come from late Chou tombs in the Hui-hsien region, began to appear on the Peking antique market. Very heavily potted and beautifully finished, the vessels included miniature *hu*, covered *ting* and *p'an*, and a garment hook and mirror, on the burnished black surface of which the inlaid geometric decoration of the Chin-ts'un bronzes was imitated in red pigment. These are indications that many, if not all, of these pieces are modern forgeries, and excavations have in fact produced two possible sources of inspiration for them. Small pottery figurines, with simplified bodies, incised features and red pigment, were discovered in 1954 in a small tomb at Ch'ang-chih in south Shansi (as works of art they are in every way inferior to the 'Hui-hsien' pieces); while as a possible model for the ritual vessels we have a group of rather similar miniature pottery vessels unearthed in 1959 in a Warring States tomb at Ch'ang-p'ing near Peking, three of which are illustrated on this page.[3]

THE ARTS OF CH'U

While what might be called the 'classical' tradition was developing in the Honan-Shensi region, a quite different style of art was maturing in the large area of central China dominated by the state of Ch'u. It is not known precisely how widely her boundaries extended (particularly in a southward direction), but they included the city of Shou-chou on the Huai River in modern Anhui, while the influence of the art of Ch'u can be traced in the bronzes of Hui-hsien, Honan and even northern Hopei. Until Ch'in rose menacing in the west, Ch'u had been secure, and in the lush valleys of the Yangtse and its tributaries had developed a rich culture in which poetry and the visual arts flourished exceedingly. So vigorous, indeed, was Ch'u culture that even after Ch'in sacked the last Ch'u capital, Shou-chou, in 223 B.C., it survived to become a significant element of Chinese civilisation in the Han Dynasty.

In the late sixth century B.C., Shou-chou was still under the state of Ts'ai. A grave of this period recently excavated in the district contained bronzes most of which were rather restrained versions of the Hsin-cheng style, and the art of Shou-chou, even after its absorption into the expanding state of Ch'u, always retained some of its northern flavour. It must also have been an important ceramic

54 Covered bowl. Grey stoneware with olive green glaze. Probably from Shou-chou, Anhui. Late Warring States period.

centre at this time, if we are to judge by the beauty and vigour of the pottery excavated there. The body is of grey stoneware with incised decoration under a thin olive green glaze, the immediate predecessor of the Yüeh-type wares of the Han Dynasty and the ancestor of the celadons of the Sung.

It is only in recent years that archaeological excavation of Ch'u sites, notably at the capital near Chiang-ling and at Changsha and Hsin-yang, has revealed both the wealth and the essentially southern character of Ch'u art. Indeed, it is interesting to speculate on the course that Chinese culture would have taken if the victory in 223 B.C. had gone, not to the Ch'in savages from the western marches, but to this relatively sophisticated and enlightened people.

Since the replanning of Changsha started in 1950, many large tombs have been brought to light. The coffin—or rather multi-layered coffins, such as the *Kuan Tzu* recommended as giving employment to worthy artisans—was placed at the bottom of a deep shaft and often surrounded by a layer of charcoal and a much thicker layer of white clay, which has in some mysterious way preserved the contents in spite of the fact that many of the tombs have been waterlogged for more than two thousand years. The space between the outer coffin and the chamber wall is often crammed with funerary furniture (*ming-ch'i*). Sometimes the body lay on a long wooden plank carved with exquisite pierced scroll patterns, while about it were set discs of jade, stone and glass (excavations have yield glass beads as early as Western Chou), bronze weapons and vessels, pottery and lacquer ware. The filter of white clay and charcoal has even preserved fragments of silk and linen, documents written with a brush on slips of bamboo,

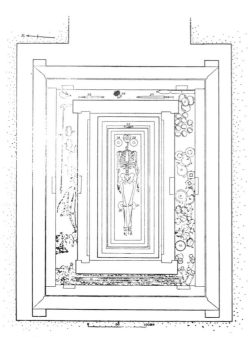

56 Painted figurines from tombs at
Changsha, Hunan. Wood. Late
Warring States or early Han period.
After Kwang-chih Chang.

55 Sketch of reconstructed tomb,
showing the *ming-ch'i* crammed
between the outer and inner coffins.
Changsha, Hunan. Late Warring States
period.

beautifully painted shields of lacquered leather, and musical
instruments.

Here for the first time we find large numbers of wooden figu-
rines of attendants and slaves. Confucius is said to have condemned
this practice as he thought it would lead people on, or back, to
burying the living with the dead. He thought straw figures were
safer. In the succeeding Han Dynasty, pottery cast in moulds was
found to be both cheaper and more enduring than wood, and
perhaps more acceptable to Confucians. The Changsha figures,
carved and painted, give useful information about late Chou cos-
tume. More spectacular are the cult objects, consisting of grotesque
monster heads, sometimes sprouting antlers and a long tongue, and
the drum or gong stands formed of birds standing back to back on
tigers or entwined serpents, decorated in yellow, red and black
lacquer. The gong stand illustrated on page 61, found in 1957 in a
tomb in the Ch'u city of Hsin-yang in Honan, reflects her contacts
with the south: similar stands are engraved on a number of bronze
vessels from Ch'u sites, while bronze drums found in the Dongson
region of northern Vietnam also bear snake and bird designs be-
lieved to be connected with rain magic.

Miraculously preserved in the Ch'u graves were the two oldest
paintings on silk yet discovered in China, one of which is illustrated
here. Swiftly sketched with deft strokes of the brush, it shows a
woman in full-skirted dress tied with a sash at the waist, standing in
profile attended by a phoenix and a dragon, whose reptilian origin is
clearly suggested. Other and far larger silk paintings, recently found
in Han tombs at Changsha, are discussed in Chapter 5. A bamboo
brush with rabbit's fur tip has also been found at Changsha, together
with other writing and painting materials. Some of the most

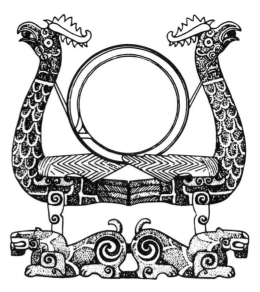

58 Drawing of drum or gong stand. Lacquered wood. From Hsin-yang, Honan. Late Warring States period.

57 Cult object or guardian in the form of a horned, long-tongued creature eating a snake. Carved and lacquered wood. Excavated in Hsin-yang, Honan. Late Warring States period.

59 Woman with dragon and phoenix. Painting on silk. From Changsha, Hunan. Late Warring States period.

beautiful painting, however, appears on the lacquer ware for which Ch'u was famous. The craft had first developed in North China during the Shang Dynasty, but now it reached a new level of refinement. Lacquer is the pure sap of the lac tree (*Rhus vernificera*), with colour added. It was applied in thin layers over a core of wood or woven bamboo; more rarely a fabric base was used, producing vessels of incredible lightness and delicacy. In late Chou and Han tombs in central China, large quantities of lacquer bowls, dishes, toilet boxes, trays and tables have been found. They are beautifully decorated in black on a red ground, or red on glossy black, with swirling volutes that may transform themselves into tigers, phoenixes, or dragons sporting amid clouds.

Also to be classed with the pictorial arts are the lively scenes cast in the body of bronze vessels and inlaid, generally with silver. On the *hu* illustrated here we can see an attack on a city wall, a fight between longboats, men shooting wild geese with arrows on the end of long cords, feasting, mulberry picking and other domestic activities, all carried out in silhouette with great vitality, elegance and humour. It is instructive to compare these essentially southern scenes with the fiercely northern combats illustrated on the *hu* in figure 51.

61

BRONZE MIRRORS Large numbers of bronze mirrors have been found both in the north and within the confines of Ch'u state. At first, and always to some degree, their purpose was not to reflect one's face only, but one's very heart and soul. An entry in the *Tso-chuan* under the year 658 B.C. says of a certain individual: "Heaven has robbed him of his mirror"—i.e., made him blind to his own faults. The mirror too is that in which all knowledge is reflected—as it was to the mediaeval encyclopaedist St. Vincent of Beauvais—"The heart of the sage is quiet," wrote Chuang Tzu, "it is a mirror of Heaven and Earth, a mirror of all things." The mirror also holds and reflects the rays of the sun, warding off evil and lighting the eternal darkness of the tomb.

60 Bowl. Painted lacquer. Late Warring States period.

61 Designs on an inlaid bronze *hu*. Late Warring States period.

62 Rubbing of back of a mirror. Bronze. Excavated from Kuo State Cemetery at Shang-ts'un-ling, Honan. "Spring and Autumn" period, early Eastern Chou.

A bronze disc with a loop-handle and dragon-and-snake decoration, believed to be a mirror, was found in a Shang tomb at Anyang. Perhaps the earliest true mirrors are those of the Ch'un-ch'iu period from Shang-ts'un-ling in Honan. Thereafter they are plentiful at Loyang. The face is polished, all decoration being confined to the back. Round the central loop (for the tassel) a mass of *lei-wen* or dragonlike creatures writhe within a confining border of ropes or twisted cowrie strings. A slightly later group (sixth to fifth centuries B.C.), most of which come from the Chin-ts'un tombs, are decorated with *t'ao-t'ieh* masks within a broad, flat rim. The earliest mirrors from Ch'u were nearly all found in the Shou-chou region. Their boss rises from a bare ring of bronze; over a background of comma patterns appear either quatrefoil petals or large staggered 山 -shaped motifs resembling the later form of the character *shan* ("mountain"), or swirling dragons or other semi-stylised creatures reminiscent of those on the lacquer vessels. Some of the most beautiful of all were made in the Loyang region in the fourth and third centuries B.C. Upon an intricate interlocked geometric or lozenge design derived from textile patterns and picked

out in minute granulations, superb creatures stride or whirl around the plain central ring. The contrast in texture between the background and the dynamic yet simple forms of the dragons, influenced by the sinuous coils of the lacquer painting, makes these mirrors a triumph of design.

This power to unite in one object the most intricate refinement of detail with a dynamic rhythm and boldness of silhouette is present also in the carved jades of the late Chou period, which must surely be among the great achievements of the Chinese craftsman. Now jade was no longer reserved for worship of heaven and earth or for the use of the dead; it became at last a source of delight for the living. Indeed, as the ritual objects such as the *pi* and *tsung* lost their original symbolic power they too became ornaments, while jade was now used for sword fittings, hairpins, pendants, garment hooks, in fact wherever its qualities could show to best advantage. Until recently very few jades had been found in controlled excavations, and dating on purely stylistic grounds is often, in view of the Chinese love of copying the antique, extremely unreliable. But the jade objects found in 1953 in a tomb at Yang-tzu-shan outside Chengtu confirm the impression that at this time the quality of carving rises to new heights; the stones are chosen for their rich, unctuous texture; the cutting is flawless and the finish beautiful. A chain of four discs in the British Museum, connected by links and carved from a single pebble less than nine inches long, is a technical tour-de-force which suggests that the iron drill and cutting disc were already in use. Few of the *pi* of the period are left plain; their surface is generally decorated with a row of spirals, either engraved or raised to form the popular 'grain pattern', and sometimes confined within an outer geometric border. Flat plaques in the form of dragons, tigers, birds and fishes combine an arresting silhouette with a surface treatment of extraordinary delicacy. One of the most beautiful early Chinese jades yet discovered is the celebrated disc in Kansas City, ornamented with heraldic dragons, two on the outer rim, a third crawling round a small inner disc in the center.

As we survey the inlaid bronzes of Chin-ts'un, the mirrors of Shou-chou, the marvellous lacquer ware of Changsha, the jades and the minor arts, we become aware that the period between 500 and 200 B.C. was one of the great epochs in the history of Chinese art. For it was at this time that the ancient symbolic creatures such as the *t'ao-t'ieh* were domesticated, as it were, and refined into a vocabulary of decorative art that was to provide an inexhaustible reservoir of designs for the craftsmen of later dynasties.

JADE

63 Mirror, Loyang type. Bronze. Late Warring States period, third century B.C.

64 Mirror, Shou-chou type. Bronze. Late Warring States period, third century B.C.

65 Chain of four discs with linking collars, carved from a single piece of jade. Warring States period.

66 Two concentric *huan* discs with dragons. Jade. Late Warring States period.

5

The Ch'in and Han Dynasties

By 221 B.C. the inexorable steamroller of the Ch'in armies had crushed the remnants of the ancient feudal order. Now all China was united under the iron rule of King Cheng, who set up his capital in Hsien-yang and proclaimed himself Ch'in Shih-huang-ti—first emperor of the Ch'in Dynasty. Aided by his Legalist minister Li Ssu, he proceeded to consolidate the new state. He strengthened the northern frontiers against the Huns and, at the cost of a million lives, linked up the sections of wall built by the previous kings of Chao and Yen into a continuous rampart 1400 miles long. The boundaries of the empire were greatly extended, bringing South China and Tonkin for the first time under Chinese rule. The feudal aristocracy were dispossessed and forcibly moved in tens of thousands to Shensi; rigid standardisation of the written language, of weights and measures and of wagon axles (important in the soft loess roads of North China) was enforced, and over it all Shih-huang-ti set a centralised bureaucracy controlled by the watchful eye of censors. All that recalled the ancient glory of Chou was to be obliterated from men's minds; copies of the classical texts were burned, and the death penalty imposed on anyone found reading or even discussing the *Book of Songs* or the *Classic of History*. Many scholars were martyred for attempting to protest. But while these brutal measures imposed an intolerable burden on the educated minority, they unified the scattered tribes and principalities, and now for the first time we can speak of China as a political and cultural entity. This unity survived and was consolidated on more humane lines in the Han Dynasty, so that the Chinese of today still look back on this epoch with pride and call themselves 'men of Han'.

The megalomania of the first emperor drove him to build at Hsien-yang vast palaces the like of which had never been seen before. One series, ranged along the riverside, copied the apartments of each of the kings whom he had defeated. The climax was the O-p'ang, or O-fang, Kung; he never lived to complete it, and it was destroyed in the holocaust which, as so often in Chinese history, marked the fall of his dynasty. The emperor lived in constant fear of

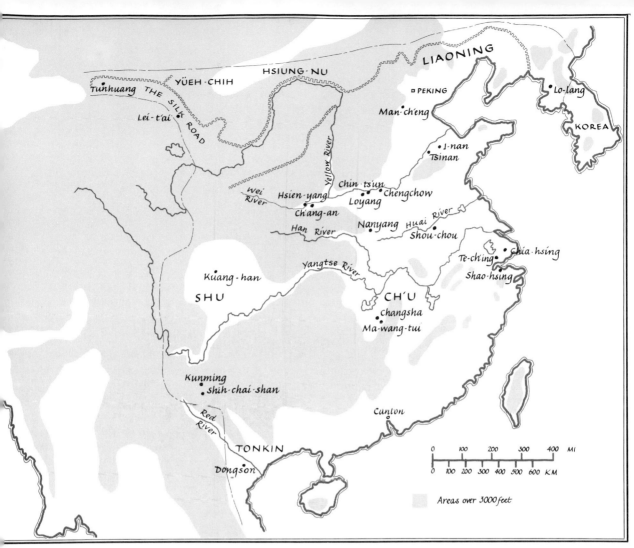

Map 5 China in the Han Dynasty.

assassination, and the roads connecting his many palaces were protected by high walls. So great was his dread of even a natural death, that he was forever seeking through Taoist practitioners the secret of immortality. In his search for the elixir, tradition has it that he sent a company of aristocratic boys and girls across the Eastern Sea to where the fabulous Mount P'eng-lai rises amid the waves, ever receding as one approaches it. They never returned, and it was later thought that they might have reached the shores of Japan.

Shih-huang-ti died in 210 B.C. The reign of his son Hu Hai was short and bitter. His assassination in 207 was the climax of a rebellion led by Hsiang Yü, a general of Ch'u, and Liu Pang, who had started his life as a bandit. In 206 the Ch'in capital was sacked; Hsiang Yü proclaimed himself King of Ch'u, while Liu Pang took the crown of Han. For four years the two rival kings fought for supremacy, till finally in 202, when defeat seemed inevitable, Hsiang Yü committed suicide and Liu Pang, after the customary refusals, accepted the title of Emperor of the Han with the reign name Kao-tsu. He established his capital at Ch'ang-an, and there inaugurated one of the longest dynasties in Chinese history.

65

So sharp was the popular reaction against the despotism of the Ch'in that the Former, or Western, Han rulers were content to adopt a policy of laissez-faire in domestic matters and even restored the old feudal order in a limited way. At first there was chaos and disunion, but Wen Ti (179–157) brought the scattered empire together and began to revive classical learning and to restore to court life some of the dignity and order that had attended it under the Chou. The early Han emperors were constantly either fighting or bribing the Hsiung-nu, who had taken advantage of the fall of Ch'in to drive their archenemy the Yüeh-chih westwards across the deserts of central Asia and invade North China. Finally, in 138 B.C. the Emperor Wu (140–87) sent out a mission under General Chang Ch'ien to make contact with the Yüeh-chih and form an alliance with them against Hsiung-nu. The Yüeh-chih were no longer interested in their old and now distant enemy and the mission failed; but Chang Ch'ien spent twelve years in the western regions, where he found Chinese silk and bamboo brought there, he was told, by way of India. He returned to Ch'ang-an with a report which must have stirred the public imagination as did the travels of

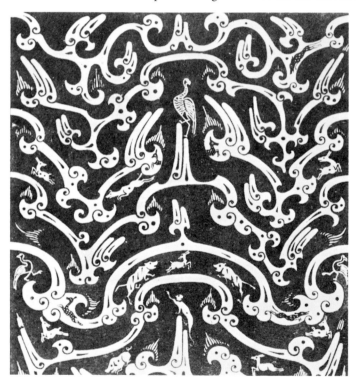

67 The hunt among mountains. Detail of decoration of a bronze tube inlaid with gold and silver. Han Dynasty.

Marco Polo or Vasco da Gama. Henceforth, China's eyes were turned westwards. Further expeditions, sent into distant Ferghana to obtain the famous 'blood-sweating' horses for the imperial stables, opened up a trade route which was to carry Chinese silk and lacquer to Rome, Egypt and Bactria. Travellers told of great snowcapped ranges reaching to the clouds, of fierce nomadic tribes and of the excitement of hunting wild game among the mountains.

Somewhere beyond the horizon lay Mount K'un-lun, the axis of the world and home of Hsi Wang Mu, Queen Mother of the West, and the counterpart of the foam-washed P'eng-lai on which dwelt Tung Wang Kung, the immortal King of the East.

During these first two centuries of the Han, the popular mind, from the emperor down, was filled with fantastic lore, much of which is preserved in pseudo-classical texts such as the *Huai Nan Tzu* and *Shan-hai-ching* (*Classic of Hills and Seas*), which are useful sources for the interpretation of the more fabulous themes in Han art. With the unification of the empire, many of these cults and superstitions found their way to the capital, where were to be found shamans, magicians and oracles from all over China. Meanwhile, the Taoists were roaming the hillsides in search of the magical *ling-chih* ("spirit fungus"), which, if properly gathered and prepared, would guarantee one immortality, or at least a span of a few hundred years. Yet, at the same time, Confucian ceremonies had been reintroduced at court, scholars and encyclopaedists had reinstated the classical texts, and Wu Ti, in spite of his private leanings towards Taoism, deliberately gave Confucian scholars precedence in his entourage.

It is these diverse elements in Han culture—native and foreign, Confucian and Taoist, courtly and popular—that give to Han art both its vigour and the immense variety of its styles and subject matter.

When Wu Ti died, China was at one of the highest points of power in her history. The empire was secure; her arms were feared across the northern Steppes, Chinese colonies were flourishing in Tonkin, Liaoning, Korea and central Asia. But Wu Ti's successors were weak and the administration crippled by palace intrigues and the power of the eunuchs, a new force in Chinese politics. In A.D. 9, a usurper named Wang Mang seized the throne and under the cloak of Confucian orthodoxy embarked upon a series of radical reforms which, had he been served by an honest and loyal administration, might have achieved a revolution in Chinese social and economic life. But by antagonising the privileged class, Wang Mang ensured his own downfall. He was murdered by a merchant and his brief Hsin Dynasty came to an end in A.D. 25. The Han house was restored and at once began the task of reconstruction. From their capital at Loyang, the Later, or Eastern, Han reached out once more into central Asia, consolidated their hold on Annam and Tonkin and for the first time made contact with Japan. By the end of the century, so great was their prestige that for a time even the distant Yüeh-chih, now established as the Kushan Dynasty in Afghanistan and northwest India, sent embassies to Ch'ang-an.

The Kushan brought Indian culture and religion into central Asia. This region became a melting pot of Indian, Persian and provincial Roman art and culture, which in turn travelled eastwards to China by way of the oases to north and south of the Tarim Basin. Buddhism may have been known by repute at least in the Former Han—the mythical mount K'un-lun was very likely a

Chinese version of the Buddhist Meru, or the Hindu Kailas, the axis of the universe—but now it began to take root in Chinese soil. The well-known story of the Emperor Ming, who in A.D. 67 dreamed of a 'golden man' (i.e., a Buddhist image) in the far west and sent emissaries to fetch it, is a late fabrication, but already two years earlier a certain Liu Ying, Prince of Ch'u, had held a great feast for monks (*śramana*) and lay brethren, which indicates that at least one monastic community was in existence in central China by that date, while there are several references to Buddhism in the *Hsi-ching-fu* ("Rhapsody [or "Rhyme-prose"] on the Western Capital" [Ch'ang-an]), by Chang Heng (A.D. 78–139). During the second century there was also a flourishing Buddhist community in Katigara (modern Tonkin), whence the new faith gradually spread northwards into South China and Szechwan.

Until the time of troubles that accompanied the downfall of the Han, however, Buddhism was merely one among many popular cults. Officially, Confucianism still reigned supreme, and the Later Han saw the enormous expansion of a scholarly and official class nurtured in the Confucian doctrines. Many of these men had been trained in the Imperial Academy, founded by Wu Ti in 136 B.C. From its graduates, selected by competitive examination in the classics, were drawn recruits for that remarkable civil service which was to rule China for the next two thousand years. Unswerving loyalty to the emperor, respect for scholarship and a rigid conservatism which sought for every measure the sanction of antiquity—these became the guiding principles of Chinese social and political life. Such ideals, however, offer no stimulus to the imagination, and it was not until Confucianism was enriched by Buddhist metaphysics in the Sung Dynasty that it became a source of highest inspiration to painters and poets.

Already in the Former Han, those who possessed skills useful to the emperor were organised under a bureau known as the Yellow Gate (*huang-men*), which was based on the somewhat idealised picture of Chou institutions set out in the *Chou-li*. The highest ranks in this professional hierarchy were known as *tai-chao*, officials in attendance on the emperor. These includes not only painters, Confucian scholars and astrologers, but also jugglers, wrestlers and fire-swallowers, who might be called upon at any time to display their various skills in the imperial presence. The lower ranks of artists and artisans, those who made and decorated furniture and utensils for court use, for example, were known as *hua-kung*. This organisation was not confined to the court, however; each commandery—in theory—had its own agency (*kung-kuan*) for the production and decoration of such things as ritual vessels, robes, weapons and lacquer ware, for which latter Ch'u and Shu (Szechwan) were especially famous. Gradually, however, this system was relaxed. Under the Later Han, the emergence of the scholar-official class, the decline of the rigid Confucian order at court, and the corresponding rise of Taoist individualism, all combined to reduce the importance and activity of these largely anonymous profes-

68 Seated Buddha in *abhaya-mudrā*. Rubbing of a relief in a shaft tomb at Chiating, Szechwan. Late Han period.

sionals. By the end of the dynasty there had come into being a gulf between the intellectual aristocracy on the one hand and the unlettered craftsmen on the other which was to have a profound influence on the character of later Chinese art.

The wonders of Ch'ang-an and Loyang are vividly described in the *fu* rhapsodies on the Han capitals by Chang Heng and Ssu-ma Hsiang-ju, and though their beauties may have been somewhat exaggerated, some idea of the scale of the palace and government buildings can be gauged from the fact that the audience hall of the Wei-yang Palace at Ch'ang-an was over 400 feet long—considerably longer than the T'ai-ho-tien, its counterpart in latter-day Peking. To the west of the capital, Han Wu Ti built a pleasure palace, linked to the Wei-yang Palace within the city by a covered two-storey gallery ten miles long. At Loyang the palace lay in the centre·of the city with a park behind it, built up with artificial lakes and hills into a fairy landscape in which the emperor could indulge his Taoist fancies. Other parks further from the capital and likewise landscaped on a colossal scale were stocked with all manner of game birds and beasts—some brought as tribute from remote corners of the empire. From time to time a vast imperial hunt, or rather slaughter, was organised, followed by lavish feasting and entertainments. The *fu* poems describe these extraordinary spectacles, in which, by some Leonardesque device, P'eng-lai and K'un-lun, with wild animals fighting on their slopes, might be made to appear out of a cloud of smoke while attendants in galleries overhead crashed great boulders together to simulate thunder. These hunts among mountains, and the wild, extravagant orgies that followed them, were to become favourite subjects in Han art.

The palace gateways were marked by pairs of tall watchtowers (*ch'üeh*), while within palace precincts stood multistoreyed pavilions (*lou*) or towers (*t'ai*) which were used for entertainment, for admiring the view, or simply for storage. When Loyang burned in A.D. 185, the Cloud Tower (*Yün-t'ai*) went up in flames, and with it a huge collection of paintings, books, records and objets d'art—to say nothing of the portraits of thirty-two distinguished generals which Wu Ti had had painted on the walls of the tower itself. This is the first recorded occasion when the art treasures accumulated through a whole dynasty were destroyed in a few hours, a disaster that was repeated again and again in Chinese history. Palaces, mansions, ancestral halls were built of timber, their straight-tiled roofs supported by a simple system of brackets resting on wooden pillars. Their timberwork was picked out in rich colours and their inner walls, like those of the Yün-t'ai, were often decorated with wall paintings.

These great mansions come vividly before our eyes as we read such poems as the *Chao Hun*, a passionate appeal addressed by an unknown Han author to the soul of a king which, in his illness, has left his body and gone wandering to the edge of the world. To lure it back, the poet describes the delights that await it in the palace:

'O soul, come back! Return to your old abode.
All the quarters of the world are full of harm and evil.
Hear while I describe for you your quiet and reposeful home.
High halls and deep chambers, with railings and tiered balconies;
Stepped terraces, storeyed pavilions, whose tops look on the high
 mountains;
Lattice doors with scarlet interstices, and carving on the square lintels;
Draughtless rooms for winter; galleries cool in summer;
Streams and gullies wind in and out, purling prettily;
A warm breeze bends the melilotus and sets the tall orchids swaying.
Crossing the hall into the apartments, the ceilings and floors are
 vermilion,
The chambers of polished stone, with kingfisher hangings on jasper
 hooks;
Bedspreads of kingfisher seeded with pearls, all dazzling in brightness;
Arras of fine silk covers the walls; damask canopies stretch overhead,
Braids and ribbons, brocades and satins, fastened with rings of precious
 stone,
Many a rare and precious thing is to be seen in the furnishings of the
 chamber.
Bright candles of orchid-perfumed fat light up flower-like faces that
 await you;
Twice eight handmaids to serve your bed, each night alternating in
 duty,
The lovely daughters of noble families, far excelling common
 maidens . . .
O soul, come back!'[1]

Much of our knowledge of Han architecture is derived from the reliefs and engravings or the stone slabs lining tombs and tomb shrines. In crude perspective, they show two-storeyed gateways

69 Gateway to a palace or mansion. Rubbing from brick relief. From Szechwan. Han Dynasty.

Supp. 8 Kneeling warrior. Terracotta; ht. 120 cm. This figure comes from Tomb Pit No. 2, discovered in 1976 near the tomb of Ch'in Shih-huang-ti, Lin-t'ung, Shensi. The standing figure in Fig. 73 (p. 74), comes from the first pit, discovered in 1974. A third, smaller, pit has since been located in the vicinity, possibly a 'command centre' for the pottery army guarding the eastern approaches to the tomb.

flanked with towers and often surmounted by a strutting phoenix, symbol of peace and of the south. The reliefs from the Wu family shrines in Shantung show a two-storeyed house in whose kitchens on the ground floor a banquet is in preparation, while the host entertains his guests on the *piano nobile* above. The humbler dwellings—farmhouses, granaries, even pigsties and watchmen's huts—survive in the rough and lively pottery models made to be placed in the tombs.

Never in Chinese history, indeed, was so much care lavished on the tomb and its contents as in the Han Dynasty. Huge numbers have survived and every day more are revealed. They are interesting not only for their contents but also for their structure, which varies considerably in different areas and provides us with almost the only surviving remains of Han architecture. They are not, of course, representative of Han building as a whole, nearly all of which was carried out in timber; the more adventurous techniques of the dome and vault in brick or stone were reserved almost exclusively for the permanent mansions of the dead. In the Chinese colonies in Korea and Manchuria, tombs were square or rectangular with flat roofs of stone slabs supported on stone pillars, or shaped like clusters of beehives with corbelled brick vaults. Tombs in Shantung were also of stone, sunk in the ground, while before them stood stone shrines, *tz'u*, for offerings to the spirits of the departed. An elaborate example of a Shantung tomb, discovered at I-nan, is shown in the sketch on

70 Isometric sketch of a stone tomb at I-nan, Shantung. Third century A.D.

this page. At Nanyang in southern Honan they were brick vaulted, long and narrow, lined with stone panels carved in relief. Sometimes the walls were plastered and painted. In Szechwan most of the tombs are small barrel-vaulted structures built of bricks on the inner face of which a lively scene was stamped in relief, though at Chiating deep tomb shafts were cut into the cliffs in groups with a common vestibule carved out to suggest a timber building. The tombs of the Ch'u people of central China, whose culture underwent a considerable revival during the Han, were either deep pits containing layered timber coffins, or rectangular chambers sometimes vaulted in brick.

71

71 Horse trampling on a barbarian archer. Stone sculpture which formerly stood before the reputed tomb of Ho Ch'ü-ping (died 117 B.C.). Hsien-yang, Shensi. Western Han Dynasty.

Elaborate as some of these tombs were, they were nothing to the tombs of the Ch'in and Han emperors, whose stone passages and vaults were enclosed in the heart of an enormous artificial hill approached by a 'spirit way' lined with colossal guardian figures carved in stone and guarded by booby traps. It has long been thought that all the tombs of the Han royal house were desecrated at the fall of the dynasty. But the accidental finding of the huge concealed rock-cut tombs of Han Wu Ti's elder brother Liu Sheng and his wife Tou Wan, clad in the jade suits described in Chapter 3, suggests that this was not the case and that, hidden Tutankhamen-like in the cliffs and valleys of North China, there may be more great tombs still intact, awaiting discovery.

SCULPTURE AND THE
DECORATIVE ARTS

It is in the Han Dynasty that we encounter the earliest monumental sculpture in stone. Its appearance at a time when China was highly receptive to Western ideas and forms, combined with the style of the sculpture itself, are more than suggestive of foreign origins. Near Hsien-yang in Shensi is a mound believed to be the grave of General Ho Ch'ü-ping who died in 117 B.C. after a brief and brilliant career of campaigning against the Hsiung-nu. Before the tomb, a life-size stone figure of a horse stands with majestic indifference over a fallen barbarian soldier who is attempting to kill him with his bow. The modelling is massive but shallow, giving the impression more of two reliefs back to back than of carving in the round, and indeed in its

72

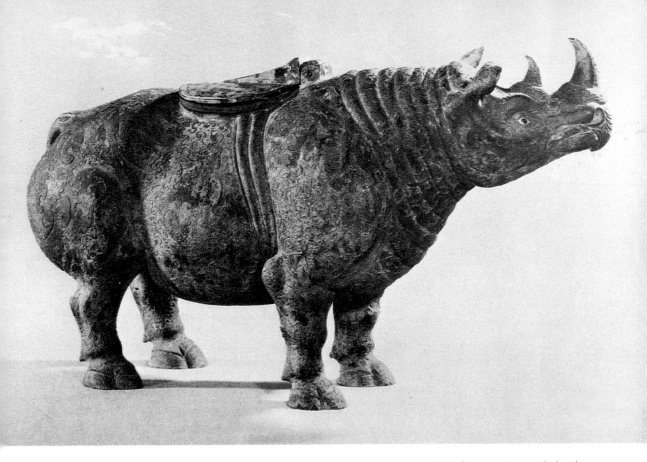

heavy, flat and somewhat coarse treatment this piece is from the technical point of view more reminiscent of the Sasanian rock-cut reliefs at Taq-i Bustan in Iran than of anything in early Chinese art. Many writers have pointed out how appropriate such a monument would be to a Chinese general whose victories over the Western nomads were due to the very horses which China had acquired from their enemy and used so effectively against them.

Clearly, however, the Chinese sculptor had not yet mastered the art of carving in the round on a big scale. Indeed, carving is not the technique in which he feels happiest. He is more at home in clay modelling and in the human figures and animals cast from clay moulds in bronze by the *cire-perdue* process. The vessel in the form of a rhinoceros illustrated here was once inlaid all over the body with an intricate pattern of scrolls, and only the glassy eye remains; but even with the inlay gone this marvellous piece, found buried in a field to the west of Sian in 1963, shows how successfully the craftsman of Ch'in or early Han was able to combine surface decoration with a lively realism. During the Han Dynasty this gift for modelling in clay found expression chiefly in the tomb figurines discussed below. These have their spectacular forerunners in the extraordinary clay figures found in 1975 in a pit to the east of the tomb of Ch'in Shih-huang-ti. This one pit alone—originally, it seems, a huge subterranean shed—contained about six thousand life-size figures of men and horses, with their chariots, while other

72 Rhinoceros. Bronze inlaid with gold. Found in Hsing-p'ing district, Shensi. About third century B.C.

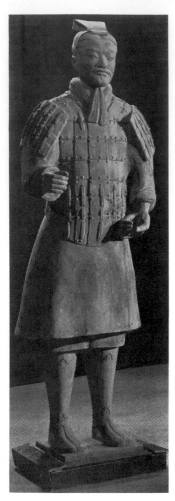

similar pits may lie at different points around the tomb. Each figure is individually fashioned. The legs are solid, the hollow body, head and arms being formed of an inner core of coiled strips of clay over which a 'skin' of finer clay was smeared, with the features stuck on or worked with a tool. The civilian officials and armour-clad soldiers bearing shining bronze swords were painted, and some bear the seals of the craftsman and foreman in charge. Unprecedented in number and size, they may well have been inspired by earlier straw figures, such as Confucius had recommended as a humane alternative to immolation.

Modelling in clay is the first stage in bronze-casting, and some of the most striking relics of Han art are the bronze figures and animals found in tombs. A particularly beautiful example in gilt bronze is the kneeling servant girl from the tomb of Liu Sheng's wife Tou Wan, holding a lamp of which the chimney is her sleeve and arm; while arresting in a more dynamic way is the bronze horse from an Eastern Han tomb discovered in Kansu in 1969. He is poised as if

73 Warrior. Painted terracotta. From the tomb pit of Ch'in Shih-huang-ti, Lin-t'ung, Shensi. Ch'in Dynasty, about 210 B.C.

74 Lamp held by kneeling servant-girl. Gilt bronze. From the tomb of Tou Wan (died c. 113 B.C.), Man-ch'eng, Hopei. Western Han Dynasty.

flying, and one of his hooves rests lightly on a swallow with wings outstretched, suggesting in a beautiful and imaginative way the almost divine power which the Chinese at this time believed the horse to possess.

While the idea of executing stone sculpture in relief may possibly have been derived from western Asia, it had been thoroughly assimilated by the Later Han. Stone reliefs have been found in almost every part of China. The most truly sculptural are the animals and figures carved on a pair of funerary pillars standing before the tomb of an official named Shen who was buried in Ch'ü-hsien in Szechwan during the second century A.D. The pillars themselves are timber towers translated into stone. In high relief between the beam ends is a monster like a gargoyle; at the corners crouching Atlantean figures—perhaps representing barbarian prisoners—support the beams, while above on each main face stand a beautifully modelled deer and rider. The only figures in flat relief are the directional symbols: on the east the dragon, on the west the tiger, to north the 'dark warrior' (snake and tortoise), to south the phoenix.

Nearly all of what passes for 'relief sculpture' in the Han period, however, is not really sculpture at all, so much as engraving in the

75 Pacing horse poised on a swallow with wings outstretched. Bronze. From a tomb at Lei-t'ai, Kansu. Eastern Han Dynasty, second century A.D.

76 Top of memorial pillar (ch'üeh) for a member of the Shen family. Stone. Ch'ü-hsien, Szechwan. Han Dynasty.

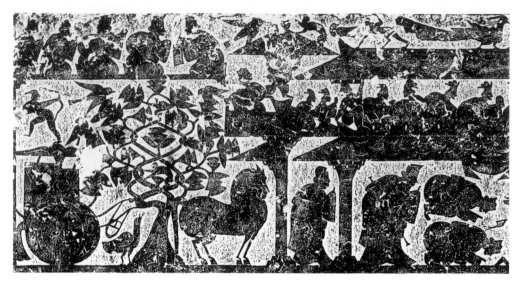

77 The archer Yi, the *Fu-sang* tree, and a mansion. Detail of rubbing from a stone relief in the tomb shrine of Wu Liang, Chia-hsiang, Shantung. Eastern Han Dynasty.

flat surface of a stone slab or flat relief with the background cut back and striated to give a contrasting texture. These slabs preserve the subject matter—and something even of the composition—of the lost mural paintings of the Han Dynasty. They not only give a vivid picture of daily life in this far-off time, but also show clear regional differences in style, so that we can without much difficulty identify the elegant dignity of some of the Shantung reliefs, the luxuriance of the stones from Nanyang in Honan, the cruder vigour of the reliefs from distant Szechwan. After the Han Dynasty, China becomes ever more of a single cultural entity, and these regional styles will largely disappear.

The stone shrines standing before the tombs were often decorated with engraved designs, the best known series being those at the Hsiao-t'ang-shan (Hill of the Hall of Filial Piety) near Fei-ch'eng in Shantung, and the slabs from four now-demolished shrines of the Wu family near Chia-hsiang in southwestern Shantung, which are dated by their inscriptions between A.D. 145 and 168. They give a vivid impression of the syncretic nature of Han art, in which Confucian ideals, historical events (real and legendary) and Taoist mythology and folklore are all brought together. On the shallow end gables of two of the shrines to east and west we find Tung Wang Kung and Hsi Wang Mu respectively; below, the legendary meetings of Confucius and Lao Tzu, or ancient kings, filial sons and virtuous women. The attempted assassination of Ch'in Shih-huang-ti, and his effort to raise one of the tripods of the emperor Yü, are favourite themes. The central recess and most of the remaining space is devoted to a banqueting scene, of which we can only show a detail. This depicts on the left the cult hero Yi, shooting out of the *Fu-sang* tree the nine extra suns (here symbolised as crows) that were scorching the earth, while to the right the guests bow to their host and a feast takes place upstairs. We see the ponderous officials in their voluminous robes, the short, deep-

chested horses of central Asian stock who trot with high-stepping precision while the air above them is filled with swirling clouds, and loud with the clamour of a fantastic assortment of winged creatures come to do honour to the dead. In this fabulous setting, the soul of the deceased can pass easily from the world of men to the world of the spirits.

There can be little doubt that both the style and the subject matter of the tomb reliefs owe much to the great cycles of wall paintings in halls and palaces, all trace of which has long since disappeared. Only a few miles away from the Wu family tombs lay the Ling-kuang Palace built by a brother of Han Wu-ti. The fame of its wall paintings is celebrated in a poem by Wang Yen-shou, written a few years before the Wu shrines were erected, which exactly describes the subject matter of their reliefs:

> Upon the great walls
> Flickering in a dim semblance glint and hover
> The Spirits of the Dead.
> And here all Heaven and Earth is painted, all living things
> After their tribes, and all wild marryings
> Of sort with sort; strange spirits of the sea,
> Gods of the hills. To all their thousand guises
> Had the painter formed
> His reds and blues, and all the wonders of life
> Had he shaped truthfully and coloured after their kinds[2]

These paintings live only in the imagination, for the buildings that housed them have long since crumbled to dust. But an increasing number of painted tombs is coming to light which give an impression of Han wall painting at a rather humbler level. Many depict with lively naturalism the daily life of a country estate not unlike the self-contained villa estates of late Roman Britain; but the paintings are difficult to reproduce satisfactorily, and published copies are deceptive. We find the same naturalism in moulded brick reliefs from tombs at Kuang-han in Szechwan. One depicts the salt mines, with pipelines of bamboo carrying the brine over the hills to the evaporating pans, methods still in use in Szechwan in the twentieth century. Another, divided horizontally, shows in the lower half men harvesting and threshing in the rice fields, while another brings their lunch; above, two hunters kneel at a lake shore, shooting up at the rising ducks with arrows trailing long cords. The border of the lake winds back, seeming almost to lose itself in the mist, while behind the hunters stand two bare trees. On the surface of the water are fishes and lotus flowers, and ducks swimming away as fast as they can go. This delightful scene shows that in the later Han, craftsmen in Szechwan were beginning to solve the problem of continuous recession in depth. Another way to solve it was simply to omit the landscape altogether. In the lively scene on the wall of a tomb in Liao-yang, with horsemen and carriages coming to the funeral feast, there is no ground, no hint of any setting, and yet we seem to be looking down from above on a open plain across which

78 Shooting birds on a lake shore and harvesting. Moulded pottery tile. From Kuang-han, Szechwan. Han.

79 Guests arriving for the funeral feast. Detail of a wall painting. From a tomb in Liao-yang, northwest China. Eastern Han Dynasty.

they dash with tremendous speed. This painting shows that the lateral movement from right to left, and the sense of a space that seems to extend far beyond the picture area, both characteristic of later scroll painting, were already mastered by painters before the end of the Han Dynasty.

Landscape, however, must have played a very subordinate part in the great fresco cycles that decorated the palaces and ancestral halls. The themes were most often Confucian, as illustrated by a passage from the *Han shu* (*History of the Han Dynasty*): "The mother of Jih Ti in teaching her sons had very high standards: the Emperor [Wu Ti] heard of it and was pleased. When she fell ill and died, he ordered her portrait to be painted on [the walls of] the Kan-ch'üan Palace. . . . Every time Jih Ti saw the portrait he did obeisance to it and wept before he passed on." Other passages in the *Han shu* bear witness to the Taoist predilections of the Han emperors. Wu Ti, for example, had a tower in the Kan-ch'üan Palace where were depicted "the demons and deities of Heaven, Earth, and the Supreme Unity. Sacrificial utensils were set out, by which the divine beings were to be addressed."

Didactic too, if in a more human and amusing way, are the figures painted on a celebrated series of tiles from the gable of a tomb-shrine now in the Boston Museum of Fine Arts. One scene depicts an animal combat; another may represent, as Sickman has suggested, an incident in the life of the virtuous Princess Chiang of the ninth century B.C. who took off her jewels and demanded to be incarcerated in the jail for court ladies as a protest against the emperor's dissipation—a threat which soon brought him to his senses. The figures, drawn in long sweeping lines with a sensitive, pliant brush, stand and move with wonderful ease and grace; the men discuss the affair in dignified agitation while the women, elegant and playful, seem to find the whole incident rather amusing. Happy the man whose tomb was adorned with such charming figures!

The power of the Chinese craftsman to impart life and movement to his subjects is vividly shown in the decoration of the lacquer objects for which Szechwan province was especially famous. That the output of her factories—especially those of Shu and Kuang-han—must have been considerable we know from the first century A.D. *Discourses on Salt and Iron*, whose author protests that the wealthy classes were spending five million copper cash annually on lacquer alone. A number of Szechwan lacquer bowls, cups and boxes, bearing dates between 85 B.C. and A.D. 71, have been found in tombs in the vicinity of Pyongyang in North Korea. Most famous, though undated, is the 'painted basket' (actually a box) found in a tomb at Lo-lang.

Around the top, under the fitted lid, are ninety-four figures of filial sons, virtuous and wicked rulers and ancient worthies. All are sitting on the floor, but monotony is avoided by the skill and inventiveness with which they turn to one side or the other, gesticulate or engage in lively conversation. Even in this crowded space we find the same sense of individuality, of interval and psychological relationship between the figures as we encountered on the Boston tiles. Other lacquer objects such as bowls and trays, of which many beautiful examples have been preserved in the water-logged soil of Changsha, are adorned with sweeping scrolls and volutes evolved out of the décor of the lacquers and inlaid bronzes of the Warring States. Now, however, these whirls erupt into flame-

80 Gentlemen in conversation. Detail of a painted pottery tile. Eastern Han Dynasty.

LACQUER

79

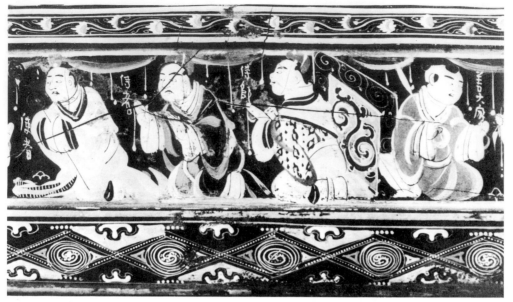

81 Paragons of filial piety. Lacquer painting on basketwork box. From Lo-lang, Korea. Eastern Han Dynasty.

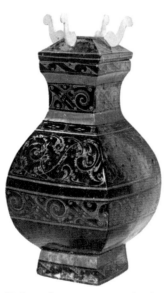

82 Covered square-section jar, *fang-hu*. Lacquered wood. From a tomb at Ma-wang-tui, Changsha, Hunan. Western Han Dynasty.

like tongues. The presence of a flying phoenix turns these tongues into clouds; when set about with tigers, deer and hunters they are magically transformed into hills; sometimes the transformation is aided, as on a beautiful bronze tube in the Hosokawa Collection, by vertical striations suggesting grass, or by little trees which grow from the volutes. There is no attempt to depict a real landscape; rather has the craftsman taken the sweeping volute as the essential form common to all things in nature and by means of a few accessories transformed it into clouds, waves or mountains without robbing it of any of its rhythmic forces. Because its forms follow the natural sweep and movement of the artist's hand, they express the rhythms of nature itself.

From the kind of pictorial art that I have been describing, rough and provincial as most of it is, we may imagine what the finest Han paintings must have been like. They were probably painted on silk or hemp cloth, for paper, a Chinese invention, was still in the early stages of its development at this time. Fragments of a hemp-fibre paper wrapping a mirror have been found in an early Western Han tomb near Sian; while in A.D. 105, the eunuch Ts'ai Lun, in charge of the Imperial Workshop (*Shang-fang*), presented to the throne what must have been a much improved paper made from vegetable fibres. Paper, however, was probably not used by artists for some time, and paintings continued to be executed on rolls of silk. Figure subjects included illustrations to the classics and histories and more fanciful works such as the *Huai Nan Tzu* and *Shan-hai-ching*, while for landscape there were illustrations to the *fu* rhapsodies describing the capitals, palaces and royal hunting parks.

It has long been thought that the hanging scroll was introduced with Buddhism from India, because the earliest known pictures in this form were the Buddhist banners of the T'ang Dynasty discovered at Tunhuang. However, in the tombs of the Marquis of Tai (ennobled 193 B.C.) and of his son at Ma-wang-tui in the suburbs of

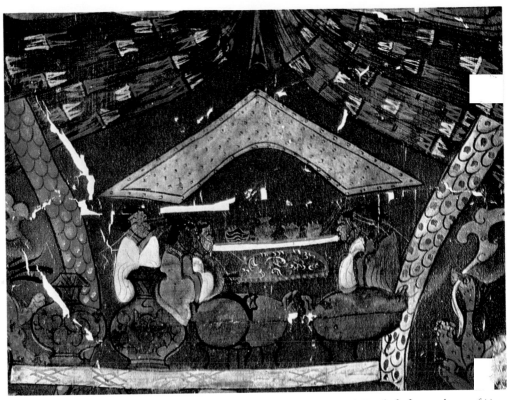

83 Detail of a funerary banner, *fei i.* Silk. From Tomb No. 1 at Ma-wang-tui, Changsha, Hunan. Western Han Dyansty.

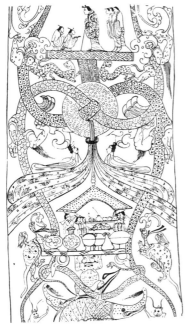

84 Line drawing of the section of the silk banner from which the detail in Fig. 83 is taken.

85 Fairy mountain incense burner, *Po-shan hsiang-lu.* Bronze inlaid with gold. From the tomb of Liu Sheng (died 113 B.C.). Man-ch'eng, Hopei. Western Han Dynasty.

81

Changsha have been found two banners that are a thousand years older than all known Chinese hanging scrolls, and leave no doubt that the format is native to China. Called "flying garments" in the inventory placed in the tomb itself, they were draped over the swathed corpse in the coffin. The T-shaped banner, six feet high and nearly three feet wide across the top, depicts beings of the nether world, the world of men, and the heavens, and includes a portrait of the deceased and a sacrificial scene. These tombs were also hung with large silk paintings of courtly and domestic pursuits, feasting and dancing, and a remarkably accurate map of the presumed domain of the Marquis, embracing much of modern Hunan and Kwangtung.

BRONZE With the fall of the Chou, the traditional rituals were forgotten, and consequently Han bronzes, while many were no doubt used in domestic rites of various sorts, are generally more utilitarian or decorative than those of Shang and Chou. Shapes are simple and functional, the commonest being the deep dish and the wine jar (*hu*) which were often decorated with inlaid designs in gold or silver. One object with definite ritual associations is the *Po-shan hsiang-lu*, a censer in the shape of a fairy mountain often covered with animals, hunters and trees modelled in relief. Its base is lapped by the waves of the Eastern Sea, while a hole behind each little peak emits the incense smoke symbolising the cloud-vapour (*yün-ch'i*) which is the exhalation of the fairy mountain—and indeed of all mountains, for according to traditional Chinese belief, all nature is alive and 'breathing'. The beautiful hill-censer inlaid with gold illustrated here was found in the Western Han tomb of Liu Sheng, the jade-clad brother of the emperor Wu.

China's neighbours to the southwest were in a far more primitive stage of development than the nomads of the north and northwest. Over the years, at Shih-chai-shan in southern Yunnan, there have been found the remains of a bronze culture of late Chou and early Han date very different from that of China proper. More than a score of tombs have been opened, containing bronze weapons and ritual objects, gold and jade ornaments. Most extraordinary are the bronze drums and drum-shaped containers filled with cowrie shells, the top of one of which is illustrated here. The figures who crowd it are evidently taking part in some sacrificial rite. Prominent are the ceremonial drums, some of which seem to be of enormous size, while a set of smaller drums stands on a platform under a wagon roof of a type still to be found in southeast Asia and Sumatra today.

From Chinese sources we know that these are the tombs of the rulers of a non-Chinese tribe, or group of tribes, which they called Tien, and which flourished in remote independence well into the Han Dynasty. As would seem natural from its geographical position, the Shih-chai-shan culture contains elements of Chinese and Dongson art and of the animal style of the western nomads. Struck by its extraordinary vigour, a recent Chinese writer has suggested

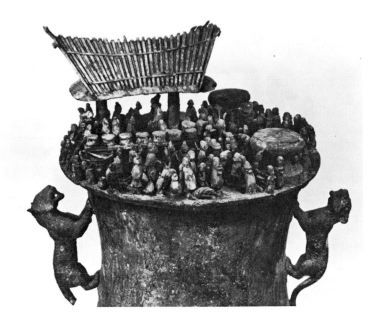

86 Drum-shaped container for cowrie
shells, with modelled sacrificial scene.
Bronze. From Shih-chai-shan,
Yunnan. Second to first century B.C.

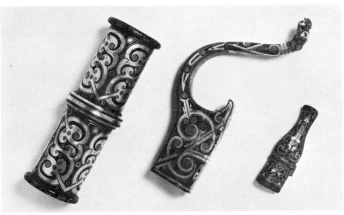

87 Carriage fittings. Bronze inlaid with
silver.

that Dongson is the debtor, and in fact, "no more than a pale
reflection of the high bronze culture of the Tien people in ancient
Yunnan." The unadulterated realism of Shih-chai-shan art, how-
ever, hardly justifies such a conclusion. Indeed, its very 'styleless-
ness' suggests that it was produced in almost total isolation from the
mainstream of Chinese culture.

In Han tombs there have been found great quantities of bronze
objects, including harnesses and carriage fittings, swords and knives,
utensils and belt buckles, many of which are inlaid with gold or
silver, turquoise or jade. Even the trigger mechanism of a crossbow
was often so cunningly inlaid as to make it an object of beauty. Some
of these show the powerful impact of the 'animal style' of the Ordos
region which in turn was influenced by that curious mixture of
stylisation and realism characteristic of the art of the northern
Steppes.

The bronze mirrors of the Han Dynasty continue the traditions developed at Loyang and Shou-chou during the Warring States. The Shou-chou coiled dragon design becomes more complex and crowded, the dragon's body being drawn in double or triple lines, while the background is generally crosshatched. Another group, also chiefly from Shou-chou, has an overall design of spirals on which a scalloped, many-pointed device is sometimes superimposed; its significance may be astronomical. Most interesting and most pregnant with symbolic meaning are the so-called TLV mirrors, of which the finest were produced in the Loyang region between 100 B.C. and A.D. 100, although the design was already being used on mirror backs in the second century B.C.

A typical TLV mirror has a large central boss surrounded by a square panel with twelve smaller bosses separating the characters of the twelve earthly branches. The Ts, Ls and Vs protrude into a circular zone adorned with animals, which, taken together with the fifth, central zone, symbolise the five elements, a system of cosmology first set down by Tsou Yen (c. 350–270 B.C.) and very popular in Han times. According to this system, the great ultimate (*t'ai-chi*) produces the positive-negative dualism of *yang* and *yin*, the interaction of which in turn gives birth to the five elements (*wu-hsing*) from which all events and objects are derived. The way in which the five elements work upon each other and are symbolized is as follows:

element	function	colour	direction	season	symbol
WATER	puts out fire	black	north	winter	'black warrior' (snake and tortoise)
FIRE	melts metal	red	south	summer	bird (phoenix)
METAL	destroys wood	white	west	autumn	tiger
WOOD	overcomes earth	green	east	spring	dragon
EARTH	absorbs water	yellow	centre		*tsung*

On the TLV mirror, the central circle within a square represents the earth symbol, *tsung*, while the four directions, seasons and colours are symbolized by their animals in the appropriate quarters. Many bear inscriptions which clearly set out the meaning and purpose of the design, such as this one on a mirror in the Museum of Far Eastern Antiquities, Stockholm:

> 'The Imperial mirror of the *Shang-fang* [imperial workshop]', it runs, 'is truly without blemish; a skilled artisan has engraved it and achieved a decoration; to the left the Dragon and to the right the Tiger eliminate what is baleful; the Red Bird and Black Warrior conform to the *yin* and *yang* forces; may your sons and grandsons be complete in number and be in the centre; on it are Immortals such as are customary [on mirrors]; may you long preserve your two parents; may your joy and wealth be splendid; may your longevity outstrip that of metal and stone; may you be like a prince or a king.'[3]

The TLV design was primarily an auspicious cosmological diagram combining celestial and terrestrial symbols. Its terrestrial elements made up the board for playing *liu-po*, a popular game in

88 TLV-type cosmological mirror. Bronze. Han Dynasty.

84

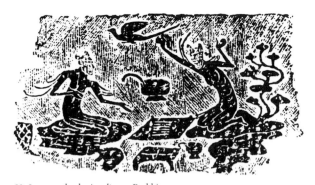

89 Immortals playing *liu-po*. Rubbing
from a stone relief on a tomb at
Hsin-chin, Szechwan. Han Dynasty.

90 Mirror with Taoist motifs. Bronze.
Late Eastern Han period, second to
third century A.D.

Han times which is represented on a number of Han reliefs and in
clay models. The object of this game, which Professor Yang Lien-
sheng has reconstructed from ancient texts, is to capture your
opponent's men or drive them into the 'benders' (presumably the Ls
on the outer edge) in order to attain the centre, or, as Cammann has
put it: "to establish an axis for symbolic control of the Universe." In
Han mythology *liu-po* was a favourite game of Tung Wang Kung
and of ambitious human heroes who sought to pitch their skill
against that of the gods and, by defeating them, to acquire magic
powers. To judge by the mirror designs, the game seems to have
gone out of fashion towards the end of the Han Dynasty. The
mirror backs of Late Han and the Three Kingdoms often preserve
the directional symbolism, but now become crowded with figures
fully modelled in relief; for the most part these are Taoist fairies and
immortals, but after A.D. 300, Buddhist themes begin to appear as
well.

In jade carving the main technical advance at the end of the Chou
Dynasty and the beginning of the Han was in the introduction of
iron cutting tools. The iron drill made it possible to cut deep into
the stone, while the rotary cutting disc enabled the lapidary to
hollow out quite large pebbles into the form of toilet boxes and
bowls such as the *yü-shang* ("Winged cup"), a small oval bowl
with flanges on the long sides made for eating and drinking, and
often included in the tomb furniture. They have been found
sometimes in sets standing on a tray, not only in jade but also in
pottery, silver and lacquer. This new technical freedom made the
lapidary more adventurous, inspiring him to carve, in three di-
mensions, figurines and animals—of which perhaps the most beau-
tiful specimen is the famous horse in the Victoria and Albert
Museum. He no longer rejects the flawed stone, but begins to
exploit the discolorations: the brown stain, for instance, becomes a
dragon on a white cloud. Jade has by this time begun to lose its
ritual significance; it now becomes instead the delight of the scholar
and the gentleman, for whom its ancient associations and beauty of
colour and texture will become a source of the profoundest intel-

JADE

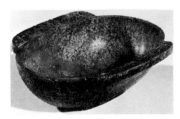

91 "Winged cup," *yü-shang*. Jade. Late
Chou Dynasty.

92 Head and shoulders of a horse. Jade. Han Dynasty.

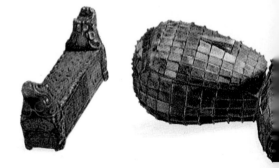

93 Burial suit. Jade plaques sewn together with gold thread. From the tomb of Liu Sheng (died 113 B.C.) at Man-ch'eng, Hopei. Western Han Dynasty.

lectual and sensual pleasure. Henceforward he will be able to enjoy his pendants and garment hooks, his seals and the other playthings on his desk, in the confident knowledge that in them aesthetic and moral beauty are united. This, however, can hardly be said of the jade burial suits described on page 49, which were made at enormous cost in human travail for members of the Han imperial family. After the fall of the Han there was a reaction against this sort of extravagance, and most Six Dynasties graves are more simply furnished.

Under the Han Dynasty, the customs and amenities which in Shang and Chou had been confined to a minute privileged aristocracy in a small region now spread over a much wider area and a much larger segment of society. At the same time, Chinese handicrafts have been found far beyond her own frontiers—in Indochina and Siberia, Korea and Afghanistan. The ruins of a Chinese-style palace recently discovered in southern Siberia contained Chinese bronze fittings, coins, tiles and pottery house models, the latter presumably made locally by Chinese potters. Chinese archaeologists have suggested that this might have been the palace of the daughter of Madame Wen-chi, who had been married to a chieftain of the Hsiung-nu in A.D. 195 but eventually was forced to return to China, leaving her devoted husband and children behind.

TEXTILES

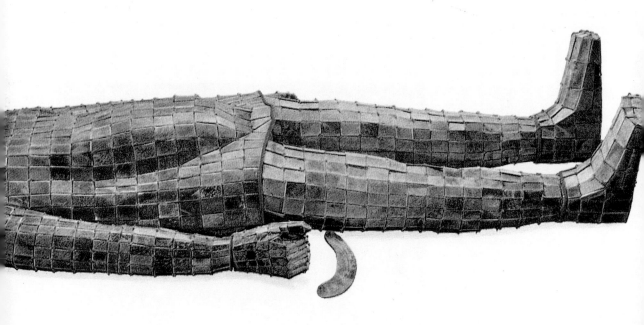

Chinese textiles, too, reached the limits of the civilised world. The Greek word *Seres* ("the Silk People") was probably first used not of the Chinese themselves—of whom the Greeks had no direct knowledge—but of the western Asiatic tribes who traded in this precious commodity. Direct intercourse with China came only after Chang Ch'ien's expedition and the establishment of the Silk Road across central Asia. This great caravan route, leaving China at the Jade Gate in modern Kansu, crossed central Asia to north or south of the Taklamakan Desert, reuniting in the region of Kashgar whence one branch led westwards across Persia to the Mediterranean world while the other struck south into Gandhāra and India. Chinese stuffs have been found in the Crimea, in Afghanistan, Palmyra and Egypt, while in Rome in the time of Augustus there was a special market for imported Chinese silk in Vicus Tuscus. According to legend, it was the consort of the Yellow Emperor who first taught the Chinese people the cultivation of the mulberry on which the silkworms feed, the spinning, dyeing and weaving of the threads; and so important has the industry been to China that, until the Revolution of 1911, the empress sacrificed to her spirit every year in her own temple in Peking.

Evidence of the art of weaving was found in the Neolithic village of Pan-p'o in Shensi; the Shang people at Anyang had tailored clothing of silk and hemp, while a number of passages in the *Book of Songs* refer to coloured woven silk. Silk panels with painted designs have been found in late Chou graves at Changsha, while equally important finds of early Chinese textiles were made in central Asia, notably in the waterlogged tumulus graves at Noin-Ula in southern Siberia, excavated by the Koslov expedition in 1924/25, and in the sand-buried sites of Turfan and Khotan, explored first by Sir Aurel Stein in the early years of the twentieth century, and more recently by Chinese archaeologists. The grave in Changsha that yielded the silk banner shown here was also

94 Figured silk fabric. From Noin-Ula, Mongolia. Han Dynasty.

95 Woven silk textile. From Tomb No. 1 at Ma-wang-tui, Changsha, Hunan. Western Han Dynasty.

crammed with rolls of silk. The techniques included moiré, damask, gauze, quilting and embroidery, and the designs were chiefly of three kinds: pictorial, generally representing animal combats such as appear also on the Ordos bronzes; diapered, with geometrical motifs repeated over the whole surface; and composed of those endless rhythmic cloud volutes which we have already encountered on the inlaid bronzes, set about with horsemen, deer, tigers and more fabulous creatures. The silk panel from Noin-Ula illustrated here is a kind of Taoist landscape composed of giant spirit-fungus (*ling-chih*) alternating with rocky crags topped by phoenixes and adorned with formalised trees, executed in a mixed Chinese-Western style which suggests that Chinese weavers were already designing for the export market.

96 Silk panel from Noin-Ula. Line drawing. Han Dynasty.

CERAMICS FOR USE AND FOR BURIAL

Han ceramics vary enormously in quality, from unglazed and roughly modelled earthenware to a high-fired, glazed stoneware verging on porcelain. Most of the grave goods were made of coarse pottery generally covered with a lead glaze which easily oxidises, producing that silvery-green iridescence which is so attractive a feature of this class of Han wares. The technique of lead glazing was known in the Mediterranean world before the Han, and if not discovered independently may have been introduced by way of central Asia. The finest of these lead-glazed wares are the jars (*hu*) for grain or wine. Their shapes are simple and robust, the imitation of bronze being aided by a very precise finish and the application of *t'ao-t'ieh* masks in relief, while incised lines or geometric motifs round the shoulder enhance the beauty of their form. Sometimes they are decorated with a frieze, depicting, in relief under the glaze, a 'hunt among mountains', in which all manner of creatures real and imaginary chase each other round and round—as on those extraordinary full-scale models of Mount P'eng-lai which were

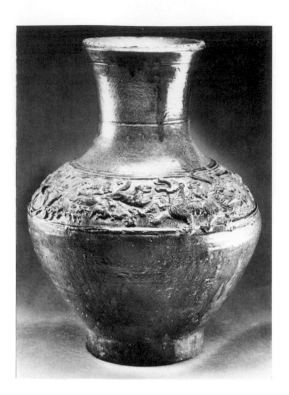

97 Jar, *hu*. Stoneware decorated with relief designs under a dark green glaze. Han Dynasty.

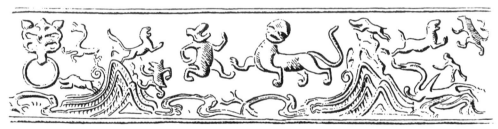

98 The hunt among mountains. Relief on the shoulder of a pottery *hu*. Line drawing. Han Dynasty.

made to appear at the hunting feasts of the Han emperors. These reliefs, in which we often find towering ranges of hills, may well preserve the designs of Han scroll paintings on silk.

In Han times, many people believed that on quitting this world one could take with him to heaven his family, servants, personal possessions, domestic animals, and even his house. As these could not actually accompany him, models (*ming-ch'i*, literally bright, or spirit, utensils) were placed in the tomb, and the custom persisted long after the fall of Han. Thus, we find in the Han tombs a retinue of servants and guards, farmhands, musicians and jugglers, such as its occupant probably never enjoyed in his lifetime. There were barns with fowl modelled in relief on the top. There were watchtowers in several storeys, their wooden beams and transoms either indicated by incisions in the clay or painted red. The houses and barns of the South China tombs are raised on stilts, like those in Southeast Asia today. Farm animals are modelled with uncanny realism; watchdogs from Szechwan graves are squat and menacing; those from Changsha, with heads erect and muzzles quivering, so

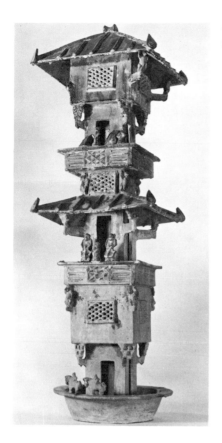

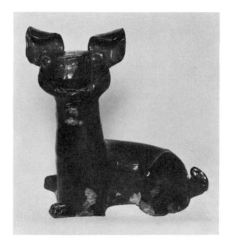

99 Watchtower. Pottery with green glaze. Eastern Han Dynasty.

100 Dog. Pottery covered with reddish-brown glaze. From Changsha, Hunan. Han Dynasty.

101 Tray with figures of musicians, dancers, acrobats, and spectators. Painted pottery. From a tomb at Tsinan, Shantung. Western Han Dynasty.

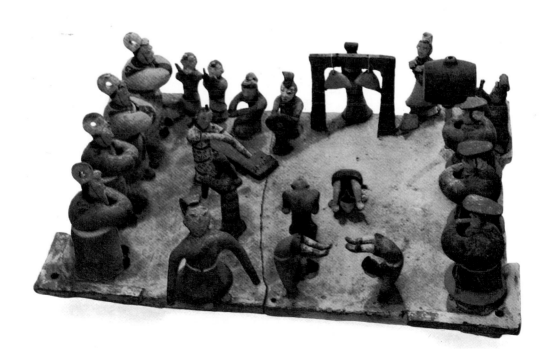

alert one can almost hear them sniffing. These figurines are a useful source of information on the daily life, beliefs and economy of Han China. The delightful tableau excavated in 1969 from a Western Han tomb at Tsinan, Shantung, depicts the kind of entertainment with music, tumblers and dancers, that was often represented on the walls of tombs and tomb shrines. They illustrate, too, the extent of China's foreign contacts at this time. The pottery stand for a bronze 'coin-tree' found in a grave in Szechwan, for example, is decorated with a frieze of elephants in relief, modelled with a lively naturalism that has no counterpart in other Han reliefs, but at once calls to mind the animals of the four quarters carved on the capital of the Aśokan column at Sarnath.

Some of the Han figurines were individually modelled, but the majority of the smaller pieces were mass produced in moulds: though the forms are reduced to essentials, none of their vitality and character is lost. At Changsha, where the clay was often poor and glazes apt to flake off, the *ming-ch'i* were generally made of painted wood, which, like the silk and lacquer found in the Changsha tombs, has miraculously survived the ravages of time.

Of quite a different kind was the fine quality felspathic stoneware, which was made in a number of centres in Chekiang. This ancestor of the Sung celadons has a hard body and thin glaze ranging in colour from grey to olive green to brown. It is often called Yüeh ware because the type-site is at Chiu-yen near Shaohsing, the old name of which is Yüeh-chou. Recent Chinese writers confine the term 'Yüeh ware' to the porcellaneous celadon made for

102 Stand for a lamp or 'coin-tree'. Pottery. From a tomb at Nei-chiang, Szechwan. Eastern Han Dynasty.

the court of Wu-Yüeh in the tenth century A.D., calling all earlier celadons simply *ch'ing tz'u* 'green porcelain'. However, in translation this is misleading, as some of it can hardly be called green, and none of it is true porcelain. In this book, therefore, the term 'Yüeh ware' is retained to cover the whole huge family of pre-Sung Chekiang celadons.[4]

The Chiu-yen kilns were in operation at least from the first century A.D.; those at Te-ch'ing, north of Hangchow, perhaps even earlier. Many of their products, found in dated tombs in the Nanking region, are imitations of bronze vessels, even to the loop-handles and *t'ao-t'ieh* masks that adorn them. Some are stamped with geometric or diaper designs under the glaze, preserving an ancient tradition of central and South China which spread not only northwards but also into the Nan-hai, the peninsula and islands of Southeast Asia. Gradually, however, true ceramic forms began to emerge, aided by a rich, luminous and even luscious glaze. The Chiu-yen kilns seem to have closed down in the sixth century, after which the Yüeh tradition was carried on in many parts of Chekiang, the chief factories being round the shores of Shang-lin Hu in Yü-yao-hsien, where the remains of more than twenty celadon kilns have so far been discovered.

103 Basin, Yüeh ware. Stoneware with modelled and incised decoration under a grey-green glaze. Third or fourth century A.D.

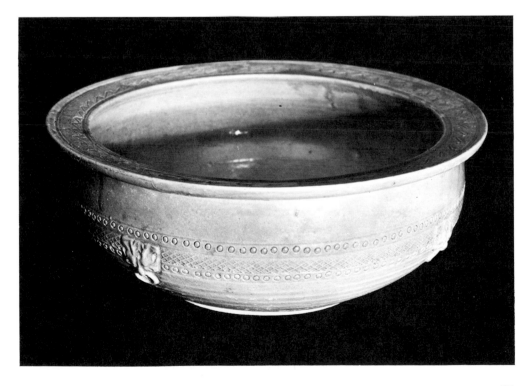

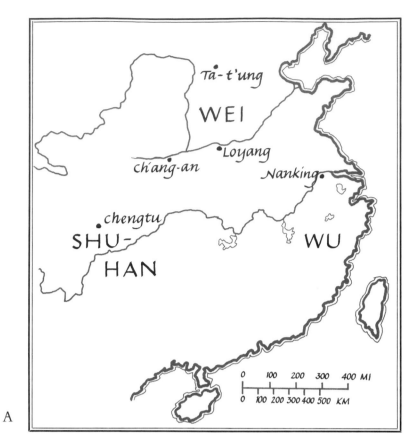

MAP 6 China during the Three
Kingdoms and Six Dynasties period.
A. A.D. 220–280. *B.* About A.D. 520.

A

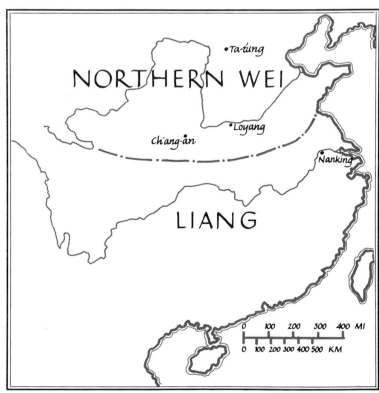

B

6
The Three Kingdoms and the Six Dynasties

During the four hundred years between the fall of the Han Dynasty and the rise of the T'ang, China went through a period of political, social and intellectual ferment comparable to that of modern Europe. No less than thirty dynasties and lesser kingdoms passed across the scene before the Sui reunited the empire in 581. At the fall of the Han Dynasty in A.D. 220, China was divided into the Three Kingdoms of Wu, Wei and Shu; in 280 it was once more reunited, under a Wei general who had usurped the throne in 265 and renamed the dynasty Chin. Beyond the northern frontiers, the Hsiung-nu and the Hsien-pi were watching with interest the incessant civil wars to which the now shrunken empire was victim. When, soon after A.D. 300, two rival princes rashly appealed to them for aid, they promptly advanced into China. In 311 the Hsiung-nu captured Loyang, massacred twenty thousand of its inhabitants and took the emperor prisoner; they then moved on to Ch'ang-an which they put to the sack, while the Chin court fled in panic to Nanking. The Hsiung-nu and Hsien-pi were not the only tribes to take advantage of China's weakness to invade the north; sixteen petty barbarian kingdoms were to rise and fall before the Toba Wei, a Turkish tribe, brought the whole of North China under their rule in 439. They established their capital near Ta-t'ung in northern Shansi, abandoned their nomadic way of life and adopted Chinese dress, eventually becoming so Sinicized that the use of the Toba language was forbidden altogether. At the same time, they energetically defended their northern borders against other and more barbarous tribes, and pushed their cavalry as far as Kucha in the Tarim Basin, thus reopening the trade route into central Asia.

The invasions had split China into two countries, with two cultures. While the north sank into barbarism, tens of thousands of Chinese refugees migrated to the south. Nanking now became the cultural and political centre of 'free China', to which merchants and Buddhist missionaries came from Southeast Asia and India. Yet this region too was in a perpetual state of turmoil and unrest, in which enormous quantities of art treasures were destroyed. Four more dynasties—the Liu Sung, Southern Ch'i, Liang and Ch'en—ruled

from Nanking before the split between north and south was healed. The Confucian order was undermined, and the southern Buddhist temples and monasteries now grew to such vast proportions—particularly under Liang Wu Ti (502–550)—that they constituted a serious threat to the political and economic stability of the realm. With the eclipse of the Confucian bureaucracy, it was often the great landed families who exerted the most influence on politics and the arts, outliving the dynasties themselves.

TAOISM

Many intellectuals in the South sought escape from the chaos of the times in Taoism, music, calligraphy and the delights of 'pure talk' (*ch'ing-t'an*). Taoism came into its own in the third and fourth centuries, for it seemed to answer the yearnings of men of feeling and imagination for a vision of the eternal in which they could forget the chaos of the present. This conglomeration of folklore, nature worship, and metaphysics was rooted in the native soil of China. It had first become a cult in the Later Han when Chang Tao-ling, a mystic and magician from Szechwan who called himself the *T'ien-shih* ("heavenly master"), gathered round him a group of followers with whom he roamed the countryside in search of the elixir of life. Sometimes he would take them to the top of the Cloud Terrace Mountain (*Yün-t'ai-shan*) and there invent ordeals to test their magic powers. By the Chin Dynasty, the movement that had originated as a private revolt against the established order had grown into a full-fledged 'church', with a canon of scriptures, a hierarchy, temples and all the trappings of a formal religion copied from the Buddhists.

On a higher level, however, the Taoists were the intellectual avant-garde. The reaction against Confucianism had produced a 'thaw' in the rigidly traditional view of art and literature, and now the imagination took flight once more in poetry more inspired than any since the elegies of Ch'u. Typical of the age is the poet T'ao Yüan-ming (365–427) who, though forced several times to take office to support his family, retired whenever he could to his country cottage where he grew his own vegetables, drank excessively and read books, though he said he did not mind if he failed to understand them completely. This was not merely escape from political and social chaos; it was escape also into the world of the imagination.

AESTHETICS

It was in these turbulent years that the Chinese painter and poet first discovered himself. Lu Chi's *Wen fu* (*Rhymeprose on Literature*), written in A.D. 300, is a penetrating, even passionate, rhapsody on that ordeal which T. S. Eliot called the "intolerable wrestle with words and meanings," and on the mysterious sources of poetic inspiration.[1] In the traditional Confucian view, art had served a primarily moral and didactic purpose in society. Now that position was abandoned, and new critical standards were evolved, culminating in Hsiao T'ung's preface of A.D. 530 to his anthology *Wen-hsüan*, in which he wrote that his selection of prose and poetry

had been guided not by moral considerations, but by aesthetic merit alone. This sophisticated position was not reached at once, however. Literary criticism in the third and fourth centuries had taken the form of *p'in-tsao*—a mere classification (often in nine grades) according to merits and faults, first applied to statesmen and other public figures, then to poets. The great painter Ku K'ai-chih used it in discussing artists of Wei and Chin (if indeed the surviving text is from his hand). It was employed more methodically by Hsieh Ho in his famous *Ku hua p'in lu* (*Ancient Painters' Classified Record*), written in the second quarter of the sixth century, in which the author grades forty-three painters of former times into six classes, a useful but undistinguished contribution to art history. What has made this brief work so significant for the whole history of Chinese painting is its preface, which sets out the six principles (*liu fa*) by which·paintings, and painters, are to be judged.

Much—perhaps too much—has been written about the six principles. But they cannot be passed over, for they have, with some variation or rearrangement, remained the pivot around which all subsequent art criticism in China has revolved. They are:

1. *Ch'i yün sheng tung*: Spirit Harmony—Life's Motion (Arthur Waley); Animation through spirit consonance (Alexander Soper).
2. *Ku fa yung pi*: bone-means use brush (Waley); structural method in the use of the brush (Soper).
3. *Ying wu hsiang hsing*: fidelity to the object in portraying forms (Soper).
4. *Sui lei fu ts'ai*: conformity to kind in applying colours (Soper).
5. *Ching ying wei chih*: proper planning in placing (of elements) (Soper).
6. *Ch'uan i mu hsieh*: that by copying, the ancient models should be perpetuated (Sakanishi).

The third, fourth and fifth laws are self-explanatory; they reflect the kind of technical problems that painting encountered in its early development. The sixth involves on the one hand the need to train one's hand and acquire an extensive formal repertoire, and on the other a reverence for the tradition itself, of which every painter felt himself to be in a sense a custodian. Making exact copies of ancient, worn masterpieces was a way of preserving them, and, at a later date, working 'in the manner of' great painters of the past, while adding something of oneself, was a way of putting new life into the tradition.

The experience of the painter—what Cézanne called, in a celebrated phrase, "une sensation forte devant la nature"—is enshrined in the phrase *ch'i yün*, Soper's 'spirit consonance'. *Ch'i* is that cosmic spirit (literally, breath or vapour) that vitalises all things, that gives life and growth to the trees, movement to the water, energy to man, and is exhaled by the mountains as clouds and mist. It is the task of the artist to attune himself to this cosmic spirit and let it infuse him with energy so that in a moment of inspiration—and no word could be more appropriate—he may

become the vehicle for its expression. William Acker once asked a famous calligrapher why he dug his ink-stained fingers so deep into the hairs of his huge brush when he was writing; the calligrapher replied that only thus could he feel the *ch'i* flow down his arm, through the brush and onto the paper. The *ch'i* is a cosmic energy that, as Acker puts it, "flows about in ever-changing streams and eddies, here deep, there shallow, here concentrated, there dispersed."[2] It infuses all things, for there is no distinction between the animate and the inanimate. Seen in this light, the third, fourth and fifth principles involve more than mere visual accuracy; for, as the living forms of nature are the visible manifestations of the workings of the *ch'i*, only by representing them faithfully can the artist express his awareness of this cosmic principle in action.

The quality in a painting through which awareness of the inner vital spirit is expressed is the second of Hsieh Ho's principles, *ku* (the "bone"), the structural strength of the brush-stroke itself, whether in painting or calligraphy. The sudden flowering of calligraphy at the end of the Han Dynasty as an art form in its own right was partly due to the development of the *ts'ao-shu* ("draft script"), the cursive style which freed the scholar from the formal angularity of the typical Han *li-shu* ("official" or "clerical script"), and enabled him to express himself in a style more personal, more charged with energy and grace, than any other writing that man has devised. It is no accident that many of the greatest calligraphers of this period, including Wang Hsi-chih and his son Hsien-chih, were Taoists. Both the techniques and the aesthetic of this subtle art had a considerable influence upon the development of Chinese painting during the three centuries following the fall of the Han.

The Taoist ideal in action is illustrated in the life and work of Tsung Ping, a distinguished Buddhist scholar and painter of the early fifth century, who spent his life wandering amid the beautiful hills of the south with his equally romantic wife, and who, when he was too old to wander any more, recreated the landscapes that he loved on the walls of his studio. A short *Preface on Landscape Painting* (*Hua shan-shui hsü*), one of the earliest surviving writings on this new art form, is attributed to him. In it he maintains that landscape painting is a high art because landscapes "both have material existence, and reach out into the realm of the spirit." He declares that he would like to be a Taoist mystic, meditating upon the void. He has tried it and is ashamed to confess that he failed; but, he asks, is not the art of the landscape painter, who can reproduce the very forms and colours that inspire the Taoist adept, even more wonderful? He is innocently amazed at the power of the artist to bring down a vast panorama of mountains within the compass of a few inches of silk. Visual accuracy he holds to be essential, for if the landscape is well and convincingly executed, if the forms and colours in the picture correspond to those in nature, then "that correspondence will stir the spirit, and when the spirit soars, truth will be attained. . . . What more," he asks, "could be added to this?"

Another brief essay, attributed to Wang Wei, a scholar, musician

and man of letters who died in 443 at the age of twenty-eight, starts by pointing out that paintings must correspond to the *pa kua* (the "eight trigrams"), meaning that just as the *pa kua* is a symbolic diagram of the workings of the universe, so must landscape painting be a symbolic language through which the painter may express not a relative, particularised aspect of nature seen at a given moment from a given viewpoint, but a general truth, beyond time and place. Though he too is full of wonder at the artist's mysterious power of pictorial compression, he insists that painting is more than the exercise of skill: "The spirit must also exercise control over it; for this is the essence of painting." The landscapes of Wang Wei, Tsung Ping and their contemporaries were all lost centuries ago, but the ideals that are enshrined in these and other writings of this critical formative period have been the inspiration of Chinese painters up to the present day.

104 After Ku K'ai-chih (c. 344–406). Illustration to *The Fairy of the Lo River*. Detail of a handscroll. Ink and colour on silk. About twelfth century.

The life and work of Ku K'ai-chih (c. 344–406), more perhaps than that of any other creative personality of this time, seem to embody the forces that inspired men in these turbulent years. Himself widely unconventional and yet a friend of the great at court, a calligrapher and painter of Taoist landscapes who yet was seldom far from the hurly-burly of intrigue in the capital, he moved unharmed among the rival politicians and warlords, protecting himself by the aura of idiocy which the Taoists held to be the only true wisdom. His biography tells us that he was famous for his portraits, in which he captured not merely the appearance but the very spirit of his subject.[3] A fascinating essay attributed to him describes how he would go about painting the Cloud Terrace Mountain and the ordeal to which Chang Tao-ling subjected one of his disciples on the top of a precipice. The text shows that he conceived of the mountain in strictly Taoist terms, bracketed east and west by the green dragon and the white tiger, its central peak ringed with clouds and surmounted by the strutting phoenix, symbol of the south. We do not know whether he ever painted this picture or not, though he probably did. Only three paintings associated with his name have

KU K'AI-CHIH AND THE
BIRTH OF LANDSCAPE
PAINTING

99

survived. One, of which there are Sung versions in the Freer Gallery and the Palace Museum, Peking, illustrates the closing moments in the *fu* of "The Fairy of the Lo River," by Ts'ao Chih. Both these copies preserve the archaic style of his time, particularly in the primitive treatment of the landscape, which provides the setting for the scene where the fairy bids farewell to the young scholar who had fallen in love with her, and sails away in her magic boat.

The Lo-shen scroll makes use of the technique of continuous narration, in which the same characters appear several times, whenever the story requires. This device seems to have come from India with the introduction of Buddhism, for there is no evidence of it in Han art. Probably the Han scrolls most often used the convention which is employed in the two other surviving works connected with Ku K'ai-chih, the *Lieh-nü t'u*, illustrating four groups of famous women of antiquity, with their parents,[4] and *The Admonitions of the Instructress to the Court Ladies*, in which the text alternates with the illustrations. The *Admonitions* scroll, illustrating a poem by Chang Hua, is not included among recorded works of Ku in T'ang texts and was first attributed to him in the collection of the Sung emperor Hui-tsung; there are, indeed, details of the landscape that suggest it may be a copy of the ninth or tenth century. Yet it clearly derives from a painting by a very early master. The scene illustrated here shows the emperor gazing doubtfully at a concubine seated in her bed-couch. The couplet (not visible) to the right runs:

105 Attributed to Ku K'ai-chih. The emperor with one of his concubines. Illustration to *The Admonitions of the Instructress*. Detail of a handscroll. Ink and colour on silk. Possibly a T'ang Dynasty copy.

106 Filial sons and virtuous women of
antiquity. Panel from a wooden screen
painted in lacquer. From a tomb dated
484 at Ta-t'ung, Shansi. Northern Wei
Dynasty.

"If the words that you utter are good, all men for a thousand leagues around will make response to you. But if you depart from this principle, even your bedfellow will distrust you." The fourth scene, now much faded and damaged, illustrates the virtuous Lady Pan refusing to distract the Han emperor Ch'eng from affairs of state by going out with him in his litter. The same scene, and almost the same composition, appear on a painted wooden screen that was discovered in 1965 in the tomb of Ssu-ma Chin-lung, a Chinese official who died at Ta-t'ung in 484 after loyally serving the Northern Wei court, and was buried in the Wei imperial mausoleum. Other scenes on this precious panel illustrate virtuous women of antiquity and, at the top, the emperor Shun meeting his future wives. While it is tempting to think that the treatment of the Lady Pan scene was inspired by a version of the Ku K'ai-chih scroll that had found its way to North China, both may be based on an older traditional rendering of the theme.

When Liang Yüan Ti abdicated in 555, he deliberately consigned to the flames over two hundred thousand books and pictures in his private collection, so it is not surprising that nothing has survived of the works of the other leading masters of the Southern Dynasties who were active in Nanking. The *Li-tai ming-hua chi*, however, records the titles of a number of paintings of this period, from which we know what kinds of subjects were popular. There were the stock Confucian and Buddhist themes, great panoramas illustrating the descriptive *fu* and other, shorter poems; landscapes depicting famous mountains and gardens; there were scenes of city, village and tribal life, fantastic Taoist landscapes and pictures of the figures symbolising the constellations, illustrations of historical events, legends such as the story of Hsi Wang Mu. Most must have had landscape settings, while several were pure landscapes, and at least three paintings of bamboo are recorded. The great majority were presumably either standing screens or long handscrolls.

107 Hunting scene. Wall painting in the 'Tomb of the Wrestlers', T'ung-kou, Kirin. About fifth century.

子舜

We can obtain some notion of the style of the time from the paintings that line the walls of tombs in North Korea, notably the 'Tomb of the Dancing Figures' and the 'Tomb of the Wrestling Scene' at T'ung-kou on the Yalu River. Although painted as late as the sixth century, these lively scenes of feasting and hunting amid mountains are in the tradition of the Han tomb paintings at Liao-yang. But to see the most advanced treatment of landscape in this indigenous style, we must look not at the provincial tomb decorations, but at the engraved slabs from North China, of which the most beautiful examples are the sides of a stone coffin now in the Nelson Gallery, Kansas City, adorned with incidents in the lives of six famous filial sons of antiquity. The figures seem hardly more than the excuse for magnificent landscape panoramas, so richly conceived and so beautifully drawn that they must surely have been copied from a handscroll or, as Sickman suggests, a wall painting, by an accomplished artist. Each incident is set off from its neighbours by hills with overlapping tops called *ch'üeh* which have powerful Taoist associations; half a dozen kinds of tree are distinguishable, tossed by a great wind that sweeps through their branches, while above the distant hills the clouds streak across the sky. The scene in which the filial Shun escapes from the well into which his jealous stepfather Yao cast him is astonishing in its animation, and only in his failure to lead the eye back through a

108 The story of the filial Shun. Detail of an engraved stone slab from a sarcophagus. Late Northern Wei Dynasty, about 520–530.

103

convincing middle distance to the horizon does the artist reveal the limitations of his time. Though its subject is respectably Confucian, its treatment exudes a joy in the face of living nature that is purely Taoist. It serves also to remind us that in spite of the ever-growing demands of Buddhism for art of an entirely different kind, there already existed at this time a purely native landscape tradition allied to calligraphy and based on the language of the brush.

<table>
<tr><td>BUDDHISM</td><td>Buddhist communities were already established in North China before the end of the Han Dynasty. Now, however, political and social chaos, loss of faith in the traditional Confucian order, and the desire to escape from the troubles of the times all contributed to a wave of remarkable religious enthusiasm, and the new doctrine spread to every corner of the empire. Its acceptance, except among the lower strata of society, was not due to blind and innocent faith—for that is not a sentiment to which the educated Chinese are prone—but perhaps to the fact that it was new, that it filled a big gap in men's spiritual lives, and that its speculative philosophy and moral justification of the renunciation of worldly ties appealed to intellectuals, who were now often reluctant to take on the perilous responsibilities of office. The new faith must have proved an effective consolation, if we are to judge by the vast sums spent on the building of monasteries and temples and their adornment during these troubled years.</td></tr>
</table>

We must pause in our narrative for a moment to consider the life and teachings of the Buddha, which form the subject matter of Buddhist art. Gautama Śākyamuni, called the Buddha, or the Enlightened One, was born about 567 B.C., the son of a prince of the Śākya clan ruling on the border of Nepal. He grew up surrounded by the luxuries of the palace, married, and had a son Rāhula. His father deliberately shielded him from all contact with the miseries of life beyond the palace gates, but in spite of the care with which his excursions were planned for him, Śākyamuni was finally confronted with the reality of old age, sickness and death, and he saw a vision of an ascetic, pointing his future path. Deeply disturbed by his experience, he resolved to renounce the world and search for the cause of so much suffering. One night he stole out from the palace, cut off his hair, bade farewell to his horse and groom, and embarked upon his quest. For many years he wandered, seeking, first with one teacher and then with another, the answer to the mystery of existence and a way of release from the intolerable cycle of endless rebirths to which all living things are subject according to *karma*, the inexorable law of cause and effect. Then one day at Bodhgayā he entered into a trance seated under a pippala tree. For three days and nights he remained motionless. The demon Māra sent his host to assault him and his three lovely daughters to dance seductively before him, but without moving from where he sat, the Lord rendered the former powerless while the latter he transformed into withered hags. Finally, in the moment of enlightenment, the answer came to him. In his first great

sermon in the Deer Park at Benares, he gave his message to the world in the form of the 'Four Noble Truths':

All existence is suffering (*dukkha*).
The cause of suffering is craving, lust, desire—even desire for existence itself.
There is an end to suffering, for this craving can be suppressed.
There is a way of suppression, through the Noble Eightfold Path.

The Buddha also taught that there is no such thing as a soul, but that all life is transitory, all in a perpetual state of becoming. By following the Eightfold Path, which involves right conduct, right belief and right meditation, the devotee can break the cycle of rebirths which binds us eternally to the wheel of existence, and so secure his release and his final merging in eternity, as a cup of water poured into the sea. Śākyamuni achieved enlightenment in his lifetime, although he continued to walk the earth, gathering disciples, performing miracles and spreading his teaching, until his final departure, the *Mahāparinirvāna*, at the age of eighty. His teaching was austere and, moreover, only for the chosen few who were prepared to renounce the world and face the rigours of life as a mendicant or, later, the regimen of the monastery. Its appeal lay partly in its simplicity—a welcome relief from the complexities of Hindu theology and metaphysics—and partly in the hope it offered of release from a destiny from which Hindu doctrine saw no escape.

The new faith grew slowly, and it was not until it was embraced by King Aśoka (272?-232 B.C.) that it became a truly national religion. That monarch devoted himself with such tremendous energy to its propagation that legend has it he erected eight-four thousand *stūpas* (relic mounds) in a single day, while his monastic and temple foundations were on a scale which many a pious Buddhist ruler has since tried to emulate. His missionary activities brought the faith to Ceylon and to Gandhāra in northwest India, where it came in contact with the religious ideas and artistic forms of the provincial Graeco-Roman world. It was probably in Gandhāra that, under these influences and encouraged by the great conference organised by King Kanishka (second century A.D.) of the Kushans, the first great development in Buddhist doctrine took place. The core of the dogma remained unaltered, but the new schools—who called themselves Mahāyāna ("greater vehicle"), referring derogatively to the more conservative sects as the Hīnayāna ("lesser vehicle")—taught that salvation was open to all men, through faith and works. Now the Buddha ceased to be an earthly teacher, but was conceived of as pure abstraction, as the universal principle, the godhead, from whom truth, in the form of the Buddhist *dharma* ("law"), radiates with a blinding light across the universe. By this elevation to a status parallel to that of the Hindu Brahmā, the Buddha receded far beyond the reach of mortal man. *Bhakti*, the adoration of a personal god, expressed in Hinduism in the love of Krishna, demanded a more approachable deity. So there came into existence the *bodhisattva* ("one destined for en-

lightenment"), who has postponed his own end that he might bring help and comfort to suffering mankind. Of the *bodhisattvas*, the most popular was Avalokiteśvara ("the Lord who looks down [in mercy]"), who on his translation to China as Kuan-yin became identified both with his female reflex, Tārā, and with the ancient Chinese mother-goddess, and thus imperceptibly acquired female sex—a process that was complete by the end of the tenth century. Almost as important were Mañjuśrī (Chinese Wen-shu) the god of wisdom, and Maitreya, the deity who, though now still a *bodhisattva*, will in the next cycle descend to earth as the Buddha; to the Chinese he has become Mi-lo-fu, the pot-bellied 'god of wealth' who sits grinning at the entrance of every temple. In time the pantheon grew to extraordinary proportions, the vast array of Buddhas and *bodhisattvas* being attempts to express the infinite aspects and powers of god. These developments were, however, for the theologians and metaphysicians. The common man needed only the comfort of Avalokiteśvara, or the secure knowledge that, merely by speaking once the name of the Buddha Amitābha, he would on quitting this world be reborn in his western paradise beyond the sunset.

It was probably in Gandhāra, and under Western influence, that the Buddha was first represented in sculpture. The style of Gandhāra is a curious mixture of the classical realism of Graeco-Roman provincial art with the Indian genius, fostered at the southern Kushan capital of Mathurā, for giving concrete, plastic expression to an abstract, metaphysical concept. From Gandhāra, Buddhism, and with it this new synthetic art, spread northwards across the Hindu Kush to central Asia, there to run like a powder trail along the string of oases to north and south of the Tarim Basin.

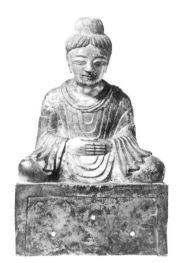

109 Śākyamuni Buddha. Gilt bronze. Dated equivalent to 338 A.D. Six Dynasties.

MAP 7 The spread of Buddhism from India into central and eastern Asia.

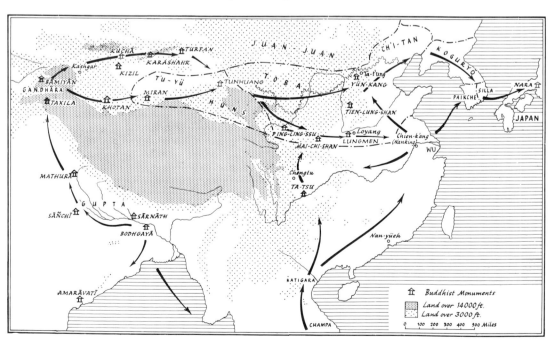

106

110 Types of pagoda. 1–3 derived from the Han timber *lou*: 1. Yünkang (Northern Wei); 2. Sian (T'ang); 3. Canton (Ming). 4 and 5 derived from the Indian *śikhara* tower: 4. Sung-shan (c. 520); 5. Sian (T'ang).

Buddhist sculpture preceded Buddhist architecture into China, for it was the images—brought in the luggage of missionaries, travellers and pilgrims, who were no doubt prepared to swear that what they carried was an exact replica of some famous icon in India or central Asia—which were most deeply venerated. The earliest known exactly dated Chinese Buddhist image, cast in 338, is clearly an imitation of a Gandharan prototype. Such icons were set up in shrines built in the traditional Chinese style, which grew until the monastery or temple became a kind of palace, with courtyards, pavilions, galleries and gardens. No attempt was made in these timber buildings to imitate the Indian temple. But the *stūpa* presented a different kind of challenge. The monk Sung Yün, returning from Gandhāra early in the sixth century, had described (as doubtless many before him) the gigantic *stūpa* erected by King Kanishka, one of the wonders of the Buddhist world. Built in timber, it was no less than seven hundred feet high, in thirteen storeys, capped by a mast with thirteen golden discs. The Chinese already possessed, in the towers called *lou* and *ch'üeh*, multistoreyed timber buildings which could be adapted to this new purpose (see p. 91). The Chinese examples of this period have all perished, but the pagodas at Hōryūji and Yakushiji near Nara in Japan still stand as monuments to this simple, graceful style. The earliest surviving dateable pagoda on Chinese soil, however, is the twelve-sided stone tower on Mount Sung in Honan, erected in about 520. It has no surviving Chinese antecedents. Its profile echoes the curve of the Indian *śikhara* tower; the arched recesses on the main faces recall the niches on the great *stūpa* at Bodhgayā, and, as Soper has observed, many of the details are Indian, or based on Southeast Asian modifications of the Indian style found in the kingdom of Champa, with which China was now in contact. But gradually the Indian elements were absorbed, and the later stone and brick pagodas will imitate, in their surface treatment, the posts, brackets and projecting roofs of their Chinese timber prototypes.

At Bāmiyān in Afghanistan a high cliff more than a mile in length had been hollowed out into cave shrines decorated with frescoes and bracketed at either end by colossal standing Buddha

BUDDHIST ART REACHES CHINA

111 Twelve-sided pagoda of Sung-yüeh-ssu on Mount Sung, Honan. Northern Wei Dynasty, about 520.

107

112 Mai-chi-shan, Kansu. View from the southeast.

figures carved out of the rock, plastered and painted. This fashion for decorated cave shrines, which had originated in India, spread to Khotan, Kucha and other central Asian city-states, where the already syncretic Graeco-Indian tradition of painting and sculpture became mixed with the flat, heraldic, decorative style of Parthia and Sasanian Persia. The routes that skirted the Taklamakan Desert joined at Tunhuang, the gateway to China. There, in A.D. 366, pilgrims had hewn from the soft rock the first of what were to develop during the next thousand years into a range of nearly five hundred chambers and niches set about with plaster sculpture and adorned with frescoes. Further stages on the pilgrim route into China were marked by cave shrines at Ping-ling-ssu, about fifty miles southwest of Lanchow, and Mai-chi-shan, twenty-eight miles southeast of T'ien-shui. The former was only rediscovered in 1951, while restoration of the latter, which had always been known to the people of the T'ien-shui district, did not begin till 1953. In their spectacular sites and the quality and richness of their sculpture these shrines surpass Tunhuang, whose glory lies chiefly in its paintings.

In 386 the Toba Turks established their ascendancy over North China as the Wei Dynasty, with their capital at Ta-t'ung. Their rulers had embraced Buddhism with enthusiasm, for, like the Kushans in India, they were excluded from the traditional social and religious system of those they had conquered.[5] At the urging of the overseer of monks, T'an-yao, they began, soon after 460, to hew out of the cliffs at Yünkang a series of shrines and colossal figures, possibly in emulation of the 'thousand foot' Maitreya at Darel in Afghanistan, which were to be a monument not only to Buddhism but also to the splendour of the royal house itself. By the time the capital was moved south to Loyang in 494, twenty large caves and some minor ones had been excavated, while work was resumed under the Sui, and again between 916 and 1125, when Ta-t'ung became the western capital of the Liao Dynasty. The earliest caves —those numbered XVI to XX—were dedicated by the emperor to himself and four earlier Wei rulers, possibly as a penance for the harsh repression of the faith by his Taoist grandfather in 444. These

BUDDHIST SCULPTURE UNDER THE NORTHERN WEI: THE FIRST PHASE

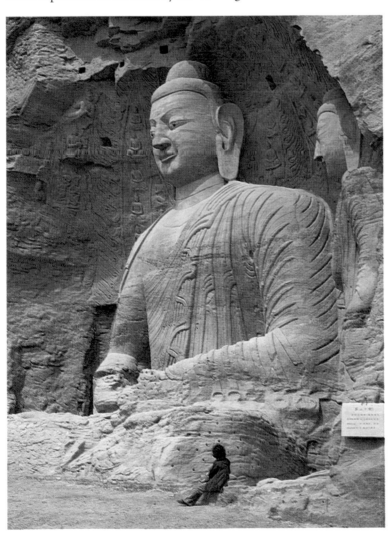

113 Śākyamuni with attendant Buddha, perhaps Maitreya. Sandstone. Cave XX, Yünkang, Shansi. Northern Wei Dynasty, about 460–470.

114 Interior of Cave VII, Yünkang. Northern Wei Dynasty, about 470–480.

five caves contain huge seated or standing Buddhas cut in the living rock, while the seated Buddha of Cave XX was originally protected by a timber façade in several stories. This colossus, fifteen metres high, sits in an attitude of meditation; his shoulders and chest are massive and yet finely proportioned, his face is clear-cut with something of the masklike quality often found in Gandhāra, while the drapery is suggested by flat, straplike bands which disappear into points as they pass round the contour of arm or shoulder. Perhaps, as Sickman has suggested, this curious convention is the result of the sculptor's following, and not properly understanding, a line drawing of some Western prototype, for great pains were taken to copy the style of the more venerated images as closely as possible.

By the end of the fifth century a change was beginning to appear in the sculpture at Yünkang, when this solid and somewhat heavy style was modified and refined by the native Chinese predilection for abstract expression in terms of the flowing, rhythmic line. The carvings in Cave VII, one of the most richly decorated of all, bear witness to this transformation. This is one of the 'paired' caves dedicated by members of the imperial family about 480 or 490. Every inch of the walls is decorated with reliefs which were once painted in bright colours and testify to the gratitude, to the generosity, and perhaps also to the anxiety about their future destiny of the imperial donors. In long panels, the life of the Buddha is told in a series of vivid reliefs, while above is the heavenly host—Buddhas, seated or standing, *bodhisattvas*, flying *apsarases*, musicians and other

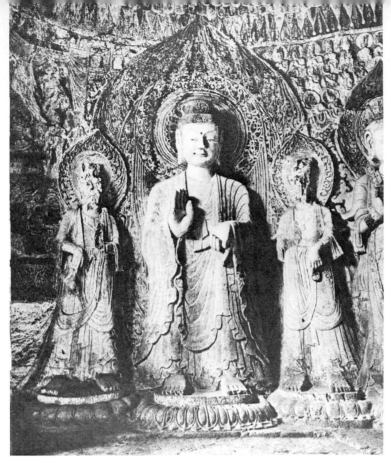

115 Buddha group, south wall of
Pin-yang-tung, Lungmen. Limestone.
Late Northern Wei Dynasty, probably
completed in 523.

celestial beings. The decoration of this cave reminds us, in its wealth
of detail, its contrast between the realism of the earthly figures and
the serenity of the heavenly ones, of the beatific visions of the Italian
primitives.

The Loyang region was closer to the centre of the purely Chinese
tradition of pictorial expression in linear, as opposed to plastic,
terms; and so it was inevitable that this tendency, already becoming
apparent in the later caves at Yünkang, should have found its
fulfillment after the move to the south in 494. At Lungmen, only
ten miles from the new capital, sculptors found a fine grey lime-
stone which permitted greater refinement of expression and finish
than the coarse sandstone of Yünkang. The new style reached its
culmination in the cave known as Pin-yang-tung, commissioned
by the emperor Hsüan-wu and probably completed in 523. Against
each of the interior walls is a large figure of the Buddha, attended
by standing *bodhisattvas* or the favourite disciples Ānanda and
Kāśyapa. On either side of the entrance, the walls were decorated
with godlings in relief, *Jātaka* tales, scenes of the celebrated debate be-
tween Vimalakīrti and Manjuśrī and two magnificent panels show-
ing the emperor and empress coming in procession to the shrine
attended by their retinue. The empress panel, badly damaged in
removal many years ago, has been restored and now forms part of
the important Chinese collection in Kansas City. Executed in flat
relief, its sweeping linear rhythms and wonderful sense of forward

BUDDHIST SCULPTURE:
THE SECOND PHASE

111

movement suggest the translation into stone of the style of wall painting which must have been current at the Wei court, and is further proof that besides the imported, hieratic forms reserved for the deities themselves there existed another and more purely Chinese style, to which painters and sculptors instinctively turned in representing secular themes.

Because of the great scarcity of Buddhist sculpture from the southern kingdoms, we are apt to think that the stylistic revolution which reached its culmination at Lungmen must have originated in the north and gradually spread southwards. But recent discoveries and research suggest that the opposite was the case, and that it was the art of the southern courts centred in Nanking which was the dominating factor in the development of Buddhist sculpture in the Six Dynasties. One of the earliest innovators had been Tai K'uei, a contemporary of Ku K'ai-chih at the Chin court in Nanking. His work, in which he is said to have raised the art of sculpture to a new level, very probably reflected the style of contemporary painting —the flat, slender body, sweeping robes and trailing scarves that we see in copies of the Ku K'ai-chih scrolls. This concept of figure and drapery does not appear in the sculpture of the north until a century later, when we first encounter it in the later stages at Yünkang and the earliest caves at Lungmen, and there is much evidence to show that it was introduced by artists and sculptors from the south.

The arrangement of the Pin-yang cave at Lungmen was probably intended to suggest the interior of a temple, whose equipment would also have included free-standing images in stone, stone

116 The Wei Empress in procession with court ladies. Restored stone relief panel from Pin-yang-tung, Lungmen. Late Northern Wei Dynasty.

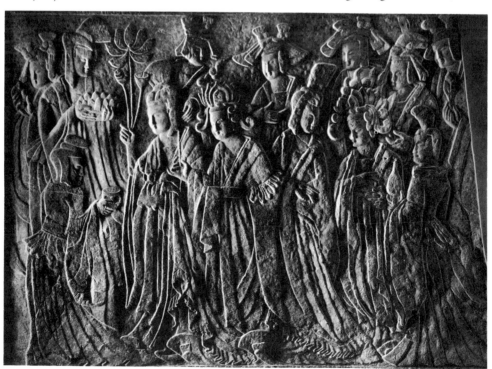

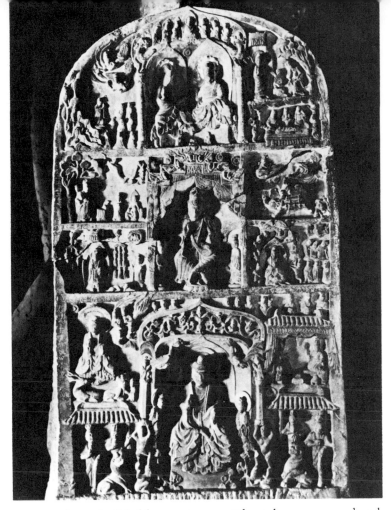

117 Stele illustrating the life of the Buddha and the teachings of the *Lotus Sūtra*. Stone. In Cave 133, Mai-chi-shan, Kansu. First half of sixth century.

votive steles and gilded bronze images. The steles were carved and set up in the temple as an act of piety or gratitude by one or more subscribers, whose names they often bear. They consisted either of a flat slab shaped like a pippala leaf against which one, or more often a group of three figures, stands out almost in the round; or of a rectangular slab decorated, often on all four sides, with Buddhas, *bodhisattvas* and lesser deities, illustrations to favourite texts such as the *Lotus Sūtra* (*Saddharmapundarīka Sūtra*) and scenes from the life of the Buddha carved in relief. Their peculiar interest and value lie in the fact that they concentrate in little space the essentials of the style and iconography of the period, and that they are frequently dated.

In Cave 133 at Mai-chi-shan, a group of eighteen of these steles still stand in their original positions against the walls where they were set up by pious devotees. Three of these are splendid examples of the mid-sixth-century style; one a veritable 'poor man's bible'. The upper central panel is devoted to the incident in the *Lotus Sūtra* in which Śākyamuni by the power of his preaching causes Prabhūtaratna, a Buddha of the distant past, to appear beside him. In the centre and below are Buddas flanked by *bodhisattvas*—a simple presentation of the paradise theme. The side panels show (on the left, going downwards) Śākyamuni descending from the

113

118 Śākyamuni and Prabhūtaratna. Gilt bronze. Northern Wei Dynasty, dated equivalent to 518.

Tuṣita heaven where he had preached to his deceased mother; Śākyamuni as a young prince; the renunciation, and the first preaching in the Deer Park. On the right: a *bodhisattva* meditating under a tree; the *Mahāparinirvāna*; Sāmantabhadra on his elephant; the temptations of Māra; and the theological disputation between Mañjuśrī and Vimalkīrti (holding the fan).

Very few of the great bronze images of this period have survived. They were nearly all destroyed or melted down in the persecutions which intermittently scarred the history of Buddhism in China. To see the largest, if not the finest, example of an altarpiece in the Wei linear style we must journey to Japan where, in the Kondō ("golden hall') of the monastery of Hōryūji at Nara, is a magnificent Buddha trinity which, though executed by an immigrant from Korea in 623, is a late survival of the style of mid-sixth-century China. Some of the smaller gilded bronze images, made most probably for domestic chapels, escaped destruction. Because of the precision of their modelling and the beauty of their material, these bronzes—ranging from simple seated Buddhas to elaborate altar groups complete with stand, flame *mandorla* and attendant deities —are among the supreme examples of Chinese Buddhist art. One of the most perfect examples of the mature Wei style is the exquisite group of Śākyamuni preaching his doctrine to Prabhūtaratna, Buddha of the remote past, dated 518, in the Musée Guimet, Paris. The form is expressively attenuated; the eyes slant, the mouth wears a sweet, withdrawn smile, while the body seems about to disappear altogether under a cascade of drapery that no longer defines the figure beneath but, like the drapery of the Romanesque sculpture of Moissac or Vézelay, in its expression of a state of spiritual ecstasy seems to deny the body's very existence. Here, the influence on sculpture of the sweeping rhythms of the painter's brush is very apparent, while the air of spirituality is certainly enhanced by the extraordinary linear elegance and almost exaggerated refinement of the style of this period as a whole.

BUDDHIST SCULPTURE: THE THIRD PHASE

After the middle of the sixth century, a further, equally momentous, change came over the style of Chinese Buddhist sculpture. Now the body began to expand once more, filling the robes, which, instead of fluttering free with a life of their own, began to mould

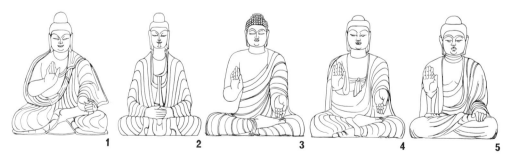

119 The development of the Buddha image: 1. Yünkang (c. 460–480); 2. Lungmen (c. 495–530); 3. Ch'i-chou (c. 550–580); 4. Sui (c. 580–620); 5. T'ang (c. 620–750). After Mizuno.

114

themselves to the cylindrical form, subtly accentuating its mass. Against these now smooth surfaces, the jewellery of the *bodhisattvas* provides a contrasting ornament; the head becomes rounded and massive, the expression austere rather than spiritual. In the stone sculpture of Northern Ch'i, Chinese craftsmen produced a style in which precision of carving and richness of detail are subordinated to a total effect of grave and majestic dignity. While the change was stimulated by a renewal of Indian influence on Chinese Buddhist art, this time it came not across central Asia, where contact with the West was now broken by fresh barbarian incursions into the Tarim Basin, but up from the Indianised kingdoms of Southeast Asia, with which the court at Nanking had close diplomatic and cultural relations. There are abundant records of Buddhist images being sent to Nanking from Indochina in the sixth century, though none of these have yet been identified. However, in 1953 there was found in the ruins of the Myriad Buddha Temple, Wan-fo-ssu, Ch'iung-lai, near Chengtu, Szechwan, a buried hoard of about two hundred pieces of Buddhist sculpture, some of which clearly show the indirect influence of Gupta art, while others have stylistic affinities with the sculpture of the Dvāravatī kingdom of Thailand, and with figures and reliefs excavated at Dong-duong and other sites in the ancient kingdom of Champa (Vietnam). Nothing comparable to the Ch'iung-lai find has yet been unearthed at Nanking itself, where the destruction of early Buddhist monuments was almost complete; but there is no doubt that the Buddhist art of Szechwan at this time was strongly influenced by artistic developments at the southern capital.

120 *Bodhisattva*. Stone. Northern Ch'i Dynasty.

121 Minor deities and worshippers. Fragment of a stone relief from Wan-fo-ssu, Ch'iung-lai, Szechwan. Sixth to early seventh century.

As with sculpture, so did the introduction of Buddhism give birth to a new school of painting of which both the content and the forms were largely foreign. A Sung writer tells of a certain K'ang Seng-hui, a Sogdian, who in A.D. 247 came to the Wu kingdom (Nanking) by way of Indochina "to install icons and practise ritual

BUDDHIST PAINTING

115

122 Buddha preaching the law. Wall painting in Cave 249 (P 101), Tunhuang. Northern Wei Dynasty.

circumambulation. It so happened that Ts'ao Pu-hsing saw his iconographic cartoons for Buddhas [in the style of] the Western Regions, and copied them; whence it came about that the Ts'ao [style] has been popular through the generations all over the world." (By the end of the sixth century, however, nothing survived to Ts'ao's work "except the head of one dragon in the Privy Pavilion.") The new style culminated in the work of Chang Seng-yu, the greatest of the painters working for the Liang emperors at Nanking. His work was remarkable—according to contemporary accounts—for its realism; he painted dragons on the wall of An-lo-ssu, and when, in spite of his warning, he was persuaded to paint in their eyes, they flew away amid thunder and lightning. He decorated many Buddhist and Taoist temples in Nanking with frescoes; he was a portraitist and also executed long scrolls illustrating such homelier themes as 'Han Wu Ti Shooting the dragon', the 'Drunken Monk', and 'Children Dancing at a Farmhouse'; but all were lost centuries ago, and none of the later pictures claiming to be copies of his work, such as the 'Five Planets and Twenty-four Constellations' in the Abe Collection in Osaka, give more than a hint of his style. Nevertheless, we may be sure that one feature of this imported manner was the Indian technique of arbitrary shading, found in the wall paintings at Ajantā, which was used to give an effect of roundness and solidity unlike anything that China had seen before.

WALL PAINTINGS AT TUNHUANG

Fortunately the wall paintings at Tunhuang, Mai-chi-shan and Ping-ling-ssu have survived—though for the most part they are but a faint echo of the grand manner of metropolitan China. The first chapel at Tunhuang had been dedicated in 366. Today paintings of the Northern and Western Wei can be seen in thirty-two of the caves, and there were probably many more before dilapidation and later repainting took their toll. Of these, the finest are in Caves 257

116

(P110) and 249 (P 101).[6] The vigorous rendering of the preaching Buddha in Cave 249 is a good example of the mixture of styles that we find everywhere at Tunhuang. The stiff heraldic pose of the Buddha shows how the 'linear' Chinese manner which we have already seen influencing the sculpture of the period has been frozen into a flat decorative pattern, indicating perhaps the hand of some itinerant painter from central Asia, who has also attempted, not very successfully, to suggest an Indian fulness in the modelling of his attendant *bodhisattvas* and *apsarases*. The subjects of these early frescoes are generally Buddhist trinities, scenes from the life of the Buddha, and endless *Jātaka* tales which, under the guise of recounting incidents in the Buddha's previous incarnations, draw upon a rich storehouse of Indian legend and folklore. It is these delightful scenes, and not the hieratic Buddhas and *bodhisattvas* crudely copying some Western model, that reveal the Chinese journeyman artist at his most spontaneous; indeed, it is not unlikely that while some of the main figures were executed by artists from central Asia and beyond, donors were content to leave these accessory scenes to local talent.

A famous panel in Cave 257 tells the story of the Buddha's incarnation as a golden gazelle. The simple humped hills slant back diagonally in rows like the seated figures in the Han banqueting scenes. Between them, the participants are painted almost in silhouette on a flower-strewn ground. The sense of open space is Chinese, as is the emphasis on linear movement; but the decorative flatness of the figures, the dappled deer and flower-sprinkled ground, have a Near Eastern origin. Most striking are the decorations on the sloping tentlike ceiling of Cave 249 (see p. 118), painted early in the sixth century. While Buddhas dominate the main walls, the ceiling is a riot of celestial beings—Buddhist, Hindu and Taoist, the latter including Hsi Wang Mu and Tung Wang Kung, with lesser deities. Beneath them runs a freize of gaily coloured mountains over which mounted huntsmen pursue their quarry after the fashion of Han decorative art. These paintings are a vivid illustration of the way in which Chinese Buddhism, at least at the popular level, came to terms with Taoism and native folklore.

123 The Buddha incarnate in a golden gazelle (the *Rūrū Jātaka*). Wall painting in Cave 257 (P 110), Tunhuang. Northern Wei Dynasty.

FUNERARY SCULPTURE

This was the heyday of Buddhist faith in China. Many people were cremated, denying themselves the elaborate burials that had been characteristic of the Han. But the Confucian rites were not altogether neglected, and some of the imperial burials were as spectacular as ever. The actual tomb mounds of the Liang emperors have never been found among the green hills and rice fields outside Nanking, but much of the monumental sculpture that lined the 'spirit way' still survives. The winged beasts of the sixth century are more graceful than those of Han, being animated by a dynamic linear movement which also found expression in miniature in the beautiful gilt-bronze lions, tigers and dragons of which there are many examples in Western museums. Some of the larger tombs in the Nanking region were lined with bricks moulded with lines in thread relief, which, when correctly laid, formed a picture that covered a large area of the wall. These relief pictures, depicting themes such as the 'Seven Sages of the Bamboo Grove' which were popular with the southern gentry, may well preserve not only the composition but also the style of early southern masters such as Ku K'ai-chih.

CERAMICS

The ceramics industry in North China only gradually recovered from the disasters of the fourth century. The quality and variety of the *ming-ch'i* deteriorated. Much rarer now are the farms and pigsties that give so delightful a picture of Han rural economy. But to compensate, the best of the grave figurines have an almost fairylike elegance which reminds us of the ladies in the Ku K'ai-chih scrolls, while the horses are no longer the tough, stocky, deep-chested creatures of Han art; they seem rather in their heraldic grace of form and the richness of their trappings to evoke a bygone age of chivalry. The Wei figurines are usually dark-bodied and unglazed, but some are painted with colours that have mellowed to soft reds and blues through long burial.

124 Landscape with fabulous beings, on lower part of ceiling of Cave 249 (P 101), Tunhuang. Northern Wei Dynasty.

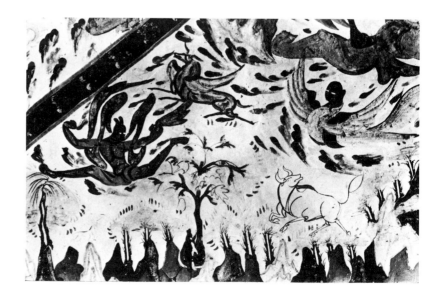

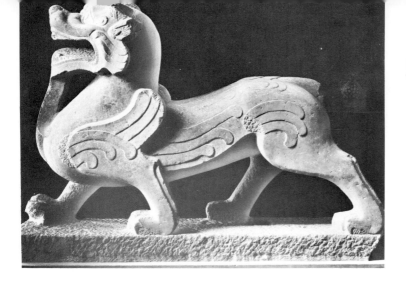

125 Chimera. Stone. Third to fourth century.

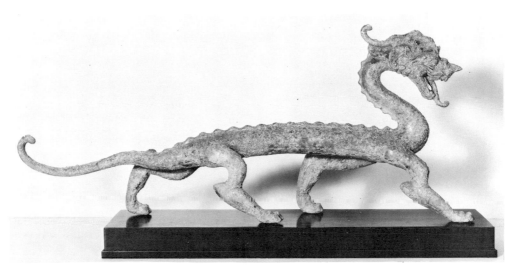

126 Dragon. Gilt bronze. Northern Wei Dynasty.

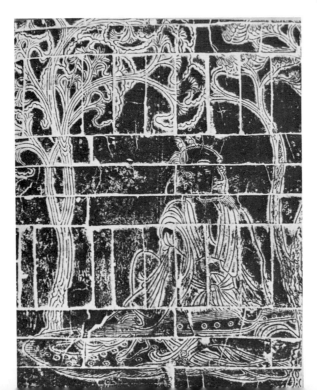

127 Hsi K'ang (223–262), one of 'Seven Sages of the Bamboo Grove'. Brick tomb relief, Nanking. About fifth century.

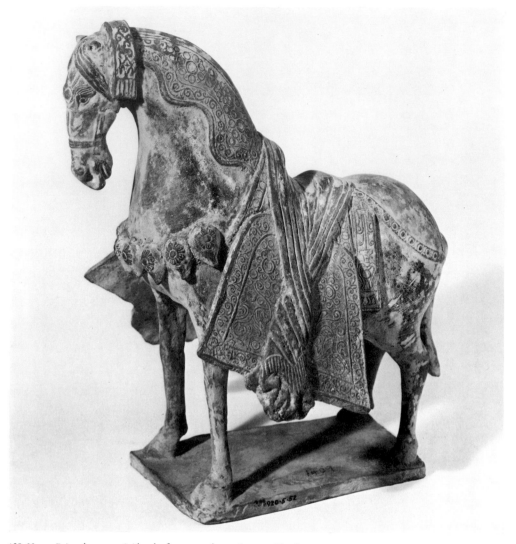

128 Horse. Painted pottery. Said to be from a tomb near Loyang. Northern Wei Dynasty.

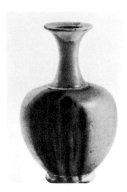

129 Vase. Stoneware slipped and splashed with green under an ivory white glaze. From a tomb of 575 at Anyang, Honan. Northern Ch'i Dynasty.

It was not until the sixth century that really fine quality wares were being made in the north. Some vessels show the same variety and robustness of style that we find in the Buddhist sculpture of the period, borrowing motifs such as the lotus from the repertoire of Buddhist art, and pearl roundels and lion masks in appliqué from Sasanian metalwork. It was a restless and uncertain age in Chinese art, although here and there an untroubled mastery was achieved, as in the beautiful procellaneous vase from the tomb of a Northern Ch'i official buried at Anyang in 575. It is covered with an ivory white, crackled glaze splashed with green—a technique hitherto thought to have been unknown in China before the T'ang Dynasty. This tomb also contained pottery flasks with Sasanian figure subjects in relief under a brown glaze. A similar mixture of Chinese and western Asiatic motifs and techniques can be seen in other crafts in China at this time, notably metalwork and relief sculpture,

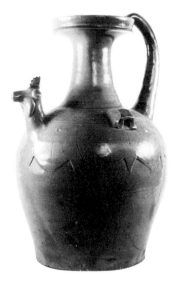

130 Flask. Stoneware decorated with dancers and musicians in relief under a golden brown glaze. From a tomb of 575 at Anyang, Honan. Northern Ch'i Dynasty.

131 Water container in the form of a lion-dog, Yüeh ware. Stoneware covered with an olive brown glaze. Chin Dynasty, late third to early fourth century.

showing that the cosmopolitanism that we think of as typical of the first half of the T'ang Dynasty was already well established in the sixth century.

So far, very few Six Dynasties kilnsites have been discovered in the north. The position in the lower Yangtse Valley is quite different. Kilns have been located in ten counties in Chekiang alone, while many of their products have been unearthed from dated tombs of the third and fourth centuries in the Nanking region. Of these pottery centres, the most important were those in Shang-yü-hsien and around the shores of Shang-lin-hu in Yü-yao-hsien, active into the T'ang and Five dynasties. In addition to celadon, the kilns at Te-ch'ing, north of Hangchow, also produced a ware with a rich black glaze. But in general the early Chekiang celadons show, in the growing strength and purity of their shapes, the final emancipation of the Chinese potter from his earlier bondage to the aesthetic of the metalworker.

Indeed, freedom in the arts seems to be the keynote of this period, not only in technique and design, but also in the attitude of the privileged classes to the arts. For this was the age of the first critics and aestheticians, the age of the first gentlemen painters and calligraphers, the age of the first great private art collections and of the birth of such cultivated pursuits as garden designing and conversation as a fine art. Just as the sixth-century anthologist Hsiao T'ung selected the poems for his *Wen-hsüan* on grounds of literary merit alone, so it seems did patrons in the Six Dynasties come for the first time to value their possessions—whether paintings or calligraphy, bronzes, jade or pottery—simply because they were beautiful.

132 'Chicken ewer', Yüeh ware. Stoneware covered with an olive brown glaze.

7
The Sui and T'ang Dynasties

The Six Dynasties had been a period when new forms, ideas and values were first, and often tentatively, tried out—ideas which could not find their fullest expression in those restless centuries, but needed an era of stability and prosperity to bring them to fruition. Wen Ti, who founded the Sui Dynasty in 581, was an able general and administrator who not only united China after four hundred years of fragmentation, but also carried the prestige of her arms out into central Asia. But his son Yang Ti squandered the resources of the empire on palaces and gardens built on the scale of Versailles, and on vast public works. These included a long section of the Grand Canal, constructed to link his northern and southern capitals, for the building of which over five million men, women and children were recruited into forced labour. These huge projects, as a Ming historian put it, "shortened the life of his dynasty by a number of years, but benefited posterity unto ten thousand generations." Combined with four disastrous wars against Korea, they were too much for his long-suffering subjects, who rose in revolt. Soon a ducal family of the name of Li joined the insurrection, and the Sui Dynasty collapsed. In 617, Li Yüan captured Ch'ang-an, and in the following year mounted the throne as first emperor of the T'ang Dynasty. In 626 he abdicated in favour of his second son, Li Shih-min, who then, at the age of twenty-six, became the Emperor T'ai-tsung, thereby inaugurating an era of peace and prosperity that lasted for well over a century.

T'ang culture was to that of the Six Dynasties as was Han to the Warring States, or, to stretch the parallel a little, Rome to ancient Greece. It was a time of consolidation, of practical achievement, of immense assurance. We will not find in T'ang art the wild and fanciful taste of the fifth century, which saw fairies and immortals on every peak. Nor does it carry us, as does Sung art, into those silent realms where man and nature are one. There is metaphysical speculation, certainly, but it is that of the difficult schools of Mahāyāna idealism which interested a small minority, and is expressed moreover in forms and symbols which touch neither the imagination nor the heart. For the rest, T'ang art has incomparable vigour, realism, dignity; it is the art of a people thoroughly at home in a world which they knew to be secure. There is an optimism, an

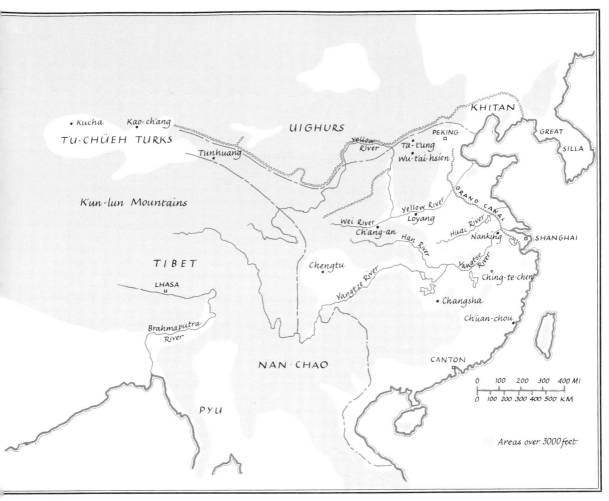

Map 8 China in the T'ang Dynasty

energy, a frank acceptance of tangible reality which gives the same character to all T'ang art, whether it be the most splendid fresco from the hand of a master or the humblest tomb figurine made by the village potter.

By the time of his death in 649, T'ai-tsung had established Chinese control over the flourishing central Asian kingdoms of Kucha and Khotan, the conquest of Korea had been begun, Tibet linked to the royal house by marriage, and relations established with Japan and the Southeast Asian kingdoms of Funan and Champa. Ch'ang-an, laid out by the Sui, now became a city of a size and splendour rivalling, if it did not surpass, Byzantium. It was planned on a grid seven miles by six. In the northern sector lay the government buildings and the imperial palace, which was later moved to a cooler, less crowded site outside the northeast corner of the city. In its streets one might have encountered priests from India and Southeast Asia, merchants from central Asia and Arabia, Turks, Mongols and Japanese, many of whom are humorously caricatured in the pottery figurines from T'ang graves. Moreover, they brought with them their own faiths, which flourished in an atmosphere of rare religious tolerance and curiosity. T'ai-tsung himself, though

Han
Dynasty
Ch'ang-an

Imperial Park

Ta-ming-kung

Palace

Administrative Quarter

Hsing-
ch'ing-
kung

West
Market

East
Market

Ta-yen Pagoda

Hibiscus
Garden

MAP 9 Ch'ang-an in the T'ang Dynasty.

personally inclined towards Taoism, at the same time for reasons of
state supported the Confucians and strengthened the administrative
system. This astonishing man also treated the Buddhists with re-
spect—notably that great traveller and theologian Hsüan-tsang,
who had left China in defiance of an imperial order in 629, and after
incredible hardships and delays had reached India, where he ac-
quired a reputation as a scholar and metaphysician. In 645 he
returned to Ch'ang-an bringing with him the texts of the idealistic
Vijñānavādin School of the Mahāyāna. The emperor came out to
meet him, and his entry into the capital was a public triumph.
Never before had Buddhism stood so high in Chinese history; but it
was not the only foreign religion on Chinese soil. There were also
Zoroastrian temples, Manichaean and Nestorian Christian churches
in the capital and, from the mid-eighth century onwards, Moslem
mosques; and the art of this period is as full of imported motifs as
were the streets of Ch'ang-an with foreigners.

 That China enjoyed a hundred years of peace and prosperity at
home and enormous prestige abroad was due not only to the
achievement of Li Shih-min, but also to two outstanding person-
alities who succeeded him. Kao-tsung, who ascended the throne in
649, was a weak and benevolent man, dominated by his concubine

124

133 Tumulus and processional way of tomb of Kao-tsung (died 683) and Wu Tse-t'ien (died 705), Ch'ien-hsien, Shensi.

Wu Tse-t'ien, who after his death in 683 had the shocking effrontery to declare herself 'emperor'. But such was the ability of this cruel and pious woman (her Buddhist patronage is immortalised in some of the finest sculpture at T'ien-lung-shan), that Confucian ministers loyally served her until her forced abdication in 705 at the age of eighty-two brought to an end two decades of stability and peace. Seven years later the throne passed to the man who, as Hsüan-tsung (Ming Huang, 713–756), was to preside over the most brilliant court in Chinese history, a period comparable to the Gupta in the reign of King Harsha or to Florence under Lorenzo de' Medici. Like T'ai-tsung, he cherished and upheld the Confucian order and in 754 founded the Imperial Academy of Letters (Han-lin Yüan), which, as Joseph Needham has observed, is older than any existing European academy by nearly a millennium. All the talent and wealth of the country which was not given to the construction and adornment of Buddhist temples seemed to be concentrated on his court, his palaces, his favourite scholars, poets and painters, his schools of drama and music, his orchestras (two of which came from central Asia), and, finally, on his mistress, the lovely Yang Kuei-fei. Through her influence, An Lu-shan, a general of Mongol or Tungus origin, had become a favourite with Ming Huang. Suddenly, in 755, he revolted, and the emperor and his court fled in panic from Ch'ang-an. To appease his escort, Ming Huang, now over seventy, was forced to hand his favourite over to the soldiers, who promptly strangled her. A few years later the rebellion was crushed by the efforts of his son Su-tsung; the dynasty staggered to its feet, and there was even something of a revival in the early years of the ninth century; but its power was broken, its glory past, and the long, slow death of the T'ang had already begun.

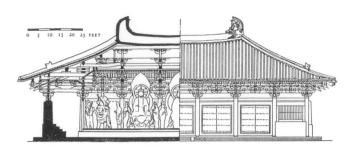

134 The main hall of Fu-kuang-ssu, Wu-t'ai-shan, Shansi. Ninth century.

In 751, Chinese armies in central Asia had been severely defeated by Moslems advancing from the west, with the result that Chinese Turkestan now came permanently under Moslem influence. The Arab conquest of central Asia began the destruction of that chain of prosperous, civilised kingdoms which had provided the overland link between China and the West in the seventh century, a process which was in due course to be completed by the ferocity of the Mongols. Contact with the Western world was now maintained by way of the southern ports. The bustling quays of Canton were thronged with Chinese and foreigners who lived in peaceful prosperity with each other until the peasant rebel Huang Ch'ao massacred the latter in 879. And at Ch'üan-chou in Fukien (Marco Polo's Zayton), recent excavations have revealed that as late as the thirteenth century Hindus, Arabs, Manichaeans and Jews were settled in that great trading port, whose cosmopolitanism is symbolised by the 'twin pagodas' of the K'ai-yüan temple, built in the twelfth century by Chinese and Indians working side by side.

ARCHITECTURE

As so often happens in history, China became less tolerant as her power declined, and the foreign religions suffered accordingly. The Taoists were jealous of the political power of the Buddhists and succeeded in poisoning the mind of the emperor against them, while the Confucians had come to look upon certain Buddhist practices (particularly celibacy) as 'un-Chinese'. The government also viewed with increasing alarm the vast sums spent on the monasteries and their unproductive inmates, who now numbered several hundred thousand. In 845 all foreign religions were proscribed and all Buddhist temples confiscated by imperial edict. The ban on Buddhism was later relaxed, but in the meantime so thorough had been the destruction and looting that today very little survives of the great Buddhist architecture, sculpture and painting of the seventh and eighth centuries. Again we must look to Japan, and it is the monasteries at Nara, itself a replica of Ch'ang-an, that preserve some of the finest of T'ang art. Tōdaiji was not an exact copy of a T'ang temple, but in its grandeur of scale and conception it was designed to rival the great Chinese foundations. It was built on a north-south axis with pagodas flanking the main approach. A huge gateway leads into a courtyard dominated by the Buddha Hall (*Daibutsuden*), 290 feet long by 170 feet deep by 156 feet high, housing a gigantic seated Buddha in bronze, consecrated in 752. Much restored and altered, this is today the largest wooden build-

ing in the world, though in its time the Chien-yüan-tien at Loyang, long since destroyed, was even larger.

The earliest known T'ang wooden temple building is the small main hall of Nan-ch'an-ssu in Wu-t'ai-hsien, Shansi, built in 782; the largest is the main hall of Fu-kuang-ssu on Wu-t'ai-shan, built in the mid-ninth century. Both of these buildings show a slight curve in the silhouette of the roof that was to become more pronounced with time and to be a dominant feature of Far Eastern architecture. Many theories have been advanced to account for this curve, the most farfetched being that it was intended to imitate the sagging lines of the tents used by the Chinese in some long-forgotten nomadic stage. But we do not need to look so far afield, for the curve is inherent in the Chinese roof truss itself. Unlike the rigid triangular Western truss with its central king post, the Chinese truss consists of a framework of horizontal beams supported on queen posts, surmounted by purlins to which the rafters are fixed. The architect has only to vary the height of the queen posts to arrive at any contour he desires. It is impossible to say just when this curve began to appear. It is perceptible in the sixth century and is used with great delicacy in the Sui, as shown by a beautiful stone sarcophagus of 608 in the Sian Museum. The lift at the corners, as well as adding to the beauty of the roof, helped to accommodate the extra bracketing required to support the enormous overhang of the eaves at that point.

By the T'ang Dynasty, the heavy bracketing system (which, with the column it is poised upon, constitutes the nearest Chinese architecture comes to an 'order' in the Western sense), is becoming a little more complex; the brackets extend outwards and upward to support two slanting cantilever arms called *ang*, the inner ends of which are anchored to a crossbeam (1). In Sung and Yüan construction, the *ang* ride freely balanced on the bracketing system (2 and 3), creating a dynamic and meaningful play of forces that reminds us of Gothic vaulting. During the Ming and Ch'ing, however, as the details become increasingly fussy and elaborate, the true function of *ang* and bracket is lost, and the whole degenerates into an intricate but structurally meaningless assemblage of carpentry, a mere decorative frieze running along under the eaves (4 and 5).

The sketch on page 128 shows a conjectural restoration of one of the palaces of the Ta-ming Kung. It is instructive to compare this with the three great halls of the Forbidden City in Peking (see p.

135 The Western rigid truss and the Chinese beam-frame truss compared.

136 The development and decline of the bracket order: 1. T'ang (857); 2. Sung (1100); 3. Yüan (1357); 4. Ming; 5. Ch'ing (1734).

1 2 3 4 5

137 Conjectural reconstruction of the Lin-te-tien of the Ta-ming Kung, Ch'ang-an. T'ang Dynasty.

138 Pagoda of Hsin-chiao-ssu, Ch'ang-an, Shensi. Brick. Built about 699 to receive the ashes of Hsüan-tsang; rebuilt 882. T'ang Dynasty.

191). While the latter is far larger in scale, the grouping of the buildings is much less interesting. The interlocking of masses on ascending levels buttressed at the sides by wings and towers, which gives such strength to the T'ang complex, was not attempted in Peking. T'ang (and indeed Sung) palaces seem to have been not only more enterprising architecturally but also more natural in scale than the vast, isolated and coldly ceremonial structures of the Ch'ing Dynasty, and suggest a more human concept of the rôle of the emperor.

A few T'ang stone and brick pagodas have survived. Some—the pagoda built for Hsüan-tsang's ashes at Ch'ang-an, for example—are straightforward translations of a form of construction derived from the Han timber tower (*lou*). The Chien-fu-ssu at Sian (see p. 107, No. 5), on the other hand, derives ultimately from the Indian *śikhara* tower of stone, which we have already encountered in its purest form in the pagoda on Mount Sung (see p. 107). Imitation of Indian forms was carried still further in the Treasure Pagoda of the Fu-kuang temple of Wu-t'ai-shan, which originally had a dome, copied perhaps from a sketch or souvenir brought back by a returning pilgrim. Under the influence of the mystical Mahāyāna sects, an attempt was even made to incorporate the dome of the stūpa into a timber pagoda; none survive in China, but the twelfth-century Tahōtō of Ishiyamadera is a Japanese example of this odd misalliance.

BUDDHIST SCULPTURE: THE FOURTH PHASE

Until the dissolution of the monasteries in 845, their insatiable demands for icons, banners and wall paintings absorbed the energies of the great majority of painters and sculptors. Some of the sculptors' names are recorded: we read in Chang Yen-yüan's history, for example, of Yang Hui-chih, a painter in the time of Wu Tao-tzu, who "finding that he made no progress, took to sculpture, which he thought was an easier craft." Chang also mentions other pupils and

colleagues of Wu who became noted for their work in clay and stone; indeed, as we shall see, T'ang sculpture in its extraordinary linear fluidity seems often to have been formed by the brush rather than the chisel. Very little secular sculpture was carried out, if we except the guardian figures and winged horses and tigers which lined the 'spirit way' leading to the tombs. The earliest and most famous example of T'ang funerary sculpture is the set of panels depicting in relief the six favourite chargers of T'ang T'ai-tsung, executed, according to tradition, after designs by the great court painter Yen Li-pen; the style is plain and vigorous, the modelling so flat that the origin of these monumental silhouettes in line drawings seems not at all improbable.

The great Buddhist bronzes of the seventh and eighth centuries have all disappeared, melted down in the persecution of 845 or lost through subsequent neglect, and the style can best be seen in the temples at Nara in Japan. Only in the cave shrines has stone and clay sculpture survived in any quantity. At Lungmen, in 672, the emperor Kao-tsung ordered the carving of a colossal figure of the Buddha Vairoćana flanked by the disciples Ānanda and Kāśyapa, with attendant *bodhisattvas*. Obviously intended to rival in size and magnificence the great Buddha of Yünkang, this figure of the Buddha of Boundless Light far surpasses it in power of modelling, refinement of proportion and subtlety of feeling. Even though badly damaged, the Vairoćana well expresses the ideal of the Mahāyāna which saw the Buddha not as a great teacher but as a universal principle radiating out in all directions for all time. More

139 Charger and groom. Stone relief from the tomb of the emperor T'ai-tsung (died 749).

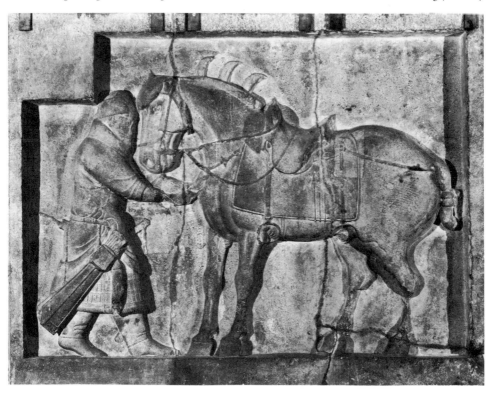

129

140 Vairocána Buddha flanked by Ānanda, Kāśyapa, and attendant *bodhisattvas*. Stone. Feng-hsien-ssu, Lungmen, Honan. T'ang Dynasty, 672–675.

141 Standing Buddha, Udayāna type. White marble. From Hsiu-te Pagoda near Ch'ü-yang, Hopei.

directly modelled on an Indian prototype—perhaps on a version of the celebrated sandalwood image reputedly made by King Udayāna in the Buddha's lifetime, a copy of which was brought back by Hsüan-tsang in 645—is the thoroughly Gupta torso in marble from Ch'ü-yang-hsien, Hopei, in the Victoria and Albert Museum. This tendency to treat stone as though it were clay reached its climax in the cave shrines carved out at T'ien-lung-shan during the reigns of Wu Tse-t'ien and Ming Huang. Here the figures are carved fully in the round with the exquisite grace and richly sensuous appeal that we find in Greek sculpture of the fourth century B.C. The modelling has an all-too-Indian suavity and voluptuousness; the drapery seems as though poured over the fleshy body. But, to compensate, there is a new mobility of movement. In these figures, the Indian feeling for solid swelling form and the Chinese genius for expression in terms of linear rhythm are at last successfully reconciled in a great synthesis, producing a style which was to become the basis of all later Buddhist sculpture in China.

The Buddhist painting of this period must have contained as rich a mixture of native and foreign elements as did sculpture. During the seventh century, the most popular subjects were those that illustrated the teachings of the T'ien-t'ai sect based on the *Lotus Sūtra*, an encyclopaedic text which in its combination of theology and metaphysics, ethics, magic and simple human appeal seemed to satisfy all human needs; we already encountered some of its themes on the sculptured steles of the Northern Wei. Even more popular were the teachings of the *Ching-t'u* ("pure land") School, which had cut its way through the growing forest of metaphysical abstractions of the later Mahāyāna with the doctrine that through simple faith one might be reborn in one of the Buddhist paradises and so find release and eternal bliss. By the mid-seventh century, however, new concepts were coming into Buddhism which were eventually to bring about its decline. The later Mahāyāna in India had become deeply coloured by a highly abstract and idealistic

BUDDHIST PAINTING:
FOREIGN INFLUENCES

131

metaphysics, on the one hand, and by the practices of the Tantric sects of revived Hinduism, on the other. Tantrism held that by sheer concentration of willpower, aided by magic spells (*mantra*) and diagrams (*mandala*), a deity could be invoked and desirable changes in the order of things thus brought about. This school also believed in the Hindu concept of the *Śakti*, a female emanation, or reflex, of a deity who would be doubly efficacious if presented clasping her in ecstatic union. At its finest, this new art has a formidable power that is overwhelming, but it too easily degenerates into the soulless repetition of magical formulae.[1] It found its true home in the bleak wastes of Tibet, whence it reached out to paralyse the art of Tunhuang during the Tibetan occupation from about 750 to 848. In course of time, the revolt of the Chinese spirit against the sentimental, the overintellectual and the diabolical aspects of these sects found expression in the Ch'an (Zen) School of contemplative mysticism, but as this doctrine did not greatly affect painting until the Sung Dynasty, we will defer discussion of it to Chapter 8.

In 847, the scholar and connoisseur Chang Yen-yüan completed his *Li-tai ming-hua chi* (*Record of Famous Painters of Successive Dynasties*), the earliest known history of painting in the world. This important book, which has happily survived, includes a catalogue of the frescoes in the temples of Ch'ang-an and Loyang and is as full of the names of great painters and their works as Baedeker's guide to Florence; but the persecution of 845, coupled with wars and rebellions, fire and sheer neglect, destroyed them all. According to contemporary accounts, the work of the foreign painters aroused much interest and had considerable influence on local artists. During the Northern Ch'i there had been Ts'ao Chung-ta, whose figures "were clad in garments which clung to the body; they looked as if they had been drenched in water"—an apt description also of the sculpture at T'ien-lung-shan. The Khotanese painter Yü-ch'ih (or Wei-ch'ih) Po-chih-na had come to Ch'ang-an in the Sui Dynasty; he specialised not only in Buddhist subjects but also in strange objects from foreign lands and flowers which he painted with great realism. His son (?) I-seng was honoured by T'ai-tsung with a ducal title. "His paintings," says another ninth-century work, the *T'ang-ch'ao ming-hua lu*, (*Record of Famous Painters of the T'ang Dynasty*) of Chu Ching-hsüan, "whether votive images, human figures, or flowers and birds, were always foreign-looking and not like Chinese things"; while Chang Yen-yüan said of his brushwork that it was "tight and strong like bending iron or coiling wire." A Yüan critic wrote of him that "he used deep colours which he piled up in raised layers on the silk." His work is of course long since lost, but it seems that his 'relief style' of flower painting was not a subtle use of shading to give an effect of solid volume as is often supposed on the basis of descriptions in early texts, but a much cruder technique wherein the pigment was piled up in a heavy impasto till the flowers actually *did* stand out from the wall. Traces of this technique survive in the much-damaged wall paintings in the caves at Mai-chi-shan.

143 The sage Vimalakīrti. Detail of a wall painting in Cave 103 (P 137 M), Tunhuang. T'ang Dynasty, eighth century.

While some T'ang painters were no doubt seduced by such devices into thoroughly un-Chinese experiments, Wu Tao-tzu, the greatest of them all, seem from contemporary accounts to have worked in a purely Chinese style, which in its grandeur of conception and fiery energy of execution makes him one with Michelangelo. Born about 700, he is said before he died to have painted three hundred frescoes (using the term in the loose sense; they were painted not on wet but on dry plaster) in the temples of Loyang and Ch'ang-an.

WU TAO-TZU

144 The paradise of Amitābha. Detail of a wall painting in the Kondō (Image Hall) of Hōryūji, Nara, Japan. Early eighth century.

None of his pictures has survived; indeed, by the eleventh century the poet Su Tung-p'o could say that he had seen but two genuine ones, his friend Mi Fu three or four. But we can obtain a vivid idea of the vigour, solidity and realism of his work from descriptions written by those who had seen it—more vivid certainly than is provided by the thirdhand copies, odd rubbings and sketches on which our estimates are generally based. The twelfth-century writer Tung Yu said of him: "Wu Tao-tzu's figures remind me of sculpture. One can see them sideways and all round. His linework consists of minute curves like rolled copper wire" (another writer says this was more characteristic of his early work: it suggests the influence of Yü-ch'ih I-seng) "however thickly his red or white paint is laid on, the structure of the forms and modelling of the flesh are never obscured." Earlier, Tung Yu had remarked that "when he paints a face, the cheek-bones project, the nose is fleshy, the eyes hollow, the cheeks dimpled. But these effects are not got by heavy ink shading. The shape of the features seems to have come spontaneously, yet inevitably." All spoke of the whirlwind energy of his brush, so remarkable that crowds would gather to watch him as he worked. Perhaps his technique is reflected in the head of the Indian sage Vimalakīrti painted by an unknown eighth-century artist on the wall of Cave 103 (see p. 133) at Tunhuang. His influence on later figure painting was enormous.

THE HŌRYŪJI
KONDŌ CYCLE

No major works survive in China itself to demonstrate that fusion of Indian formal ideals with the traditional Chinese language of the brush which took place in the T'ang Dynasty, and which we have

134

already referred to in sculpture as the 'fourth phase'. But such a great synthesis did take place, and was in turn passed on to Korea and Japan. Early in the eighth century, the walls of the Kondō were decorated by an unknown master with four large square panels depicting the paradises of the Buddhas of the four directions, and eight vertical panels with *bodhisattvas*. These paintings, after miraculously surviving for twelve hundred years, were almost totally destroyed by fire in 1949, a disaster to the art of the world as great as if the frescoes in the Sistine Chapel or those in the cave temples of Ajantā had perished. A part of the most popular paradise—that of Amitābha—is illustrated here. The composition is a simple and serene arrangement of deities, the *bodhisattvas* Mahāsthāmaprāpta and Avalokiteśvara standing on either side of Amitābha, who sits turning the wheel of the law on his lotus throne beneath a bejewelled canopy. The figures are drawn with a sweeping brush-line of extraordinary delicacy and precision which evokes a feeling of the solid form, from which the Indian tactile sensuality has been abstracted away. Indeed, except for the iconography and the contours themselves there is little that is Indian here. Arbitrary shading is used with great restraint to amplify the roundness of an arm or chin, but much more is accomplished by the almost imperceptible modulations of the brush-line itself, while the folds of the drapery are emphasised by a kind of shading which—if the *Admonitions* scroll is a faithful copy of the style of Ku K'ai-chih—goes back to the fifth century. Only in the jewellery is there a hint of that rich impasto with which the Yü-ch'ih had astonished Ch'ang-an. Apart from these details, the forms, as Tung Yü said of Wu Tao-tzu, "seem to have come spontaneously, yet inevitably."

Long after the cult of Amitābha had declined in metropolitan China, it lived on in the hearts of the pilgrims and country folk at Tunhuang, who must have gazed with awe and wonder at the huge heavenly visions which filled the walls of the seventh- and eighth-century caves. In a walled-up storeroom at Tunhuang, Sir Aurel Stein found a great hoard of manuscripts and silk banners. Many were craftsman's work, but, taken as a whole, they represent the only considerable group of undoubtedly genuine Chinese silk paintings from the T'ang Dynasty that have survived. The most remarkable is a banner on which are very carefully drawn a series of Buddha figures almost certainly copied from sketches of well-known Indian images made on the spot. One represents the Buddha of the enlightenment at Bodhgāya, two are faithful reproductions of Gandhāran models, another shows the Buddha preaching on the Vulture Peak, while Stein identified yet another as identical in style with two great stucco reliefs which he discovered in the ruins of a monastery in Khotan. The banners also include a number of paradises and single deities (especially the increasingly popular Kuanyin), painted in warm colours, with a wealth of detail and floral ornament. The most appealing and lively parts of these banners are the little panels at the sides, which, like the

TUNHUANG

predella of a quattrocento altarpiece, tell in miniature the story of the Buddha's life on earth, generally in a landscape setting. It seems that until Tibetan esoteric Buddhism laid its cold hand on Tunhuang, the Chinese painters there used a landscape setting wherever they could. Sometimes, indeed, it dominates the theme in a thoroughly un-Indian fashion. In Caves 103 (P 54) and 217 (P 70), for example, the old subdivision into superimposed horizontal scrolls has been replaced by a panoramic landscape of towering peaks which fills the whole wall. There is still a tendency to break it up into smaller connected 'space cells', and the transition through the middle distance to the horizon is hardly better managed than on the stone sarcophagus in Kansas City. But other paintings at Tunhuang, notably the landscape vignettes in Cave 323 (P137M), show that this problem was successfully solved in the eighth century.

COURT PAINTING We must return from the rustic pleasures of Tunhuang naturalism to the splendour of the T'ang court. A famous scroll in Boston bearing portraits of thirteen emperors from Han to Sui has traditionally been attributed to Yen Li-pen, the son and brother of two famous artists, who had been a court painter in attendance (*tai-chao*) to T'ai-tsung and rose to the high office of Minister of the

136

Right under his successor. This handscroll—or part of it, for more than half is a copy of the Sung Dynasty—is the very epitome of the Confucian ideal, now restored to its proper place as the pivot of Chinese society. While each group makes a monumental composition by itself, together they form a royal pageant of incomparable dignity. The figures are full, the robes ample, the brush-line fluent and of even thickness. Arbitrary shading is used with restraint to give volume to the faces, more generously in the folds of the robes, as on the Amitābha in the Kondō at Hōryūji.

In recent years our knowledge of T'ang painting has been suddenly enlarged by the opening of a group of richly decorated princely tombs in Ch'eng-hsien to the northwest of Sian. Is it perhaps the hand of a pupil of Yen Li-pen that we see in the lovely paintings that line the tomb of Princess Yung-t'ai? The unfortunate girl was murdered, or forced to commit suicide, at the age of seventeen by the 'emperor' Wu Tse-t'ien. When that monstrous woman died, the restored emperor built, in 706, a subterranean tomb for his daughter, of which the walls were adorned with the figures of serving girls. The drawing is free and vivacious, sketchy yet perfectly controlled. These paintings, done solely for the pleasure of the dead princess, bring us closer to an understanding of T'ang courtly wall painting as it approached its climax in the eighth century. Meanwhile, the vast double tomb of Kao-tsung and Wu Tse-t'ien sleeps, unviolated, in the depths of a hill of rock not far away, and until at some future date it is opened, we can only imagine the treasures of art and craft that it must contain.

146 Pilgrims and travellers in a landscape. Landscape in the boneless style. Detail of wall painting in Cave 217 (P 70), Tunhuang. T'ang Dynasty, eighth century.

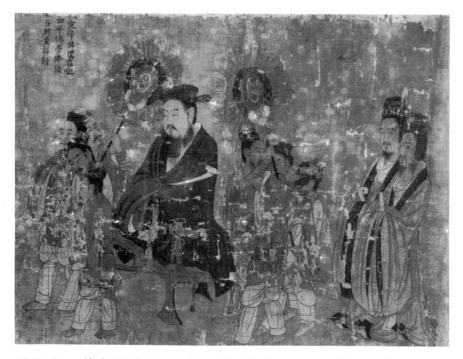

147 Yen Li-pen (died 673): The Emperor Hsüan of the Ch'en Dynasty. Detail of a handscroll of thirteen emperors from Han to Sui. Ink and colours on silk. T'ang Dynasty.

148 Female attendants. Detail of a wall painting in the tomb of Princess Yung-t'ai, Ch'ien-hsien, Shensi. T'ang Dynasty, about 706.

The quality of T'ang court life is further revealed in the paintings attributed to Chou Fang and to Chang Hsüan, a court painter under Ming Huang who was chiefly celebrated for his paintings of 'young nobles, saddle horses and women of rank'. So far as is known, none of their works survive in the original, but there exists what is possibly a careful copy of a T'ang painting by one or the other of these masters, 'Court Ladies Preparing Silk', attributed to the Sung emperor Hui-tsung, but more likely a product of his palace studio: it is hard to imagine the emperor having the time for making replicas of this sort, although he often put his name to them. We see a lady, about to pound the silk strands, rolling up her sleeves; another draws out the thread, a third is sewing, on the left a servant fans the charcoal brazier. The colour is rich and glowing, the detail of jewel-like precision. There is neither ground nor background, but the picture has depth, and there is a subtle and uniquely Chinese sense of almost tangible space between the figures.

Court painters such as Chou Fang and Chang Hsüan were kept busy by the emperor, as were the poets, in celebrating the more memorable social and cultural events of court life, and in portrait painting. This included portraits not only of the emperor's favourite concubines and virtuous ministers, but also of strangers from the West whose exaggerated features have been a never-failing source of delight to the Chinese. In more serious vein were portraits of Buddhist priests, such as the series of the patriarchs of the *Chen-yen* (Shingon) sect, painted by Li Chen, a contemporary of Chou Fang. Long forgotten in China, the work of this artist has been cherished in Japan for its austere and noble evocation of the spirit of mystical Buddhism.

Court artists were not always treated with the respect they felt was due to them. Chang Yen-yüan tells of the indignity to which the great Yen Li-pen was once subjected, when he was rudely

149 Attributed to Sung Hui-tsung (1101–1125). *Court Ladies Preparing Silk*. Detail of a handscroll after a T'ang Dynasty original. Ink and colours on silk. Sung Dynasty.

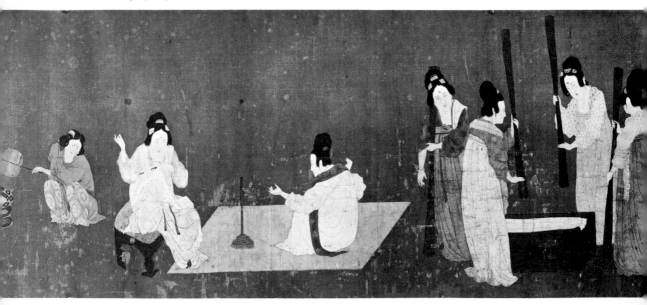

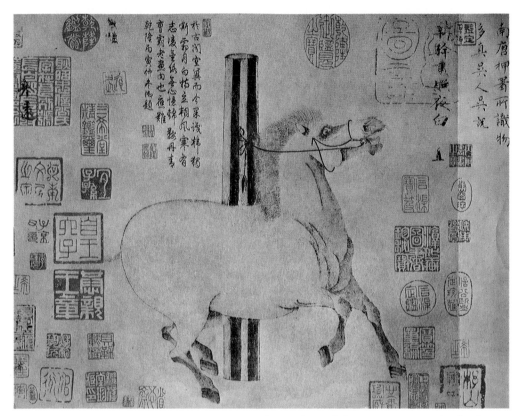

150 Attributed to Han Kan (active 740–760). *Night White*, a favourite horse of T'ang Ming Huang. Handscroll. Ink on paper. T'ang Dynasty.

summoned—the courtiers used the term *hua shih*, roughly equivalent to 'master craftsman painter' (a term that would never be applied to a scholar, a high official, or a gentleman)—to sketch some ducks that were swimming about on the palace lake in front of T'ai-tsung, after which he advised his sons and pupils never to take up the art. Ming Huang was passionately fond of horses, particularly the tough, stocky ponies from the western regions, and is said to have had over forty thousand in his stables. The striking painting of one of his favourites, Night White, has long been attributed to the noted horse specialist Han Kan. Tethered to a post, the horse rears up with eyes dilated as though the painter had startled him. All but the head, neck and forequarters are the work of a later restorer, and the tail has vanished, but enough remains to suggest a dynamic energy of movement and solidity of modelling such as we find also in the best of the T'ang pottery figurines.

During these prosperous years, when painters were busily occupied with Buddhist frescoes, portrait painting and other socially useful activities, their hearts, if not their feet, were roaming the hills and valleys far from the glitter of the capital. The tradition of landscape painting which was later to rise to such supreme heights had been born in the Six Dynasties, but it had advanced little—partly because

LANDSCAPE PAINTING

139

of the ever-increasing demands for Buddhist icons, partly because artists were then still struggling with the most elementary problems of space and depth. But during the T'ang Dynasty these difficulties were mastered.

According to later Chinese critics and historians, two schools of landscape painting came into being in the T'ang Dynasty. One, practised by the court painter Li Ssu-hsün and his son Li Chao-tao, painted in the precise line technique, derived from earlier artists such as Ku K'ai-chih and Chan Tzu-ch'ien, adding decorative mineral colours; the other, founded by the poet-painter Wang Wei, developed monochrome landscape painting in the *p'o-mo* ("broken ink") manner. The first, later called the Northern School, became in course of time the special province of court painters and professionals, while the second, the so-called Southern School, was the natural mode of expression for scholars and amateurs. As we shall see when we come to a discussion of Ming painting, this doctrine of the Northern and Southern schools, and of the founding rôle of Wang Wei, was invented by a group of late Ming scholar-critics to bolster up their belief in the superiority of their own kind of painting over that of the professionals and court painters of the day. But I mention it here because it has dominated Chinese thinking about landscape painting for nearly four hundred years. In fact, the line between the two kinds of painting was not so sharply drawn in the T'ang Dynasty. Wang Wei's elevation to this pinnacle in the history of Chinese painting was an expression of the belief, shared by all scholar painters from the Sung Dynasty onwards, that a man's painting, like his handwriting, should be the witness, not to his skill with the brush, but to his quality as a man. Because Wang Wei was the ideal type of man, it was argued, he must also have been the ideal type of painter.

A gifted musician, scholar and poet, Wang Wei (699–761?) joined the brilliant group of painters and intellectuals round Ming Huang's brother Prince Ch'i. He got into political difficulties at the time of the An Lu-shan rebellion, but was extricated by his brother and restored to imperial favour. When his wife died in 730 he became a devout Buddhist, though whether this influenced his painting is not known. He was famous in his lifetime for his snow landscapes, but the work for which he is best remembered by later painters was the long panoramic handscroll depicting his country estate, Wang-ch'uan, outside Ch'ang-an. This picture disappeared long ago, and although the general composition has been preserved in many later copies, one of which was engraved on stone in the Ming Dynasty, these give little idea of the style, still less of the technique of the original. Perhaps the nearest we shall ever get to his intensely poetic relationship with nature is the beautiful little 'Riverside Under Snow', formerly in the Manchu Household Collection, and now believed to be lost. To judge from reproductions, it might be a late T'ang or tenth-century painting in his manner. The landscape conventions are archaic, the technique simple, yet no early Chinese landscape painting evokes more movingly the at-

mosphere of a river bank in the depths of winter, when the snow covers the ground, the roofs, and the bare branches, and men hurry home to their cottages at dusk.

It is difficult to write with any certainty about the style of T'ang landscape painting when almost all we have to go on are the frescoes and banners from Tunhuang and the recently discovered paintings in the T'ang tombs. But enough has been revealed to suggest that by the eighth century three styles had come into being, which might be called the 'linear', the 'boneless', and the 'painterly'. In the linear style, which traces its origin back to Ku K'ai-chih and beyond, the forms are drawn in fine, clear lines of more-or-less even thickness and filled with washes of colour, as in the landscape from the tomb of I-te of which a detail is illustrated here. In the boneless style, exemplified in the detail from Cave 217 at Tunhuang, colour is broadly applied in opaque washes with little or no outline, a technique which seems to have been reserved for wall painting. In the third style, the painterly, an articulated, calligraphic line is combined with broken interior ink washes to produce a richly integrated texture. This style, in the development of which Wang Wei's contemporary Chang Tsao rather than Wang Wei himself was a key figure,[2] seems to have become fully expressive in the

151 Style of Wang Wei(?). *Riverside Under Snow*. Part of a handscroll(?). Ink and colour on silk. About tenth century.

152 Landscape in the linear style. Copy of wall painting in the tomb of I-te, Ch'ien-hsien, Shensi. T'ang Dynasty, 706.

153 Covered jar with swing handle, decorated with parrots amid peonies. Beaten silver with traced decoration in gilt. Excavated at Ho-chia-ts'un, Sian. T'ang Dynasty, eighth century.

eighth century, and can be illustrated, in rather crude form, by the detail from one of the Tunhuang banners shown on p. 136. The painterly style was to develop into the mainstream of ink landscape painting in the hands of major painters of later dynasties, while the linear style sank for the most part to the level of the professional craftsman painters, and the boneless style, at least in China, sank out of sight altogether. In the last century of T'ang, the focus of cultural activity shifted away from Ch'ang-an and Loyang to the southeast, which was rapidly becoming more populous and more prosperous. It was in the region of Nanking and Hangchow that landscape painters now made their most daring experiments in 'breaking the ink', while the breakdown of traditional restraints on artistic, as on social, behaviour encouraged the eccentrics to indulge in techniques of ink-flinging and -splashing quite as wild as those of the New York School of the 1950s. The work of these expressionists, alas, is lost, but their styles were taken up by some of the Zen painters of the tenth century and again in the late Southern Sung.

The objects, apart from paintings and sculpture, with which our Western collections illustrate the achievements of T'ang culture are, for the most part, grave goods. These, though they have an appealing vigour and simplicity, bear little relation to the finest of T'ang decorative arts. But masterpieces of T'ang crafts were placed in the tomb as well, and sometimes buried for other reasons. In 1970, two large pottery jars were unearthed at Sian, crammed with gold and silver vessels and other treasures, believed to have been buried when their owner fled from the rebel An Lu-shan in 756. Among the finest pieces was the covered jar illustrated here, decorated with parrots and peonies in gilt repoussé. But if all of it were put together it would not give the overwhelming impression of the splendour and refinement of T'ang decorative art that we get from one single collection in Japan. In 756 the empress Kōken dedicated to the great

DECORATIVE ARTS

154 Octagonal wine cup. Beaten silver with traced and relief decoration in gilt. Excavated at Ho-chia-ts'un, Sian. T'ang Dynasty, eighth century.

Buddha of Tōdaiji at Nara the treasures which her deceased husband Shōmu had collected in his lifetime. These and other objects were put in a treasury, called the Shōsōin, in which they have survived virtually intact until this day. This remarkable collection contains furniture, musical instruments and gaming boards painted, lacquered, or inlaid with floral and animal designs in mother-of-pearl, tortoise shell, gold and silver; there are glass vessels from the Arab world, silver platters, jugs and ewers, mirrors, silk brocades, weapons, pottery, maps, paintings and calligraphy. What is astonishing about this collection is the triumphant confidence with which the Chinese craftsman—assuming most of these pieces to be of Chinese origin, or copies of Chinese work—has mastered foreign forms and techniques. This is particularly true of the art of the goldsmith and silversmith which came into their own in the T'ang Dynasty. Hitherto, silverwork had been largely dominated by bronze design, but under Near Eastern influence it is emancipated. Some silver vessels, such as the two huge bowls in the Shōsōin, were cast, but precious metals were scarce, and a massive appearance was often gained with little material by soldering thin sheets together to form the outer and inner surface, which also made it possible to trace designs in the metal, both outside and inside. Many of the shapes such as the stem cup, foliated bowl and flat platter with animal designs in repoussé, and the octagonal cup illustrated here, are of Persian origin; the decoration, applied with a typically T'ang combination of lavishness and delicacy, includes animals and figures, hunting scenes, flowers, birds and floral scrolls, generally chased or engraved, and set off against a background of rows of tiny punched circles, a technique borrowed from Sasanian metalwork.

The extravagant taste of the T'ang Dynasty also demanded that mirror backs be gilded or silvered. The old abstract and magical designs have now been replaced by a profusion of ornament whose

155 'Lion-and-grape' mirror. Bronze. T'ang Dynasty.

significance is auspicious in a more general way. Symbols of conjugal felicity, entwined dragons, phoenixes, birds and flowers in relief or inlaid in silver or mother-of-pearl account for most of the designs. Two beautiful mirrors in the Shōsōin retain something of the ancient symbolism of the TLV design by bearing landscapes of foam-washed peaks ringed with clouds and set about with fairies, immortals and other fabulous creatures; while the influence of Manichaean symbolism may be seen, as Cammann has suggested, in the 'lion-and-grape' design which was extremely popular for a short time; its sudden disappearance may have coincided with the suppression of foreign religions in 843/45.

T'ang ceramics, too, made much use of foreign shapes and motifs. The metal ewer was copied in stoneware, often with appliqué designs in relief under a mottled green and brown glaze; the rhyton was reproduced from an old Persian shape; the circular pilgrim bottle, which appears in the blue-glazed pottery of Parthian Persia and Syria, reappears in China, decorated rather roughly in relief with vintaging boys, dancers, musicians and hunting scenes. The Hellenistic amphora in Chinese stoneware loses its static symmetry; the playful dragon handles, the lift and buoyance of its silhouette, the almost casual way in which the glaze is splashed on, all bespeak the touch of the Chinese craftsman, who brings the clay to life under his hands.

The T'ang Dynasty is notable in the history of Chinese ceramics for the dynamic beauty of its shapes, for the development of coloured glazes, and for the perfecting of porcelain. Now, no longer are potters limited to the simple green- and brown-tinted glazes of the Han. A white ware with blue-green splashes was already being made in North China under the Northern Ch'i Dynasty (550–577). The fine white earthenware of the T'ang Dynasty is often clothed in a polychrome glaze, made by mixing copper, iron or cobalt with a colourless lead silicate to produce a rich range of colours from blue and green to yellow and brown; this glaze is applied more thinly than before, often over a white slip, is generally very finely crackled and stops short of the base in an uneven line. Dishes are stamped with foliate or lotus patterns and decorated with coloured glazes, which are confined by the incised lines of the central design, whereas elsewhere the colours tend to run together. The T'ang love of rich effects is seen also in the marbled wares, made by mixing a white and a brown clay together and covering the vessel with a transparent glaze. The more robust T'ang wares were exported to the Near East where they were imitated in the poor-quality clays of Persia and Mesopotamia.

These coloured earthenwares were produced in a number of kilns in the north, while attempts to imitate them were made in other parts of China. But as T'ang culture centred on Ch'ang-an and Loyang descended deeper into its long twilight after 756, the coloured wares also became rarer, although they persisted in grave figurines in Szechwan and in the ceramic sculpture of North China

CERAMICS

156 Ewer with dancer and dragons in relief under a polychrome glaze. Earthenware. T'ang Dynasty.

157 Jar decorated with splashed polychrome glaze. Earthenware. T'ang Dynasty.

145

158 Lobed bowl, Yüeh ware.
Stoneware covered with greyish-olive
glaze. T'ang Dynasty.

159 Vase, possibly Hsing ware.
Porcelain covered with a creamy white
glaze. T'ang Dynasty.

well into the Sung Dynasty. In the meantime, however, as the north declined the southeast grew in prosperity. Before the end of the dynasty, Yüeh ware had reached a high pitch of perfection at the Shang-lin-hu kilns near Hangchow. The body is porcellaneous; bowls and vases (the most common shapes) are sometimes decorated with moulded or incised flowers and plants under an olive green glaze. The soft-bodied North China wares have a flat or slightly concave base, but the Yüeh wares have a fairly high, and often slightly splayed, foot.

It was probably in the seventh century that the Chinese potters perfected true porcelain, by which is meant a hard, translucent ware fused at high temperature with the aid of a high proportion of felspar, causing it to ring when struck. In 851 a work entitled *The Story of China and India* by an unknown author appeared at Basra; it contained information about the Cantonese supplied by a merchant named Sulaiman, who writes of them: "They have pottery of excellent quality, of which bowls are made as fine as glass drinking cups; the sparkle of water can be seen through it, although it is pottery."[3] Indeed, this white ware was already in demand far beyond China's shores, for fragments of both green Yüeh ware and white porcelain were found in the ruins of the Abbasid city of Samarra, which was the summer residence of the Caliphs from 836 to 883. Although the site was occupied after that date, the greater part of the huge quantity of shards belongs to the years of its heyday and bears witness to a flourishing export trade in Chinese ceramics. What was this white ware? An *Essay on Tea* (the *Ch'a-ching*), written, it is believed, by the poet Lu Yü in the latter half of the ninth century, says that for drinking tea one should use Yüeh bowls which give it the colouring of ice or jade, or the ware of Hsing-chou which was as white as snow or silver. A number of pieces have been

146

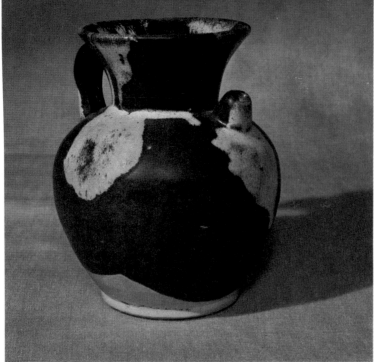

160 Jar, Huang-tao ware. Stoneware covered with a brownish-black glaze with phosphatic splashes. T'ang Dynasty.

identified as possibly Hsing-yao on account of their hardness, their creamy whiteness and their typically T'ang shapes, but the kilns have not yet been discovered and its identification remains uncertain.[4] In these white wares the most characteristic shapes are bowls, often with a slightly everted and foliated lip, globular jars and ewers of generous contour, and stem cups imitating silver vessels.

The white porcelain soon became popular and was widely imitated, notably in the white-slipped stonewares of Hunan and Szechwan. At the same time, the number of kilns making the finer wares begins to multiply. In the latter half of the dynasty, white porcellaneous wares were made—if a single reference in a poem of Tu Fu is acceptable evidence—at Ta-yi in Szechwan; while pale bluish-white ware, the predecessor of the lovely Sung *ch'ing-pai* (*ying-ch'ing*), was already being produced in the Shih-hu-wan kilns near Ching-te-chen, and at Chi-chou, both in Kiangsi. Yüeh-type celadons were being manufactured near Changsha in Hunan, and in Hsiang-yin-hsien north of the city, where some of the earliest experiments in underglaze and enamel painting in China

161 Camel carrying a band of musicians. Earthenware painted and polychrome glazed. From a tomb at Sian, Shensi. T'ang Dynasty.

147

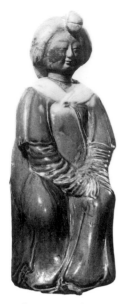

162 Seated woman. Earthenware painted and polychrome glazed. From a tomb at Loyang, Honan. T'ang Dynasty.

163 Tomb guardian trampling on a demon. Earthenware painted and polychrome glazed. T'ang Dynasty.

were undertaken. A hard, grey stoneware, ancestor of the famous splashed Chün wares of the Sung Dynasty, was made in kilns at Huang-tao in Chia-hsien, not far from Chün-chou. The full, massive shapes covered with a rich brown or black felspathic glaze are often made even more striking by bluish-white phosphatic splashes.

The fact that most of the T'ang wares that we enjoy today were made, not for the collector's pleasure, not even for domestic use, but simply as cheap grave goods probably accounts for their unsophisticated charm and vigour. These qualities are most apparent in the great numbers of figurines placed in the tombs, which give a vivid picture of daily life in T'ang times. They vary in size from animals and toys a few inches high to gigantic horses, Bactrian camels, armed men and fantastic squatting guardian creatures popularly called *ch'i-t'ou* or *pi-hsieh*. They include a fascinating array of officials, servants, dancing girls and musicians; indeed, among them women predominate. Women rode horseback with the men and even played polo. A passage in the 'Treatise on Carriages and Dress' in the *Chiu T'ang-shu* (*Old T'ang History*) records that "at the beginning of the K'ai-yüan period [713–742] the palace ladies who rode behind the carriages all wore central Asian hats, exposing the face, without a veil. Suddenly, their hair also was exposed when they broke into a gallop. Some were wearing men's dress and boots."[5]

Something of the gaiety of this courtly life is recaptured in these pottery figurines. The fairylike slenderness of the Six Dynasties women gives way in the fashion of the eighth century to an almost Victorian rotundity—Yang Kuei-fei herself was said to have been plump. But these women make up in character what they lack in elegance, while Chinese potters derived much amusement from caricaturing the extraordinary clothes, the beards and great jutting noses of the foreigners from central and western Asia. The human figurines were almost always made in moulds, the front and back being cast separately, while the larger figures and animals were made in several pieces, generally with the base, or underside of the belly, left open. Though sometimes left in the slip and painted, they were most often lavishly decorated with three-colour glazes, which in time acquired a minute crackle very difficult for the forger to imitate.

The most spectacular of the T'ang figurines are the fierce armed men who are often represented standing on demons. They may represent actual historical figures. Once, when the emperor T'ai-tsung was ill, ghosts started screeching outside his room and throwing bricks and tiles about. A general Chin Shu-pao, who claimed that he had "chopped up men like melons, and piled up corpses like ant-hills," offered, with a fellow officer, to stand guard outside the imperial sickroom, with the result that the screeching and brick-throwing abruptly ceased. The emperor was so pleased that he had the generals' portraits painted to hang on either side of his palace gate. "This tradition," the T'ang book tells us, "was carried down to later years, and so these men became door-gods."[6]

8
The Five Dynasties and the Sung Dynasty

T'ang China never fully recovered from the An Lu-shan rebellion, and gradually what had been a great empire shrank, in both body and spirit. The loss of central Asia to Islam, the Tibetan invasion, rebellions by warlords and peasants and the consequent breakdown in the irrigation system on which prosperity and good order depended, all made the downfall of the dynasty inevitable. In 907, China finally disintegrated into the state of political chaos dignified with the name of the Five Dynasties. The title is an arbitrary one, chosen to cover those royal houses which had their capitals in the north; set up mostly by military adventurers, they had such grandiose names as Later T'ang, Later Han and Later Chou. Between 907 and 923, Later Liang had four rulers belonging to three different families. Although the south and west were divided among the Ten (Lesser) Kingdoms, in fact those regions were far more peaceful and prosperous. Szechwan, as before when the country was disunited, was, until the destruction of Former Shu by Later T'ang in 925, a flourishing kingdom, distinguished for its scholars, poets and artists who had come as refugees from the T'ang court, bringing with them something of the imperial splendours of Ch'ang-an and Loyang. The style of late T'ang decorative art is reflected in the jades, wall painting, silverwork and relief sculpture in the tomb of the Former Shu ruler Wang Chien, who died at Chengtu in 918.

Meantime, as before, the northern barbarians watched with patient interest the disintegration of their old enemy. In 936, the first ruler of Later Chin made the fatal gesture of ceding to the Khitan the area between Peking and the sea south of the Great Wall, with the result that once again the nomads had a footing on the edge of the North China Plain. Ten years later they established the kingdom of Liao over a wide area of North China, which was not to be finally restored to Chinese hands for over four hundred years.

In 959, the last emperor of the Later Chou died and in the following year the regent, General Chao K'uang-yin, was persuaded to ascend the throne as the first emperor of a new dynasty. At first it seemed that the Sung would be just one more in a succession of short-lived houses. But Chao was an able man; in sixteen years of vigorous campaigning he had practically united China, though, as Goodrich observed, the Sung armies never succeeded in breaking the

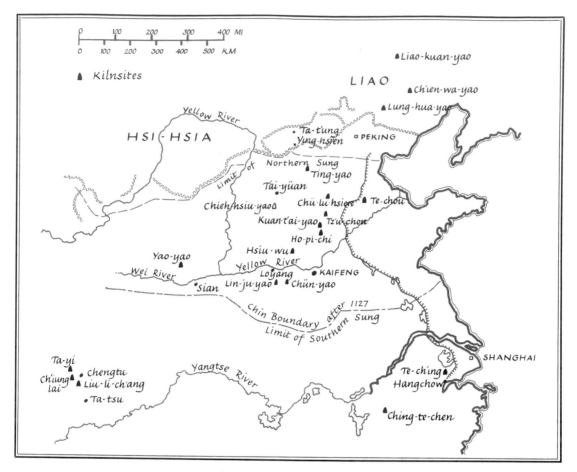

MAP 10 China in the Sung Dynasty.

iron ring that had been forged round the imperial boundaries by the Khitan (until 1125), the Jurchen Tungus (until 1234) and the Mongols in the north; by the Tangut, a Tibetan people (c. 990–1227), and the Mongols in the northwest; and by Annam and Nan-chao in the southwest. In 1125, the dynasty suffered a disaster from which it barely recovered when the Jurchen raided the capital at Kaifeng and captured the whole court including the emperor Hui-tsung, famous throughout history as a painter, collector and connoisseur. In 1127, a young prince and the remaining officials fled south beyond the barrier of the Yangtse, where the court wandered from place to place for several years before they set up what they hoped was to be their temporary capital at Hangchow. The Jurchen, who named their dynasty Chin, were now in control of all China north of the Yangtse—Yellow River watershed. Like the Liao, they were only prevented from further incursions into Sung territory by the enormous tribute which China paid every year, chiefly in coin and rolls of silk, until Genghis Khan with his savage hordes descended from the north, obliterating friend and foe alike.

Hemmed about by hostile powers, the Sung looked inward upon herself. Han China had lived in a fabulous world whose bounda-

150

ries were mythical K'un-lun and P'eng-lai far beyond the horizon; T'ang China flung out her arms to embrace central Asia and welcome all that the West had to offer. Sung China, at peace with itself and buying peace with its neighbours, proceeded to examine the world with a new curiosity, a deeper reverence. She rediscovered the world of feeling and imagination which had been revealed to her in the Six Dynasties, but had been lost again under the strong light of T'ang positivism. It was this depth of philosophical insight, combined with a perfect balance of creative energy and technical refinement, that made the tenth and eleventh centuries one of the great epochs in the history of Chinese art.

During this time, China was ruled by a succession of emperors more truly cultivated than any before or since. Under them, the intellectuals who ran the government were an honoured élite, permitted to remain seated in the imperial presence and to debate rival policies with complete freedom. Their prestige was perhaps partly due to the rapid spread of printing, for which Chengtu, the capital of Shu, was already the chief centre in the ninth century. There, the first paper money had been printed, the first edition of the *Classics* was issued in 130 volumes between 932 and 953, the Buddhist *Tripitaka* in over five thousand volumes and the Taoist canon before the end of the tenth century. With the aid of this new craft it became possible to synthesise knowledge as never before, and there began the unending compilation of dictionaries, encyclopaedias and anthologies which was to become ever more characteristic of Chinese intellectual activity until the revolution. It was this desire for intellectual synthesis which led to the founding by Chou Tun-i and Chu Hsi of the doctrine of Neo-Confucianism, in which the Confucian moral principle (*li*) became identified with the Taoist first cause (*t'ai-chi*) seen as both a metaphysical and a moral force, and at the same time was enriched by a theory of knowledge and a way of self-cultivation derived partly from Buddhism. To the Neo-Confucianist, *li* became the governing principle which gives to each form its inherent nature. By 'investigating things'—that is, by a process of study, part scientific, part intuitive, and leading outwards from the near and familiar—the cultivated man could deepen his knowledge of the world and of the workings of *li*. The intense realism of Northern Sung painting, whether revealed in the painter's knowledge of the texture of rocks, the true form of flowers and birds, or the construction of a river boat, bears witness to the profound and subtle examination of the visible world which found philosophical expression in Neo-Confucianism.

An important by-product of the Confucian revival, or parallel manifestation of the same backward-looking impulses perhaps, was the new interest taken in ancient arts and crafts, creating a demand for reproductions of archaic ritual vessels and implements, in bronze and jade, which was to grow with the centuries. While there is little secure evidence for dating these reproductions, the general opinion is that those of the Sung Dynasty are on the whole more accurate and archaic in feeling than those of Ming and

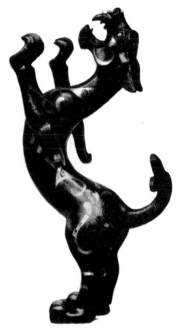

164 Winged lion in the style of the Warring States period. Bronze inlaid with gold and silver. Attributed to the Sung Dynasty.

151

殿堂等七鋪作
副階五
鋪作
雙槽草架側樣第十二

殿側樣十架椽身內雙槽殿身
外轉七鋪作重栱出雙抄兩下
昂裏轉六鋪作重栱出三抄副
階外轉五鋪作重栱出單抄單
昂裏轉五鋪作出雙抄
並各計心
以上

165 Seven-tiered bracket for a palace hall. Illustration from the Sung Dynasty architectural manual, *Ying-tsao fa-shih* (1925 edition). Woodcut.

Ch'ing. Illustrated catalogues of the bronzes and jades in the collection of the emperor Hui-tsung were published in the twelfth century, and subsequently reprinted in more unreliable editions which provided the source for many of the fanciful reproductions of later centuries.

ARCHITECTURE

166 Twelve-sided pagoda of Fu-kung-ssu, Ying-hsien, Shansi. Sung Dynasty, 1058.

It is also in character with the synthesising trend of the period that the first great manual of architectural practice, the *Ying-tsao fa-shih*, presented to the emperor in 1100, should have been written in the Sung Dynasty. The author, Li Chieh, a practising architect in the Board of Works, combines historical scholarship with a considerable amount of straightforward technical information on materials and construction, which in his time was becoming increasingly complex and refined—if not so grand in scale as in the T'ang Dynasty. The *ang*, for example, is now no longer a simple cantilevered arm jutting out to hold up the eaves; it is cut loose from supports at either end and poised on the top of an intricate bracketing system, held in balance by a complex play of stresses and strains. In time, this intricacy for its own sake will lead to degeneration, but in Sung timber construction it combines structural boldness with refinement of detail. Sung taste also preferred the delicate to the robust, the tall and slender to the gigantic and solid, and Kaifeng was a city of spires. Temples had roofs of yellow tiles and were floored with yellow and green. Timber and stone pagodas now acquired little projecting roofs at each storey, curving up at the point where two faces met.

167 Interior of Lower Hua-yen-ssu, Ta-t'ung, Shansi. Liao Dynasty, 1038. Photo by the author, 1975.

As the Toba Wei had fostered Buddhism because they themselves were aliens on Chinese soil, so did the Liao and Chin, and under their patronage there was a revival of the faith in North China, as well as in the Sung domain itself. The twelve-sided pagoda of Fu-kung-ssu at Ying-hsien in Shensi (1058) is one of the few surviving examples of a major Sung pagoda, rich in detail, dynamic in bracketing, noble in proportion. In the city of Ta-t'ung in northern Shansi, a secondary capital under both Liao and Chin, two important temples stand side by side: Lower Hua-yen-ssu, completed in 1038 under the Liao, and still virtually intact, and Upper Hua-yen-ssu, rebuilt after a fire in 1140, although the five great Buddhas were remade in the Ming Dynasty and the frescoes repainted late in the nineteenth century. At Lower Hua-yen-ssu, not only is the sculpture original but the walls retain the original *sūtra* cases fashioned like scaled-down pavilions, their intricate carpentry providing a rare example of the style of the period. In this sumptuous shrine, architect and sculptor have combined their arts in the service of theology to create a fabulous Buddha world by which the worshipper, on entering the hall, is surrounded and enveloped. Buddhas, *bodhisattvas*, guardians and *arhats* take their apportioned place in a gigantic three-dimensional *mandala*, the total effect of which is to saturate the eye, and the mind of the believer, with the manifold and all-embracing powers of God.

One of the most impressive—and deceptive—examples of Liao-Chin sculpture is the set of pottery figures of *lohan* (*arhats*) which

168 Lohan. Pottery covered with green and brownish-yellow glaze. From I-chou, Hopei. Liao Dynasty, tenth to eleventh century.

SCULPTURE

169 Kuanyin. Sculpture in wood and gesso, painted and gilded. Late Sung or Yüan Dynasty.

were found some years ago in a cave at I-chou near Peking. One is in the British Museum, five others in Western collections. The vigorous modelling, the dignity and realism, and above all the three-colour glaze, all suggested a T'ang date at a time when the possibility of art of any quality being produced under the Liao and Chin was not seriously considered. But it is now known that North China at this time was the centre of a flourishing culture in which the traditions of T'ang art were preserved, with subtle differences, not only in sculpture but also in ceramics, and there is no disgrace in assigning them to the Liao or Chin. These figures, and others executed in dry lacquer, are not so much portraits of individual monks, as expressions of a variety of spiritual states. In the face of the young *arhat* in the Nelson Gallery is portrayed all the inward struggle, the intensity of concentration, of the meditative sects of

which Ch'an was the chief. When we turn to the figure in the Metropolitan Museum, we see in the bony skull, lined features and deep-set eyes of an old man, the outcome of that struggle; it has taken its toll of the flesh, but the spirit has emerged serene and triumphant.

But not all sculpture of this period was an archaistic revival or a prolongation of the T'ang tradition. The figures in wood and plaster represent an evolution beyond the T'ang style. The Buddhas and *bodhisattvas* are still fully modelled—even to the extent of a fleshiness that can be displeasing—but what they have lost in dynamic energy they gain in a new splendour of effect. They stand against walls covered with huge frescoes painted in the same ample and spectacular manner. In fact, so closely does the style of the one echo that of the other that Sickman's vivid description of the sculpture could apply equally to the painting:

> An almost uncanny impression of movement, as though the gods were stepping forward with an easy, stately pace, or had just taken their seats on the lotus throne, is produced by the great agitation and restless movement of the garments and encircling scarves. These latter accessories are especially important in creating an almost spiral movement in three dimensions as the long, broad ribbons trail over the arms, loop across the body and curve around the back. In the actual carving the folds are deep, with sharp edges, so that the maximum contrast is obtained between highlight and shadow. Frequently the ends of garments and scarves are caught up in whorls and spirals obviously derived from the calligraphic flourishes of painting.[1]

This suave and restless splendour was clearly designed, like that of

170 Soul suffering the torments of hell. Stone relief sculpture on a cliff at Ta-tsu, Szechwan. Sung Dynasty.

the high baroque art with which it has so much in common, to capture the attention of the worshipper through its emotional appeal. It is no accident that it finds its most splendid expression in the figures of Kuanyin, the comforter, the giver of children, the preserver from peril of all those who call upon her name. She looks down upon suffering humanity with calm detachment; yet she is not indifferent, and her regard is full of sweetness without being sentimental. In this beautiful figure, a potential extravagance of effect is held delicately in check by the refinement of Sung taste.

At another level, Sung sculpture could be anything but refined. Although, after the mid-T'ang, institutional Buddhism appealed less and less to the intelligentsia, its doctrines of rewards and punishments continued to exert their hold on the common people. Some very down-to-earth Sung religious art was produced for the edification of the masses. Among the most astonishing examples of Sung sculptural realism is the figure of a soul suffering the torments of hell, one of hundreds of reliefs carved by unknown craftsmen on the cliff at Ta-tsu in Szechwan. These vivid carvings belong to a tradition of popular didactic sculpture that survived till recent times in Buddhist and Taoist temples, and has been vigorously revived in the People's Republic, a striking example being the 'Rent Collection Courtyard' of 1965, illustrated on page 266.

CH'AN PAINTING IN THE FIVE DYNASTIES

Buddhism as a popular religion, however, never fully recovered from the suppression of 845. During the later T'ang the speculative and Tantric sects decayed, partly because they had no roots on Chinese soil. But for the Ch'an sect (known in Japan as Zen) the position was different. Like Taoism, it emphasised quietism, self-cultivation, the freeing of the mind from all intellectual and material dross so as to leave it open and receptive to those flashes of blinding illumination when suddenly, for a moment, the truth is revealed. To create the right atmosphere for meditation, the Ch'an monks built their temples in beautiful secluded places, where the only sound might be the wind in the trees and the rain falling on the stones of the temple courtyard. Their aims, and the very techniques by which they were to be realised, had much in common with those of the Taoists, although they were a good deal more strenuous. So it was chiefly in Ch'an that Buddhism, after being on Chinese soil for nearly a thousand years, finally came to terms with Chinese ideals.

In seeking a technique with which to express the intensity and immediacy of his intuition, the Ch'an painter turned to the brush and monochrome ink, and with the fierce concentration of the calligrapher proceeded to record his own moments of truth in the outward forms of Buddhas and *arhats* or indeed of any subject that he chose to paint. Already in the last century of the T'ang Dynasty there were artists practising techniques as wildly eccentric as those of any modern Western 'action painter'. None of their work survives, but contemporary descriptions of it suggest that these individualists were either Ch'an adepts or were fired by the same impulse towards irrationality and spontaneity as that which inspired the Ch'an

171 In the manner of Shih K'o (active mid-tenth century). *Two Minds in Harmony*. Part of a handscroll. Ink on paper. Sung Dynasty.

painters. Only slightly later was Kuan-hsiu who, after a lifetime of painting Buddhist subjects in the lower Yangtse region, came, full of years and honour, to the court of Wang Chien at Chengtu, where he died in 912. His *arhats* were drawn with that exaggeration bordering on perversity which is typically Zen; with their bony skulls, huge eyebrows and pronounced Indian features, they have the ugliness of caricature, as if only by deliberate distortion can the sudden, electrifying experience of the Ch'an mystic be suggested. For the experience itself is incommunicable; all the artist can do is to give the viewer a shock which may jolt him into awareness. But even to suggest that these paintings have a purpose may be suggesting too much, and we should see them simply as pictorial metaphors for an event, or 'happening', in the mind that cannot be described. "Illumination," they seem to say, "is like this."

The few surviving copies of Kuan-hsiu's work are treasured in Japan, where Zen long outlasted its popularity in China. When Kuan-hsiu died, his mantle fell upon Shih K'o, a wild and eccentric individual who, according to an eleventh-century historian, "liked to shock and insult people and compose satirical rhymes about them." By this time, writers were fond of classifying painters into three grades: *neng* (capable), *miao* (wonderful) and *shen* (divine, superhuman); but for Shih K'o and his like even *shen* was not enough, for it still implied obedience to the rules. For them they coined the term '*i*', meaning 'completely unrestrained by rules'. "Painting in the *i* style," said another author, "is most difficult; those who follow it . . . despise refinement and rich colouring and draw the forms quite sketchily, but grasp the natural (*tzu-jan*) spontaneously." The notion of *i* was to crop up again and again in the history of Chinese painting to describe painters who, so far as the orthodox canons were concerned, were *hors concours*.

In the meantime, quite another tradition was flourishing at Nanking, whose painters might have raised their hands in horror at

the antics of the fauves up in Chengtu. There, Li Hou-chu, the 'emperor' of Southern T'ang, had recreated in miniature the luxury and refinement of the T'ang court under Ming Huang. One recent writer describes the art produced under his patronage as the twilight of the T'ang, another as 'premature Sung'; all we can say is that it provides an important link between the two great epochs. Under his patronage, the spirit of Chou Fang and Chang Hsüan was reborn in Chou Wen-chü and Ku Hung-chung. The painting, of which a detail is reproduced here, is probably a very close copy, dating from about the twelfth century, of a scroll by Ku Hung-chung depicting the nocturnal revels of the vice president Han Hsi-tsai, rumours of whose thoroughly un-Confucian behaviour with singing and dancing girls, of whom he had at least a hundred, had reached the ears of the emperor. Li Hou-chu sent a painter in attendance (*tai-chao*) to observe and record what was going on, and then confronted Han Hsi-tsai with the evidence of his dissipation. The scene looks respectable enough, but the casual attitudes of Han, his friends and his singing girls, the meaningful glances, the figures half hidden behind bed-curtains, are all highly suggestive; indeed, not the least intriguing thing about this picture is the way in which licentiousness is suggested in a formal language of such exquisite refinement and dignity. The painting, which the fourteenth-century writer T'ang Hou considered "not a pure and fitting object for a high-class collection," is also extremely revealing as a document on tenth-century costume, furniture and porcelain, and shows how lavishly paintings, including monochrome landscapes, were used in interior decoration, forming panels on the beds as well as tall free-standing screens. It would seem that the hanging scroll has not yet become fashionable.

The last great exponent of the T'ang figure-painting tradition was Li Kung-lin (1040–1106), better known as Li Lung-mien from the name of his country estate of which he, in emulation of

172 Attributed to Ku Hung-chung (tenth century). *A Night Entertainment of Han Hsi-tsai.* Detail of a handscroll. Ink and colour on silk. Possibly a Sung Dynasty copy.

Wang Wei, painted a long, panoramic handscroll. Several versions of its exist. Li Lung-mien moved in an intellectual circle at court that included the poet Su Tung-p'o and the historian Ou-yang Hsiu, while it is recorded that even the great statesman Wang An-shih, who was 'careful in choosing his friends', condescended to visit him. In early life he was a famous painter of horses—until, so the story goes, a Taoist told him that if he continued much longer in this vein he would become like a horse himself, whereupon he switched to other themes. He was throughly eclectic, spending years in copying the old masters, and though his own technique was restricted largely to ink-line (*pai-miao*), his subject matter included everything from horses and genre scenes to Taoist fairy landscapes, Buddhist figures and paintings of Kuanyin amid rocks, of which he created an ideal conventional type. His sweeping brush-line, char-acterised by a typically Sung refining of the manner of Wu Tao-tzu, also provided a model for figure painters that endured down to Ming times.

173 Attributed to Li Lung-mien (c. 1040-1106). *Horse and Groom*. One of five tribute horses. Detail of a handscroll. Ink and colour on paper.

The reverence for the past revealed in Li Lung-mien's sedulous copying of the old masters is from now on to loom large in Chinese connoisseurship, and to present the most formidable problems to the expert. In the case of a master we may assume that his motives were the honourable ones of training his hand and of transmitting the ancient models in the spirit of the sixth principle of Hsieh Ho. To paint in the manner of Wu Tao-tzu, therefore, was no less 'original' than for a pianist to play the works of Bach and Beethoven; for what the artist sought was not originality but a sense of identity, both with nature and with the tradition itself. The West-ern artist particularises; and his painting is generally the result of a direct examination of what is before his eyes. The Chinese painter generalises, and his work, ideally, reveals not the particular but the

CONNOISSEURSHIP

159

quintessential forms of nature, animated by his élan and by his mastery of the brush. To achieve this he must, like the pianist, have the language of expression at his fingertips so that no technical impediment, no struggle with form or brushwork, should come between the vision and its realisation. An important part of his training is the study of the old masters. He might perhaps make an exact reproduction by tracing (*mu*), he might copy the picture with the original before him (*lin*), or he might freely interpret the manner of the master (*fang*). Paintings in either of the first two categories which passed into the hands of unscrupulous collectors or dealers would often acquire false signatures, seals and colophons, and the new attribution would then be attested by further colophons. In many cases, such are the vicissitudes through which the painting has passed that the authenticity of an ancient masterpiece can never be proved, and the most that can be said is that a given work is in the style of a certain master or period and *looks* old enough, and good enough, to be genuine. Sometimes a painting is exposed as a copy by the subsequent appearance of a still finer version. In this most difficult branch of connoisseurship there is not an expert who has not been deceived, and the recent tendency in the West has been perhaps towards an excessive caution not shared by the majority of Chinese and Japanese connoisseurs.

LANDSCAPE PAINTING: THE CLASSICAL IDEAL IN NORTH CHINA

This uncertainty applies particularly to the few great landscape paintings of the Five Dynasties and early Sung which are generally attributed to such masters as Ching Hao, Li Ch'eng, Tung Yüan and Chü-jan, all of whom were working in the tenth century, and Fan K'uan, Hsü Tao-ning and Yen Wen-kuei who were active into the eleventh. In the hundred years between 950 and 1050 a galaxy of great names succeed each other in what must be looked upon as the supreme moment in classical Chinese landscape painting. Ching Hao, who was active from about 900 to 960, spent much of his life in retirement amid the mountains of eastern Shansi. An essay attributed to him, the *Pi-fa chi* (*Record of Brush Methods*) or *Hua shan-shui lu* (*Essay on Landscape Painting*), puts his thoughts on the art into the mouth of an old man whom he pretends he met when wandering in the mountains, and who gave him a lecture on principles and technique. The old man tells him of the six essentials in painting: the first is spirit, the second rhythm, the third thought, the fourth scenery, the fifth brush, and sixth ink; a more logical system than that of Hsieh Ho, for it proceeds from the concept to its expression, and thence to the composition, truth to nature (scenery), and finally technique. The sage further distinguishes between resemblance, which reproduces the outward, formal aspect of objects, and truth, which involves the inner reality, the synthesis of the two producing a perfect integration of form and content. He seeks a just correspondence of the type of brush-stroke with the object depicted. He insists that flowers and trees should be those appropriate to the season, and that men be not larger than trees—not simply for the sake of objective realism, but because only by

174 Attributed to Li Ch'eng (919–967). *Buddhist Temple in the Hills After Rain*. Hanging scroll. Ink and colour on silk. Northern Sung Dynasty.

faithfully reproducing the visible forms of nature can the artist hope to express, through them, their deeper significance. To default in this, therefore, is a sign that the artist has not fully understood how nature operates.

This doctrine of a realism raised to the level of idealism is elaborated in a well-known essay by the eleventh-century master

175 Kuo Hsi (eleventh century), *Early
Spring*. Hanging scroll dated equivalent
to 1072. Ink and colour on silk.
Northern Sung Dynasty.

Kuo Hsi, who combined in his spectacular landscapes the strong drawing and jagged silhouette which we associate with Li Ch'eng, with a modelling of relief in ink-wash which was probably derived from the late T'ang individualists. Kuo Hsi was to Sung landscape what Wu Tao-tzu had been to T'ang Buddhist art—a painter of enormous energy and output, who loved to cover large walls and standing screens with monumental compositions. In his *Advice on Landscape Painting* (*Shan-shui hsün*), he insists again and again on the necessity, amounting to an ethical obligation, for the artist to study nature in every aspect, to mark the procession of the seasons, the way the same scene may look at morning and evening; to note and express the particular, unique character of every changing moment; to select with care; to impart movement to water and cloud, for, as he says, "watercourses are the arteries of a mountain; grass and trees its hair; mist and haze its complexion." Indeed, as the painter knows the very mountains to be alive, so must he transmit that life (*ch'i*) into the mountains that he paints.

How was it then, one might ask, that the Chinese painter, who insisted on truth to natural appearance, should have been so ignorant of even the elementary laws of perspective as the West understands it? The answer is that he deliberately avoided it, for the same reason that he avoided the use of shadows. Scientific perspective involves a view from a determined position, and includes only what can be seen from that single point. While this satisfies the logical Western mind, it is not enough for the Chinese painter; for, why, he asks, should we so restrict ourselves? Why, if we have the means to depict what we know to be there, paint only what we can see from one viewpoint? The Sung Dynasty critic Shen Kua took Li Ch'eng to task for "painting the eaves from below" and thereby putting an arbitrary restriction on his power to "view the part from the angle of totality." "When Li Ch'eng paints mountains, pavilions and buildings," he writes in his *Meng-ch'i pi-t'an*, PERSPECTIVE

> he paints the eaves from below. He believes that looking up one perceives the eaves of a pagoda as a person on the level ground and is able to see the beams and rafters of its structure. This is absurd. All landscapes have to be viewed from "the angle of totality to behold the part," much in the manner in which we look at an artificial rockery in our gardens. If we apply Li's method to the painting of real mountains, we are unable to see more than one layer of the mountain at a time. Could that be called art? Li Ch'eng surely does not understand the principle of viewing the part from the angle of totality. His measurement of height and distance certainly is a fine thing. But should one attach paramount importance to the angles and corners of buildings?[2]

The composition of a Chinese painting is not defined by the four walls of its mount as is a European painting within its frame. Indeed, the Chinese artist hardly thinks of it as a 'composition' at all. Those formal considerations to which the Western painter devotes so much attention, he takes very largely for granted. THE AIMS OF THE LANDSCAPE PAINTER

Rather is his picture, as Shen Kua suggests, a fragment—chosen as it were at random, yet profoundly significant—of eternity. What the Chinese artist records is not a single visual confrontation, but an accumulation of experience touched off perhaps by one moment's exaltation before the beauty of nature. The experience is transmitted in forms that are not merely generalised, but also richly symbolic. This kind of generalisation is quite different from that of Claude Lorrain and Poussin, whose idyllic landscapes deliberately evoke a long-forgotten golden age. The Chinese artist may paint a view of Mount Lu, but the actual shape of Mount Lu is of little interest to him in itself; the mountain is significant only if, in contemplating it, wandering through it, painting it, he is made aware of those things that for him make Mount Lu, for the moment, the very embodiment of 'mountainness'. Likewise, the bird on a branch painted by some Sung academician is not a thing in itself, defined by its frame, but seems poised in limitless space, a symbol chosen by the artist to express what we might call the 'bird-on-bough' aspect of eternity. We are often told that the Chinese painter leaves large areas of the picture space empty so that we may 'complete it in our imagination'. But that is not so. The very concept of completion is utterly alien to the Chinese way of thinking. The Chinese painter deliberately avoids a complete statement because he knows that we can never know everything, that what we can describe, or 'complete', cannot be true except in a very limited sense. All he can do is to liberate the imagination and set it wandering over the limitless space of the universe. His landscape is not a final statement, but a starting point; not an end, but the opening of a door. For this reason, Rembrandt's drawings, and the work of the modern abstract expressionists, are much closer to the spirit of Chinese art than are the idealised, classical compositions of European landscape painters of the seventeenth century.

In the passage I have quoted above, Shen Kua clearly explains the attitude behind the 'shifting perspective' of Chinese painting, which invites us to explore nature, to wander through the mountains and valleys, discovering fresh beauty at every step. We cannot take in so great a panorama at a glance; indeed, the artist intends that we should not. We would need perhaps days or weeks to walk the length of the stretch of countryside he presents in his scroll; but by revealing it to us little by little as we proceed, he combines the element of time with that of space in a four-dimensional synthesis such as Western art has not achieved until modern times. The nearest parallel is to be found not in European art, but in music, in which the theme unfolds and develops in time. As we unroll as much of the great panorama as we can comfortably pass from right hand to left (never opening it out fully as is done in museums), we find ourselves drawn unwittingly into the scene spread out before us. The artist invites us to follow him down the winding paths, to wait at the river bank for the ferryboat, to walk through the village—disappearing from view for a few moments, perhaps, as we pass behind a hill—to re-emerge and find ourselves standing on the

176 Fan K'uan (active late tenth to early eleventh century), *Travelling amid Mountains and Gorges*. Hanging scroll. Ink and colour on silk. Northern Sung Dynasty.

bridge, gazing at a waterfall; and then perhaps to saunter up the valley to where a monastery roof can just be seen above the treetops, there to rest, fan ourselves after our exertions, and drink a bowl of tea with the monks.

Only by a shifting perspective, which opens out a fresh view at every turn of the path, is such a journey possible. Indeed, we can only truly appreciate a great Chinese landscape painting if it does have this power to send our spirits wandering. At the end of the scroll, the artist will leave us standing at the lake shore, gazing out across the water to where distant peaks rise through the haze, while an infinity of space stretches above them, carrying us with it beyond the horizon. Or he may close the scroll with a rocky tree-clad spur in the foreground, and thus bring us back to earth once more.

This power in a great Chinese landscape painting to 'take us out of ourselves' was widely recognised as a source of spiritual solace and refreshment. Kuo Hsi opens his essay by declaring that it is the virtuous man above all who delights in landscapes. Why the virtuous man particularly? Because, being virtuous (in other words, a good Confucian), he accepts his responsibilities to society and the state, which tie him down to the urban life of an official. He cannot 'seclude himself and shun the world', he cannot wander for years among the mountains, but he *can* nourish his spirit by taking imaginary journeys through a landscape painting into which the artist has compressed the beauty, the grandeur and the silence of nature, and return to his desk refreshed.

FAN K'UAN The great masters of the tenth and eleventh centuries are sometimes called classical because they establish an ideal in monumental landscape painting to which later painters returned again and again for inspiration. In nearly every case, the attributions to such masters as Ching Hao, Li Ch'eng, Kuan T'ung and Kuo Chung-shu are merely traditional. But by a miracle there has survived one masterpiece bearing the hidden signature of the great early Sung painter Fan K'uan which is almost certainly an original from his hand. Born about the middle of the tenth century, and still living in 1026, Fan K'uan was a shy, austere man who shunned the world. At first, like his contemporary Hsü Tao-ning, he modelled himself on Li Ch'eng, but then it came to him that nature herself was the only true teacher, and he spent the rest of his life as a recluse in the rugged Ch'ien-t'ang Mountains of Shansi, often spending a whole day gazing at the configuration of rocks, or going out on a winter night to study with great concentration the effect of moonlight upon the snow. If we were to select one single painting to illustrate the achievement of the Northern Sung landscape painters, we could not do better than to choose his 'Travelling amid Mountains and Gorges', in which we see a train of pack horses emerging from a wood at the base of a huge precipice. The composition is still in some respects archaic; the dominating central massif goes back to the T'ang Dynasty, the foliage retains several early conventions while the texture strokes (*ts'un*) are still almost mechanically repeated and narrow in range; their full expressive possibilities are not to be realised for another two hundred years. Yet this painting is overwhelming in its grandeur of conception, its dramatic contrasts of light and dark in the mist, rocks and trees, and above all in a

concentrated energy in the brushwork so intense that the very mountains seem to be alive, and the roar of the waterfall fills the air around you as you gaze upon it. It perfectly fulfills the ideal of the Northern Sung that a landscape painting should be of such compelling realism that the viewer will feel that he has been actually transported to the place depicted.

The high point of Sung realism was reached in a remarkable handscroll depicting life on the outskirts of the capital just before the Ch'ing-ming festival in spring. The artist reveals an encyclopaedic knowledge of the look of houses, shops, restaurants and boats, and of the variety of people of high and low degree who throng the streets. His vision is almost photographic, while he displays complete mastery of shadowing (in the hulls of the boats) and foreshortening. It is worth noting that the painter, Chang Tse-tuan, otherwise almost unknown, was a member of the scholar-gentry and that he did not consider it beneath him to concern himself with so mundane a subject. But the Ch'ing-ming scroll, painted perhaps around 1120, is both the climax and the swan song of pictorial realism as an ideal for painters of his class: from now on, the literati will leave this kind of painting to the academicians and professionals.

These painters were all men of North China, nurtured in a hard, bleak countryside whose mood is well conveyed in the austerity of their style. The painters of the south lived in a kinder environment. The hills of the lower Yangtse Valley are softer in outline, the sunlight is diffused by mist, and winter's grip less hard. In the works of Tung Yüan and Chü-jan, both active in Nanking in the middle decades of the tenth century, there is a roundness of contour and a looseness and freedom in the brushwork that is in marked contrast to the angular rocks and crabbed branches of Li Ch'eng and Fan K'uan. Shen Kua said that Tung Yüan "was skilled in painting the mists of autumn and far open views," and that "his pictures were meant to be seen at a distance, because their brushwork was very rough." Tung also, rather surprisingly, worked in a coloured style like that of Li Ssu-hsün. The revolutionary impressionism which Tung Yüan and his pupil Chü-jan achieved by means of broken ink-washes and the elimination of the outline is well illustrated by

177 Chang Tse-tuan (late eleventh to early twelfth century), *Life Along the River on the Eve of the Ch'ing-ming Festival*. Detail of a handscroll. Ink and slight color on silk. Northern Sung Dynasty.

TUNG YÜAN AND CHÜ-JAN

178 Attributed to Tung Yüan (tenth century). *Scenery Along the Hsiao and Hsiang Rivers*. Detail of a handscroll. Ink and colour on silk. Early Sung Dynasty (?).

Tung Yüan's scroll depicting scenery along the Hsiao and Hsiang rivers in Hunan, sections which are now in the museums in Peking and Shanghai. In this evocation of the atmosphere of a summer evening, the contours of the hills are soft and rounded, the mist is beginning to form among the trees, while here and there the diminutive figures of fisherman and travellers go about their business. Over the scene hangs a peace so profound that we can almost hear their voices as they call to each other across the water. Here for the first time an element of pure lyricism appears in Chinese landscape painting.

THE PAINTING OF THE LITERATI

Vestiges of Northern Sung realism lingered on in the Southern Sung Academy, and in professional painting even through the Ming and Ch'ing Dynasties—as, for example, in the landscape by Yüan Chiang illustrated on page 235—but this apparent realism was a mere convention: the artist was no longer looking at nature with fresh eyes; he was simply concocting pictures out of his head. But even while a realism based on genuine observation was reaching its climax in the Northern Sung period, the seeds of a very different notion of the purposes of painting were taking root in the minds of a small circle of intellectuals of whom the leaders were the great poet Su Tung-p'o (1036–1101), his teacher in bamboo painting Wen T'ung (died 1079), Mi Fu, (or Mi Fei, 1051–1107), and the scholar and calligrapher Huang T'ing-chien (1045–1105). These gentlemen put forward the revolutionary idea that the purpose of painting was not representation, but expression. To them, the aim of a landscape painter was not to evoke in the viewer the same kind of feelings as he would have if he were actually wandering in the mountains himself, but to reveal to his friends something of his own mind and feelings. They spoke of merely 'borrowing' the forms of rocks, trees or bamboo in which, for the moment, to find 'lodging' for their thoughts and feelings. Of a panorama of the Hsiao and Hsiang rivers such as that attributed to Tung Yüan they might say, not "From this you can tell what the scenery of Hsiao and Hsiang is like," but "From this, you can tell what kind of a man Tung Yüan was." Their brushwork was as personal and as revealing of character as was their handwriting.

So it was that in their painting, the passion of a Fan K'uan for the hills and streams gave way to a more urbane, detached attitude; for they avoided becoming too deeply involved either in nature or in material things. Above all, they were gentlemen, poets and scholars first, and painters only second; and, lest they might be taken for professionals, they often claimed that they were only playing with ink and that a certain roughness or awkwardness was a mark of unaffected sincerity. By choice, they painted in ink on paper, deliberately avoiding the seduction of colour and silk. It is not surprising that of all the streams of Chinese pictorial art, the painting of the literary men, the *wen-jen hua*, is the hardest to appreciate, even for the Chinese themselves. The lines that the Sung scholar Ou-yang Hsiu wrote of the poetry of his friend Mei Yao-

ch'en would apply equally well to the paintings of Su Tung-p'o, Wen T'ung or Mi Fu:

> His recent poems are dry and hard;
> Try chewing on some—a bitter mouthful!
> The first reading is like eating olives,
> But the longer you suck on them, the better the taste.[3]

Just what brought about this momentous change in the educated man's view of the purposes of art is not quite clear. The germs of it might be found in the life and work of the T'ang poet-painter Wang Wei, regarded by the later literati as the founding father of this tradition of landscape painting; but its emergence as a philosophy of art belongs to the Sung, and seems to go hand in hand with the tendency, which found its subtlest and most complex expression in the philosophy of the second generation of Neo-Confucianists, to unite all phenomena, natural forces, qualities of mind, in a universal system of relationships that can only be grasped through intuition. The very existence of such a synthetic philosophy—the ancient *pa-kua* had been a primitive attempt in the same direction—encouraged thinkers to leap from the object of experience straight to the general, all-embracing principle without investigating it for itself. As this approach to knowledge took stronger hold on intellectuals, more and more did it discouraged both scientific investigation and realism in art, while the gulf that began increasingly to separate the intellectual élite from the rest of society ensured that henceforth scholars would no longer concern themselves (except in their capacity as administrators) with worldly affairs. It would have been utterly impossible, for instance, for a gentleman in the Yüan, Ming or Ch'ing Dynasty to have painted a scroll like Chang Tse-tuan's panorama illustrated on page 167.

Whatever the causes of this momentous shift in emphasis—and there are many—it is well illustrated in the handful of surviving paintings that have been attributed to members of this small group of Northern Sung scholar-painters. The short handscroll illustrated here was first attributed to Su Tung-p'o in the thirteenth century,

179 Attributed to Su Tung-p'o (1036–1101). *Bare Tree, Bamboo and Rocks.* Handscroll. Ink on paper.

180 Mi Yu-jen (1086–1165), *Misty Landscape*. Hanging scroll. Ink on paper. Southern Sung Dynasty.

and its actual author is unknown. But it is typical of the taste and technique of the eleventh-century scholar-painters in its choice of medium, its dry, sensitive brushwork, its avoidance of obvious visual appeal, and in the sense that this is a spontaneous statement as revealing of the man himself as of what he depicts.

The work of these early scholar-painters was always original, not because they strove for originality for itself, but because their art was the sincere and spontaneous expression of an original personality. One of the most remarkable of these men was Mi Fu, critic, connoisseur and eccentric, who would spend long evening with his friend Su Tung-p'o, whom he first met, probably in Hangchow, in 1081, surrounded by piles of paper and jugs of wine, writing away at top speed till the paper and wine gave out, and the small boys grinding the ink were ready to drop with fatigue. In painting landscapes, Mi Fu, it is said, abandoned the drawn line altogether, forming his mountains of rows of blobs of wet ink laid on the paper with the flat of the brush—a technique probably derived from Tung Yüan's impressionism and highly evocative of the misty southern landscape that Mi Fu knew so well. This striking 'Mi-dot' technique, as it came to be called, had its dangers, however; in the hands of the master or of his son Mi Yu-jen (1086–1165), who seems to have modified it somewhat, it achieved marvels of breadth and luminosity with the simplest of means, but it was fatally easy to imitate.

So radical was this technique of Mi Fu's that the emperor Hui-tsung would have none of his work in the imperial collection, nor would he permit the style to be practised at court. It is not known whether an official painting academy ever existed before the Southern Sung. Painters at the T'ang court had been given a wide variety of civil and military ranks, most of which were sinecures. Wang Chien, ruler of Former Shu, seems to have been the first to give his painters appointments in his own Hanlin Academy of Letters, and this practice was followed by the Southern T'ang emperor Li Hou-chu at Nanking, and by the first emperors of the Sung. Contemporary writers often speak of distinguished painters as being in attendance (*tai-chao*) in the Yü-hua-yüan (Imperial Academy of Painting); yet no such institution is ever mentioned in the Northern Sung history, and if such a body did in fact exist, it was presumably a subdivision of the Hanlin Academy.

The tradition of direct imperial patronage culminated in Hui-tsung (1101-1125), the last emperor of Northern Sung, whose passion for pictures and antiquities blinded him to the perils into which his country was drifting. In 1104 he set up an official School of Painting (*Hua-hsiieh*) in the palace, but in 1110 this was abolished and painting was once more put under the Hanlin Academy. Hui-tsung kept tight control over the painters at court. He handed out the subjects to be painted and set examinations as though the painters were candidates for administrative posts. The theme was

SUNG HUI-TSUNG AND THE ACADEMY

181 Sung Hui-tsung (reigned 1101-1125), *The Five-Colour Parakeet.* Hanging scroll. Ink and colour on silk. Northern Sung Dynasty.

generally a line from a poem, and distinction went to the most ingenious and allusive 'answer'. When, for example, he chose the theme 'A Tavern in a Bamboo Grove by a Bridge', the winner did not put in the tavern at all, but simply suggested it by a signboard set among the bamboos. Thus, what Hui-tsung required of these artists was not mere academic realism, so much as the kind of intellectual agility, the avoidance of the obvious, the play upon ideas that was expected also of literary scholars. But the emperor, himself a painter of great ability, tolerated no indiscipline in the ranks. He imposed a dictatorship of form and taste upon his academicians as rigid as that of Le Brun over the artists working for Louis XIV, who were in much the same position. The penalty for independence was dismissal. For all his talent and enthusiasm, his influence cannot have been beneficial. The imposition of a rigid orthodoxy laid the foundation for a decorative, painstaking 'palace style' which was to govern court taste until modern times, while his insatiable and somewhat unscrupulous demands as a collector —demands which no owner could refuse—helped to ensure the destruction, in the disastrous events of 1125/27, of most of the still-surviving masterpieces of ancient art.

Whenever Hui-tsung produced a masterpiece, the painters in the academy vied with each other in copying it and if they were lucky succeeded in having their versions inscribed with the emperor's own cypher. So closely indeed did they model their work on his that it is now almost impossible to disentangle the one from the other, though some attempts have been made to do so. It would even be wrong to assume that the better the painting the more likely it is to be from the imperial hand. The pictures associated with his name are for the most part quiet, careful studies of birds on branches—'A Dove on a Peach Tree,' 'Sparrows on Bamboo,' and so on—painted with exquisite precision, delicate colour, and faultless placing. Often their beauty is enhanced by the emperor's highly elegant calligraphy which, we may be sure, was not infrequently applied also as a mark of approval to paintings executed by members of the academy. A typical product of this sophisticated circle is the famous 'five-Colour Parakeet', which bears a poem and signature penned by the imperial brush. This exquisitely balanced picture reveals a certain stiffness (much clearer in the original than in the photograph), an anxiety to be correct at all costs—just the qualities we might expect to find in Hui-tsung himself.

BIRD AND
FLOWER PAINTING

The art of flower painting which Hui-tsung and his academicians practised was not, in origin, wholly Chinese. Buddhist banner paintings brought from India and central Asia were richly set about with flowers, painted in a technique which influenced the late-sixth century master Chang Seng-yu. Speaking of some of Chang's paintings in a temple at Nanking, a T'ang author had written: "All over the gate of the temple 'flowers-in-relief' are painted. . . . Such flowers are done in a technique brought here from India. They are painted in vermilion, malachite greens and azurite blues. Looking at

them from a distance, one has the illusion that they are [carved] in relief, but close at hand they are seen to be flat."[4] T'ang Buddhist art is rich in this decorative style of flower painting, but by the tenth century it had become an art in its own right. Later painters loved to animate their flower studies with birds, and thus 'birds and flowers' (*hua-niao*) became recognised as an independent category in the repertoire.

The tenth-century master Huang Ch'uan is said to have invented a revolutionary technique of flower painting at the court of Wang Chien in Chengtu. He worked almost entirely in delicate, transparent washes of colour, sometimes laid one over the other, a style requiring great skill in handling the medium, which is related to the boneless technique we have already encountered in landscape painting.

The technique of his contemporary and great rival at Nanking, Hsü Hsi, was apparently quite different, for he drew his flowers and leaves swiftly in ink and ink-wash, adding only a little colour. Huang Ch'üan's style was considered the more skillful and decorative, and eventually became more popular with professionals and court painters, while Hsü Hsi's, because it was based on the free use of brush and ink, found favour among the literati. Huang's son Huang Chü-ts'ai, among others, successfully combined elements of both styles. No original from the hand of Huang Ch'üan or Hsü Hsi has survived, but their techniques are still popular with flower painters today.

A comment by the critic Shen Kua on the work of Huang and his son, on the one hand, and Hsü, on the other, throws an interesting light on the standards by which this kind of painting was judged in the Sung Dynasty.

> The two Huangs' flower paintings are marvellous [*miao*] in their handling of colours. Their brushwork is extremely fresh and finely detailed. The ink lines are almost invisible, and are supplemented only by washes of light colours. Their sort of painting you might call sketching from life. Hsü Hsi would use his ink and brush to draw in a very broad way, add a summary colouring, and that would be all. With him the spiritual quality is pre-eminent, and one has a special sense of animation. Ch'üan disliked his technique, called his work coarse and ugly, and rejected it as being without style.[5]

This was the true professional speaking.

When, after the disaster of 1125, the Sung shored up the ruins of their house amid the delights of their 'temporary' capital at Hangchow, they set out to recapture the dignity and splendour of the old life at Kaifeng. At Wu-lin outside the city, a formal Academy of Painting, *Hua-yüan*, was set up, for the first and only time in Chinese history. Venerable masters from the north were assembled there to re-establish the tradition of court painting, and no national catastrophe it seemed, provided that it was ignored, could disturb the even tenor of their life and art. The classic northern tradition was transformed and transmitted to the Southern Sung by

LI T'ANG

182 Attributed to Huang Chü-ts'ai (933–993). *Pheasant and Sparrows amid Rocks and Shrubs.* Hanging scroll. Ink and colour on silk. Northern Sung Dynasty.

183 Attributed to Li T'ang (c. 1050–
1130). *A Myriad Trees on Strange
Peaks*. Fan. Ink and colour on silk.
Sung Dynasty.

184 Attributed to Chao Po-chü
(1120–1182). *Rocky Mountains Along a
River in Autumn*. Detail of a handscroll.
Ink and mineral colours on silk.
Southern Sung Dynasty.

174

185 Ma Yüan (active 1190–1225), *On a Mountain Path in Spring*, with a poem by Yang Mei-tzu, consort of Ning-tsung. Album-leaf. Ink and colour on silk. Southern Sung Dynasty.

Li T'ang, *doyen* of Hui-tsung's academy. History credits Li T'ang with a monumental style based on the *fu-p'i ts'un* ("axe-cut texture stroke"), a graphic description of his method of as it were hacking out the angular facets of his rocks with the side of the brush. A powerful landscape in this technique in the Palace Museum, Taipei, signed and dated equivalent to 1124, may be a later copy, and it is likely that no original from his hand survives today. Perhaps the little fan painting, 'A Myriad Trees on Strange Peaks', brings us as close to his style as we shall ever get. He was an old man when Kaifeng fell, and most of his work must have perished with the imperial collection. But copies, attributed paintings, and literary sources suggest that his style and influence were dominant in the twelfth century, making him a vital link between the remote grandeur of Northern Sung and the brilliant romanticism of Southern Sung painters such as Ma Yüan and Hsia Kuei.

The first great Southern Sung landscape painter of whom we have any knowledge was Chao Po-chü, a member of the Sung imperial family who as a youth had been in Hui-tsung's academy —and lived on to become a favourite of Kao-tsung (1127–1162) and a high office-holder in Chekiang. He is said to have excelled in landscapes with figures in the green-and-blue style that had originated with Li Ssu-hsün. His handscroll, 'Rocky Mountains Along a River in Autumn', of which a detail is illustrated here, combines restrained echoes of the precise, decorative T'ang manner with a monumental *intimisme* that is typical of Sung landscape painting at its best.

Perhaps because of its obvious visual and emotional appeal, the work of the Ma-Hsia School, as it is called, has come in Western eyes to represent the very quintessence of Chinese landscape painting, and not only in the West, for this style was to have a profound influence too on the development of landscape painting in Japan. Its language of expression was not altogether new. We have found an anticipation of its spectacular tonal contrasts in Fan K'uan and Kuo Hsi, its clawlike trees and roots in Li Ch'eng, its axe strokes in Li T'ang. But in the art of Ma Yüan and Hsia Kuei these elements all

MA YÜAN AND HSIA KUEI

175

186 Hsia Kuei (active 1200–1230), *Pure and Remote View of Hills and Streams*. Detail of a handscroll. Ink on paper. Southern Sung Dynasty.

appear together, united by a consummate mastery of the brush which would border on mannerism if it were not so deeply infused with poetry. Without this depth of feeling, the style is in itself decorative and easily imitated in its outward aspects—qualities which were to be seized upon by the painters of the Kanō School in Japan. What is new is the sense of space, achieved by pushing the landscape to one side, opening up a vista of limitless distance. There are many night scenes, and the atmosphere is often redolent of a poetic sadness that hints at the underlying mood of Hangchow in this age of deepening anxiety.

Ma Yüan became a *tai-chao* at the end of the twelfth century, Hsia Kuei early in the thirteenth. It is not always easy to disentangle the style of the one from the other. If we say, looking at the 'Four Old Recluses' in Cincinnati attributed to Ma Yüan, that his brushwork is bold and fiery, we will find the same quality even more brilliantly displayed in Hsia Kuei's 'Pure and Remote View of Hills and Streams', in the Palace Museum collection, Taipei. It is hard to believe that this almost violently expressionistic work was painted by a senior member of the Imperial Academy. Both he and Ma Yüan used Li T'ang's axe stroke *ts'un* with telling effect, both exploited brilliantly the contrast of black ink against a luminous expanse of mist; all we can say is that of the two Ma Yüan generally seems the calmer, the more disciplined and precise, Hsia Kuei the expressionist, who may in a fit of excitement seem to stab and hack the silk with his brush. The brilliant virtuosity of his style appealed

176

strongly to the Ming painters of the Che School (see p. 213), and there is little doubt that the great majority of paintings generally attributed to Hsia Kuei are in fact pastiches by Tai Chin and his followers. For there is in the real Hsia Kuei a noble austerity of conception, a terseness of statement, a brilliant counterpoint of wet and dry brush, a sparing and telling use of *ts'un*, which his imitators failed altogether to capture.

187 Mu-ch'i (active mid-thirteenth century), *Evening Glow on a Fishing Village*, one of "Eight Views of the Hsiao and Hsiang Rivers." Detail of a handscroll. Ink on paper. Southern Sung Dynasty

The art of Hsia Kuei is not far removed, in the explosive energy of its brushwork, from that of the Ch'an Buddhist masters, who at this time were living not far from the capital in point of distance—their monasteries lay in the hills across the West Lake from Hangchow—but who were in their lives and art far removed from the court and all it stood for. Of these, the chief were Liang K'ai, who after rising to be *tai-chao* under Ning-tsung (1195–1224), retired to a temple, taking with him the brilliant brush style of Hsia Kuei, and Mu-ch'i, who from his monastery, the Liu-t'ung-ssu, dominated the Ch'an painting of the Hangchow region throughout the thirteenth century. There was hardly a subject that Mu-ch'i did not touch. Landscapes, birds, tigers, monkeys, *bodhisattvas*—all were the same to him. In all he sought to express an essential nature that was not a matter of form, for his forms may break up or dissolve in mists—but of inner life, which he found because it was in the painter himself. His famous 'Six Persimmons' is the supreme example of his genius for investing the simplest thing with profound significance. Less often recognised is his power of monumental design, shown above all in the central panel of his great triptych in Daitokuji, Kyōto, depicting the white-robed Kuanyin seated in meditation amid the rocks, flanked by paintings of a crane in a bamboo grove, and gibbons in the branches of a pine tree. Whether or not these scrolls were painted to hang together is immaterial, for, in Ch'an Buddhism, all living things partake of the divine essence. What is most striking about these scrolls, and common to all the best Ch'an painting, is the way in which the artist rivets the viewer's attention

CH'AN PAINTING

188 Mu-ch'i, *The White-Robed Kuanyin*, flanked by crane and gibbons. Hanging scroll. Ink on silk. Southern Sung Dynasty.

by the careful painting of certain key details, while all that is not essential blurs into obscurity, as in the very act of meditation itself. Such an effect of concentration and control was only possible to artists schooled in the disciplined techniques of the Ma–Hsia School; the brush style of the literati, for all its spontaneity, was too relaxed and personal to meet such a demand.

DRAGONS The influence of the academic attitude toward art in the Sung Dynasty is revealed in a growing tendency to categorise. The catalogue of the emperor Hui-tsung's collection, *Hsiian-ho hua-p'u*, for instance, was arranged under ten headings: Taoist and Buddhist themes (which, though less popular than before, still preserved a prestige conferred by tradition); figure painting (including portraits and genre); palaces and buildings (particularly those in the ruled *chieh-hua* style); foreign tribes; dragons and fish; landscapes; domestic animals and wild beasts (there was a whole school of painters specialising in water buffaloes); flowers and birds; ink bamboo; and vegetables and fruit. The last category requires no special mention; and bamboo we will leave to Chapter 9. But before leaving the subject of Sung painting we must say a word on the subject of dragons. To the 'man in the street' the dragon was a benevolent and generally auspicious creature, bringer of rain and emblem of the emperor. To the Ch'an Buddhists he was far more than that. When Mu-ch'i painted a dragon suddenly appearing from the clouds, he was depicting a cosmic manifestation and at the same time symbolising the momentary, elusive vision of truth which comes to the Ch'an adept. To the Taoists, the dragon was the *Tao* itself, an all-pervading force which momentarily reveals itself to us only to vanish again and leave us wondering if we had actually seen it at all.

189 Ch'en Jung (active 1235–1260), *The Nine Dragons*. Detail of a handscroll. Ink on paper. Southern Sung Dynasty.

"Hidden in the caverns of inaccessible mountains," wrote Okakura Kakuzō,

> or coiled in the unfathomed depths of the sea, he awaits the time when he slowly rouses himself to activity. He unfolds himself in the storm clouds; he washes his mane in the blackness of the seething whirlpools. His claws are in the forks of the lightning, his scales begin to glisten in the bark of rain-swept pine trees. His voice is heard in the hurricane which, scattering the withered leaves of the forest, quickens the new spring. The dragon reveals himself only to vanish.[6]

Ts'ao Pu-hsing in the third century had been the first prominent painter to specialise in dragons, but the greatest of all was Ch'en Jung, who combined a successful career as an administrator during the first half of the thirteenth century with a somewhat unorthodox technique as a dragon painter. His contemporary, T'ang Hou, tells us that when he was drunk he would give a great shout, seize his cap, soak it with ink and smear on the design with it, afterwards finishing the details with a brush. His celebrated 'Nine Dragons', painted in 1244, could well have been executed thus, the dragons with his brush, the clouds with his cap; indeed, on the original the imprint of some textile in the clouds can be seen quite clearly.

CERAMICS: NORTHERN WARES

The art of the Sung Dynasty which we admire today was produced by, and for, a social and intellectual élite more cultivated than at any other period in Chinese history. The pottery and porcelain made for their use is a natural reflection of their taste. Some T'ang wares may be more robust, Ch'ing wares more perfectly finished, but the Sung have a classical purity of form and glaze which holds a perfect balance between the vigour of the earlier wares and the refinement

179

of the later. Although some of the porcelain for the Northern Sung court came from kilns as far away as Chekiang and Kiangsi, the most famous of the Northern Sung *kuan* ("official") wares was manufactured in the kilns at Ch'ien-tz'u-ts'un, near Ting-chou in Hopei, where a white porcelain was already being made in the T'ang Dynasty. The classic Ting ware is a finely potted, high-fired white porcelain, with a creamy white glaze which has a brownish tinge where it runs into the 'tear-marks' described in early texts. The floral decoration of earlier pieces such as the masterly tomb pillow illustrated here was freely carved in the 'leather-hard' paste before firing; later, more elaborate patterns were impressed in the paste from pottery moulds. As the vessels were fired upside down, the rims of bowls were left unglazed and often had to be bound with bronze or silver. Chinese connoisseurs recognise, in addition to the true *pai* ("white") Ting, a fine-grained *fen* ("flour") Ting, a *tzu* ("purple"—actually soya-sauce brown) Ting, and a coarse yellowish *t'u* ("earth") Ting. Varieties of Ting and near-Ting, however, are not always easy to distinguish.

The extensive surveys and excavations of recent decades have made it apparent that not only was one type of ware often made in a number of different kilns, with the inevitable local variations in character and quality, but also that one kiln centre might turn out a wide range of products. To take two examples, Koyama Fujio and, more recently, Chinese investigators discovered in the ruins of the Ting kilns white, black, and persimmon red glazed porcelain, unglazed, painted porcelain, pottery with white slip, with patterns in iron oxide, with carved designs, with black, and with buckwheat brown glaze. The Sung kilns at Ho-pi-chi, T'ang-yinhsien, Honan first investigated in 1955, while turning out chiefly plain white wares, also produced coloured wares, white wares with

190 Funerary pillow, Ting ware. Porcelain covered with creamy white glaze. Northern Sung Dynasty.

coloured decoration, cups glazed black outside and white inside, a high-quality, Chün-type stoneware, and black glazed vases with vertical yellowish ribs in relief, such as the lovely vessel illustrated here. The value and beauty of the Ting wares lies not merely in their glaze and decoration but also in the exquisite purity of their shapes, many of which were copied not only in other Sung kilns, but also in the Korean wares of the Koryŏ period. After the fall of Kaifeng in 1127, wares of Ting type were made at Chi-chou in central Kiangsi, very probably by refugee potters who had fled to the south. Before leaving the white wares, we must also mention the beautiful white stoneware jars and vases found in the ruins of the town of Chü-lu-hsien, between Ting-chou and Tz'u-chou, which was inundated and destroyed when the Yellow River changed its course in 1108. Long immersion in the river mud has given them a dull surface and large, uneven crackle, and has stained them with subtle hues of pink and old ivory which by no means mar their beauty.

Since the Sung Dynasty, Chinese connoisseurs have classed Ting-yao as a 'classic' ware of Northern Sung, together with Ju-yao, Chün-yao, and the now legendary Ch'ai-yao, which had a glaze 'blue like the sky after rain'. When the too-fastidious emperor Hui-tsung decided that, presumably because of its 'teardrops' and metal rim, Ting-yao was no longer good enough for palace use, kilns were set up to make a new *kuan* ware, both at Ju-chou and within the confines of the capital itself. The latter kilns have long since been buried or swept away in the floods that periodically inundate the Yellow River Valley, and it is not known for certain what kind of porcelain they produced, although the Palace Museum authorities in Taiwan have recently published a number of fine pieces, close both to Ju-yao and to Hangchow kuan-yao, as products of the Kaifeng imperial kilns. Ju-yao, one of the rarest of all Sung porcelains, has been more positively identified. It has a buff or pinkish-yellow body, covered with a bluish-grey glaze with a lavender tint, netted over with a fine crackle like mica. The shapes, chiefly bowls, brush washers and bottles, are of an exquisite simplicity matching the quality of the glaze. Ju-chou was also one of several centres in addition to the large factory in T'ung-ch'uan-hsien, north of Sian, which produced 'northern celadon' —an apt name for a stoneware often richly decorated with carved or moulded floral designs under a dull green glaze. A kind of celadon had been made at Yao-yao in T'ung-ch'uan-hsien as early as the Six Dynasties, but when the Sung expanded to absorb Chekiang, production and quality in the Yao-yao kilns seem to have been influenced by the Yüeh potters, some of whom may have been sent to North China.

Much more closely related to Ju, however, is the well-known Chün ware, made not only at Chün-chou and Ju-chou, but also at other centres in the neighbourhood of Ho-pi, Anyang and Tz'u-chou. The finest Chün was of palace quality, and so is sometimes called *kuan* Chün by Chinese collectors. The potting is

191 Vase, *mei-p'ing*. Stoneware covered with black glaze. From Ho-pi-chi, Honan. Northern Sung Dynasty.

192 Bottle with copper-bound rim, Ju ware. Stoneware covered with dove's egg blue glaze. Northern Sung Dynasty.

193 Pitcher, northern celadon. Stoneware with carved decoration under an olive green glaze. Northern Sung Dynasty.

194 Jar, Chün ware. Stoneware covered with lavender-blue glaze splashed with purple. Sung Dynasty.

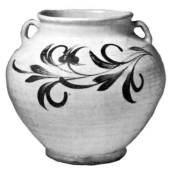

195 Jar, Tz'u-chou ware. Stoneware slipped and painted in black under a transparent glaze. Sung Dynasty.

much heavier than that of Ju-yao, however, and myriads of tiny bubbles, which burst on the surface of the thick lavender-blue glaze, give it a seductive softness and warmth. It was the Chün potters who discovered that spots of copper oxidised in the glaze during firing produced crimson and purple splashes, a technique which they used with exquisite restraint. On later varieties of Chün ware, however, such as the numbered sets of flower pots and bulb bowls made in the Ming Dynasty at Te-hua and Canton, these 'flambé' effects were often used with tasteless extravagance.

The Tz'u-chou wares represent perhaps the most striking example of the extent to which the discoveries of the last fifteen years have altered the ceramic picture. Tz'u-chou is a convenient name for a large family of North China stonewares decorated chiefly by painting under the glaze or by carving or incising through a coloured slip. The technique of underglaze painting had been tentatively tried out in Honan during the T'ang Dynasty, but the Tz'u-chou potters of the Sung used it with easy mastery. The unaffected grace and confidence of the brush drawing gives the Tz'u-chou wares an immediate appeal, although until very recently they have been considered too close to a peasant art to command the respect of educated people in China itself.

The kilns at Tz'u-chou are well known, and still active today, but recent Chinese excavation and research have revealed that the 'North China decorated stoneware', as perhaps it ought to be called, was made across the breadth of the country, from Shantung to Szechwan. Of the known kilns, the most important so far excavated, in addition to Tz'u-chou itself, are Ho-pi, already mentioned, the stratified kilnsite at Kuan-t'ai on the Honan-Hopei border, among whose products were a white ware with designs incised or stamped through the glaze to a darker body, and the kilns at Hsiu-wu (or Chiao-tso) on the Shansi-Honan border, which turned out striking vases with floral designs reserved on black or boldly carved through a black glaze.

Before the end of the Sung Dynasty, North China potters, at P'a-ts'un in Honan, at Pa-i in Shansi, and at Te-chou in Shantung, had developed the revolutionary technique of overglaze painting. Their delightful bowls and dishes decorated with birds and flowers swiftly sketched in tomato red, green and yellow over a creamy glaze are the earliest examples of the enamelling technique which was to become so popular in the Ming Dynasty.

At the fall of the T'ang, the northeast was lost to a Khitan tribe who called their dynasty Liao (907–1124). We have already noted how a 'T'ang revival' school of Buddhist art was flourishing at Yünkang and elsewhere under their patronage, and have assigned the famous ceramic Lohans to this period. Liao sites in Manchuria have yielded fragments of Chun-, Ting- and Tz'u-chou-type wares, but Japanese scholars and collectors and, more recently, Chinese archaeologists have also recovered large quantities of a distinct local ware which combines something of the sgraffiato floral decoration of Tz'u-chou with the three-colour glazes and

197 Bowl, Tz'u-chou ware. Stoneware decorated with coloured enamels over a creamy white glaze. Late Sung or Yüan Dynasty.

196 Vase, *mei-p'ing*, Tz'u-chou ware. Stoneware with designs carved through black to white slip under a transparent glaze. From Hsiu-wu, Honan. Sung Dynasty.

198 Traveller's flask. Stoneware with cockscomb relief ornament in green enamel over white glaze. North China. Liao Dynasty.

the robust—though now provincial and often ungainly—shapes of the T'ang Dynasty, such as the chicken ewer, pilgrim flask and trumpet-mouthed vase. The finest Liao wares are the equal of Sung porcelains in elegance, and even the rough grave wares such as the imitation of a leather water flask carried at the saddle have the same spontaneous, unsophisticated charm that we admire in mediaeval European pottery.

Among the most striking of the northern wares are those with a black glaze, which used to be called 'Honan *temmoku*'. This name forms a link with South China, for it was in the south that tea drinking had first become popular during the T'ang Dynasty and it was discovered that a black glaze effectively set off the pea green colour of the tea. *Temmoku* is the Japanese equivalent of T'ien-mu, a mountain near Hangchow, whence certain of these southern wares were shipped to Japan. The true *temmoku*, made at Chien-an in Fukien as early as the tenth century, consisted almost exclusively of the type of tea bowls which proved so popular in Japan. They have a dark stoneware body decorated with a thick, oily iron glaze running to big drops at the foot. The colour is basically a very dark brown verging on black, often streaked with blue or steel grey, producing marks known as 'hare's fur', or bluish 'oil spots', caused by the coagulation of grey crystals. These were imitated in a rather coarse, lustreless ware made at Chi-chou in Kiangsi, often con-

SOUTHERN WARES

MAP 11 Kilnsites in the Hangchow area.

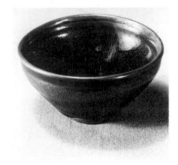

199 Tea bowl, Fukien *temmoku* ware. Stoneware with black 'hare's fur' glaze. Southern Sung Dynasty.

fusingly called 'Kian ware' in older books, and at other kilns in Fukien such as Kuang-che, Fu-ch'ing and Ch'uan-chou.

When, after a few years at Hangchow, the Southern Sung court began to realise that this was to be more than a temporary halting place, steps were taken to enlarge the palace and government offices and to set up factories to manufacture utensils for court use which would duplicate as closely as possible those of the old northern capital. The supervisor of parks, Shao Ch'eng-chang, who was in charge of this work, established a kiln near his own office (*Hsiu-nei Ssu*) on Phoenix Hill just to the west of the palace, which lay at the southern end of the city. There, according to a Sung text, Shao's potters made "a celadon which was called *Nei-yao* [palace ware]. Its pure body of exceptional fineness and delicacy, its clear and lustrous glaze, have been prized ever since." The Phoenix Hill area has been repeatedly built over, and the kilns have not been discovered, nor is it known how long they were in operation. But before long another imperial factory was set up to the southwest below the suburban Altar of Heaven (*Chiao-t'an*). This has become a place of pilgrimage to ceramics enthusiasts, who over the years have picked up quantities of shards of the beautiful 'southern *kuan*' which graces many Western collections. Its dark body is often thinner than the glaze, which is layered, opaque, vitrified, and sometimes irregularly crackled, ranging in colour from a pale bluish-green through blue to dove grey. The ware has an air of courtly elegance combined with quietness and restraint that made it a fitting adornment for the Southern Sung court.

We should not try to draw too sharp a line between Hangchow *kuan* ware and the best of the celadons made at Lung-ch'üan in southern Chekiang. The imperial kilns at Hangchow made a light-bodied ware in addition to the dark, while Lung-ch'üan turned out a small quantity of dark-bodied ware as well as the characteristic light grey. It seems certain that the finest Lung-chüan celadons were supplied to the court, and could hence be classed as *kuan*.

Probably of all Sung porcelains the celadons are the most widely appreciated—outside China, at least. The name is believed to have been taken from that of Céladon, a shepherd dressed in green who appeared in a pastoral play, *l'Astrée*, first produced in Paris in

184

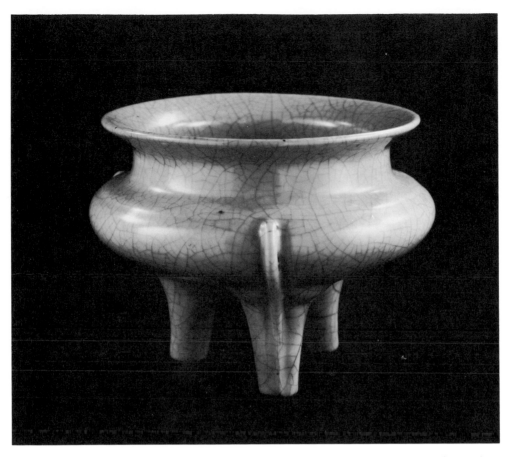

200 Tripod incense burner, southern *kuan* ware. Stoneware with crackled bluish-green celadon glaze. Southern Sung Dynasty.

1610. These beautiful wares, known to the Chinese as *ch'ing tz'u* ("blue-green porcelain"), were made in a number of kilns, but those of Lung-ch'üan were the finest, as well as the most abundant, and were, indirectly, the heirs of the Yüeh wares. The light grey body of Lung-ch'üan ware burns yellowish on exposure in the kiln, and wears an unctuous iron glaze ranging in colour from leaf green to a cold bluish-green, which is sometimes, though by no means always, crackled. Crackle, originally an accidental result of the glaze shrinking more than the body when the vessel cooled after firing, was often exploited for its decorative effect, as in the *ko*-type celadons, in which a closer, secondary crackle was also developed. To the finest Lung-ch'üan celadons, which have a lovely, cloudy blue-green colour, the Japanese gave the name *kinuta* ("mallet"), perhaps after the shape of a particularly famous vase. Almost every shape appears in the Lung-ch'üan repertoire: many are purely ceramic, but we also encounter adaptations of archaic bronze forms, notably incense burners in the form of the three- and four-legged *ting*—a mark of that antiquarianism which was now beginning to develop in Chinese court art and was to have an ever-increasing influence on cultivated taste.

We can trace the development of the Chekiang celadons through dated pieces well into the Ming Dynasty, when the potting becomes

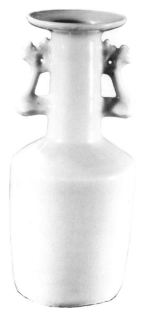

201 Vase, Lung-ch'üan (*kinuta*) ware. Stoneware with grey-green celadon glaze. Southern Sung Dynasty.

202 Vase, *ch'ing-pai* or *ying-ch'ing* ware. White porcelain. Southern Sung Dynasty.

heavier, the glaze greener and more glassy, and the scale more ambitious. From Southern Sung onwards they formed a large proportion of China's export trade. Thousands of shards of Lung-ch'üan ware, for instance, have been picked up on the beaches at Kamakura near Tokyo. Until the Ming Dynasty, celadons, including much coarser imitations made in other kilns in Kiangsi and Fukien, formed the bulk of China's exports to Indochina, Borneo, the Philippines, Malaya and Indonesia; while, as every amateur knows, the ware was much in demand among the potentates of the Arab world because they believed that it would crack or change colour if it came into contact with poison.

Also exported in large quantities (although it was originally a purely domestic ware), was a beautiful translucent porcelain with a granular, sugary body and pale bluish glaze. Some doubt as to its respectability in Chinese ceramic history was long caused by the fact that the name for it used in the West is *ying-ch'ing*, a recent term which was invented by Chinese dealers to describe its shadowy blue tint, and for which scholars had searched in vain in Chinese works. In fact, its original name *ch'ing-pai* ("bluish-white") occurs frequently in texts going back to the Sung Dynasty—although Chinese writers are very inconsistent, and the term may on occasion, in later periods at least, have meant blue and white. Because of its high felspar content, the hard clay could be potted in shapes of wonderful thinness and delicacy. The tradition, which began humbly in the T'ang kilns at Shih-hu-wan some miles to the west of Ching-te-chen, achieved a perfect balance between living form and refinement of decoration in the Sung wares, whose shapes included teapots vases, stem cups and bowls often with foliate rim and dragons, flowers and birds moulded or incised with incredible lightness of touch in the thin paste under the glaze. Already in the Sung Dynasty *ch'ing-pai* wares were being imitated in many kilns in South China, and a good proportion of their output was exported to Southeast Asia and the Indonesian Archipelago, where the presence of *ch'ing-pai* or celadon in an archaeological site often provides the most reliable means of dating it.

9
The Yüan Dynasty

During the twelfth century, China had come to uneasy terms with her northern neighbours and, after her custom, civilised them. But beyond them across the deserts of central Asia there roamed a horde which Fitzgerald called "the most savage and pitiless race known to history"—the Mongols. In 1210 their leader, the great Genghis Khan, attacked the buffer state of Chin, and in 1224 destroyed the capital at Peking. In 1227 he destroyed the Hsi-hsia, leaving only one hundredth of the population alive, a disaster by which the northwest was permanently laid waste. Three years later Genghis died, but still the Mongol hordes advanced, and in 1235 they turned southward into China. For forty years the Chinese armies resisted them, almost unsupported by their own government. But the outcome was inevitable, and when in 1279 the last Sung pretender was destroyed, the Mongols proclaimed their rule over China, calling themselves the Yüan. China was spared the worst of the atrocities which had been visited upon all other victims, for, as a Khitan advisor had pointed out, the Chinese were more useful alive, and taxable, than dead. But the wars and breakup of the administration left Kublai master of a weak and impoverished empire, whose taxpayers had been reduced from a hundred million under the Sung to less than sixty million. Although Kublai Khan (1260–1294) was an able ruler and a deep admirer of Chinese culture, the Mongol administration was ruthless and corrupt. Seven emperors succeeded one another in the forty years following the death of Kublai.

In 1348, Chinese discontent against the harsh rule of the last Khan broke into open rebellion. For twenty years rival bandits and warlords fought over the prostrate country, which the Mongols had long since ceased to control effectively. Finally, in 1368, the Khan fled northwards from Peking, the power of the Mongols was broken forever, and the short, inglorious rule of the Yüan was at an end. In conquering China they had realised the age-long dream of all the nomad tribes, but in less than a century the Chinese drained them of the savage vitality which had made that conquest possible, and threw them back into the desert, an empty husk.

Politically, the Yüan Dynasty may have been brief and inglorious, but it is a period of special interest and importance in the

203 Incense burner, *liu-li* ware. Pottery covered with polychrome lead glaze. Excavated in the remains of the Yüan capital Ta-tu (Peking). Yüan Dynasty.

204 Sketch map of the Yüan Dynasty Ta-tu (broken line) compared with Peking of Ming and Ch'ing (unbroken line).

history of Chinese art—a period when men, uncertain of the present, looked both backward and forward. Their backward looking is shown in the tendency, in painting as much as in the decorative arts, to revive ancient styles, particularly those of the T'ang Dynasty, which had been preserved in a semi-fossilised state in North China under the alien Liao and Chin dynasties. At the same time, the Yüan Dynasty was in several respects revolutionary, for not only were those revived traditions given a new interpretation, but the divorce between the court and the intellectuals brought about by the Mongol occupation instilled in the scholar class the conviction of belonging to a self-contained élite that was not undermined until the twentieth century, and was to have an enormous influence on painting.

In the arts and crafts, the Yüan Dynasty saw many innovations, a reaction against Sung refinement and a new boldness, even garishness, in decoration. Some of these changes reflect the taste of the Mongol conquerors themselves and of the *Se-mu*, the non-Chinese peoples such as Uighurs, Tanguts and Turks whom the Mongols had swept up in their *Drang nach Osten* and established as fief-holders and landlords in occupied China—a new and partly Sinicised aristocracy which the dispossessed Chinese gentry, particularly in the south, looked on with a mixture of envy and contempt.

The Mongols dragooned artisans and craftsmen of all the con-

quered races into their service, organising them in quasi-military units. Although there were central Asians, Persians and even Europeans among them, the dominating influence on the arts was of course Chinese. Yet, Marco Polo's description of Kublai's palace at Khanbalik, or Cambaluc as he called it,[1] and Friar Odoric's account of the Mongol summer palace at Shang-tu (Coleridge's Xanadu), show that while the buildings were mostly Chinese in style, the Mongols displayed their new wealth in the lavish use of gold and brilliant colours, the very antithesis of Sung taste, while they betrayed their nomad origins in the thick mats, furs and carpets that covered the floors, and the skins that draped the walls, of the imperial apartments, giving them the air of some unbelievably sumptuous yurt. The brightly glazed incense burner shown here, which was excavated from a Yüan mansion in Peking in 1964, vividly illustrates the demand of the invaders, and of the Chinese traders who profited by the occupation, for objects that were traditionally Chinese in form but showy, even barbaric, in flavour.

Very little is left above ground of Kublai's Khanbalik, and the city that we see today is essentially the creation of the Ming emperor Yung-lo, who moved the capital back from Nanking to Peking in 1417, and of his Ming and Ch'ing successors. The Ming capital, which came to be called the Tartar City after its occupation by the Manchus in 1644, is actually smaller than that laid out by the Mongols, though the total area was greatly increased again when the Manchus created to the south the Chinese City for the native inhabitants. Peking consists of a city within a city within a city. Surrounded by a wall fifteen miles long, the Tartar City comfortably holds the Imperial City with a perimeter of six and half miles, in the heart of which lies the Purple Forbidden City—the Imperial Palace itself. At the extreme southern end of a north-south axis that stretches for seven and half miles, lie the three-tiered marble Altar of Heaven and the circular Ch'i-nien-tien (Hall of Annual Prayers)—the Temple of Heaven whose blue-tiled roofs are familiar to every visitor to Peking.

Ancient Chou ritual, to which the Ming and Ch'ing rulers rigidly conformed, had prescribed that the Son of Heaven should rule from 'three courts'. Accordingly, the heart of the Forbidden City is dominated by three great halls of state, the San Ta Tien, set one behind the other at the climax of the great axis. The first from the south, and the largest, is the T'ai-ho-tien (Hall of Supreme Harmony) used by the emperor for his grander audiences, raised on a huge platform and approached by marble staircases. Behind it lies the waiting hall, Chung-ho-tien (Hall of Middle Harmony), while beyond is the Pao-ho-tien (Hall of Protecting Harmony), used for state banquets. The private apartments, offices of state, palace workshops and gardens occupy the northern half of this vast enclosure. Not many of the palace buildings we see today are the original structures, however. The T'ai-miao (Grand Ancestral Shrine) is indeed Ming, having been rebuilt in 1464 after a fire; but

ARCHITECTURE

the history of the T'ai-ho-tien is more typical. First built by Yung-lo in 1427, it was largely rebuilt on the same plan in 1645, while a further reconstruction was started in 1669 and not finished till thirty years later. It was again rebuilt in 1765, since when it has been frequently restored and repainted, though so conservative were the Ch'ing architects that it is unlikely that they departed much from the Ming original—which was itself a cautious repetition of the style of the fourteenth century.

Indeed, from Yüan times onwards, Chinese architecture became less and less adventurous. Gone are the daring experiments in quadripartite gables, spiral canopies and dynamic bracketing that give such interest and vitality to Sung architecture. Now each building is a plain rectangle. The eaves have become so heavily

loaded with unnecessary carpentry that the architect has to place an extra colonnade under their outer edge to support the weight, thus making superfluous the elaborate cantilevered system of brackets and *ang*, which now shrinks away to a decorative and meaningless frieze or is masked behind a band of scrollwork suspended from the eaves. The splendour of the Forbidden City lies not in its details, but rather in its rich colour, now wonderfully mellowed by age, the magnificently simple sweep of its roofs, and the stupendous scale of its layout. These buildings were all of timber. A few barrel-vaulted stone or brick temple halls were built in the sixteenth century, but, as before, the use of the vault and dome was largely confined to tombs, a typical example being the tomb of the Wan-li emperor in the Western Hills, the excavation of which, completed in 1958, occupied a team of Chinese archaeologists for two full years.

Like other invaders before them, the Mongols supported the Buddhists as a matter of policy. They were particularly attracted to the esoteric and magical practices of the Tibetan Lamaists, who were encouraged to set up their temples in Peking. The Buddhist architecture and sculpture produced by Chinese craftsmen under their patronage represents no real advance upon that of the Sung, except perhaps in sheer scale and magnificence. The effect of the Mongol invasion on painting was far more profound. There were still Ch'an masters, such as Yen Hui and Yin-t'o-lo, for example, and professional painters who satisfied the conservative trend in courtly taste with works in the manner of Ma Yüan, or who

ART UNDER
THE MONGOLS

206 The Three Great Halls, San Ta Tien, of the Forbidden City, looking south.

191

207 Ch'ien Hsüan (c. 1235–1301), *Wang Hsi-chih Watching Geese*. Detail of a handscroll. Ink and colour on paper.

carried on the tradition of monumental landscape painting that had survived in the north under the patronage of enlightened Chin rulers; but such professional painters are barely mentioned in the literature of Chinese painting, which was written by the scholars themselves, and we know very little about them. The southern gentry, viewed with deep suspicion by the Mongols, deprived of the right to rise in public service, kept themselves alive by teaching, practising medicine or fortunetelling, while some of the better off devoted their enforced leisure to the writing of a new kind of fiction and drama which has permanently enriched Chinese literature. With few exceptions, the great scholar-painters also put themselves beyond the conqueror's reach.

Ch'ien Hsüan (c. 1235–c. 1300), already middle-aged when the Sung Dynasty fell, lived out his life in seclusion, loyal to the last. Two small album paintings, of a squirrel and a sparrow, show him (if indeed they are his) as an exponent of Sung *intimisme*; but in his gentle way he was a revolutionary too. For he was perhaps the first major Chinese painter, apart from the eccentric Mi Fu, deliberately to seek inspiration in the past. His choice of the archaic T'ang style for his charming handscroll of the calligrapher Wang Hsi-chih watching geese, and indeed of the very subject itself, may be seen both as a rejection of the Sung culture that had betrayed itself and as the beginning of the creative reinterpretation of the art of the past that was to become henceforward a major preoccupation of the scholar-painters.

It would be strange indeed if so splendid a court as that of Kublai Khan had had in its service no painters of talent, and in Kao

208 Oracle bone script, *chia-ku-wen*. From Anyang. Shang Dynasty.

209 Seal script, *chuan-shu*. Rubbing from one of the 'Stone Drums'. Chou Dynasty.

K'o-kung, a Sinicised native of Turkestan, and above all in Chao Meng-fu (1254–1322), the emperor found men ideally suited to bridge the gulf that lay between his régime and the Chinese educated class. Chao was a descendant of the first Sung emperor and had already served the old dynasty in a minor post for several years when Kublai appointed him. His first job was the writing of memorials and proclamations, but he soon rose to the rank of cabinet minister, confidential advisor to the emperor and secretary to the Hanlin Academy. Though he often regretted his decision to collaborate (made the more reprehensible by his close family relationship to the Sung royal house), it was men of his kind who civilised the Mongols, and thus indirectly encompassed their eventual downfall. Chao Meng-fu was also a great calligrapher, versed in all the styles from the archaic 'big seal' script, through the clerical (*li*) style and the standard (*k'ai*) style, to the running draft character.

CALLIGRAPHY

I have said little in this book about the eloquent and exacting art of calligraphy, an art whose finer points can only be appreciated with long study and training. "Affection for the written word," wrote Chiang Yee, "is instilled from childhood in the Chinese heart." From the merchant who hoists up his newly written shop sign with ceremony and incense to the poet whose soul takes flight in the brilliant sword dance of the brush, calligraphy is revered above all other arts. Not only is a man's writing a clue to his temperament, his moral worth and his learning, but the uniquely ideographic nature of the Chinese script has charged each individual character with a richness of content and association the full range of which even the most scholarly can scarcely fathom.

Our illustrations show the main stages in the development of the Chinese script from the earliest known writing, the crude pictographs and ideographs scratched on the oracle bones (*chia-ku-wen*) and sunk in the ritual bronzes (*chin-wen*) of the late

210 Clerical script, *li-shu*. Rubbing from a stone slab. Han style. After Driscoll and Toda.

211 Draft script, *ts'ao-shu*. Ch'en Shun (1483–1544), part of the inscription on his *Studies from Life*, 1538. Handscroll. Ink on paper. Ming Dynasty.

212 Regular script, *k'ai-shu*. Emperor Hui-tsung (reigned 1101–1125), part of his *Poem on the Peony*, written in the 'thin gold' (*shou-chin*) style. Handscroll. Ink on paper. Sung Dynasty.

Shang Dynasty. After the fall of the Shang, this script, which got its forms most probably from writing on clay with a stylus, evolved into the monumental 'big seal' (*ta-chuan*) script seen on the long bronze inscriptions of the middle Chou period.

As China expanded and fragmented during the Warring States, a number of regional variants of the *ta-chuan* script inevitably evolved. These were standardised, with everything else, by the Ch'in chief minister Li Ssu in the form called 'small seal' (*hsiao chuan*). This is still used for seal carving today, but the strokes are too even and regular to be easily made with the brush. With the fall of Ch'in, the seal script went out of fashion (except for formal and ritual purposes) and was replaced by the 'clerical script' (*li-shu*), a style which for the first time really conveyed the supple rhythm of the Chinese brush, which was greatly improved during the Han Dynasty.

Some Chinese characters have as many as twenty and more strokes. According to tradition, it was the need for a script that

194

震大明湖時來泉上 蒸華不注波瀾聲 熊東海姑雲霧潤 久恕元氣迴歲旱不 地湧出白玉壺谷靈 濼水發源天下無 趵突泉

213 Running script, *hsing-shu*. Chao Meng-fu (1254–1322), part of his *Pao-t'u Spring Poem*. Handscroll. Ink on paper. Yüan Dynasty.

could be written quickly in the heat of battle that gave birth to the highly cursive 'draft script' (*ts'ao-shu*). In fact, some such abbreviated script must have been in existence for some time for practical and commercial uses, but in the Han it developed into an art form in its own right. Indeed, in the turbulent post-Han period it became, in company with the 'intellectual Taoism' fashionable at the time, something of a cult among the literati. Meantime, the rather formal and angular Han *li-shu* was evolving naturally into the more flowing and harmonious 'regular script' (*k'ai-shu*, or *cheng-shu*) which has, with its variants, remained the standard form, learned by every child, up to the present day.

The great calligrapher Wang Hsi-chih (303–379), an older contemporary of Ku K'ai-chih in Nanking, developed a suave and fluent *k'ai-shu* and a more cursive form derived from it (the *hsing-shu*, "running script"), in contrast to the northern style of the Wei Dynasty, which continued to preserve something of the angular strength of the old Han *li-shu*. Through the Six Dynasties the two traditions, southern and northern, suave and angular, developed side by side. When China was reunited under the Sui and T'ang some great calligraphers, notably Yen Chen-ch'ing, succeeded in reconciling the somewhat archaic power of the northern style with the elegant fluidity of the southern.

By this time the main traditional schools were well established. Beyond them lay the calligraphy of the individualists, Zen adepts, Taoist eccentrics and drunkards, each of whom created his own style of *k'uang* ("crazy") *ts'ao-shu*, in which energy, oddity and illegibility competed for the honours. A gentleman in Chao Meng-fu's position might admire writing of this kind, but he would be very unlikely to practise it himself.

214 Crazy draft script, *k'uang-ts'ao-shu*. Hsü Wei (1521–1593), poem. Handscroll. Ink on paper.

215 Chao Meng-fu (1254–1322), *The Autumn Colours on the Ch'iao and Hua Mountains*. Detail of a handscroll dated equivalent to 1295. Ink and colour on paper. Yüan Dynasty.

CHAO MENG-FU Chao Meng-fu's popular fame rests not only on his calligraphy, however, but also on his almost legendary skill in the art of painting horses, so much so that almost any good example with a respectable claim to antiquity used to be attributed to him. As court painter to the Mongols it would be surprising if his oeuvre had *not* contained a number of pictures of the animal so dear to their hearts. But it is chiefly as a landscape painter that Chao Meng-fu must be remembered. He might, indeed, have said of himself, with Cézanne, "I am the primitive of the way I have discovered." He occupies a pivotal position in the history of Chinese landscape painting, for, living at a

time when the Sung tradition had exhausted itself, or exploded into Zen gestures with the brush, he united a direct, spontaneous expression of feeling with a deep reverence for the antique. Looking back beyond the orthodox Sung styles, he rediscovered the poetry and the brushwork of the long-neglected 'southern' manner of Tung Yüan and Chü-jan. In doing so, he opened the way not only for the next generation of Yüan amateur painters—notably the Four Masters discussed below—but for almost all subsequent scholarly landscape painting up to the present day. In his most famous surviving landscape, painted to evoke for a friend the ancestral homeland that he had never seen, Chao Meng-fu with dry scholarly wit combines references to the quaintly archaic landscape style of the T'ang Dynasty and to the broad, calm vision of Tung Yüan.

The movement of which Chao Meng-fu was the initiator found its fulfillment half a century later in the Four Great Masters of the Yüan Dynasty: Huang Kung-wang, Ni Tsan, Wu Chen and Wang Meng. The oldest was Huang Kung-wang (1269–1354) a detail of whose greatest surviving work, 'Living in the Fu-ch'un Mountains', is reproduced here. Little is known about his career except that for a time he held a minor official post and that he retired to a life of scholarship, teaching, painting and poetry in his native Chekiang. His masterwork was painted slowly, as the mood took him, over a period of three years, being finished in 1350. The treatment is magnificently broad, relaxed and unaffected, with not the least hint of the decorative silhouette, the 'one-corner composition', and other mannerisms of the Hangchow Academy. We feel that this is the painter himself speaking from the depths of his heart. Colophons by the Ming painters Shen Chou and Tung Ch'i-ch'ang both mention Tung Yüan and Chü-jan as having inspired him, but the spontaneity of his touch shows clearly that

THE FOUR
GREAT MASTERS
OF LANDSCAPE PAINTING

216 Huang Kung-wang (1269–1354), *Living in the Fu-ch'un Mountains*. Detail of a handscroll dated equivalent to 1350. Ink on paper. Yüan Dynasty.

217 Ni Tsan (1301–1374), *The Jung-hsi Studio*. Hanging scroll. Ink on paper. Yüan Dynasty.

Huang Kung-wang has caught the spirit of antiquity without becoming its slave.

This noble simplicity of utterance was carried even further by Ni Tsan (1301–1374), a wealthy country gentleman who, to escape ruinous taxation, spent his later years drifting in a houseboat through the lakes and hills of southeastern Kiangsu, putting up at monasteries and staying with friends. The establishment of the Ming Dynasty in 1368 enabled him to return to his old home and

die in peace. To the Ming *wen-jen* he was the ideal type of the untrammelled scholar-painter. If Huang Kung-wang was austere, then what word can we use to describe Ni Tsan? A few bare trees on a rock, a few hills across the water, an empty pavilion; that is all. The forms are spare and simple. The ink is dry and of an even greyness, touched here and there by sparsely applied *ts'un*, set down, very black, with the side of the brush; it was said of Ni Tsan that "he was as economical of ink as if it were gold." No concessions are made to the viewer; no figures, no boats or clouds enliven

218 Wang Meng (1308–1385), *Thatched Halls on Mount T'ai*. Hanging scroll. Ink and colour on paper. Yüan Dynasty.

the scene, and nothing moves. The silence that pervades the picture is that which falls between friends who understand each other perfectly. The innumerable imitations of his style produced by later artists show clearly how much strength is hidden in his apparent weakness, how much skill in his fumbling with the brush, what richness of content in his emptiness.

Of quite a different type was Wang Meng, whose turbulent, congested landscapes seem to embody something of the violence of the times he lived in. He had held office under the Mongols, served as a magistrate after the Ming restoration, and died in prison in 1385. He was a master of a close-knit texture made up of tortuous, writhing lines and a rich variety of ts'un; but though he seems to leave nothing out, his touch is sensitive and his composition clear-cut. He is one of the few Chinese painters—Shih-ch'i is perhaps another—who, though using a brush technique of restless intensity, can achieve a final effect of repose.

A gratifying number of great paintings of the Yüan Dynasty have survived to testify to the remarkable revolution by which these and other gifted men broke free from the conventions of Southern Sung and set Chinese painting upon a new path. Moreover, the divorce which occurred under the Mongols between the court and its patronage on the one hand and the scholar-painters on the other was to remain a feature of the painting of the Ming and Ch'ing dynasties. It goes without saying that the divorce between the culture of the literati and that of the masses was even more complete, to the impoverishment of both. It is with the Yüan painters that the intensely intellectual and literary associations of landscape painting come to the fore. Now it becomes customary for the painter himself to write a poem or inscription on the painting; this may be joined by others written by friends and later admirers, till the picture is almost obliterated under inscriptions and seals which, far from ruining it in Chinese eyes, may greatly enhance its value.[2] From now on, also, painters of the literary school much prefer to paint, like the calligraphers, on paper, which is more absorbent than silk and consequently responds more readily to the touch of the brush.

BAMBOO PAINTING

It is not surprising that the difficult art of bamboo painting should have found special favour in the Yüan Dynasty, for it was a natural subject for the proud and independent wen-jen, who lived out their secluded lives far from the Mongol court. To them, indeed, the bamboo was itself a symbol of the true gentleman, pliant yet strong, who maintains his integrity unsullied no matter how low the adverse winds of circumstance may bend him. The lithe grace of its stalk and the dashing sword point of its leaves offered the perfect subject to his brush; but above all the painting of bamboo in monochrome ink brought the painter closest to that most difficult of arts, calligraphy. In painting bamboo, the form and place of every leaf and stalk must be clearly adumbrated; the awkward juncture cannot be hidden in mist as in landscape painting; the gradations from black ink in the near leaves to pale in the distance must be

precisely judged, the balance of stalks to leaves, of leaves to empty space, exactly struck. Having achieved this the painter must still know how the bamboo grows, and give to his own the springing movement of the living plant. A great bamboo painting is a virtuoso performance of a very high order.

The art had first become fashionable in the Six Dynasties,[3] when it was the custom, except when painting on a very small scale, to outline the stem and leaves in ink and fill them with body colour. This painstaking technique was chiefly handed down by the academicians, though the Sung artist Ts'ui Po and the four-teenth-century master Wang Yüan also used it occasionally. Bam-boo painting seems to have gone somewhat out of fashion during the T'ang Dynasty (Hui-tsung had no T'ang specimens in his collection), but had become widely popular by Northern Sung, when its greatest exponents were Wen T'ung and the poet and calligrapher Su Tung-p'o. In the Yüan Dynasty several of the great literati were accomplished painters of bamboo in monochrome ink, notably Ni Tsan and Chao Meng-fu, although in this most exacting art the latter had a rival in his wife Kuan Tao-sheng, one of China's greatest women painters. Li K'an (c. 1260–1310), who took as his master Wen T'ung, devoted his whole life to bamboo, which he studied both as an amateur botanist and as a painter. His illustrated manual on the bamboo, *Chu-p'u hsiang-lu*, became an essential tool in the hands of every practitioner, as well as providing the starting point for all later writers on the subject. A more natural and spontaneous rendering of the subject than Li K'an ever achieved is

220 Wu Chen (1280–1354), *Bamboo*. Album-leaf dated equivalent to 1350. Ink on paper. Yüan Dynasty.

the little album-leaf by Wu Chen illustrated here, remarkable for its economy of statement and subtle union of the twin arts of painting and calligraphy.

CERAMICS It used to be thought that the decorative arts in China declined, if they did not actually come to a standstill, in the Yüan Dynasty. But now it is realised that this was, on the contrary, a period of innovation and technical experiment. In ceramics, for example, new techniques such as painting in underglaze red or blue, were discovered or imported, and old techniques, such as modelling in relief under the glaze, revived. The northern kilns, except for those at Tz'u-chou and Chün-chou, barely survived the Liao, Chin and Mongol invasions, and now the focus of the ceramic industry shifts permanently to the centre and south. The kilns at Lung-ch'üan and Li-shui in Chekiang continued to produce celadons on a large scale—indeed, production must have increased to keep pace with the demand for exports to the Near East which the *Pax Tartarica* had stimulated. A baluster vase dated 1327 in the Percival David Foundation in London is typical of the more baroque preferences of the period, being elaborately and somewhat tastelessly decorated with floral scrolls moulded in relief under the glaze. More daring was the technique of leaving the central decorative motif on a dish, such as a dragon, unglazed in relief. Sometimes these reliefs were modelled by hand, but the presence in the Percival David Foundation of a celadon dish and a flask bearing identical dragons (the former unglazed and the latter glazed) indicates that moulds were

221 Dish. Porcelain, covered with celadon glaze, leaving the dragon and clouds in biscuit relief. Yüan Dynasty.

222 Vase and stand. *Ch'ing-pai* porcelain with relief and pearl-bead decoration under bluish-white glaze. Yuan Dynasty.

223 Kuanyin. *Ch'ing-pai* porcelain. Excavated in the remains of the Yüan capital, Ta-tu (Peking). Yüan Dynasty.

also used. It is possible that spotted celadon (*tobi-seiji*) may also have been a Yüan innovation. There are signs, however, that by the mid-fourteenth century the quality of Lung-ch'üan wares was beginning to fall off, the probable reason being the competition from the factories at Ching-te-chen in Kiangsi.

During the Sung Dynasty, the finest products of the Ching-te-chen kilns had been white porcelains, chiefly *ch'ing-pai* ware and an imitation of the northern Ting-yao. But by the beginning of the fourteenth century new techniques were already being explored. The *Annals of Fou-liang*, written before 1322, notes that at Ching-te-chen "they have experts at moulding, painting and engraving." Painting we will consider in a moment. Moulding and engraving can be seen in the so-called *shu-fu* ("privy council") wares. It seems likely that the *shu-fu* was the first ware to be made at Ching-te-chen on imperial order. It comprises chiefly bowls and dishes with incised, moulded or slip decoration—generally consisting of flower sprays, lotus leaves, or phoenixes amid clouds—under a bluish-white (*ch'ing-pai*) glaze. Sometimes the characters "*shu-fu*" are included, or other auspicious words such as *fu* ("happiness"), *shou* ("long life") or *lu* ("emolument"). Closely related to these are the stem cups, ewers, bottles and jars whose decoration consists of applied reliefs often in zones separated by pearl beading, and the figurines, chiefly the *bodhisattvas*, which

224 Wine jar. White porcelain decorated with openwork panels and painting in underglaze red and blue. Excavated at Pao-ting, Shensi. Yüan Dynasty.

were used in domestic shrines. Several exquisite examples, including the Kuanyin illustrated here, have been excavated from Yüan-period sites in Peking.

UNDERGLAZE RED AND BLUE

Another of the innovations at Ching-te-chen which may have occurred before the middle of the fourteenth century was painting in copper red under the glaze. It is not known where this technique was invented. It is certainly not Near Eastern and may possibly, as some Japanese scholars have suggested, have originated in Korea in the Koryŏ period at the end of the twelfth or beginning of the thirteenth century. Some of the most attractive early Chinese examples are the bottles with graceful pear-shaped body and flaring lip decorated with sketchily drawn flower sprays or clouds. During the Ming Dynasty the designs become more elaborate, but the copper red had a dull colour and a tendency to run, and was consequently abandoned in the fifteenth century in favour of the more manageable underglaze cobalt blue. For a while, attempts were made to combine not only underglaze copper red and cobalt blue but also beading, carving and openwork. The wine jar illustrated here, excavated at Pao-ting in Shensi, is a splended example of the extravagant blending of techniques that is so typical of Yüan taste.

In the whole history of ceramics, probably no single ware has been so much admired as Chinese blue and white. It has been imitated in Japan, in Indochina and Persia, and it was the inspiration of the pottery of Delft and other European factories; its devotees have ranged from the headhunters of Borneo to Whistler and Oscar Wilde, and its enchantment is still at work. There is much debate as to when blue and white was first made in China. Underglaze painting had been practised in the T'ang Dynasty, and

225 Pair of vases dedicated to a temple in Kiangsi in 1351. Porcelain decorated in underglaze blue. Yüan Dynasty.

more successfully in the Tz'u-chou and Ch'i-chou wares of the Sung. The earliest securely dated pieces of Chinese blue and white now known are the famous vases in the Percival David Foundation, dedicated to a temple in Kiangsi in 1351, which show a mature handling of this difficult technique. The earliest textual reference—if indeed the term *ch'ing-hua* ("blue-green flower") alone means blue and white—occurs in the *Ko-ku yao-lun* of 1387–1388, which dismisses it, along with five-colour wares, as 'very vulgar'. The general opinion is that the technique was developed at Ching-te-chen in the second quarter of the fourteenth century. It may not have originated there, however. Painting in underglaze blue was already practised in the Near East in the ninth and tenth centuries. Among finds in the remains of the first Mongol capital at Karakoram were shards of an apparently locally made coarse blue and white which was very probably decorated by captured Chinese potters in the service of the Khan. When about 1263 Kublai moved his capital down to Peking and Karakoram began rapidly to decline, Chinese craftsmen flocked back to their native land, and some of them may have brought with them the technique of painting in cobalt under the glaze, which they could have learned from Near Eastern potters during their desert captivity.

The pieces that can with confidence be dated in the Yüan period include large, boldly decorated dishes, pear-shaped vases, ewers and flasks in Near Eastern shapes, bowls and stem cups. Decoration includes both Near Eastern ogival panels and Chinese dragons, lotus and chrysanthemum scrolls, and narrower bands of petals some of which had already appeared in the Ch'i-chou wares of the Southern Sung. By the time the David vases were made, the potters and painters at Ching-te-chen had fully mastered their art, and the vases and dishes of the next hundred years are unequalled for their splendour of shape and beauty of decoration. The drawing is free and bold, yet delicate, the blue varying from almost pure ultramarine to a dull, greyish colour, with a tendency to clot and turn black where it runs thickest—a fault which was eradicated by the sixteenth century and cleverly imitated in the eighteenth.

205

10
The Ming Dynasty

The ferment into which central China had sunk as the Mongols lost control of the country was finally resolved when in 1368 Chu Yüan-chang, in turn shepherd, monk, bandit, warlord and emperor, sent his armies north to occupy Peking, from which the last Yüan ruler had fled. He proclaimed himself emperor of the Ming Dynasty, set up his capital in Nanking, and within four years had not only recovered all the territories held by the T'ang at the height of their power, but had extended his control over the Trans-Baikal region and Manchuria as well. He built at Nanking a capital with a city wall twenty miles in circumference, the longest in the world, and under him and his successor central and South China enjoyed a new importance and prosperity. But in 1417 the third emperor, the usurper Yung-lo,[1] moved his capital back to Peking whence he had received his chief support in his struggle for power, and it was he who rebuilt it on the scale we see today. But Peking, on two counts, was a bad site: it was situated too far to the north of China's new economic centre of gravity, the Yangtse Valley; it was also highly vulnerable. For China's northern enemies—now the Manchus—had only to cross the Great Wall to be at the gates of the city. The troubles that beset the Ming Dynasty throughout its subsequent history were largely due on the one hand to the remoteness of the capital from the parts of China that mattered most—the centre and south—and on the other hand to the constant tension along the Great Wall which lay only forty miles from Peking. Yung-lo was aggressive and secured the frontier, but his successors were weak and corrupt, the victims of eunuchs at court and rebellions in the provinces, and before long the northern defences were left unguarded.

We have already drawn a parallel between the Warring States and classical Greece on the one hand and Han China and ancient Rome on the other. It is said that history never repeats itself, but the similar relationship of Ming China to Sung is too close to be passed over. For the mixture of power and corruption, grandeur and lack of imagination that characterised the Roman Empire is equally marked in the Ming Dynasty, which took as its model not the weak and dreamy Sung, whom they despised, but the splendour, the vigour—and, be it said, the occasional vulgarity—of T'ang. In the

226 The Great Wall at Pa-ta-ling.
Chiefly Ming period.

early fifteenth century Ming China was immensely powerful. Her navies roamed the southern seas under the remarkable admiral Cheng Ho, a eunuch in high favour with the emperor. But he was, characteristically, not bent on conquest: his five expeditions between 1405 and 1433 were carried out for the purpose of showing the flag, making alliances and opening up trade routes, and incidentally collecting curiosities for the entertainment of the court. China had no other interest in the outside world. Before the end of the century, however, Vasco da Gama had rounded the Cape of Good Hope; by 1509 the Portuguese were in Malacca, by 1516 in Canton, and China was finally forced to take account of the existence of the Western barbarians by reason of their aggressive conduct around her own shores.

The splendour of the Ming court concealed a creeping paralysis. Officials, selected by civil service examinations which centred round the stultifying complexities of the 'eight-legged essay', became increasingly conservative and conventional in outlook. The energies

227 The Liu-yüan Garden in Soochow.

of savants at court were devoted less to original scholarship than to the preparation of such vast works as the *Yung-lo ta-tien*, an encyclopaedia in 11,095 volumes compiled between 1403 and 1407. The Sung emperors had been men of taste and education, able to inspire the best in their scholars and painters; the Ming emperors were for the most part ruffians, usurpers, or weak victims of court intrigue. As a result, the palace tradition in painting petered out in a frozen academicism, and for significant developments we must look not to the court, but to the scholars, collectors and amateurs, many of them men of private means, who carried on the tradition that had been established by the independent literati of the Yüan Dynasty. If the history of later Chinese painting is to be told in the lives and work of the scholar-gentry—and there are many in China today who would dispute this—then we must focus our attention from now on almost exclusively on the corner of Southeast China that embraces southern Kiangsu and northern Chekiang, a region rich in agriculture, silk, and thriving cities where most of the material and cultural wealth was now created and enjoyed. Here, chiefly in Soochow, the landed gentry of the fifteenth century cultivated their

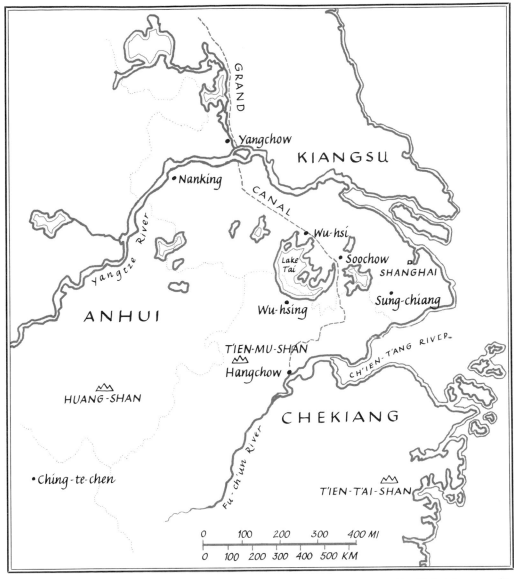

MAP 12 Artistic centres of Southeast China.

estates, digging pools and heaping up artificial hills to create those famous gardens in which scholars, poets and painters could enjoy the fruits of the good life. Here too were concentrated the great private collections, those, for example, of Hsiang Mo-lin (1525–1590) and of Liang Ch'ing-piao (1620–1691) whose seal on a painting, if accepted as genuine, was often all the collector required to attest to its authenticity. It was these and other private collectors in the southeast, rather than the Ming emperors, who preserved the remaining masterpieces of Sung and Yüan, some of which were to find their way back into the imperial collection in the eighteenth century.

The good life meant leisure, not only for the practice of the arts but also for the pleasures of philosophy. There were many schools

active in the Ming, most of which were Neo-Confucian with a colouring of Buddhist and Taoist ideas. The Northern Sung Neo-Confucianists had stressed the importance, in self-cultivation, of the 'investigation of things', which included not only the mind, and the underlying principles of things, but phenomena and objects in themselves. By the Ming, however, study of the external world had largely given way to study of such questions as the relationship between 'mind' and 'principle', and between knowledge and action. For a rigorous analysis of things, Ming thinkers substituted a tendency to generalise about them. The painting of the Ming scholars, like their thinking, likewise tended to be more intuitive and generalised, as if their predecessors had learned all they needed from the study of the natural world, and now they had only to 'borrow', as Su Tung-p'o had put it, mountains and water, rocks and trees, as vehicles for the expression of thought and feeling.

Ming painting consequently does both less and more than that of the Sung: less in that it tells us so little about nature as we see it—compare, for example, the landscapes of Shen Chou and Wen Cheng-ming in this chapter with those of Fan K'uan and Chang Tse-tuan—and more in the sense that the painting is now made to carry a much heavier burden of poetic and philosophical content; or, to put it another way, the painter is saying things which cannot be fully expressed in terms of the conventional language of land-scape. It was to help carry that burden, to extend, as the Chinese put it, the idea beyond the pictorial image itself, that the painter's inscription becomes longer and more richly poetic or philosophical in tone. Thus did the art of painting at its upper levels become more and more interwoven with the ideals and attitudes of the élite, and more and more remote from the experience of the rest of society.

COLOUR PRINTING

This was a great age of art scholarship. Not only the connoisseurs and collectors but the painters themselves were students of the tradition, often deriving inspiration less from nature than from the great works of the old masters which they studied and copied as an essential part of their artistic activity.

The encyclopaedic knowledge of the styles of the old masters which amateur painters begin to display at about this time was aided by the development of colour printing. The earliest colour printing known in China—indeed, in the world—is a two-colour frontispiece to a Buddhist *sūtra* scroll, dated 1346. Under the Ming, erotic books were illustrated in line blocks using up to five colours. One of the first books to include full-colour printing was the *Ch'eng-shih mo-yüan* (*Mr. Ch'eng's Miscellany*), published in 1606, for which a few of the monochrome illustrations were copied from prints given to the author by the great Jesuit missionary Matteo Ricci. The art of colour printing reached its peak in the rare group of anonymous seventeenth-century prints known as the 'Kaempfer Series', after an early collector of them, and in the *Shih-chu-chai shu-hua p'u* (*Treatise on the Paintings and Writings of the Ten Bamboo Studio*), published in 1633. Thereafter, handbooks on the art of

不須更佩

宜男草

只合庭前

搖石榴

亮苑氏

painting as a pastime were to proliferate, the most famous being the *Chieh-tzu-yüan hua-chüan* (*Painting Manual of the Mustard Seed Garden*), first published in five parts in 1679, later expanded, and still used as a technical primer by Chinese students and amateurs today.

In the late-seventeenth century Chinese colour prints reached Japan, stimulating the growth of the art, although full-colour printing was not perfected in Japan till the middle of the eighteenth century. But, while in Japan the colour print developed as a vital art form in its own right, of which the masters recognised and exploited the very limitations of the medium, in China it was, like so much else, the servant of painting, and was always at its best when it most nearly gave the effect of ink and watercolour. After a sad decline in the nineteenth century, the art was revived in the 1920s, and the Jung-pao-chai studio in Peking has become famous both for its decorated letter papers and for its faithful replicas of paintings printed with up to two hundred individual blocks.

MING COURTLY AND PROFESSIONAL PAINTING

At the Ming court there was no personality of the stature of Chao Meng-fu to mediate between the academicians and the literati, who kept their distance and made no attempt to influence court art for the better. The Ming emperors, following the T'ang model, made the Bureau of Painting a subdivision of the Hanlin Academy, but it was no longer the centre of culture and art that it had been in former

230 Lü Chi (late fifteenth to early sixteenth century), *Pair of Wild Geese on a Snowy Bank*. Hanging scroll. Ink and colour on silk. Ming Dynasty.

231 Shih-jui (mid-fifteenth century), *Landscape in the Blue and Green Style*. Detail of a handscroll. Ink and colour on silk. Ming Dynasty.

times. It was set up in the Jen-chih Palace within the Imperial City, and a special office under the Directorate of Palace Eunuchs was established to control it. Painters were honoured with high military titles (to distinguish them from civil officials!) and treated with great favour. This favour, however, depended upon absolute obedience to a rigid code of rules and regulations. They lived, moreover, in terror of their lives. Under Hung-wu, four court painters, including Chou Wei and Chao Yüan, were executed for having incurred that savage monarch's displeasure, and it is astonishing that any good work was produced at all. By the time of the Hsüan-te emperor (Hsüan-tsung, 1426–1435), who was a painter himself, the lot of the senior court artists had much improved, and they were now given the time-honoured rank of *tai-chao*, yet Tai Chin could be dismissed from the emperor's service because he had allegedly painted the garment of a fisherman red, the colour reserved for officials at imperial audiences.

Among the most talented of the court painters was Pien Wen-chin (c. 1400–1440), who specialised in painting birds and flowers in the careful, decorative, outline-filled-with-colour style of the Five Dynasties master Huang Ch'üan. In his day he was considered one of the three greatest artists living; and, indeed, his works have a delicacy and perfection of drawing and colour which link him rather to Hui-tsung than to any of the host of decorators who turned out paintings by the hundred to adorn the innumerable rooms of the palace. Dominant among these was the late-fifteenth-century painter Lü Chi, whose magnificently decorative compositions, rich in colour, definite and precise in form, conservative in style, were exactly suited to the taste of his imperial patrons. In landscape, the models for the academicians were Ma Yüan and Hsia Kuei, partly because they too had been academicians, partly because the basis of their work, like that of the flower painters, was not self-expression but technique, and technique could be learned. Ni Tuan, for example, modelled himself on Ma Yüan, Chou Wen-ching on both

Ma Yüan and Hsia Kuei, Li Tsai—who is said to have impressed the great Japanese landscape painter Sesshū—on Ma Yüan and Kuo Hsi, while Shih-jui, in a beautiful handscroll in the Cleveland Museum of Art, skillfully combined the monumental manner of the Northern Sung with the rich mineral-blue-and-green colouring of a still older tradition. In most of their works, however, the element of mystery in the Sung romantics has hardened into a brilliant eclecticism, its poetry into prose.

Tai Chin (1388–1452), a highly skilled landscapist at the Ming court, was a native of Hangchow in Chekiang, where the styles of the Southern Sung academy still lingered on in the fifteenth century. After his dismissal and return to Hangchow, his influence in the area became so wide as to give the name of his province to a very loosely connected group of professional landscape painters. The Che School, as it was called, embodied the forms and conventions of the Ma-Hsia tradition but treated them with a quite unacademic looseness and freedom, as is shown for instance in the detail from Tai Chin's handscroll, 'Fishermen', in the Freer Gallery. Other outstanding artists of the Che School were Wu Wei and Chang Lu, both of whom specialised in figures in a landscape setting. At the very end of the dynasty, the Che School enjoyed a brief final flowering in the elegant and eclectic art of Lan Ying (1578–1660).

During the prosperous middle years of the Ming Dynasty, the Wu district was the artistic capital of China and Shen Chou (1427–1509) its greatest ornament, and so regarded as the founder of the Wu School, although he was only the chief of a long line of landscape painters in Wu that we could trace back to Chang Tsao in the T'ang Dynasty. Shen Chou never took office, living in comfortable retirement, a benevolent landlord and member of a circle of scholars and collectors. Under his scholarly teacher Liu Chüeh, he early mastered a wide range of styles from those of the Southern Sung academicians to those of the Yüan recluses. His well-known landscapes in the manner of Ni Tsan are extremely revealing of the change that was coming over the literary man's art during the Ming

PAINTING OF THE LITERATI: THE WU SCHOOL

213

載鶴推橋琴湖
上歸白雲紅葉
互交飛儂家
正在山深處竹
裡書聲半榻
庵 沈周

234 Shen Chou, *Returning Home from the Land of the Immortals*. Album-leaf mounted as a handscroll. Ink and colour on paper. Ming Dynasty.

Dynasty; for while Ni Tsan is almost forbiddingly plain and austere, Shen Chou is something of an extrovert who cannot help infusing a human warmth into his paintings. As he said of himself, "Ni Tsan is simple; I am complex," and whenever he painted in the manner of that difficult master his teacher would shout at him "Overdone! Overdone!"

For Shen Chou was no mere copyist. He distilled a style that is uniquely his own. Whether in long panoramic landscapes, tall mountain scrolls or small album paintings, his brushwork, seemingly so casual, is in fact firm and confident, his detail crystal clear yet never obtrusive, his figures—like those of Canaletto—reduced to a kind of shorthand yet full of character, his composition open and informal yet perfectly integrated; and when he used colour he did so with an exquisite freshness and restraint. It is not surprising that he became so popular, not only with the literati of his own time but also with modern connoisseurs. His debt to Huang Kung-wang is subtly evoked both in the style of the album-leaf which I have illustrated and in the subject, a self-portrait, *Returning Home from the Land of the Immortals*, with, as his companion, a crane who might be the spirit of crazy old Huang himself. Above it Shen Chou writes:

> With crane and lute aboard, I am homeward bound across the lake;
> White clouds and red leaves are flying together.
> My home lies in the very depths of the mountains,
> Among the bamboo, the sound of reading, a tiny couch and a humble
> gate.[2]

Such album-leaves are full of a natural charm, and it is only when we compare Shen Chou with Huang Kung-wang or Wu Chen that

235 Wen Cheng-ming (1470–1559), *Cypress and Rock*. Handscroll dated equivalent to 1550. Ink on paper. Ming Dynasty.

we realise that something of their grandeur and breadth of vision is lost. But it was Shen Chou who transformed their lofty style into a language which other, less gifted, painters could draw upon.

As Shen Chou dominated the Wu district in the fifteenth century, so did his follower Wen Cheng-ming (1470–1559) in the sixteenth. Ten times Wen Cheng-ming sat for the civil service examinations, and ten times he failed; but he was called to the capital where he spent a few unhappy years as an official before returning in 1527 to Soochow, to devote the rest of his life to art and scholarship. There he systematically collected and studied the works of the old masters, not only the Yüan literati but such classical and academic figures as Li Ch'eng and Chao Po-chü. His studio became an informal academy through which he passed on his high standards and encyclopaedic knowledge of the history and technique of painting to his many pupils, who included not only his son Wen Chia and his nephew Wen Po-jen, but the flower painter Ch'en Shun (Ch'en Tao-fu, 1483–1544) and the fastidious landscapist Lu Chih (1496–1576). Although much of his own work is refined and sensitive, in his last years Wen Cheng-ming painted a series of remarkable scrolls of old juniper trees in pure monochrome ink which in their rugged, twisted forms seem to symbolise the noble spirit of the old scholar painter himself.

Two painters active in the first half of the fifteenth century cannot be classified as belonging either to the Che or to the Wu School. T'ang Yin (1479–1523) ruined a promising career when he became involved in a scandal over the civil service examinations; he could thus no longer be considered a gentleman, and spent the rest of his life between the brothels and wine shops of Soochow on the one hand and the seclusion of a Buddhist temple on the other, painting for a living. He was a pupil of Chou Ch'en, but his true teachers were Li T'ang, Liu Sung-nien, Ma Yüan and the great Yüan masters. He was also a friend of Shen Chou and Wen Cheng-ming,

T'ANG YIN AND CH'IU YING

215

236 T'ang Yin (1479–1523),
*Gentleman Playing the Lute in a
Landscape*. Detail of a handscroll. Ink
and colour on paper. Ming Dynasty.

and because of this is often classed with the Wu School. But his towering mountains painted in monochome ink on silk are a re-creation of the forms and conventions of the Sung landscapists, though with a hint of mannerism and exaggeration. 'Gentleman Playing the Lute in a Landscape' (Palace Museum, Taipei) is a good example of his work at its most refined—scholarly in content, yet highly professional in technique. It is these conflicting qualities in his style and social position that make him so hard to place and have caused a Japanese scholar to label him 'neo-academic'.

Into the same class falls Ch'iu Ying (c. 1494–c. 1552), a man born also in Wu-hsien, but of lowly origins, who was neither court painter nor scholar, but a humble professional, idealising in his pictures the leisurely life of the gentry whose equal he could never be, and happiest if one of the great literati would condescend to write a eulogy on one of his paintings. He is also famous for his long handscrolls on silk depicting with exquisite detail and delicate colour such popular themes as the 'Lute Song', life at the court of Ming Huang, or the multifarious activities of the ladies of the palace. As a landscapist he was the last great exponent of the green and blue style, though he worked also in the ink-washes of the Wu School. His delightful pictures are widely appreciated both in China and in the West, and next to Wang Hui he is probably the most-forged painter in the history of Chinese art.

TUNG CH'I-CH'ANG AND THE NORTHERN AND SOUTHERN SCHOOLS

In the development of the literary school no man played a more significant part than the scholar painter Tung Ch'i-ch'ang (1555–1636), who rose to high office under Wan-li. For not only did he embody, in his paintings, the aesthetic ideals of his class, but he also gave them theoretical formulation through his critical writings. Tung Ch'i-ch'ang was himself a noted calligrapher and a painter of landscapes in monochrome ink, but though he worked

freely in the manner of the great masters of the past he was not content merely to paraphrase. His creative reinterpretations of earlier styles are animated by a passion for pure form, an expressive distortion, which few of his followers understood. They preferred to take his theories more literally, to the detriment of scholarly painting during the ensuing three centuries.

For it is as a critic that Tung Ch'i-ch'ang is most famous. It was he, borrowing an idea first put forward by the poet-painter Tu Ch'iung in the fifteenth century, who formulated the theory of the Northern and Southern schools for the express purpose of demonstrating the superiority of the *wen-jen* tradition above all others. It was primarily through landscape painting, he maintained, that the scholar and gentleman expressed his understanding of the working of the moral law in nature, and hence his own moral worth. The *wen-jen*, indeed, was the only kind of man who *could* do this successfully, for only he was free from both the control of the academy on the one hand and the necessity to make a living on the other; moreover being a scholar his wide reading in poetry and the classics gave him an understanding of the nature of things combined with an epicurean nobility of taste which the lower orders of professional painters could never hope to acquire. In the spontaneous play of ink and brush, in his freedom to select, omit, suggest, the *wen-jen* had at his command a language capable of conveying the loftiest and subtlest concepts.

The tradition of the independent scholar painter Tung Ch'i-ch'ang called the 'Southern School', because he saw in it an analogy to the southern school of Ch'an Buddhism in the T'ang Dynasty which had held that enlightenment came of itself, spontaneously and suddenly, as opposed to the northern or gradual school which had maintained that it could only be attained by degrees, after a lifetime of preparation and training. To Tung Ch'i-ch'ang, all the

237 Ch'iu Ying (c. 1494–1552+), *Saying Farewell at Hsün-yang*. Detail of a handscroll. Ink and colour on paper. Ming Dynasty.

238 Tung Ch'i-ch'ang (1555–1636),
Dwelling in the Ch'ing-pien Mountains.
Hanging scroll. Ink and colour on
paper. Ming Dynasty.

great gentleman-painters were members of the Southern School, beginning in the T'ang Dynasty with his hero Wang Wei—for a genuine work from whose hand he spent a lifetime in searching—and passing down through the great Northern Sung masters Tung Yüan, Chü-jan, Li Ch'eng and Fan K'uan, via Mi Fu (another ideal 'Southern' type) to the four great masters of Yüan, ending in his own time with Shen Chou and Wen Cheng-ming. To the Northern School he relegated all academic and court painters, beginning with Li Ssu-hsün and his followers in the green-and-blue style, including among them Li T'ang and Liu Sung-nien, Ma Yüan and Hsia Kuei. He had some difficulty over Chao Meng-fu. As a scholar, calligrapher and landscapist Tung admired him greatly, but he could never bring himself to include Chao among the Southern painters because he had compromised himself in the eyes of the literati by taking office under the Mongols.

This arbitrary scheme has dominated, and bedevilled, Chinese art criticism for three centuries, while its obvious inconsistencies have caused endless confusion. We may discount Tung Ch'i-ch'ang's prejudices and refuse to accept his classification in individual cases, but his division into Northern and Southern schools does in fact represent a just division between two kinds of painting—the one in its purest manifestations academic, eclectic, precise and decorative; the other free, calligraphic, personal, subjective. At the same time, the doctrine of the two schools is a reflection of the feelings of the scholars themselves at this time. The corrupt Ming Dynasty was approaching its downfall, and men of integrity were once again withdrawing from public service into obscurity. Amateur painters found comfort and reassurance in the belief that they were the élite, upholding the Confucian virtues, while painters and scholars in the service of the emperor were prostituting their talents. However vague or inaccurate it might be as an interpretation of the history of Chinese painting, the doctrine is important as a symptom of the predicament of the late Ming literati—a predicament that is also reflected in their own painting.

The court by now was hopelessly corrupt and no longer the focus of loyalty and enlightened patronage. Intellectuals withdrew in despair, a few courageous spirits forming semi-secret protest groups such as the Tung-lin Society, with which Tung Ch'i-ch'ang was loosely connected. Yet the decay of the dynasty produced no real closing of the ranks, and the literati were often divided and isolated. Soochow, Sung-chiang and Nanking were only the chief among many centres of artistic activity, and it has been said that there were now as many schools as there were painters.

But, to compensate, the breakdown also loosened the traditional restraints upon originality. While many artists still followed in the footsteps of Shen Chou and Wen Cheng-ming, others broke free, even if their new direction was only into a highly individualistic, if not willfully perverse, reinterpretation of some aspect of the tradition itself. In Soochow, for example, Shao Mi and Chao Tso turned back to the Northern Sung for inspiration, Ch'en Hung-shou gave

239 Shao Mi (active 1620–1640). Leaf from an album of landscapes dated equivalent to 1638. Ink and colour on paper. Ming Dynasty.

240 Ch'en Hung-shou (1599–1652), *Portrait of the Poet Po Chü-i*, in the manner of Li Lung-mien. Detail of a handscroll dated equivalent to 1649. Ink and colour on paper. Ch'ing Dynasty.

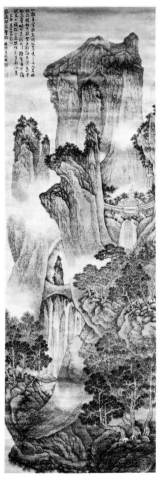

an ironic twist to the ancient figure-painting style that derived from Ku K'ai-chih, Wu Pin produced fantastic distortions of the classic styles of Li Ch'eng and Fan K'uan whose realism was for a time influenced by European engravings brought by the first Jesuit missionaries. Some artists defended the Ma-Hsia School, and one even went so far as to denigrate the immaculate Ni Tsan. In such a chaotic and crumbling world, in which a painter's search for a style, an attitude, a place in the tradition was at the same time a search for his own identity, it is easy to see how a dominating personality such as Tung Ch'i-ch'ang could take command of all but the most independent painters and sweep them along behind him down the path to a new orthodoxy.

To many people 'Ming' means not painting—for it is only recently that Ming painting has come to be appreciated outside China—but the decorative arts. Before we discuss them, however, we should say a word about sculpture. As, during the Sung and Yüan dynasties, Buddhism gradually loosened its hold over the mind and heart of China, so did Buddhist sculpture decline. Under the Ming revival, what it lacks in spiritual content it makes up for in vigour—a vigour shown, for example, in the colossal guardian figures of officials, warriors and animals which line the 'spirit way' leading to the

241 Wu Pin (c. 1568–1626), *Fantastic Landscape*. Hanging scroll dated equivalent to 1616. Ink and colour on paper. Ming Dynasty.

SCULPTURE

242 Yen-lo-wang (Yama). Pottery decorated with coloured glazes, *liu-li* ware. Inscribed 'Made by Master Ma', and dated equivalent to 1524. Ming Dynasty.

TEXTILES

243 *Magician Changing a Bamboo Walking-Stick into a Dragon. K'o-ssu* silk tapestry. Ming Dynasty.

tombs of the Ming emperors outside Nanking and Peking. The casting of large figures in iron had developed during the Sung Dynasty as a substitute for the more precious bronze. The finest of these figures have a simplicity and compactness of modelling that makes them extremely impressive. Far greater freedom of movement was possible in ceramic sculpture, which now lent an air of gaiety and splendour to the roof ridges of palaces and temples, already glittering with yellow, blue and green tiles. The boldly conceived figure of a man in green-and-brown-glazed terracotta (*liu-li*) inscribed 'Made by Master Ma', and dated equivalent to 1524, is a splendid example of the confident manner in which Ming craftsmen revived and transformed the style of the T'ang Dynasty.

The Ming love of colour and of all that made for luxurious living was satisfied by the cloisonné enamel, the lacquer and the richly woven textiles which were worn both by officials and by the wealthier members of the middle class. Figured silks, embroideries and brocades have a long history in China: examples of all types going back to the T'ang Dynasty and earlier have been found in the dry desert sand of Chinese Turkestan, and are more perfectly preserved in the Shōsōsin Repository at Nara. Many T'ang motifs were still in use in the Sung Dynasty, to be revived once again in the Ming and continued, with some modifications, in the Ch'ing. The great achievement of the Sung weavers had been the perfecting of *k'o-ssu*, a form of tapestry woven from silk, using a needle as a shuttle. This technique had been invented in central Asia, possibly by the Sogdians, improved by the Uighurs, and finally passed on to the Chinese early in the eleventh century. The term *k'o-ssu*, translatable as 'cut silk', is descriptive of the vertical gaps between adjacent areas of colour visible when it is held up to the light, but other variants suggest that *k'o-ssu* is probably a transliteration of the Persian *gazz* or Arabic *khazz* referring to silk and silk products. After the debacle of 1125–27, the art was taken to the Southern Sung court at Hangchow where a historian records that *k'o-ssu* was used for mounting paintings and binding books in the Imperial Collection. It was also used for robes, decorative panels and, most astonishingly, for translating paintings and calligraphy into the weaver's art. We can form some idea of its microscopic fineness when we realise that whereas the finest Gobelins tapestry has 8–11 warp threads to the centimetre, Sung *k'o-ssu* has up to 24, and 116 weft threads per centimetre of warp as against the 22 of Gobelins. In the Yüan Dynasty, when trade across central Asia was probably easier than at any other period in history, panels of *k'o-ssu* were exported at enormous expense to Europe, where they were incorporated into the vestments of the cathedrals in Danzig, Vienna, Perugia and Regensburg, while splendid examples have also been found in Egypt. Hung-wu, the spartan and ferocious first emperor of the Ming, forbade its manufacture, but it was revived early in the fifteenth century under Hsüan-te.

Little Sung *k'o-ssu* has survived until today, but we may get an impression of the splendour of the weaver's art from the court robes of the Ming Dynasty. These include both the ceremonial robes made for the imperial sacrifices and decorated with the 'twelve emblems'—sacred symbols which go back to hallowed antiquity and are described in the early Chou *Classic of History* (*Shu-ching*)—and the so-called 'dragon robes', a term used to describe a long semi-formal robe worn by courtiers and officials from Ming times onwards, embroidered with a number of motifs of which the chief, and most conspicuous, is the dragon. If we are to judge from surviving paintings, dragons with three claws had been a principal motif on T'ang robes and became an established institution under the Yüan. Strict sumptuary laws introduced in the fourteenth century permitted a robe with four-clawed dragons (*mang-p'ao*) to lesser nobles and officials, while restricting to the emperor and royal princes dragons with five claws. The Ming emperors wore robes decorated with both the dragons and the twelve symbols. Dragon robes became extremely popular under the Ch'ing, when the regulations of 1759 confined the twelve symbols, at least in theory, to the emperor's personal use.

244 Imperial dragon robe. Woven silk tapestry. Ch'ing Dynasty.

The Ming and Ch'ing official robes were further embellished with 'Mandarin squares', badges of rank which had already been used decoratively in the Yüan Dynasty and were first prescribed for official dress in the sumptuary laws of 1391. The Ming squares were broad and made in one piece generally from *k'o-ssu* tapestry. The Manchus, who were content with embroidery, used them in pairs back and front, splitting the front panel down the centre to fit the open riding jacket. Official regulations prescribed bird motifs (symbolising literary elegance) for civilian officials, animals (suggesting fierce courage) for the military; the emblems were precisely graded from the fabulous monster *ch'i-lin* (for dukes, marquesses and imperial sons-in-law), through white crane or golden pheasant (for civil officials of the first and second ranks), down to the silver pheasant for the fifth to ninth. Military ranks had a corresponding animal scale. Though these woven and embroidered robes vanished from the official world with the passing of the Manchus in 1912, they may still be seen today lending their glitter and pageantry to the traditional theatre.

245 Cup stand. Carved lacquer. Yung-lo (1403–1424) reign mark and Ch'ien-lung inscription dated equivalent to 1781. Ming Dynasty

Lacquer, as we have seen, was already a highly developed craft in the Warring States and Han. At that time, decoration was restricted to painting on a ground of solid colour or incising through one colour to expose another beneath it. In the T'ang Dynasty there started the practice of applying lacquer in many layers—to mirror backs, for example—and then before it had completely hardened, inlaying it with mother-of-pearl. Sung taste preferred simple unadorned shapes such as foliated bowls in plain dark red, brown or black. By the Yüan, lacquer was again being inlaid or engraved, while a new technique known by its Japanese name *guri* involved cutting scroll

LACQUER

246 Rectangular dish. Red, greenish-black, and yellow lacquer carved with a design of dragons amid clouds and waves. Ming Dynasty, Wan-li period (1573–1620).

patterns in V-shaped channels that revealed the multiple layers of contrasting colour.

The typical Chinese lacquer of the Ming period was carved in red with rich floral or pictorial designs (*t'i-hung*); these were either modelled in full relief or the background was cut away leaving the design in flat relief as on many Han engraved stones. By the Chia-ching period, two styles, one sharp edged, the other more rounded, can be identified. The cup stand illustrated here is a richly carved example of Ming *t'i-hung*; it was evidently a palace piece through two dynasties, for in addition to the reign mark of Yung-lo (1403–1424) it carries round the inside an inscription by Ch'ien-lung, dated 1781. The polychrome tray is typical of the more elaborate and intricate taste of the seventeenth century. The names of several master craftsmen of the early Ming period are recorded. Nevertheless, lacquer is easy to imitate, and many of the signed pieces of the fifteenth century, and those bearing Ming reign titles (*nien-hao*), may well be later Chinese or Japanese forgeries. Indeed, by the fifteenth century the Japanese had become so expert in lacquerwork that Chinese craftsmen were journeying to Japan to learn the art.

CLOISONNÉ ENAMEL The earliest known reference to *cloisonné* enamel in China occurs in the *Ko-ku yao-lun*, a collectors' and connoisseurs' miscellany first published in 1388, where it is referred to as Ta-shih ("Moslem") ware. No authentic examples of fourteenth-century Chinese enamel work have yet been identified, though it is quite possible that pieces were being made for ritual use in the Lama temples of Peking during the latter part of the Yüan Dynasty.[3]

This art, which permits of such rich and vibrant colour effects, came into its own in the Ming Dynasty, and the oldest positively dateable pieces have the Hsüan-te reign mark (1426–1435). They include incense burners in archaic shapes, dishes and boxes, animals and birds, and pieces for the scholar's desk. In the early Ming pieces the *cloisons* are not perfectly filled and the surface has a certain roughness; but the designs are bold, vigorous and endlessly varied.

247 Incense burner. Cloisonné enamel. Ming Dynasty, sixteenth century.

Unfortunately, as the technique improved these qualities were lost, till we come to the technically perfect yet lifeless and mechanical enamelware of the time of Ch'ien-lung. Identical shapes and designs were produced through the nineteenth century, while today the reappearance of these same designs bears eloquent witness to the archaistic revival of traditional arts under the People's Republic.

CERAMICS

Porcelain collectors are generally agreed that a climax of refinement combined with freedom of drawing was reached in the blue and white of the Hsüan-te period (1426-1435) to which belong the earliest pieces bearing genuine reign marks. In addition to dishes there are stem cups, jars and flattened pilgrim flasks, in which an earlier tendency to crowd the surface with flowers, waves, tendrils and other motifs set in ogival panels has given way to a delicate play of lotus scrolls, vines or chrysanthemums over a white surface. The influence of courtly flower painting on porcelain decoration is very evident in the lovely blue-and-white flask illustrated here.

The blue and white of each reign has its own character, which the connoisseur can readily recognise. The Hsüan-te style continued in

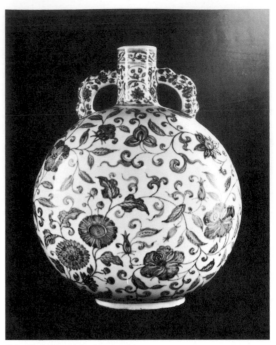

248 Wine vessel, *tsun*, in the form of a phoenix. Cloisonné enamel. Ch'ing Dynasty, eighteenth century.

249 Flask. Porcelain decorated in underglaze blue. Ming Dynasty, Yung-lo period (1403–1424).

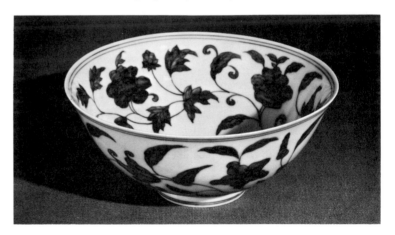

250 Bowl. Porcelain decorated in underglaze blue. Ming Dynasty, Ch'eng-hua period (1465–1487).

the Ch'eng-hua era, though beside it there now appeared in the so-called 'palace bowls' a new style more delicate and less sure in its drawing and consequently easier for the eighteenth-century potter to imitate. In the Cheng-te period (1506–1521) there was a great demand among the Moslem eunuchs at court for the so-called 'Mohammedan wares' consisting mostly of brush rests, lamps, boxes and other articles for the writing-table whose decoration incorporated inscriptions in Persian or Arabic. The pieces of the reign of Chia-ching (1522–1566) and Wan-li (1573–1620) show a change from the old floral decoration to more naturalistic scenes, while in the former reign the Taoist leanings of the court made popular such auspicious subjects as pine trees, immortals, cranes and deer.

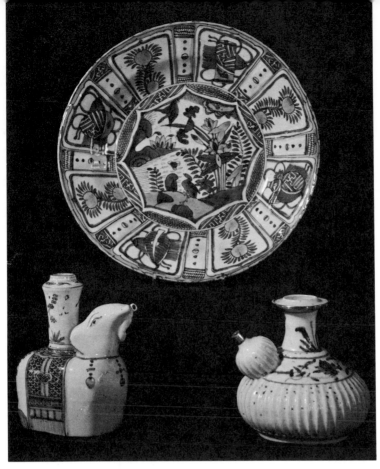

The imperial wares of the Wan-li period closely follow those of Chia-ching; but there now begins a general decline in quality, the result of mass production, rigidity in the requirements of the palace, and the exhaustion of the fine-quality clay-beds at Ching-te-chen. The most pleasing and vigorous blue and whites of the last hundred years of the Ming are wares made in the numerous commercial kilns. These are of two kinds: those made for domestic consumption (*min*: literally, "people's"), and the even more roughly modelled and painted export wares, made for sale or barter to the countries of Southeast Asia, to which I shall refer again. Soon after 1600 a particular type of thin, brittle Wan-li export blue and white began to reach Europe. This ware, called *kraak* porcelain because it had formed part of the cargo of two Portuguese carracks captured on the high seas by the Dutch, caused a sensation when it appeared on the market in Holland, and was soon being imitated in the painted faience of Delft and Lowestoft. In spite of intense efforts on the part of European potters, however, it was not until 1709 that the Dresden potter Johann Böttger, an alchemist in the service of Augustus the Strong of Saxony, succeeded for the first time in making true porcelain—more than a thousand years after it had been perfected in China.

By the middle of the fifteenth century, Ching-te-chen had become the greatest ceramic centre in China. It was ideally situated near the

CHING-TE-CHEN

225

252 'Monk's hat' jug. Porcelain covered with *pao-shih-hung*, 'precious stone red', glaze. Ch'ien-lung inscription of 1775 engraved on the base. Ming Dynasty, Hsüan-te period (1424–1435).

Poyang Lake, whence its products could go by lake and river to Nanking and by the Grand Canal to Peking. An apparently inexhaustible supply of china clay lay in the Ma-ch'ang hills nearby, while just across the river at Hu–t'ien was to be found the other essential ingredient in the manufacture of porcelain, namely 'china stone' (*tz'u-shih*, often called *pai tun-tzu* when in its prepared form). By this time there had evolved out of the nearly white *ch'ing-pai* and *shu-fu* wares of Sung and Yüan a true white porcelain, which was perhaps already being made at the imperial factory for the Hung-wu emperor. The most beautiful pieces, however, were those made in the Yung-lo period, most of which are decorated with motifs incised or painted in white slip under the glaze—a technique aptly called *an-hua* ("secret decoration"), for it is scarcely visible unless the vessel is held up to the light. From the technical point of view, the eighteenth-century white glaze is perhaps more perfect, but it lacks the luminous warmth of the Ming surface. In some Yung-lo bowls the porcelain body is pared down to paper thinness so that the vessel appears to consist of nothing but glaze: these are the so-called 'bodiless' (*t'o-t'ai*) pieces. Almost as beautiful are the monochromes produced at Ching-te-chen, notably the dishes, stem cups and bowls decorated in 'sacrificial red' (*chi-hung*) or with imperial dragons under a yellow or blue glaze.

253 Kuanyin, Fukien Te-hua ware. White porcelain. Early Ch'ing Dynasty.

Ching-te-chen, though the largest, was by no means the only Ming factory producing monochrome wares. A white porcelain was being made at Te-hua in Fukien as early as the Sung Dynasty. The Fukien wares, indeed, form a race apart. They never bear reign marks and are extremely difficult to date accurately, while they range in quality from the finest porcelain with a luminous, warm and lustrous glaze with a brownish tint where it runs thick, to the more metallic products of the last hundred years. In addition to vessels, boxes, and ceremonial objects such as incense burners and other bronze shapes, the Te-hua potters modelled figurines in white porcelain, a lovely example being the Kuanyin from the Barlow Collection at the University of Sussex. Here the subtle turn of the body and the liquid flow of the drapery show how much ceramic modelling was influenced by the sweeping linear rhythms of figure painting. From the seventeenth century onwards, Te-hua ware was shipped from Amoy to Europe where, as 'blanc-de-Chine', it had a considerable vogue and was widely imitated.

TE-HUA WARES

Robust Ming taste is more typically expressed in the so-called *san-ts'ai*, 'three-colour' wares. The exact origin of this family is not known, though there is reason to believe that it may have been produced in stoneware at Chün-chou in Honan, where the kilns were still active in the sixteenth century, while it was also, and more perfectly, made in porcelain at Ching-te-chen. The colours are generally more than three in number, but the ware takes its name from the rich turquoise, dark blue and aubergine which predominate. They are thickly applied in bold floral motifs and separated by raised ridges which perform the same function as the *cloisons* on Ming enamels. Occasionally the turquoise glaze was used alone, as on a magnificent vase in the Percival David Foundation inscribed on the shoulder "For general use in the Inner Palace." Although this ware follows the range of shapes earlier made in Chün ware—storage jars, flowerpots and bulb bowls—the vigour of the shapes and the strong, rich-coloured glazes show how much closer in feeling Ming art often comes to that of the T'ang Dynasty than to that of the Sung.

Another important Ming family comprises the five-colour wares (*wu-ts'ai*), a name given to the white porcelain painted with enamel colours, an art which was perfected by Chinese potters, possibly in the reign of Hsüan-te or slightly earlier. The colours were prepared from the material of lead glaze, applied over the glaze or directly 'on the biscuit', and the vessel fired again at a lower temperature. These pieces are generally small and often of the bodiless variety, the painting—chiefly vines, flower sprays and flowering branches—disposed with perfect taste and a subtle balance over the white ground. Sometimes, as in the *tou-ts'ai* ware, the enamels were combined with underglaze blue, but this phrase, which means 'contesting colours', hardly does justice to their delicate harmony. The five-colour enamels of the Ch'eng-hua period were never surpassed for their purity of form and decoration; they

ENAMELLED WARES

254 Vase. Stoneware decorated in *san-ts'ai* (three-colour) enamels. Ming Dynasty.

255 'Fish jar'. Porcelain decorated in *wu-ts'ai* (five-colour) enamels. Ming Dynasty, Chia-ching period (1522–1566).

were already being copied in the Wan-li period, while even to the expert the finest of eighteenth-century copies are almost indistinguishable from them.

EXPORT WARES — Besides these exquisite enamels the sixteenth century saw the appearance of a more full-blooded style, often decorated with genre scenes chiefly in red and yellow; this style was to be echoed in the *wu-ts'ai* wares made for export in the South China kilns—known generally by the misleading term 'Swatow' ware. No pottery was made at Swatow itself, but some of these rough and vigorous porcelains (both blue and white and five-colour enamels) were made up-river at Ch'ao-chou and probably at Shih-ma in Fukien, while a kiln producing blue and white export ware has recently been found in Ch'üan-chou. Swatow, however, was most probably the main port of dispatch.

China's export trade to the *Nan-hai* ("South Seas") was already flourishing in the Sung and Yüan dynasties. Early Ming wares, including celadon, Ching-te-chen white porcelain, Tz'u-chou, *ch'ing-pai* and Te-hua have been found in huge quantities over an area extending from the Philippines to East Africa. These export wares had a profound influence on the native pottery of Southeast Asia. Blue and white was not only successfully imitated in Japan (Imari ware), but also in Annam and, less successfully because they lacked the cobalt, by the Thai potters at Sawankalok, although the Siamese kilns succeeded in producing a beautiful celadon of their own. Before the end of the Ming Dynasty, the Chinese factories were also making porcelain on order for European customers, notably through the Dutch 'factory' established at Batavia (Jakarta) in 1602; but this trade, which was to play so great a part in the contacts between Europe and China, we must leave to Chapter 11.

256 Dish, 'Swatow' ware. Porcelain decorated in underglaze blue and enamel red. Probably from Shih-ma, Fukien. Late Ming period.

11
The Ch'ing Dynasty

The Ming Dynasty was brought down by the same inexorable laws of decay which had operated on previous occasions in Chinese history: corruption and the power of the eunuchs at court, leading to breakdown of the administration, large-scale banditry in the provinces, and an enemy on the northern frontier patiently awaiting their opportunity to pounce. In 1618 the Manchu nation had been founded on the banks of the bleak Sungari River. Seven years later the Great Khan, Nurhachi, set up his capital in Mukden, calling his new dynasty Ch'ing ("pure") to parallel the Chinese Ming ("bright"). Their moment came when in 1644 the Chinese general Wu San-kuei appealed to them for help to expel the rebel leader Li Tzu-ch'eng who had forced his way into Peking. The Manchus promptly accepted, drove Li out of the city and, while Wu San-kuei was pursuing him into the west, quietly occupied the capital and proclaimed the rule of the Ch'ing Dynasty. Their unexpected success left the Manchus momentarily exposed, but Wu San-kuei waited ten years before attempting to dislodge them, and then it was too late. But for nearly four decades he and his successors held South China, which was not finally secured for the Manchus until the capture of Kunming in 1682. As a result of this long civil war there grew up a bitter hostility between north and south; Peking became increasingly remote and suspicious, the south ever more rebellious and independent.

It would be wrong, however, to picture the Manchus as barbarous and destructive. On the contrary, they felt an intense admiration for Chinese culture and leaned heavily on the Chinese official class; but the more independent-minded of the Chinese intelligentsia remained, as under the Mongols, a potential source of danger to the régime, and the Manchu trust of the literati did not extend to a sympathetic consideration for the 'new thought' of the eighteenth century. Having no cultural traditions of their own, they clung to the most reactionary forms of Confucianism, becoming more Chinese than the Chinese themselves and strenuously resisting up to the end every one of the attempts at reform which were made by the literati, some of whom were responsible and far-seeing men. This hidebound refusal to recognise the inevitability of change eventually brought about the collapse of the dynasty. But for the

first century and a half, China basked in the sunlight of her restored power and prosperity, which was due largely to the work of the second emperor, K'ang-hsi (Sheng-tsu), who ruled from 1662 to 1722. It was he who pacified all China and restored her to a paramount position in Asia.

During the seventeenth and first half of the eighteenth century, China was treated with enormous respect by the European powers; admiration for her principles of government filled the writers of the Enlightenment, while her arts gave birth to two waves of chinoiserie, the first late in the seventeenth century, the second at the height of the eighteenth. During this period, indeed, China had far more influence upon the thought, art and material life of Europe than had Europe on China. Western influence was confined to court, where, ever since the arrival of the Jesuit missionary Matteo Ricci in 1601, the emperors and their immediate entourage of officials and savants had been in close touch with Western art and learning. But apart from Adam Schall's reform of the calendar and Verbiest's ordnance factory, the arts and techniques brought by the Jesuits were treated by all but a tiny minority of scholars as mere curiosities. This was not entirely true of painting, however. For, while the literati completely ignored European art, some academicians at court made strenuous efforts to master Western shading and perspective in the interest of greater realism.

The most characteristic intellectual achievement of the Ch'ing Dynasty was, like that of the Ming, not creative so much as synthetic and analytical; indeed, in the production of such works as the huge anthology *Ku-chin t'u-shu chi-ch'eng* (1729), and the *Ssu-k'u ch'üan-shu*, an encyclopaedia in 36,000 volumes begun in 1773 and completed nine years later, the Ch'ing scholars far surpassed their Ming forbears in sheer industry. Characteristically, also, the latter work was compiled not primarily in the interest of scholarship, but as a means of seeking out all books whose contents might reflect upon the legitimacy of the Manchu Dynasty. Nevertheless this enormous compilation contains many otherwise unknown texts and the fruits of much scholarly research. For this was an antiquarian age when, as never before, men looked back into the past, burrowing into the classics, dabbling in archaeology, forming huge collections of books and manuscripts, paintings, porcelain and archaic bronzes. Most famous among the collectors of paintings were Liang Ch'ing-piao, whom we have already referred to, and the salt magnate An I-chou (c. 1683–c. 1740), many of whose treasures were later acquired by the Ch'ien-lung emperor. Ch'ien-lung, who had succeeded the able but ruthless Yung-cheng in 1736, possessed a prodigious enthusiasm for works of art, and in his hands the imperial collection grew to a size and importance it had not seen since the days of Hui-tsung.[1] His taste, however, was not always equal to his enthusiasm, and he could not resist the temptation to write indifferent poems all over his most treasured paintings and stamp them with large and conspicuous seals. His abdication in 1796 (because he considered it unfilial to occupy the

257 Peking, the Forbidden City, looking north from the Wu-men to the T'ai-ho-men. A corner of the T'ai-ho-tien is visible beyond. Ming and early Ch'ing dynasties.

throne longer than his illustrious grandfather) marks the end of the great days of the Ch'ing Dynasty. To the familiar story of internal dissolution was added the aggressive advance of the European powers, whose original admiration had now given way to hostility, provoked by impatience at irksome trade restrictions. We need not linger over the tragic history of the nineteenth century, the shameful Opium Wars, the failure of the Taiping rebels to regenerate China, and her final abasement after 1900. This was not a time for greatness either in politics or in the arts. Though a few of the literati maintained a certain independence of spirit, the educated class as a whole took its lead more and more from the reactionary attitude of the Manchus.

ARCHITECTURE

The architecture of the Ch'ing Dynasty was, in the main, a tame and cautious continuation of the style of the Ming—with one notable exception. To the northwest of the capital, the K'ang-hsi emperor laid out an extensive summer palace, in emulation of the great hunting parks of the Han and Liang emperors. It was enlarged by Yung-cheng, who gave it the name Yüan-ming-yüan, and again by Ch'ien-lung who added to the many palaces already built in it an assembly of pleasure pavilions designed by the Italian Jesuit missionary and court painter Guiseppe Castiglione (1688–1766) in a somewhat 'Chinesified' version of Italian eighteenth-century baroque. These extraordinary buildings were set about with fountains and waterworks devised by Father Benôit, a French Jesuit who had familiarised himself with the fountains at Versailles and

231

258 Yüan-ming-yüan. Ruins of the
Belvedere (Fang-wai-kuan), designed
by Giuseppe Castiglione (Lang
Shih-ning, 1688–1766).

259 The *Po-hai* and the Summer
Palace, Peking. Late Ch'ing Dynasty.

260 The Hall of Annual Prayers, *Ch'i-nien-tien*, in the Precinct of the Altar of Heaven, Peking. Late Ch'ing Dynasty.

Saint-Cloud. Every detail down to the furniture was specially designed (much of it copied from French engravings) and the walls hung with mirrors and Gobelins tapestries sent out by the French court in 1767. The total effect must have been bizarre in the extreme. But the heyday of the Yüan-ming-yüan was brief. Before the end of the eighteenth century the fountains had long ceased to play, and Ch'ien-lung's successors so neglected their transplanted Versailles that by the time the Western allies destroyed the foreign-style buildings and looted their treasures in 1860, the Yüan-ming-yüan had already fallen into a sad autumnal state of disrepair. But we can obtain some idea of what it looked like in its prime from the engravings made by Castiglione's Chinese assistants in 1786. The last great architectural achievement—if indeed it deserves the name—of the Manchus was the Summer Palace built by the dowager empress Tz'u-hsi on the shore of the Po-hai to the west of the Forbidden City with funds raised by public subscription to construct a navy. Although she was condemned at the time for her extravagance, it has since been observed that had she built a fleet it would certainly have been sunk by the Japanese in the war of 1895, while the Summer Palace will endure for centuries. Less pretentious and far more appealing among the late Ch'ing ceremonial buildings is the Ch'i-nien-tien (Hall of Annual Prayers), erected near the Altar of Heaven in the southern quarter of the city late in the nineteenth century. Its gleaming marble terraces, its richly painted woodwork and the deep blue of its tiles dazzle the eye. But we need only to glance at the poverty of its detail, its reliance upon paint rather than imaginative carpentry, to realise that, fairylike as is its total effect, the Hall of Annual Prayers marks the final exhaustion of a great tradition.

In a corner of the Forbidden City, K'ang-hsi set aside a courtyard known as the Ch'i-hsiang-kung as a studio and repair shop where Chinese and Jesuit artists and mechanics worked side by side, painting, engraving, repairing clocks and musical instruments. The

EUROPEAN INFLUENCE ON COURTLY ART

261 Chiao Ping-chen (active c. 1670–
1710), *Country Pursuits*. Detail of
a hanging scroll. Ink and colour on silk.
Ch'ing Dynasty.

262 Giuseppe Castiglione, *A Hundred
Horses in a Landscape*. Detail of a
handscroll. Ink and colour on silk.
Ch'ing Dynasty.

court painter Chiao Ping-chen studied perspective there under the Jesuits and embodied what he learned in forty-six illustrations to the famous agricultural work *Keng-chih-t'u*, while his pupil Leng Mei was noted for delightful but over-elegant paintings of court ladies, generally in a garden setting and showing some knowledge of Western perspective.[2] Castiglione, who had arrived in Peking in 1715, was already an accomplished painter. He soon mastered the academic manner of his Chinese colleagues, and proceeded to create a synthetic style in which a Chinese medium and technique are blended with Western naturalism, aided by a subtle use of shading. He was a favourite at court, where his still-life paintings, portraits and long handscrolls depicting horses in a landscape or scenes of court life signed, very carefully, with his Chinese name, Lang Shih-ning, were greatly admired. He had numerous pupils and imitators, for the decorative realism of his style was particularly suited to the kind of 'furniture painting' which the palace required in such quantities to decorate its endless apartments. Castiglione, however, no more affected the general trend of Chinese painting in his time than did the Chinese artists working for the Europeans in Canton and Hongkong. Tsou I-kuei (1686–1772), a court artist to Ch'ien-lung noted for the painstaking realism of his flower paintings (an art in which he probably influenced the style of his colleague Castiglione), much admired Western perspective and shading. "If they paint a palace or a mansion on a wall," he wrote, "one would almost feel induced to enter it." But he makes it clear that these are mere technicalities, to be kept in their proper place. "The student should learn something of their achievements so as to improve his own method. But their technique of strokes is negligible. Even if they attain perfection it is merely craftsmanship. Thus, foreign painting cannot be called art."[3]

The most interesting and neglected of the Ch'ing professional painters, however, was the group centred round Li Yin and Yüan Chiang, both of whom were working in prosperous Yangchow between about 1690 and 1725, after which the latter, like his son(?) Yüan Yao, became a court painter. They are chiefly noted for having given a violent twist to the long-moribund 'Northern' tradition by applying to the style and composition of early Sung masters such as Kuo Hsi the fantastic distortions of the late Ming expressionists. The blend of fantasy and mannerism in their work can be seen in the meticulously painted landscape by Yüan Chiang illustrated here.

The literati shared none of the academician's admiration for European painting, for they now felt themselves to be the custodians of a tradition infinitely more precious than anything the West had to offer. Through the sheer force of his personality, Tung Ch'i-ch'ang had given a new interpretation to the style of Tung Yüan and Chü-jan, but his less-gifted followers in the Ch'ing Dynasty took his injunction to restore the past, *fu ku*, too literally, and in the work of many of the hundreds of painters who now appear on the

263 Yüan Chiang (early eighteenth century), *Gentlemen Conversing in a Landscape*. Hanging scroll. Ink and colour on silk. Ch'ing Dynasty.

WEN-JEN HUA

235

264 Hung-jen (1610–1664), *The Coming of Autumn*. Hanging scroll. Ink on paper. Ch'ing Dynasty.

scene, the free, unfettered styles of the leading Ming literati froze into a new academicism that has justly been called 'art-historial art', for too often the artists' inspiration was not nature but the very tradition itself. But even if many of the amateur painters played the same tunes over and over again, they played them beautifully, and the enjoyment we derive from this kind of painting comes not from any sudden revelation or strength of feeling, but from subtle

nuances in the touch of the brush such as we savour in listening to an all-too-familiar piano sonata interpreted by different hands.

But to give the impression that all Ch'ing painting is conventional would be utterly misleading. For the story of the seventeenth century—of the decay and death of the Ming, the Manchu invasion, the civil war and decades of uncertainty that followed it, and the return to stability under K'ang-hsi—can all be read in the painting of the period, which for this reason is one of the most fascinating, and intensely studied, in the history of Chinese art. The Ming loyalists, called *I-min* (literally, "people left over"), suffered acutely, for their code forbade their taking or holding office under a new dynasty, most of all an alien one. Some committed suicide, some became destitute, some turned wanderer, monk, recluse or eccentric, while some even lived to become loyal and contented servants of that remarkable Manchu ruler K'ang-hsi.

Thus, the *I-min* responded to the crisis in a number of ways, and there can be no greater contrast than that between, say, the two masters, Hung-jen and Kung Hsien. The Anhui monk Hung-jen (1610–1664) faced his predicament by transcending it; expressing an inner serenity of spirit through his sparse, dry landscapes, fragile yet incredibly solid, sensitive yet monumental, that exude an atmosphere of almost unearthly purity very close to that of Ni Tsan. By contrast, the Nanking painter Kung Hsien (1620–1689) seems to have been 'on the run' for some years after the fall of the Ming, harried by political enemies and private anxieties. His desolate, prisonlike landscape in the Drenowatz Collection, in which no life seems possible, nothing stirs, may owe something to the expressive distortions of Tung Ch'i-ch'ang, but like other pictures of his middle years it is also symbolic, both of the condition of his native

265 Kung Hsien (1620–1689), *A Thousand Peaks and Myriad Ravines.* Hanging scroll. Ink on paper. Ch'ing Dynasty.

267 Chu Ta, *Two Birds*. Album-leaf. Ink on paper. Ch'ing Dynasty.

266 Chu Ta (Pa-ta Shan-jen, 1626–c. 1705), *Landscape in the Manner of Tung Yüan*. Hanging scroll. Ink on paper.

land raped by the Manchus, and of his own desperate sense of having, literally, nowhere to turn. Yet, his whole career cannot have been so turbulent, for he was also a noted poet, calligrapher, publisher and art teacher—his pupil Wang Kai was the chief compiler of the *Painting Manual of the Mustard Seed Garden* referred to in Chapter 10—while the calm, monumental landscapes of his later years seem to suggest that he had found peace at last.

These masters were certainly individualists, but that label is often, and arbitrarily, reserved for three great painters who dominated the art of early Ch'ing as Hung-jen and Kung Hsien never did. These men are: Chu Ta (1626–c. 1705), K'un-ts'an (Shih-ch'i, c. 1610–c. 1670) and Tao-chi (Shih-t'ao, 1641–c. 1710). Chu Ta, or Pa-ta Shan-jen as he signed himself in his later years, was a distant descendant of the Ming imperial house who on the advent of the Manchus became a monk. When his father died, so the story goes, he was struck dumb and would only shout and laugh, the butt of the children who ran after his ragged figure in the streets. He turned his back not only upon the world but upon the art of painting as practised in his time. His brush style appears careless and slapdash, and yet, like that of the Ch'an eccentrics who were his spiritual ancestors, it is incredibly sure and confident. His landscapes executed in a dashing shorthand carry Tung Ch'i-ch'ang's creative

268 K'un-ts'an (Shih-ch'i, c. 1610–1693), *Autumn Landscape*. Handscroll dated equivalent to 1666. Ink and colour on paper. Ch'ing Dynasty.

distortion of the Southern tradition to a pitch that must have shocked the orthodox disciples of the late Ming master. Perhaps his peculiar genius shows best in his swift album sketches, in which a small angry-looking bird perches upon a rock in an infinity of space, or in his studies of fishlike rocks and rocklike fishes, drawn in a few brilliant sweeping lines of the brush. This is 'ink-play' at its most unrestrained; yet it is no mere empty virtuosity, for Pa-ta's deceptively simply style captures the very essence of the flowers, plants and creatures he portrays.

Shih-t'ao and Shih-ch'i are linked together by Chinese art historians as the Two Stones (*Erh Shih*), yet there is no positive evidence that they were close friends. Shih-ch'i was a devout Buddhist who spent all his life as a monk, his later years as abbot of a monastery at Nanking, an austere and unapproachable recluse. The texture of his landscapes, painted with a dry, scrubby brush, has the groping, almost fumbling, quality that we find in Cézanne, and as in Cézanne this very awkwardness, this refusal to make concessions to the viewer, are witness to the painter's integrity. Yet the final effect—in the beautiful autumn landscape in the British Museum, for example—gives an impression of grandeur and serenity.

Shih-t'ao, whose family name was Chu Jo-chi, was a lineal descendant of the founder of the Ming Dynasty, which fell when he was still a child. He later joined the Buddhist community on Lu-shan, taking the monastic name Tao-chi. But he was no recluse, and never a real monk. In 1657 he went to live in Hangchow, and thereafter spent much of his life wandering about China, visiting sacred mountains in the company of monks, scholars, and painter friends such as Mei Ch'ing. He spent nearly three years in Peking (where he and Wang Yüan-ch'i collaborated on a picture of 'Bamboo and Rocks'), and finally settled in Yangchow, where he severed his monastic vows and, because he had no private income, became a professional, though highly respected, painter. A chronicle of Yangchow, a city famous for its gardens, says that one of his favourite hobbies was 'piling up stones'—i.e., designing gardens,

239

269 Shih-t'ao (Tao-chi, 1641–c. 1710), *The Peach Blossom Spring*, illustrating a story by T'ao Yüan-ming. Detail of a handscroll. Ink and colour on paper. Ch'ing Dynasty.

among which his 'Garden of Ten Thousand Rocks' laid out for the Yü family was considered his masterpiece. It may be that some of his little album landscapes were actually suggestions for garden designs.

Shih-t'ao's aesthetic philosophy is contained in the *Hua yü lu*, a profound and often obscure document that cannot possibly be summarised in a paragraph, for it is not a statement of a coherent aesthetic theory so much as a series of utterances that touch on reality, nature, man, and art at many levels.[4] Central to Shih-t'ao's thinking is the concept of the *i hua* (literally, "one line" or "one painting"); but the very word *i* might mean the transcendent 'One', the unity of man and nature, or simply 'the single', and *hua* either the art of painting, 'delineation', or simply 'line'. Drawing both upon earlier aesthetic theorists going back as far as Tsung Ping and Hsieh Ho, and upon Buddhist and Taoist metaphysics, and not unaware of his own genius, Shih-t'ao meditates upon the artist's power to express his sense of oneness with living nature in the unified, uninterrupted flow of inspiration through his brush. While we may not be able to analyse Shih-t'ao's thought with any precision, in reading the *Hua yü lu* we become aware of what the art, and the act, of painting could mean to the inspired practitioner.

In his own painting, Shih-t'ao justifies his claim in the *Hua yü lu* that by establishing the one-line method he has created a method out of an absence of method. His concept of the ecstatic union of the artist with nature is by no means new, but nowhere in the whole of later Chinese art will we find it expressed with so much spontaneous charm. Whether in a handscroll, such as the delightful illustration to T'ao Yüan-ming's *The Peach Blossom Spring*, or in a towering landscape such as the magnificent view of Mount Lu in the Sumitomo Collection, or in any of his album-leaves, his forms and

colours are ever fresh, his spirit light, his inventiveness and wit inexhaustible.

All these masters, although they drew upon the tradition, developed and enriched it and so touched the heights. At a rather lower level we encounter a host of painters who represent the orthodox stream, flowing down from Shen Chou, Wen Cheng-ming and Tung Ch'i-ch'ang, that survived the upheaval and kept its steady, if seldom adventurous, course, growing ever broader and shallower as the Ch'ing Dynasty settled into its long stagnation. In the seventeenth century, however, the stream still runs strong in the work of the 'Six Great Masters of the Early Ch'ing Dynasty' who included the Four Wangs, Wu Li and Yün Shou-ping. The earliest of the four was Wang Shih-min (1592–1680) who had learned to paint from the hand of Tung Ch'i-ch'ang himself. Like his master, he deeply admired the broad, relaxed manner of Huang Kung-wang, and his great series of landscapes in the manner of the Yüan recluse, painted in his seventies, are among the noblest achievement of the Ch'ing literati. Wang Chien (1598–1677), his close friend and pupil, was an even more conscientious follower of the Yüan masters. More gifted was Wang Hui (1632–1717), who as a poor student had been introduced to Wang Shih-min, whose pupil he became. He devoted much of his talent to the imitation of early masters, and his huge oeuvre consists chiefly of endless variations on the styles of

270 Shih-t'ao, *A Man in a House Beneath a Cliff*. Album-leaf. Ink and colour on paper. Ch'ing Dynasty.

272 Wang Yüan-ch'i (1642–1715),
Landscape in the Manner of Ni Tsan.
Hanging scroll. Ink and colour on silk.
Ch'ing Dynasty.

271 Wang Hui (1632–1717),
Landscape in the Manner of Fan K'uan.
Hanging scroll dated equivalent to
1695. Ink and colour on paper. Ch'ing
Dynasty.

Tung Yüan and Chü-jan as they had been successively reinterpreted
by Huang Kung-wang, Tung Ch'i-ch'ang and Wang Shih-min.
The Palace Museum collection also contains a number of clever
pastiches of tenth-century and Northern Sung landscapes which are
almost certainly his work.

Of the four Wangs, Wang Yüan-ch'i (1642–1715) was the most
gifted and original. The grandson of Wang Shih-min, he rose to
high office under the Manchus, becoming chancellor of the Hanlin
Academy and vice president of the Board of Finance. He was a
favourite of K'ang-hsi, who frequently summoned him to paint in

273 Yün Shou-p'ing (1633–1690), *Autumn Fragrance: Chrysanthemum and Convolvulus*. Ink and colour on paper. Ch'ing Dynasty.

274 Wu Li (1632–1718), *White Clouds and Green Mountains*. Detail of a handscroll. Ink and colour on silk. Ch'ing Dynasty.

his presence, and he was appointed one of the editors of the great anthology of painting and calligraphy, *P'ei-wen-chai shu-hua-p'u*, published on imperial order in 1708. But Wang Yüan-ch'i was no academician. Although he drew his themes from the Yüan masters, notably Ni Tsan, and his curious angular rocks and gaunt trees from Tung Ch'i-ch'ang, he had an obsession with form, unique in a Chinese painter, which has caused some Western writers to liken him to Cézanne. With deep concentration, he would, as it were, pull apart and reassemble the rocks and mountains in his paintings like a cubist. These are not landscapes to wander in; they are rather semi-abstract creations of the painter's mind, totally convincing in their own terms, and remote from the mannered distortions of Yüan Chiang and his school.

Yün Shou-p'ing (commonly known as Yün Nan-t'ien, 1633–1690) was the son of a Ming loyalist and consequently had to live in partial obscurity in the Soochow-Hangchow region far from the capital, where he supported himself by his painting and calligraphy. He had aspirations as a landscape painter, but feeling himself unable to compete in this field with his close friend Wang Hui, he turned to flower painting, chiefly in the boneless style. At his best in the intimate art of painting fans and album-leaves, his pictures have become deservedly popular for the beauty of their colour and the skill of their brushwork and arrangement.

275 Chin Nung (1687–1764), *Plum Blossoms*. Hanging scroll dated equivalent to 1761. Ink on paper. Ch'ing Dynasty.

Wu Li, born in 1632, is of unusual interest because he came under the influence of the Jesuits, was baptised, and spent six years studying theology in Macao where he was ordained in 1688, thereafter devoting the rest of his life to missionary work in Kiangsu. However, his conversion in no way changed his style of painting. A pupil of Wang Chien and an intimate friend of Wang Hui, he called himself Mo-ching Tao-jen, the Taoist of the inkwell (in the literal sense of Alice's treacle-well), continuing, after an unproductive period following his conversion, to paint in the eclectic manner of the early Ch'ing *wen-jen*, without a hint of European influence, until his death in 1718.

By the eighteenth century the settled state of China had created a great demand for works of art, notably in such prosperous cities as Yangchow, at the juncture of the Grand Canal with the Yangtse River. Here, to bear witness to their newly acquired gentry status, salt merchants and other rich traders built up libraries and art collections, entertained scholars, poets and painters, and expected to be entertained in return. Among the many artists who competed for their patronage the most talented was a group that came later to be known as the Eight Eccentrics of Yangchow, whose idiosyncrasies of behaviour or technique were, in some cases at least, partly assumed for professional reasons. The hallmark of Chin Nung's art, for instance, was not so much his deft ink paintings of birds, flowers or bamboo, as his heavy square calligraphy, derived from Han stone inscriptions, which offers a teasing contrast to the light touch of the brushwork in his 'Plum Blossoms' illustrated here; his contemporary, Huang Shen (1687–c. 1768), playfully distorted the figure style of Ch'en Hung-shou, which was itself already a playful distortion of ancient models; while the art of the immensely prolific Hua Yen (1682–c. 1755) is often an airy commentary on the styles of the great masters of Sung bird and flower painting. In all the works illustrated there is an appeal to the antique, but the attitude of these painters is much less serious than that of their late Ming and early Ch'ing predecessors, and they carry the burden of tradition more lightly. Their purpose, after all, was to please.

Groupings such as the 'Four Wangs' and the 'Eight Eccentrics of Yangchow' have little foundation in fact. Where, for instance, does individualism stop and eccentricity begin? Were there really eight eccentrics in Yangchow? There were many kinds of eccentricity, natural and assumed. Some of these men were friends, others not; some were outstanding, others obscure. But these traditional groupings are helpful, as much to Chinese as to Western readers, in reducing the bewildering number of Ch'ing painters to some sort of order.

The careers of some of the Yangchow eccentrics point to a change in the status of the so-called 'amateur' painter in China. Ideally, he was a salaried official or a man of means who painted for pleasure in his spare time. But among the Ch'ing gentlemen-painters were many—indeed, a majority—who were not officials and had no

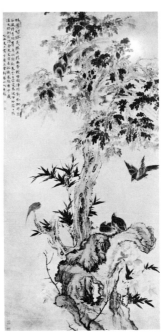

276 Huang Shen (1687–1768+), *The Poet T'ao Yüan-ming Enjoys the Early Chrysanthemums*. Album-leaf. Ink and colour on paper.

277 Hua Yen (1682–1755+), *Birds, Tree and Rock*. Hanging scroll dated equivalent to 1745. Ink and colour on paper. Ch'ing Dynasty.

private income, and so were forced (although this was not openly acknowledged) to paint for a living. Wang Hui, for example, painted industriously for the patrons in whose mansions he lodged for months on end, Chin Nung for a time was reduced to decorating lanterns, while competition for the patronage of the Yangchow salt merchants forced artists such as Chin Nung and Huang Shen to cultivate a deliberate oddity to attract their attention. The miracle is that the discipline of the brush still held, and that there is still so much sensibility and freshness in their art.

The art of the individualists and eccentrics can be interpreted as their private protest against the academicism of the painting of the time. But as the Ch'ing settled deeper into the stagnation that seems to have been the fate of every long-lived dynasty in Chinese history, the lamp of individualism burned more and more dimly, while a kind of spiritual paralysis seemed to grip the scholar class as a whole. Only in Canton and in the brash new treaty port of Shanghai, grown suddenly rich in the late nineteenth century, was patronage to be found. Though not of the kind that a fastidious scholar-painter would have sought, it did breathe new life into one corner of the Chinese art world, just as the onslaught of Western industrial civilisation was about to be unleashed on China.

The political disasters that so deeply affected the seventeenth-century painters touched all Chinese society. None except perhaps the poorest peasant was unaffected. Confusion, banditry and civil war, which had begun after the death of Wan-li in 1620 and was not stilled until well into the reign of K'ang-hsi, brought havoc on the ceramics industry at Ching-te-chen. Already before the end of the Ming Dynasty the imperial wares had sharply declined both in

CERAMICS

quality and quantity. The reign of T'ien-chi is noted for a coarse, brittle blue and white prized in Japan as *tenkei* ware, but marked pieces from his successor Ch'ung-cheng's era are very rare and of poor quality. During these years China lost to Japan the great market she had built up in Southeast Asia and Europe, and did not fully recover it again till Wu San-kuei had been defeated and South China brought once more under the control of the central government. Consequently the so-called 'transitional wares' of the mid-seventeenth century, being for the most part continuations of earlier styles, are not always easy to identify. The most characteristic of them are strongly built blue and white jars, bowls and vases decorated with figures in landscapes, rocks and flowers (especially the 'tulip', possibly based on a European motif) in a thick violet glaze which Chinese collectors call 'ghost's-face blue' (*kuei-mien-ch'ing*) and Western connoisseurs 'violets in milk'. Many of them were made primarily for export and, like the export blue and white of Chia-ching and Wan-li, have a freedom of drawing that gives them considerable appeal.

CHING-TE-CHEN

No abrupt change at Ching-te-chen followed the establishment of the new dynasty. The imperial factory was still functioning after a fashion in the 1650s, and pieces produced during these unsettled years represent, as we would expect, a continuation of the style of the Wan-li period. Between 1673 and 1675, Kiangsi was laid waste by Wu San-kuei's rebel horde, and in the latter year the imperial factories at Ching-te-chen were destroyed. They were rebuilt a few years later. In 1682 K'ang-hsi appointed as director of the Imperial Kilns Ts'ang Ying-hsüan, a secretary in the Imperial Parks Department. Ts'ang, who arrived at Ching-te-chen early in the following year, was the first of three great directors whose names are linked to this supreme moment in the history of Ching-te-chen. It is not known precisely when Ts'ang retired. In 1726 Yung-cheng appointed Nien Hsi-yao, who in turn was succeeded in 1736 by his assistant T'ang Ying, who held the office until 1749 or 1753. Thus, Ts'ang's directorship corresponds roughly to the K'ang-hsi period, Nien's to Yung-cheng, and T'ang Ying's to the first years of Ch'ien-lung.

Two Chinese works give us useful information on the Imperial Kilns and their output, though both were written after the factory had begun to decline. Chu Yen published his *T'ao-shuo* in 1774, while the *Ching-te-chen t'ao-lu* written by Lan P'u did not appear till 1815. The most valuable description however is that contained in two letters written by the French Jesuit Père d'Entrecolles, who was in China from 1698 to 1741, and not only had influential friends at court but also many converts among the humble artisans in the factories at Ching-te-chen. These letters, dated 1712 and 1722, give a vivid picture of the whole process of manufacture, of which he was an intelligent observer;[5] he recounts how the *petuntse* ("china stone") and kaolin ("china clay") are quarried and pre-

pared, and the enormous labour involved in kneading the clay. He describes a degree of specialisation among the decorators so minute that it is a wonder the painting has any life at all: "One workman does nothing but draw the first colour line beneath the rims of the pieces; another traces flowers, while a third one paints. . . . The men who sketch the outlines learn sketching, but not painting; those who paint [i.e., apply the colour] study only painting, but not sketching," all in the interests of absolute uniformity. Elsewhere he says that a single piece might pass through the hands of seventy men. He speaks of the hazards of the kiln and of how a whole firing is often lost by accident or miscalculation. He tells how the emperor would send down Sung Dynasty *kuan*, Ju, Ting, and Ch'ai wares to be copied, and of the gigantic fishbowls ordered by the palace which took nineteen days to fire. The greatest challenge however was set by the agents of the European merchants at Canton who demanded openwork lanterns, tabletops, and even musical instruments in porcelain. As early as 1635 the Dutch were forwarding, via Formosa, wooden models of the shapes of vessels required. We can get some idea of the extent of the foreign trade from the fact that in 1643 no less than 129,036 pieces of porcelain were sent via Formosa to the Dutch governor general of Batavia for shipment to Holland. Most of it must have been produced at Ching-te-chen.

The most beautiful K'ang-hsi wares, and those which have been most admired in both China and the West, are the small monochromes, which in their classic perfection of form, surface and colour recapture something of the subtlety and restraint of the Sung. The *T'ao-lu* says that Ts'ang Ying-hsüan's clays were rich, his glazes brilliant, his porcelain thin-bodied, and that he developed four new colours—eel-skin yellow, spotted yellow, snakeskin green and turquoise blue. He also perfected a mirror black which was often decorated with gold; an exquisite soft red shading to green known as 'peach-bloom' and used, it seems, for a very small range of vases and vessels for the scholar's desk; an 'imperial yellow'; and a clear, powder blue, blown on through a bamboo tube and then often painted with arabesques in gold. The latter were especially admired in France where it was the fashion to mount them in ormolu. The most splendid effect was a rich red produced from copper, known in Europe as *sang-de-boeuf* ("oxblood") and in China as Lang-yao; several members of the Lang family have been suggested as possible candidates for the honour of having this ware named after them—the most likely being Lang T'ing-chi who, as governor of Kiangsi from 1705 to 1712, took an active interest in the kilns at Ching-te-chen. The glaze was probably applied by spraying and ran down the sides of the vase, stopping miraculously short of the foot—a degree of control which was lost in the Ch'ien-lung period and has only recently been recovered; while a beautiful effect appears around the rim where the colour has failed to 'develop' and the glaze has a pale greenish tinge. The K'ang-hsi potters also copied

278 Vase, *mei-p'ing*. Porcelain with ox-blood (Lang-yao) glaze. Ch'ing Dynasty, K'ang-hsi period (1662–1722).

279 Bottle. Porcelain decorated with plum blossoms reserved on a ground of underglaze blue. Ch'ing Dynasty, K'ang-hsi period.

280 Teapot. *Famille verte* porcelain with enamels in *Ku-yüeh-hsüan* style. Ch'ing Dynasty, Ch'ien-lung period (1736–1796).

the beautiful white 'eggshell' bowls of Yung-lo, their versions being more flawless than the Ming originals, and made a fine imitation of the classical Ting ware of the Sung period.

These monochromes appealed chiefly to cultivated taste. Much more widely appreciated were the underglaze blue and enamelled wares, for which there was a huge demand both in China and abroad. Most K'ang-hsi blue and white was produced by the mass-production methods of which Père d'Entrecolles gives so depressing a picture, and as a result has a technical perfection combined with dead uniformity only partly redeemed by the colour of the cobalt itself which has a vivid, intense luminosity never equalled before or since. It had a great vogue in Europe in the first half of the eighteenth century, particularly popular being the 'ginger jars' decorated with blossoming prunus on a blue ground reticulated with lines suggesting ice cracks. Thereafter it was largely replaced in favour by the brightly coloured enamelled wares. Between 1667 and 1670 an imperial edict had been issued forbidding the use of the K'ang-hsi *nien-hao*. It is not known how long the ban remained in force, but there are comparatively few genuine pieces with the K'ang-hsi mark, and a correspondingly large number to which the potters added the fictitious marks of the Ming emperors Hsüan-te and Ch'eng-hua.

The great achievement of the potters working under Ts'ang Ying-hsüan, however, was in the enamels, of which two kinds had been developed by the end of the Ming Dynasty: *wu-ts'ai* (five colours) enamelled over the glaze, and *san-ts'ai* (three colours) applied directly 'on the biscuit'. In the K'ang-hsi *wu-ts'ai*, overglaze violet-blue replaces the underglaze blue of Wan-li, but the dominating colour is a transparent jewel-like green which led its European admirers in the nineteenth century to christen it *famille verte*. Most of these pieces are vases and bowls, made purely for ornament, and decorated with birds or butterflies amid flowering branches, disposed with an exquisite and subtle sense of balance which strongly suggests that these designs were inspired by paintings. The revived *san-ts'ai* enamel-on-biscuit was used chiefly for reproductions of archaic bronzes and for figurines of Buddhist and Taoist divinities, children, birds and animals. Also enamelled directly on the biscuit is the so-called *famille noire*, whose polychrome floral decoration is set off against a background of a rich black made almost iridescent by being washed over with a transparent green glaze. Until recently this spectacular ware had an enormous vogue among foreign collectors, and, like certain other Ch'ing enamels, still commands prices out of all proportion to its aesthetic worth. Examples of both *famille verte* and *famille noire* were sometimes adorned with Ch'eng-hua reign marks to show how highly their makers regarded them. Towards the end of the K'ang-hsi period, the robust vigour of the *famille verte* began to yield to a new style dominated by a delicate rose pink, which is known in Europe as *famille rose* and which the Chinese call *yang-ts'ai* ("foreign colour"). It had been invented, about 1650, by Andreas Cassius of Leyden, who succeeded in producing a rose red from gold chloride.

A saucer dish in the Percival David Foundation dated 1721 must be one of the earliest Chinese examples of the use of this colour, which was probably introduced by the Jesuits.

The *famille rose* came to its full flowering with the appointment of Nien Hsi-yao as director of the imperial factories in 1726. Nien's directorship is chiefly famous for its "imitation of the antique and invention of novelties." As a typical example of the former we have his exquisite copies of classical Sung wares, so perfect that a Ju ware bottle now in the Percival David Foundation was for many years accepted as a genuine Sung piece by the Palace Museum authorities, until its carefully concealed Yung-cheng mark was discovered. Indeed, many Yung-cheng pieces had the reign mark ground away so that they might be passed off as Sung when they were illicitly sold out of the Palace Collection. Nien's 'novelties' included the 'tea-dust' glaze, made by blowing green enamel onto an iron, yellow-brown glaze, an improvement on the exquisite pale blue glaze known in Europe as *clair-de-lune*, and such rococo effects as painting in ink black flecked with gold or in greenish-blue flecked with red. Already in 1712 d'Entrecolles had been asked by the officials at Ching-te-chen for curious European objects which might be copied in porcelain and sent to court, and during the Yung-cheng period—and increasingly under Ch'ien-lung—this taste for extravagant forms and new effects was to absorb the energies of the potters at the cost of real refinement of taste. Its

YUNG-CHENG PERIOD WARES

281 Bottle, copy of Ju ware. Porcelain covered with bluish-grey crackled glaze. Ch'ing Dynasty, Yung-cheng period (1723-1735).

282 Double vase, *t'ao-p'ing*. Porcelain, the inner vessel decorated in underglaze blue; the outer, with pierced sides, in *fen-ts'ai* enamels. Ch'ing Dynasty, Ch'ien-lung period.

249

most lamentable results can be seen in the decline of *famille rose*, which early in the Yung-cheng period had had an exquisite delicacy; it was spoilt by the foreign demand for rich and garish decoration, finally degenerating into the livid salmon pink of the nineteenth century.

CH'IEN-LUNG
PERIOD WARES

In point of sheer craftsmanship the Ch'ien-lung period is supreme, and the finest of the enamelled wares produced under the directorship of T'ang Ying are unsurpassed. T'ang lived and worked with his potters, had complete mastery of their techniques and was continually experimenting with new effects, reproducing the colour and texture of silver, grained wood, lacquer, bronze, jade, mother-of-pearl and even cloisonné. He copied Italian faience drug pots, Venetian glass, Limoges enamels and even Delft painted pottery and Japanese 'old Imari' ware which were themselves copies of late Ming blue and white. T'ang Ying also reproduced all the familiar Sung wares (his rather glassy copies of Lung-chüan celadon being particularly fine), while his versions of the robust Canton wares were considered a great improvement on the originals. But the most beautiful of the porcelains produced under his direction are the enamelled eggshell vessels and bowls such as the lovely lavender vase decorated with mallow flowers and chrysanthemums and bearing a poem believed to be by T'ang Ying himself. In recent years, fashion has swung away from these exquisite objects to the more free and vital wares of T'ang and Sung, in which we can see and feel the touch of the craftsman's hand, but nothing can surpass the finest of these Ch'ien-lung pieces for sheer perfection of craftsmanship.

283 Vase. Porcelain decorated with flowers in *famille rose* enamels and a poem by T'ang Ying. Ch'ing Dynasty, Ch'ien-lung period.

The influence of European taste on the decoration of Ching-te-chen porcelain, which had been growing since the end of the K'ang-hsi period, is nowhere more clearly seen than in a small and choice group of *famille rose* enamelled pieces known as *Ku-yüeh-hsüan*.[6] Indeed, many of them are decorated with European scenes, and even the Chinese flower motifs have a foreign quality in the realistic drawing, shading and handling of perspective. They generally bear poems followed by red seals, while the *nien-hao* on the base is in embossed enamel.

PORCELAIN FOR THE
EUROPEAN MARKET

A few words should be said on the subject of the porcelain made for the European market during the seventeenth and eighteenth centuries. Already in the sixteenth century the South China potters were decorating dishes with Portuguese coats of arms, and the Dutch trade vastly increased the demand in the seventeenth century. It was the Dutch who chiefly furnished the 'porcelain rooms' in the great houses of France and Germany, of which the unfinished 'Japanese Palace' of Augustus the Strong, King of Poland and Elector of Saxony, was the most ambitious. Augustus is reputed to have bartered a regiment of grenadiers for a set of *famille verte* vases. During the seventeenth century, European enthusiasts had been quite content to receive Chinese shapes decorated in the Chinese

taste, but by the end of the century the practice was growing of sending out to Canton not only specimen shapes but also subjects for decoration, in response to which Ching-te-chen sent white porcelain 'in the blank' down to Canton, where it was painted under the supervision of the European agents. The motifs included armorial bearings, genre scenes, figure subjects, portraits, hunting scenes, pictures of ships taken chiefly from engravings, and religious subjects such as the Baptism, Crucifixion and Resurrection—the so-called 'Jesuit China'. Towards the end of the eighteenth century, however, the enthusiasm for things Chinese began to wane, as Europe was beginning to supply her needs from her own porcelain factories. The great days of the export trade were over, and the so-called 'Nankeen ware' (enamelled porcelain) of the nineteenth century bears eloquent witness to its decay.

Although the imperial factory continued to flourish until the end of the eighteenth century, its great era ended with the departure of T'ang Ying. Thereafter the decline was slow but steady. At first we see an even greater ingenuity and elaboration in the manufacture of such freakish objects as boxes with porcelain chains and perforated and revolving vases. But after the beginning of the nineteenth century, the decay is more rapid, and though some of the wares of the reign of Tao-kuang (1821–1850) are of fine quality, the industry suffered a crippling blow when Ching-te-chen was sacked by the Taiping rebels in 1853. Thereafter, there was a revival under T'ung-chih (1862–1873), and a further revival has taken place in the twentieth century. Today the factories at Ching-te-chen are run on modern industrial lines, but care is being taken to preserve the skills and techniques of the traditional potters.

While the Imperial Kilns were concentrating on an ever greater technical perfection, it was the provincial factories in the south which most successfully maintained their vigour and vitality. Of the scores of these kilns we can only mention a few. I-hsing in Kiangsu specialised in the production of little vessels, made of red stoneware, for the scholar's table, most ingeniously fashioned in the form of

284 'Jesuit China' dish. Porcelain decorated in underglaze blue, with a Baptism scene after a European engraving. Ch'ing Dynasty.

NINETEENTH CENTURY AND PROVINCIAL WARES

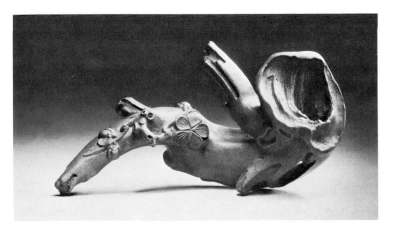

285 Ch'en Ming-yüan (active 1573–1620), brush-rest, I-hsing ware. Unglazed stoneware. Ming Dynasty.

plants, tree trunks, beetles, rats and other creatures, and in the manufacture of teapots. Te-hua continued to make the fine white porcelain developed in the Ming Dynasty. Other provincial wares were made either for local use or for shipment to regions less exacting in their demands than the Europeans. This applies particularly to the vulgar but vigorous brown stonewares made at Shekwan, near Fatshan in Kwangtung, consisting chiefly of ornamental pieces, figures and large jars decorated with a thick blue glaze streaked and flecked with grey and green, which since the Ming Dynasty had both gratified local taste and been exported in quantity to the Nan-hai.

About the year 1680, K'ang-hsi set up workshops in the palace precincts for the manufacture of porcelain, lacquer ware, glass, enamel, furniture, jade and other objects for court use. The porcelain project, intended to replace distant Ching-te-chen, was found impracticable and soon abandoned, but the other workshops turned out a variety of decorative arts of superb quality and continued in production for the rest of the dynasty. The finest pieces of jade carving are often assigned, with very little reason, to the reign of Ch'ien-lung. Carved jade is extremely difficult to date, and work of the highest quality has been produced right up to the present day.

Other factories supplied the needs of the wealthy middle class and of the export market. Peking and Soochow, for example, specialised in carved lacquer, Foochow and Canton in the painted sort. The Canton products were considered inferior both in China and abroad because they were often made hastily to meet the demands of European merchants who were only permitted to reside in Canton for a few months of the year. The Foochow lacquer folding screens and cabinets, with their bold carving and rich colours embellished with powdered gold, were exported not only to Europe but also to Russian, Japan, Mecca and India. So many were transshipped from the Coromandel Coast of South India that this kind of lacquer became known in eighteenth-century England as Coromandel ware.

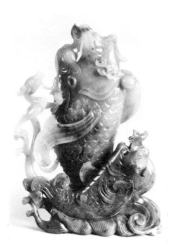

286 Carp leaping out of the water. Carved green and brownish jade. Ch'ing Dynasty.

K'ang-hsi's glass factory turned out a wide variety of coloured glass bottles and vases, the specialty being an opaque glass laminated in several contrasting colours, through which the designs were carved by the intaglio method. 'Snuff bottles' (originally made for medicine in the Sung and Yüan dynasties) were carved in glass and painted with enamel colours. They were also made in an endless variety of semi-precious substances such as lacquer, jade, crystal, coral, agate and enamel, all of which were imitated in porcelain at Ching-te-chen. In the eighteenth century the art of 'backpainting' on glass was introduced from Europe into China. It was said to have been practised by Castiglione in Peking, and soon became popular for painting delightful genre scenes on the backs of mirrors. The application of this technique to the decoration of the inside surface of transparent snuff bottles, first attempted about 1887, represents the last effort of the dying arts of the Ch'ing Dynasty to venture into new fields.

287 Taoist paradise. Panel of carved red lacquer inset with jade, lapis lazuli, and gilt metal. Ch'ing Dynasty.

288 Snuff bottle. Enamelled glass inscribed *Ku-yüeh-hsüan* on the base. Ch'ing Dynasty.

12

The Twentieth Century

It was towards the end of the nineteenth century that China began to stir once more to life, roused by the aggressive penetration of the Western powers. But it was to be decades before her response to Western art was anything more than passive or reluctantly imitative. China's rulers, unlike their Japanese counterparts of the Meiji period, did not see the arts of Europe as an aid to modernisation and reform. If they had any attitude at all to Western culture, as opposed to Western guns and machines, it was one of hostility and contempt, and the problems of the cultural confrontation were left to take care of themselves.

ARCHITECTURE From the mid-nineteenth century onwards, Western-style commercial buildings, schools and churches were rising wherever the foreigners penetrated. If those put up by the foreigners were bad, the Chinese imitations of them were even worse. A hybrid style combining Chinese and Western elements soon came into being, but until well into the present century, practising architects knew too little about traditional building methods to be able to adapt them successfully to modern materials, and the results were generally disastrous.

In 1930 a group of architects founded the Chinese Architectural Research Society to remedy this defect, and to explore new ways of adapting traditional forms to modern needs. It was joined in the following year by Liang Ssu-ch'eng, who became the dominating influence in Chinese architecture for three decades. The results of their work, and that of foreign architects such as Henry K. Murphy, can be seen in government and university buildings put up in Nanking, Shanghai, Peking and elsewhere during the few peaceful years before the Japanese invasion of 1937. Attractive as some of these are, they are still essentially Western buildings Sinicised with a traditional curved roof and enriched with detail translated from timber into painted concrete. A recent, deplorable example of this style is the National Palace Museum in Taipei, beloved of tourists. These architects had not yet discovered the truth, long since grasped by the Japanese, that the essence of their traditional architecture lies not in the curved roof, lovely as it is, but in the post-and-frame structure which, unlike the roof, is readily adaptable to modern needs and materials.

289 The Great Hall of the People, Peking, 1959.

After liberation in 1949, Chinese official architecture came for a time under the influence of the Soviet wedding-cake style, which left its mark on a group of public buildings put up in the 1950s, notably the Military Museum of the Chinese People's Revolution. This style has since been repudiated on economic no less than ideological grounds. Movement towards acceptance of what is loosely called the international modern style has been slow and cautious. Beginning with the Peking Children's Hospital (1954), it has been most successful where a major structural challenge had to be met, for instance in the Peking Worker's Gymnasium (1961) and the Capital Gymnasium (1971). The Great Hall of the People in Peking, seating ten thousand and completed in 1959 in the astonishingly short time of eleven months, is less remarkable for its style, which is conservative, than for its vast size, the classical dignity of its proportions, and its success as a symbol of the enduring strength of the new China.

DECORATIVE ARTS

The decorative arts of the last hundred years reveal the same unresolved conflict between new alien styles and stagnant traditional ones. Although the level of craftsmanship remained high, the porcelain, lacquer and carved jade produced before 1950 was derivative and uninspired. Liberation, however, brought with it a vigorous revival of traditional crafts, fostered initially by the Peking Handicrafts Research Institute. To take but one example, in the Peking Jade Studios alone there are today fifteen hundred carvers at work; young apprentices learn secrets once jealously guarded by old master craftsmen, and together they are producing work of a technical quality probably higher than at any time since the reign of Ch'ien-lung.

290 Ivory carving. *Ch'ang O Flies to the Moon*. Peking, 1972.

Much of the output of these workshops is produced for the export market, which demands chiefly traditional designs. But at the same time, the needs of a socialist society in process of rapid industrialisation are met by mechanisation, notably in some of the great ceramic factories at Ching-te-chen; while ever-popular traditional subjects are admitted by the simple device of investing them with new political symbolism. Of the ivory carving of Ch'ang O flying to the moon with the elixir of life to become a goddess—a technical achievement to match any in the Ch'ing Dynasty—we are told that the legendary heroine is "rebelling against feudal oppression and longing for a good life, as she flies skyward." While popular themes are thus easily brought into line, the design problems that arise during transition from handicraft to industrial mass-production have yet to be completely solved; but this should cause no surprise when we remember how long this process took in Europe.

PAINTING The painting of the last hundred years presents perhaps the most vivid illustration of the tensions between old ideas and new, native styles and foreign, that are shaping modern China. By the nineteenth century, the court painters, once so highly honoured, had sunk to a status hardly higher than that of palace servants, and even their names are not known. The literati too were victims of the growing paralysis of Ch'ing culture, and there were few outstanding amateur painters. In the first half of the century, Tai Hsi (1801–1860) and T'ang I-fen (1778–1853) were typically ortho-

291 Jen Po-nien (1840–1896), *Pine Tree and Mynah Birds*. Hanging scroll. Ink and colour on paper. Ch'ing Dynasty.

292 Wu Ch'ang-shih (1842–1927), *Lychee Nuts*. Hanging scroll. Ink and colour on paper.

dox followers of the academic literary style of Wang Hui. But after mid-century there came a gradual change. The style of Jen I (Jen Po-nien, 1840–1896), the most interesting of the late Ch'ing artists, owed part of its vigour to an infusion from popular art, part to the new restless spirit that was then abroad in the prosperous coastal cities such as Shanghai where Jen I worked.

For, in Shanghai where Jen Po-nien lived the impact of European civilisation was beginning to be felt. It showed itself in painting less in any change of style than in a new energy and boldness, which was perhaps the unconscious answer of the literati to the challenge of Western art. This new spirit burst forth in a handful of late followers of the Wu School such as Chao Chih-ch'ien (1829–1884), a distinguished scholar noted for his paintings of vines and flowers amid rocks, whose compositions and brush techniques were to influence the modern master Ch'i Pai-shih. Chao's follower Wu Ch'ang-shih (1842–1927) was a prolific painter chiefly of bamboo, flowers and rocks, which he combined with calligraphy in compositions of considerable power. The heavy, emphatic ink and strong colour these artists employed comes as a refreshing contrast to the timid good manners of the earlier generation.

Among the twentieth-century artists who may have been provoked into a reassertion of traditional styles, were Huang Pin-hung (1864/65–1955) and Ch'i Pai-shih (1863–1957). Huang Pin-hung was one of the last of the great Wu School landscape painters. He led the busy life of a 'professional amateur' between Shanghai and

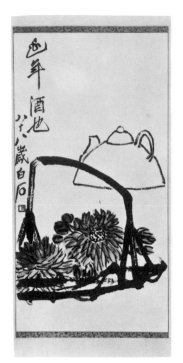

293 Ch'i Pai-shih (1863–1957), *The Thing for Prolonging Life Is Wine!* Hanging scroll. Ink and colour on paper.

294 Chang Dai Chien (born 1899), *Ten Thousand Miles of the Yangtse.* Detail of a handscroll, showing the Min River at Kuan-hsien, Szechwan. Ink and colour on silk.

Peking, as painter, teacher, art historian and connoisseur, developing a style that became more and more daring and expressionistic as he approached old age. From a very different milieu came Ch'i Pai-shih, son of a small tenant farmer in Hunan who by talent and sheer determination became a dominating figure among painters in Peking, expressing himself with great boldness and simplicity. In his sixties he painted some very original landscapes, but he is best known for his late paintings, chiefly of birds and flowers, crabs and shrimps, which he reduces to essentials while miraculously preserving their inner life. A far more versatile and sophisticated figure is the painter, collector and connoisseur Chang Dai Chien (Chang Ta-ch'ien), born at Nei-chiang in Szechwan in 1899 and trained in the Ch'ing literary style. While in the landscapes of his later years he made bold experiments in ink-flinging and -splashing that reflect the influence of abstract expressionism—a movement that has stimulated many Far Eastern painters since 1950—he always remained a traditionalist at heart, in his dress and bearing seemingly a survival from another age. The best of his work, such as the great landscape 'Ten Thousand Miles of the Yangtse' painted in 1968, combines a breadth of conception with a sharpness and clarity of detail that reminds us of Sung landscape painting.

THE MODERN MOVEMENT

It might be thought that Westernisation in the first half of the twentieth century would have dealt Chinese traditional art the same crippling blow that had struck Japanese art in the nineteenth. This did not happen, partly because of the overpowering strength of the tradition itself and the cultural self-confidence of the educated class, partly because 'fine art' was in the custody of amateurs and kept separate from their professional lives. Their work and milieu might change, but when they took up the brush, it was still to express themselves in the language of Tung Ch'i-ch'ang and Wang

Hui. Such was their belief in the validity of the tradition, moreover, that for the most part they could take what they wanted from Western art without surrendering to it. When, much later, Chairman Mao exhorted artists to "make foreign things serve China," and to "make the past serve the present," he was pointing a path forward that they found easy to follow, and one indeed that had already been taken by some artists, notably Hsü Pei-hung (Ju Péon, 1895–1953), a decade earlier. In spite of the artistic controversies that enlivened the twenties and thirties, Chinese artists on the whole avoided the violent oscillations between acceptance and rejection of the West that had shaken Japanese art since the Meiji restoration of 1868.

After tentative beginnings here and there in the coastal cities, the modern movement in Chinese art was launched in 1916 by Kao Chien-fu, who had recently returned to Canton from Japan. While in Tokyo, he had come under the influence of the Nihonga movement, dedicated to the revival of the Japanese tradition by introducing Western techniques such as shading and chiaroscuro, and contemporary subject matter: one of Kao Chien-fu's most famous

295 Hsü Pei-hung (Ju Péon, 1895–1953), *Magpies on an Old Tree*. Ink on paper. About 1944.

259

early hanging scrolls depicted a tank and an aeroplane. The work of Kao Chien-fu's *Ling-nan p'ai* (Cantonese School), as it was called, was too Japanese in feeling, and too deliberately synthetic, to command a wide following, but it showed that the traditional medium could be adapted to modern themes. Since 1949, shorn of its somewhat slickly decorative texture, the style created by the *Ling-nan p'ai* has been developed in China as one solution to the problem of expressing realistic, revolutionary content in the traditional medium.

The first modern art school in the Orient had been founded in 1876 in Tokyo. But no developments took place in China until 1906, when Nanking High Normal School and the Peiyang Normal School in Peking each opened a department of fine art on the Western pattern. They were soon followed in Shanghai by several private studios modelled upon romantic notions of the typical Paris atelier which had been acquired, very much at second hand, from Japanese artists who had studied in France. Soon after the end of the First World War, art schools were being opened in Peking and Shanghai, Nanking and Hangchow, while the more fortunate students were flocking to Paris where they came under the influence of the post-impressionists, Picasso and Matisse.

By the middle twenties, Hsü Pei-hung had returned to Nanking, Liu Hai-su to Shanghai, and Lin Feng-mien to Hangchow, and there was beginning to flourish in the big coastal cities an art which was for the most part just as academic as that of the traditional painters, the only difference being that now the medium was not Chinese ink but oil paint. The French Concession in Shanghai became a little Montmartre, the centre of a transplanted bohemianism that was inevitably quite out of touch with the feelings and aspirations of the mass of the Chinese people. In Hangchow, on the other hand, Lin Feng-mien and his pupils were beginning to develop a kind of painting that was both contemporary in feeling and Chinese in medium and technique.

296 Li Hua (born 1907), *Refugees: A Contrast*. Woodcut. About 1939.

297 Huang Yung-yü (contemporary), *Mountain Tribespeople*. Woodcut. About 1947.

In the early thirties, as the menace of Japanese aggression rose on the horizon, the atmosphere began to change. In Shanghai, the cosmopolitan Société des Deux Mondes founded by the modern painter P'ang Hsün-ch'in was dissolved, and the Storm Society took its place. Artists and writers became involved in bitter debates about their responsibility to society, the bohemians proclaiming a doctrine of art for art's sake, the realists urging a shift to the left and a closer identity with the people.

Finally, all doubts about the place of the artist in modern China were resolved by the Japanese attack on Peking in July 1937. Three years of steady retreat brought the painters and intellectuals close to the heart of the real China; and the later work of P'ang Hsün-ch'in, of the realists such as Hsiao Ting, and of the best of the wood engravers, is full of a sense of discovery—not only of their own people, but also of their own land. For they had been driven by the war far into the interior, to come for the first time face to face with the beauty of the western provinces, as yet untouched by the hybrid culture of the treaty ports. As the war dragged on, however, artists with a social conscience became bitterly disillusioned by the moral decay and corruption on the home front. Some joined the woodcut movement, which had been founded by the great writer Lu Hsün in the 1920s and was now being promoted as a weapon of socialist propaganda; others turned in protest to political cartooning or, to get round the censor, to an elaborate and indirect form of social symbolism.

The Japanese surrender in 1945 left China exhausted and longing for peace. But hardly had the firing died away when this unhappy land was plunged into civil war and all hopes of peaceful reconstruction were shattered. The art of the last years before the fall of the Kuomintang régime was marked by anger and bitterness on the part of the realist, or an almost defiant lyricism in the work of P'ang Hsün-ch'in, the wood engraver Huang Yung-yü, and Chao Wu-chi (Zao Wou-ki), a young student of Lin Feng-mien at the Hangchow Academy who had emerged from the obscurity of the

298 Chao Wu-chi (Zao Wou-ki, born 1921), untitled. Oil on canvas.

299 Lin Feng-mien (contemporary), *The Yangtse Gorges*. Ink and colour on paper.

300 Tseng Yu-ho (born 1923), *Hawaiian Village*. Ink on paper. 1955.

Japanese occupation with a highly sensitive and original style which seemed to point the way to a new direction in Chinese painting. In 1948, Chao Wu-chi went to Paris where he has since acquired an international reputation. Perhaps the most remarkable metamorphosis occurred in the art of Tseng Yu-ho who, from being a competent academic painter in the manner of her master P'u Ch'in in postwar Peking, has, since she went to live in Honolulu, come under the influence of some of the most advanced movements in Western art.

For nearly three decades, Chinese artists living outside the People's Republic have been expressing themselves as Chinese on the international scene. While the first Asian response to abstract expressionism took place in Japan in the 1950s, the Chinese painters who embraced the movement in the sixties gave it a new depth; for their response was at the same time a rediscovery of the abstract, calligraphic roots of their own tradition and not merely, as it had been for some Japanese artists, a skillful adoption of yet another new style from abroad. Yet, even when their work appears most abstract, it is, like that of the late T'ang expressionists, never entirely divorced from the natural world, and the fact that we can 'read' their abstractions as landscapes gives them an added, and very Chinese, dimension. The pioneers were the Fifth Moon group in Taipei, Lü Shou-k'un (Lui Shou Kwan), and members of the lively Circle and In Tao groups in Hongkong. Notable among Chinese artists in Southeast Asia, Chung Ssu-pin (Cheong Soo-pieng) in Singapore, before he became an abstract painter and worker in metal, was responding to the exotic beauty of the tropics with a style refreshingly free from the obvious influence of Gauguin. At the moment, the work of these artists has no place in China, where it would be

301 Lü Shou-k'un (1919–1976), *Mountain*. Hanging scroll. Ink on paper. 1962.

263

condemned as 'bourgeois formalism', however Chinese the artists themselves may feel. Yet it must be recognised as a uniquely Chinese contribution to the increasingly international character of modern art.

ART IN CHINA
SINCE LIBERATION

Meantime, within the People's Republic the total mobilisation of hands and minds to the task of transforming China into a great modern power has had a profound effect upon the arts. Chairman Mao's exhortations to creative artists to serve the people, and to take both from foreign art and from their own tradition what China could use, have borne fruit most spectacularly, not so much in painting as in a group of operas and ballets, such as *The White Haired Girl* and *The Red Detachment of Women*. In their novel combination of traditional and Western techniques, these dramatic works are certainly experimental, although they convey their meaning much too explicitly to be considered avant-garde in the usual Western sense of the term. There is today, in any case, no room, in any walk of Chinese life, for the individualist. Not only has orthodoxy been re-established from above, but the artists themselves are anxious to communicate with a public still largely uneducated in the arts. For them, modern Western movements which push the frontiers of art to new limits, or require a commentary to be comprehensible at all, have no appeal.

One might have expected that the dictates of socialist realism would have forced artists to abandon the traditional landscape conventions enshrined in such handbooks as the *Painting Manual of the Mustard Seed Garden* and simply paint what they saw. There is in China today a good deal of realistic art—or rather what is called 'revolutionary romanticism'; for it illustrates in semi-Westernised techniques not the actual state of society but what it ideally should be. At a more sophisticated level, however, artists are not abandoning their repertoire of conventional brushstrokes so much as checking it against nature itself and making it accord with their own visual experience. By thus "checking his *ts'un*" (the phrase is Ch'ien Sung-yen's), Li K'o-jan in his delightful 'Village in the Mountains' gives a new lease of life to the traditional language of landscape painting. In the 1950s and 1960s, Li K'o-jan, Ch'ien Sung-yen, Shih Lu, Ya Ming and other painters of the older generation thus succeeded in establishing a new traditional style, and their influence on younger artists has been considerable.

Although, by Western standards, the culture of the early 1960s was limited and conformist, it became the target for the Great Proletarian Cultural Revolution of 1966/69, which launched a devastating attack upon current 'bourgeois' trends in education, scholarship and the arts. Universities and art schools were closed, museums shut their doors, there were no more art exhibitions, and in June 1966 publication of all the art and archaeology journals abruptly ceased. Almost everyone engaged in these activities was criticised for 'revisionist' attitudes, and in some cases publicly disgraced and humiliated. The impression formed abroad was that

302 Li K'o-jan (born 1907), *Village in the Mountains*. Hanging scroll. Ink and colour on paper. About 1960.

all scholarly and artistic activity had come to an end—an impression which the Chinese authorities themselves did nothing to dispel. To remove all traces of élitism in the arts, the centre of artistic activity was shifted from the cities and art academies to factories and rural communes, while trained artists were urged to identify themselves with the masses. Vast numbers of workers, peasants and soldiers took up the arts as amateurs, developing new styles and techniques to express their own experience. Much of this new art lacks individuality, but it is bright in colour, sometimes daring in composition, and positive, if not overtly propagandist, in tone. There is no doubt that the 'New Year Pictures' such as those produced by members of the Hu-hsien commune near Sian, while utterly remote from the modern international movement, are contemporary in spirit and have a very wide appeal in China today.

265

During the turbulent years of the Cultural Revolution, artists and sculptors tended to sink their individuality in anonymous group projects such as 'The Rent Collection Courtyard', which, although completed in 1965, was praised by the leaders of the Cultural Revolution as a model and widely copied. A dramatic tableau of life-size figures in clay plaster, this much-admired work recreates around the courtyard of a rapacious former landlord in Szechwan a harrowing scene that had been only too familiar to the local tenant farmers before liberation. By 1972, some artists of whom nothing had been heard for six years were found to be quietly going on with their work, and in May of that year the first major exhibition of contemporary Chinese painting since 1966 was held in Peking. It was noted that a number of the pictures in that exhibition once again bore the signature and seal of the artist himself. But there was no return to the comparatively liberal position before 1966.

The relaxation of the extreme tensions of the Cultural Revolution years was accompanied by the reappearance of the archaeological journals, after six years of silence, when it became clear that rumours that had been circulating abroad about the destruction of the works of art and ancient monuments by extremist elements in the Red Guard had been greatly exaggerated, and that even though the museums were closed to the public, archaeology and conservation had continued at the high level they had attained in the years after 1949. A number of the discoveries made during these tumultuous years are illustrated in these pages.

Earlier editions of this book ended with the suggestion that the storms of the previous years were over and that Chinese civilisation had resumed its steady flow into the future. The upheaval of 1966/69, however, and some more recent developments, had left us wondering whether the flow was quite as steady as it had appeared.

303 Anonymous team of sculptors, *The Rent Collection Courtyard*. Detail of a life-size tableau in clay-plaster, in a former landlord's mansion at Ta-yi, Szechwan. 1965.

266

Chairman Mao has said that dynamic upheaval is good for society and that the Cultural Revolution was only the first of many to come. Certainly to maintain the level of intense idealism and dedication that the revolution generated demands unrelenting effort, although the observer cannot help wondering whether the constant assault of propaganda on the human mind does not in the end defeat itself. Yet, there is no denying the extraordinary achievement of the People's Republic that has made of China a potentially great power, that has fed, clothed and educated eight hundred million people, given them a security known nowhere else in the world, and brought the arts to every corner of the country. That some artists and writers have been under heavy pressure is undeniable. Readers of this book brought up in the Western liberal tradition may ask, has it been worth it? Is the improvement in the lot of the masses not bought at too great a cost? Does not the playing down of individual creative achievement in the arts lead to the stifling of the human spirit, and so to the death of art itself?

To these questions the Chinese answer today is a decisive 'no'. For the current Chinese view of the relationship of art to society, while certainly a political one, is also an ethical one. Forget yourself, the artist is told, and serve your fellow men. And if he claims that he can best serve society in total freedom, the challenge comes back: what is so special about *you*, that you, unlike the rest of us, should make demands for *yourself*? Because this appeal is a moral one, it is difficult to resist, particularly in China where in the past the ideal of intellectual or artistic freedom—or indeed of personal freedom in general—has only touched a very small segment of society. Moreover, it must be acknowledged that there is a deep satisfaction to be got from serving and helping to educate one's fellow men, from writing poems and painting pictures that move them, a sense of being wanted by society which some Western artists, driven to exploit a personal idiosyncrasy to gain any attention at all, may well envy.

The Chinese moreover take now, as always, a very long view. The time to talk about the freedom of the individual, they say, will come when the basic conditions of security and a livelihood for all have been fulfilled. They feel that at this moment in their history they are faced with but two alternatives: to create for an élite and lose touch with the masses, or to work for the masses and so raise the level of Chinese culture as a whole; and they have decisively chosen the latter course. Some artists, musicians and writers made the choice entirely voluntarily, others only after thorough and agonising 're-education'. What choices will be open to them when the general standard of performance and appreciation in the arts has been raised remains to be seen. But unless, as seems extremely unlikely, 'revisionism' once more gains the upper hand, and Chairman Mao's philosophy is repudiated, the guiding principle for creative artists and craftsmen must surely continue to be to 'serve the people'.

Notes to the text

CHAPTER 1

1. This is not in fact a very ancient legend, for in early times the Chinese had no creation myths at all, believing rather in a self-generating cosmos. Frederick Mote, *Intellectual Foundations of China* (New York, 1971), pp. 17–19, follows Derk Bodde in suggesting that it might even be of non-Chinese origin. But the fact that it became so well-accepted suggests that it fulfilled a need, at least at the popular level.

2. These are the latest published dates, corrected against the chronology of the bristle-cone pine. But there is reason to think that even these dates should be accepted with caution, for recent work at the British Museum and elsewhere suggests that there may have been wide fluctuations in atmospheric carbon 14 even within a period of a decade or less, and as a result archaeologists are beginning to wonder whether dating errors of many hundred years may sometimes occur because of these sudden fluctuations. See *Nature* 262 (July, 1976).

3. Kwang-chih Chang (Chang Kwang-chih), *The Archaeology of Ancient China*, 2nd ed. (New Haven, Connecticut, 1968), page 148.

CHAPTER 2

1. Mizuno Seiichi, *Bronzes and Jades of Ancient China* (1959), pages 8–9.

2. Some years ago Bernhard Karlgren, studying the form and decoration of a large number of Shang bronzes, divided them into two distinct styles, A and B. He could not explain, however, why there should be two styles. Recently, Chang Kwang-chih has suggested a simple solution to the problem. He has shown that the Shang rulers had a dualistic system whereby the succession went to two different groups of the royal house alternately; there were two traditions of the oracle-bone scripts, two parallel rows of royal ancestral halls, two clusters of royal tombs. It is reasonable to suppose, therefore, that the two bronze styles may have been associated with the two lines of succession of the royal family. See Kwang-

chih Chang, *The Archaeology of Ancient China*, page 255.

3. S. Howard Hansford, *Chinese Jade Carving* (London, 1950), page 31.

CHAPTER 3

1. Arthur Waley, *The Book of Songs*, (London, 1937), pages 282–283.

2. Slightly adapted from Bernhard Karlgren, *A Catalogue of the Chinese Bronzes in the Collection of Alfred F. Pillsbury* (Minneapolis, 1952), page 105. The last sentence, a common formula in the inscriptions, makes it clear that the bronzes were made for ritual use rather than for burial.

CHAPTER 4

1. It was Arthur Waley in *An Introduction to the Study of Chinese Painting* (London, 1923, pages 21–23) who first pointed out the importance of Ch'u in the emergence in ancient China both of creative art and of a consciousness of the power of the artistic imagination. More recently, David Hawkes has discussed the contribution of Ch'u in his *Ch'u Tz'u, The Songs of the South* (Oxford, 1959). He ends his "General Introduction" (page 19) with these words: "As we begin to learn from the archaeologists something of the art of that great but ill-fated Kingdom of Ch'u, it becomes apparent that what we have in the earlier poems of *Ch'u Tz'u* is not an isolated and unaccountable literary phenomenon, but the full flowering of a remarkable and fascinating culture."

2. David Hawkes, *op. cit.*, page 108. The phrase *hsi-pi*, indicating the Western origin of these buckles, may be derived from the Turkic-Mongol word for a garment hook, *särbe*.

3. See Su T'ien-chun, "Report on the Excavation of a Warring States Tomb at Sung-yüan-ts'un, Ch'ang-p'ing District, Peking," *Wen Wu* 9, 1959, pages 53–55 (in Chinese). These remarks, written in 1966, are borne out by a thermoluminescence test on twenty-two typical 'Hui-hsien' pieces, chiefly from

well-known English and American collections, all of which were proved to be modern. See S. J. Fleming and E. H. Sampson, "The Authenticity of Figurines, Animals and Pottery Facsimiles of Bronzes in the Hui Hsien Style," *Archaeometry* 14, 2 (1972), pages 237–244.

CHAPTER 5

1. David Hawkes, *Ch'u Tz'u, The Songs of the South* (Oxford, 1959), pages 105–107. Hawkes suggests (page 103) that this poem may have been written in 208 or 207 B.C.

2. Translated by Arthur Waley, *Introduction to the Study of Chinese Painting* (London, 1923), pages 30–31.

3. B. Karlgren, "Early Chinese Mirror Inscriptions," *B.M.F.E.A.* 6 (1934), page 49.

4. As fresh discoveries increase the number of known kilns—only a very few of which are mentioned in this book—the problem of nomenclature becomes more and more acute. But until Chinese ceramics experts produce a new definitive classification it would not be helpful to the reader to depart too far from accepted names for well-known wares. For an up-to-date list of known kilns, see Yokata Mino and Patricia Wilson, *An Index to Chinese Ceramic Kiln Sites from the Six Dynasties to the Present* (Royal Ontario Museum, Toronto, 1973).

CHAPTER 6

1. Beautifully translated by Ch'en Shih-hsiang in *Literature as Light Against Darkness*, rev. ed. (Portland, Maine, 1952).

2. William R. B. Acker, *Some T'ang and Pre-T'ang Texts on Chinese Painting* (Leiden, 1954), page XXX.

3. There are a number of delightful stories about him in his official biography and in that fascinating collection of gossip, *Shih-shuo hsin-yü*. See Arthur Waley's account of him in *An Introduction to the Study of Chinese Painting*, pages 45–66, and Ch'en Shih-hsiang's translation of the official life, No. 2 in the University of California's translations of Chinese Dynastic Histories (Berkeley, 1953).

4. A Late Sung version of the *Lieh-nü t'u* in Peking is illustrated in *Wen wu ts'an-k'ao tzu-liao*, 1958, 6, pages 22–24. The copyist has made effective use of the shading technique for drapery (visible also in the bed hangings of the *Admonitions* scroll), which seems to have been a peculiarity of Ku's style.

5. This motive was frankly admitted in an edict of one of the barbarian rulers of Later Chao (c. A.D. 335): "We were born out of the marches," he declared, "and though We are unworthy, We have complied with our appointed destiny and govern the Chinese as their prince. . . . Buddha being a barbarian god is the very one we should worship." See Arthur Wright, "Fo-t'u-teng, A Biography," *Harvard Journal of Asiatic Studies* II (1948), page 356.

6. The caves were first documented by Sir Aurel Stein, who visited them in 1907 and brought away with him a large collection of manuscripts and paintings from a sealed library. In the following year, the great French sinologue Paul Pelliot systematically photographed and numbered the caves. His numbers, totalling nearly 300, are familiar to Western readers and appear in my text in brackets, preceded by the letter "P." A second system of numbering was used by the noted painter Chang Ta-ch'ien, who with his assistants copied some of the frescoes during the Second World War. A third system was adopted by the National Art Research Institute at Tunhuang, which since 1943 has been actively engaged in preserving, restoring and copying the painting under the directorship of Ch'ang Shu-hung. This organisation has now identified 492 caves and niches, and I have used their system in this book.

CHAPTER 7

1. It was probably the demands of Mahāyāna Buddhism for the endless multiplication of icons, diagrams, spells and texts that brought about the rapid development of block printing during the T'ang Dynasty. The earliest printed text yet discovered is a Buddhist charm dated equivalent to A.D. 770, found at Tunhuang by Sir Aurel Stein. It is likely, however, that the Chinese and Tibetans had been experimenting with block printing since the middle of the sixth century, while the use of seals in Shang China and the practice of taking rubbings of inscriptions engraved on stone (made possible by the Han invention of paper) point to the existence of printing of a sort at a far earlier date.

2. Chang Tsao's contribution to the evolution of T'ang landscape style is discussed in my article "A Forgotten T'ang Master of Landscape Painting," *The Burlington Magazine*, July, 1975, pages 484–486.

3. *Aḥbār aṣ-Ṣīn Wa I-Hind*. Trans. and ed. Jean Sauvaget (1948), 16, Section 34.

4. The Ting ware kilns at Chien-tz'u-ts'un in Hopei were already producing a fine white porcelain, which may have been the elusive Hsing yao.

5. See *Chinese Tomb Pottery Figurines* (Hongkong, 1953), page 9.

6. From the *Compendium of Deities of the Three Religions, San chiao sou shen ta chuan*, quoted in Lu Hsün, *A Brief History of Chinese Fiction*, trans. Yang Hsien-yi and Gladys Yang (Peking, 1959), pages 21–22.

CHAPTER 8

1. Sickman and Soper, *The Art and Architecture of China* (London 1968), pages 97–98.

2. This passage has been slightly adapted from Tsung Pai-hua, "Space-consciousness in Chinese Painting," *Sino-Austrian Cultural Association Journal* I (1949), page 27 (trans. Ernst J. Schwartz). Chinese

theorists distinguish three kinds of perspective in Chinese painting: *kao yüan* ("high distance") depicts the mountains as they would be seen by someone who was looking upwards from below; *shen yüan* ("deep distance") presents a bird's-eye view over successive ranges to a high and distant horizon; while *p'ing yüan* ("level distance") involves a continuous recession to a rather low horizon, such as we most often encounter in European landscape painting.

3. Yoshikawa Kōjirō, trans. Burton Watson, *Introduction to Sung Poetry* (Cambridge, England, 1967), page 37.

4. This passage has been slightly adapted from Naitō Tōichirō, *The Wall-Paintings of Hōryūji*, trans. William Acker and Benjamin Rowland (Baltimore, 1943), pages 205-206. Although the temple in question was burned down at the end of the Liang Dynasty, and the connection with Chang Seng-yu is legendary, there is little doubt that this technique was practised in sixth-century wall painting.

5. Osvald Sirén, *Chinese Painting* I (1956), p. 175.

6. K. Okakura, *The Awakening of Japan* (1905), page 77.

Chapter 9

1. See Sir Henry Yule, trans., *The Travels of Marco Polo*, (London, 1903).

2. For a discussion of what and why the Chinese write on paintings, see my *Three Perfections: Chinese Painting, Poetry and Calligraphy* (London, 1974).

3. Chang Yen-yüan in the *Li-tai ming-hua-chi* mentions three bamboo paintings executed before A.D. 600, and bamboo can be seen in the murals in several of the Six Dynasties caves at Tunhuang.

Chapter 10

1. Yung-lo is not, properly speaking, the name of the emperor, but an auspicious title which he gave to his reign period as a whole, thus doing away with the old system of choosing a new era name every few years. The custom continued during the Ch'ing Dynasty. K'ang-hsi, for example, is the title of the reign period of the emperor Sheng-tsu, Ch'ien-lung that of Kao-tsung. But because these reign titles have become so well known in the West, chiefly through their use as marks on Chinese porcelain, I shall continue to use them in this book.

2. Adapted from Richard Edwards, *The Field of Stones: A Study of the Art of Shen Chou* (Washington, D.C., 1962), page 40.

3. See Sir Percival David, *Chinese Connoisseurship: the Essential Criteria of Antiquities* (London, 1971), pages 143-144.

Chapter 11

1. The catalogue of the Ch'ien-lung collection, *Shih-ch'ü pao-chi*, was compiled in three volumes between 1745 and 1817. Buddhist and Taoist works were catalogued separately. A survey made by the Palace Museum authorities in 1928-31 showed the vast scale of the collection: 9000 paintings, rubbings and specimens of calligraphy, 10,000 pieces of porcelain, over 1200 bronze objects, and a large quantity of textiles, jades and minor arts. Some of the finest pieces had been sold or given away by the last Manchu emperor, P'u-yi, during the twenty years following the revolution of 1911. All but a fraction of the remainder were shipped to Taiwan by the Kuomintang in 1948.

2. For a discussion of the European impact on Chinese art, see my book *The Meeting of Eastern and Western Art* (London and New York, 1973), and Cecile and Michel Beurdeley, *Giuseppe Castiglione: A Jesuit Painter at the Court of the Chinese Emperors*, trans. Michael Bullock (Rutland, Vermont, 1972).

3. Europe, at this time, felt much the same way about China. "In *Painting*," wrote Alvarez de Semedo in 1641, "they have more curiositie than perfection. They know not how to make use of either *Oyles* or *Shadowing* in the Art. . . . But at present there are some of them, who have been taught by us, that use *Oyles*, and are come to make perfect pictures." Sandrart, in his *Teutsche Akademie* (1675), expressed a similar view. Cf. my article, "Sandrart on Chinese Painting," *Oriental Art* I, 4 (Spring, 1949), pages 159-161.

4. For a translation and commentary on this difficult text, see Pierre Ryckmans, *Les 'Propos sur la Peinture' de Shitao* (Brussels, 1970).

5. They were originally published in the Jesuit miscellany *Lettres édifiantes et curieuses*, vols. XII and XVI (1717 and 1724), reprinted in S. W. Bushell, *Description of Chinese Pottery and Porcelain* (Oxford, 1910), and translated in part by him in his *Oriental Ceramic Art* (New York, 1899). Some interesting passages are quoted by Soame Jenyns in his *Later Chinese Porcelain* (London, 1951), pages 6-14.

6. The various theories about the origin and meaning of the name are discussed by Soame Jenyns in Appendix I of his *Later Chinese Porcelain*, pages 87-95.

Books for Reference and Further Reading

General Works on China

Raymond Dawson, ed., *The Legacy of China* (Oxford, 1964).

C. P. Fitzgerald, *China: A Short Cultural History*, 3rd rev. ed. (London, 1961).

Charles O. Hucker, *China's Imperial Past: An Introduction to Chinese History and Culture* (Stanford, 1975).

Joseph Needham, *Science and Civilisation in China*, vol. I (Cambridge, England, 1954).

General Works on Chinese Art

S. Howard Hansford, *A Glossary of Chinese Art and Archaeology*, rev. ed. (London, 1961).

Sherman E. Lee, *A History of Far Eastern Art* (London, 1964).

Laurence Sickman and A. C. Soper, *The Art and Architecture of China*, rev. ed. (London, 1968).

Michael Sullivan, *Chinese Art in the Twentieth Century* (London, Berkeley and Los Angeles, 1959); *Chinese and Japanese Art*, vol. IX of *Great Art and Artist of the World* (New York, 1966); *The Meeting of Eastern and Western Art* (London and New York, 1973).

Exhibitions and General Collections

Jan Fontein and Tung Wu, *Unearthing China's Past* (Boston, 1973).

S. Howard Hansford, *Chinese, Central Asian and Luristan Bronzes and Chinese Jades and Sculptures*, vol. I of *The Seligman Collection of Oriental Art* (London, 1957).

R. L. Hobson and W. P. Yetts, *The George Eumorfopoulos Collection*, 9 vols. (London, 1925–1932).

Sherman E. Lee and Wai-Kam Ho, *Chinese Art Under the Mongols: The Yüan Dynasty (1279–1368)* (Cleveland, 1969).

Nelson Gallery—Atkins Museum, Kansas City, and Asian Art Museum of San Francisco, *The Chinese Exhibition: A Pictorial Record of the Exhibition of Archaeological Finds of the People's Republic of China* (Kansas City, Missouri, 1975).

Nils Palmgren, *Selected Chinese Antiquities from the Collection of Gustav Adolf Crown Prince of Sweden* (Stockholm, 1948).

Royal Academy of Arts, *The Chinese Exhibition: A Commemorative Catalogue of the International Exhibition of Chinese Art in 1935–36* (London, 1936).

Michael Sullivan, *Chinese Ceramics, Bronzes and Jades in the Collection of Sir Alan and Lady Barlow* (London, 1963).

Archaeology

Terukazu Akiyama and others, *Arts of China, Neolithic Cultures to the T'ang Dynasty. New Discoveries* (Tokyo and Palo Alto, 1968).

J. G. Andersson, *Children of the Yellow Earth* (London, 1934).

Anon, *Historical Relics Unearthed in New China* (Peking, 1972).

Kwang-chih Chang, *The Archaeology of Ancient China*, rev. ed. (New Haven, Connecticut, and London, 1968).

Cheng Te-k'un, *Archaeology in China*: Vol. I, *Prehistoric China* (Cambridge, England, 1959); Vol. II, *Shang China* (Cambridge, England, 1960); Vol. III, *Chou China* (Cambridge, England, 1966); *New Light on Prehistoric China* (Cambridge, England, 1966).

Ping-ti Ho, *The Cradle of the East* (Chicago, 1976).

Li Chi, *The Beginnings of Chinese Civilisation* (Seattle, 1957).

Michael Sullivan, *Chinese Art: Recent Discoveries* (London, 1973).

Bronzes

Noel Barnard, *Bronze Casting and Bronze Alloys in Ancient China* (Canberra and Nagoya, 1961).

Bernhard Karlgren, *A Catalogue of the Chinese Bronzes in the Alfred F. Pillsbury Collection* (Minneapolis, 1952); many important articles in the *Bulletin of the Museum of Far Eastern Antiquities* (Stockholm).

Max Loehr, *Chinese Bronze Age Weapons* (Ann Arbor, Michigan, 1956); *Ritual Vessels of Bronze Age China* (New York, 1968).

J. A. Pope and others, *The Freer Chinese Bronzes*, 2 vols. (Washington, D.C., 1968).

Mizuno Seiichi, *Bronzes and Jades of Ancient China* (in Japanese with English summary, Kyoto, 1959).

William Watson, *Ancient Chinese Bronzes* (London, 1962).

Painting and Calligraphy

James Cahill, *Chinese Painting* (New York, 1960); *The Restless Landscape: Chinese Painting of the Late Ming Period* (Berkeley, 1971).

Chiang Yee, *Chinese Calligraphy* (London, 1954).

Lucy Driscoll and Kenji Toda, *Chinese Calligraphy*, 2nd ed. (New York, 1964).

Richard Edwards, *The Field of Stones: A Study of the Art of Shen Chou* (Washington, D.C., 1962); *The Art of Wen Cheng-ming* (1470–1559) (Ann Arbor, Michigan, 1975).

Marilyn and Shen Fu, *Studies in Connoisseurship: Chinese Paintings from the Arthur M. Sackler Collection in New York and Princeton* (Princeton, New Jersey, 1973).

Basil Gray and John B. Vincent, *Buddhist Cave Paintings at Tunhuang* (London, 1959).

R. H. van Gulik, *Chinese Pictorial Art as Viewed by the Connoisseur* (Rome, 1958).

Kuo Hsi, *An Essay on Landscape Painting*, trans. S. Sakanishi ("Wisdom of the East" series, London, 1936).

Thomas Lawton, *Chinese Figure Painting* (Washington, D.C., 1973).

Sherman E. Lee, *Chinese Landscape Painting*, rev. ed. (Cleveland, 1962).

Chu-tsing Li, *A Thousand Peaks and Myriad Ravines: Chinese Paintings in the Charles A. Drenowatz Collection*, 2 vols. (Ascona, 1974).

S. Sakanishi, *The Spirit of the Brush* ("Wisdom of the East" series, London, 1939).

Osvald Sirén, *The Chinese on the Art of Painting* (New York, 1963); *Chinese Painting: Leading Masters and Principles*, 7 vols. (London, 1956 and 1958).

A. C. Soper, *Kuo Jo-hsü's Experiences in Painting, T'u-hua chien-wen chih* (Washington, 1951).

Laurence Sickman, ed., *Chinese Painting and Calligraphy in the Collection of John M. Crawford, Jr.* (New York, 1962).

Michael Sullivan, *The Birth of Landscape Painting in China* (Berkeley, Los Angeles and London, 1961); *The Three Perfections: Chinese Painting, Poetry and Calligraphy* (London, 1974).

Tseng Yu-ho Ecke and Jean Gordon Lee, *Chinese Calligraphy* (Philadelphia, 1971).

Arthur Waley, *An Introduction to the Study of Chinese Painting* (London, 1923; more fully illustrated ed., 1958).

Sculpture

Leroy Davidson, *The Lotus Sutra in Chinese Art* (New York, 1954).

Mizuno Seiichi and Nagahiro Toshio, *Unko Sekkutsu: Yun-kang, The Buddhist Cave Temples of the Fifth Century A.D. in North China*, 16 vols. in Japanese with English summary, (Kyoto, 1952–1955); *Chinese Stone Sculpture* (Tokyo, 1950); *Bronze and Stone Sculpture of China: From the Yin to the T'ang Dynasty*, in Japanese and English, (Tokyo, 1960).

Alan Priest, *Chinese Sculpture in the Metropolitan Museum of Art* (New York, 1954).

Richard Rudolf, *Han Tomb Art of West China* (Berkeley and Los Angeles, 1951).

Osvald Sirén, *Chinese Sculpture from the Fifth to the Fourteenth Centuries*, 4 vols., (London, 1925).

A. C. Soper, *Literary Evidence for Early Buddhist Art in China* (Ascona, 1959).

Michael Sullivan and Dominique Darbois, *The Cave Temples of Maichishan* (London, Berkeley and Los Angeles, 1969).

Architecture

Andrew Boyd, *Chinese Architecture and Town Planning* (London, 1962).

J. Prip-Møller, *Chinese Buddhist Monasteries* (Copenhagen and London, 1937).

Osvald Sirén, *The Walls and Gates of Peking* (London, 1924); *The Imperial Palaces of Peking*, 3 vols., (Paris and Brussels, 1926); *Gardens of China* (New York, 1949).

Ceramics

John Ayers, *Chinese and Korean Pottery and Porcelain*, Vol. II, *The Seligman Collection of Oriental Art* (London, 1964); *The Baur Collection*, 2 vols. (London, 1972).

Stephen Bushell, *Description of Chinese Pottery and Porcelain: Being a Translation of the T'ao Shuo* (Oxford, 1910).

Sir Harry Garner, *Oriental Blue and White* (London, 1954).

G. St. G. M. Gompertz, *Chinese Celadon Wares* (London, 1958).

A. L. Hetherington, *Chinese Ceramics Glazes* (London, 1948).

R. L. Hobson, *Chinese Pottery and Porcelain* (London, 1915); *The Wares of the Ming Dynasty* (London, 1923); *A Catalogue of Chinese Pottery and Porcelain in the Collection of Sir Percival David* (London, 1934).

W. B. Honey, *The Ceramic Art of China and Other Countries of the Far East* (London, 1945).

Soame Jenyns, *Ming Pottery and Porcelain* (London, 1953); *Later Chinese Porcelain*, rev. ed. (London 1965).

John A. Pope, *Fourteenth-Century Blue and White: A Group of Chinese Porcelains in the Topkapu Sarayi Musesi, Istanbul* (Washington, 1952); *Chinese Porcelain from the Ardebil Shrine* (Washington, 1956).

Suzanne G. Valenstein, *A Handbook of Chinese Ceramics* (New York, 1975).

G. D. Wu, *Prehistoric Pottery in China* (London, 1938).

See also Exhibitions and General Collections.

JADE AND MINOR ARTS

Schuyler Cammann, *China's Dragon Robes* (New York, 1952).

Martin Feddersen, *Chinese Decorative Art* (London, 1961).

Sir Harry Garner, *Chinese and Japanese Cloisonné Enamels* (London, 1962)

S. Howard Hansford, *Chinese Jade Carving* (London, 1950); *Chinese Carved Jades* (London, 1968).

Soame Jenyns and William Watson, *Chinese Art: The Minor Arts* (London, 1963).

George N. Kates, *Chinese Household Furniture* (London, 1948).

Berthold Laufer, *Jade: A Study in Chinese Archaeology and Religion* (New York, 1912).

Max Loehr, *Ancient Chinese Jades from the Grenville L. Winthrop Collection* (Cambridge, England, 1975).

Alfred Salmony, *Chinese Jade Through the Wei Dynasty* (New York, 1963).

Pauline Simmons, *Chinese Patterned Silks* (New York, 1948).

PERIODICALS

Archives of Asian Art, formerly *Archives of the Chinese Art Society of America*, (New York, 1945–).

Ars Orientalis (Washington, D.C., and Ann Arbor, Michigan, 1954–).

Artibus Asiae (Dresden, 1925–1940); Ascona, 1947–).

Bulletin of the Museum of Far Eastern Antiquities (Stockholm, 1929–).

China Reconstructs (Peking, 1950–).

Far Eastern Ceramic Bulletin (Boston, 1948–1950; Ann Arbor, Michigan, 1951–1960).

Oriental Art (Oxford, 1948–1951, New Series, 1955–).

Ostasiatische Zeitschrift (Berlin, 1912–1943).

Revue des Arts Asiatiques (Paris, 1924–1939).

Transactions of the Oriental Ceramic Society (London, 1921–).

Maps and Illustrations

of Art and Atkins Museum, Kansas City, Mo.

38 Ritual vessel, *hu*. Ht. 60.6 cm. Center of Asian Art and Culture, The Avery Brundage Collection, San Francisco.

39 Ritual vessel, *hu*. Ht. 52 cm. People's Republic of China.

40 Ritual and funerary jades.

41 Ritual tube, *tsung*. Ht. 21.5 cm. British Museum, London.

42 Jar. Ht. 27.5 cm. From a tomb at Pei-yao-ts'un, Loyang, Honan.

MAP 4 China in the Warring States period.

43 Chariot burial. Lui-li-ko, Hui-hsien, Honan.

44 Ritual vessel, *ting*, with reversible cover, "Li-yü style." Ht. 23.5 cm. Center of Asian Art and Culture, The Avery Brundage Collection, San Francisco.

45 Flask, *pien-hu*. Ht. 31.1 cm. Freer Gallery of Art, Washington, D.C.

46 Ritual vessel, *ting*. Ht. 15.2 cm. Probably from Chin-ts'un, Loyang. The Minneapolis Institute of Arts.

47 Striking the bells. From a rubbing of a third-century A.D. stone relief in the tomb at I-nan, Shantung.

48 Bell, *chung*. Ht. 66.4 cm. Freer Gallery of Art, Washington, D.C.

49 Bell, *chung*. Detail of decoration on top. Freer Gallery of Art, Washington, D.C.

50 Harness plaques. Upper, L. 11.4 cm., Freer Gallery of Art, Washington, D.C.; lower, L. 11.5 cm. British Museum, London.

51 Ritual vessel, *hu*. Ht. 39.3 cm. Center of Asian Art and Culture, The Avery Brundage Collection, San Francisco.

52 Belt-hook. L. 15.7 cm. Fogg Art Museum, Cambridge, Mass., Grenville R. Winthrop Bequest.

53 Miniature vessels. Excavated at Ch'ang-p'ing. People's Republic of China.

54 Covered bowl. Ht. 16.5 cm. Probably from Shou-chou, Anhui. Honolulu Academy of Arts.

55 Sketch of reconstructed tomb, showing the *ming-ch'i* crammed between the outer and inner coffins. Changsha, Hunan.

56 Painted figurines from tombs at Changsha, Hunan. After Kwang-chih Chang.

57 Cult object or guardian in the form of a horned, long-tongued creature eating a snake. Ht. 195 cm. Excavated in Hsin-yang, Honan. People's Republic of China.

58 Drawing of drum or gong stand. Ht. 163 cm. From Hsin-yang, Honan. People's Republic of China.

59 Woman with dragon and phoenix. Ht. 30 cm. From Changsha, Hunan. People's Republic of China.

60 Bowl. Diam. 35.4 cm. Seattle Art Museum, Eugene Fuller Memorial Collection.

61 Designs on an inlaid bronze *hu*.

62 Rubbing of back of a mirror. Diam. 6.7 cm. Excavated from Kuo State Cemetery at Shang-ts'un-ling, Honan. People's Republic of China.

63 Mirror, Loyang type. Diam. 16 cm. Museum of Fine Arts, Boston.

64 Mirror, Shou-chou type. Diam 15.3 cm. Ashmolean Museum, Oxford.

65 Chain of four discs with linking collars, carved from a single piece of jade. L. 21.5 cm. British Museum, London.

66 Two concentric *huan* discs with dragons. Diam. of outer disc 16.5 cm. Nelson Gallery of Arts and Atkins Museum, Kansas City, Mo.

MAP 5 China in the Han Dynasty.

67 The hunt among mountains. Former Hosokawa Collection, Tokyo.

68 Seated Buddha in *abhaya-mudrā*. Rubbing of a relief in a shaft tomb at Chiating, Szechwan.

69 Gateway to a palace or mansion. Rubbing from brick relief. Ht. 41 cm. From Szechwan. People's Republic of China.

70 Isometric sketch of a stone tomb at I-nan, Shantung.

71 Horse trampling on a barbarian archer. Ht. 188 cm. Hsien-yang, Shensi. People's Republic of China.

72 Rhinoceros. L. 57.8 cm. Found in Hsing-p'ing, Shensi. People's Republic of China.

73 Warrior. Ht. 182 cm. From the tomb pit of Ch'in Shih-huang-ti, Lin-t'ung, Shensi.

74 Lamp held by kneeling servant-girl. From the tomb of Tou Wan (died c. 113 B.C.), Man-ch'eng, Hopei. People's Republic of China.

75 Pacing horse poised on a swallow with wings outstretched. L. 45 cm. From a tomb at Lei-t'ai, Kansu. People's Republic of China.

76 Top of memorial pillar (*ch'üeh*) for a member of the Shen family. Ch'ü-hsien, Szechwan.

77 The archer Yi, the *Fu-sang* tree, and a mansion. Detail of rubbing from a stone relief in the tomb shrine of Wu Liang, Chia-hsiang, Shantung.

78 Shooting birds on a lake shore and harvesting. Moulded pottery tile. Ht. 42 cm. From Kuanghan, Szechwan. People's Republic of China.

79 Guests arriving for the funeral feast. Detail of a wall painting. From a tomb in Liao-yang, northwest China.

80 Gentlemen in conversation. Detail of a painted pottery tile. Ht. 19 cm. Museum of Fine Arts, Boston.

81 Paragons of filial piety. Lacquer painting on basketwork box. Ht. of figures about 5 cm. From Lo-lang, Korea. National Museum, Seoul.

82 Covered square-section jar, *fang-hu*. Ht. 50.5 cm. From a tomb at Ma-wang-tui, Changsha, Hunan. People's Republic of China.

83 Painted funerary banner, *fei i*. Detail. Ht. 205 cm. From Tomb No. 1 at Ma-wang-tui, Changsha, Hunan. People's Republic of China.

84 Detail of funerary banner, *fei i*. People's Republic of China. Line drawing.

85 Fairy mountain incense burner, *Po-shan hsiang-lu*. Ht. 26 cm. From the tomb of Liu Sheng (died 113 B.C.) at Man-ch'eng, Hopei. People's Republic of China.

86 Drum-shaped container for cowrie shells, with modelled sacrificial scene. Diam. 34 cm. From Shih-chai-shan, Yunnan. People's Republic of China.

87 Carriage fittings.

88 TLV-type cosmological mirror. Diam. 18 cm. Seligman Collection, Arts Council of Great Britain, London.

89 Immortals playing *liu-po*. Rubbing from a stone relief on a tomb at Hsin-chin, Szechwan.

90 Mirror with Taoist motifs. Diam. 13.7 cm. Center of Asian Art and Culture, The Avery Brundage Collection, San Francisco.

91 "Winged cup," *yü-shang*. L. 13.2 cm. Freer Gallery of Art, Washington, D.C.

92 Head and shoulders of a horse. Ht. 18.9 cm. Victoria and Albert Museum, London.

93 Burial suit. L. 188 cm. From the tomb of Liu Sheng (died 113 B.C.) at Man-ch'eng, Hopei. People's Republic of China.

94 Figured silk fabric. From Noin-Ula, Mongolia. Hermitage Museum, Leningrad.

95 Woven silk textile. From tomb No. 1 at Ma-wang-tui, Changsha, Hunan. People's Republic of China.

96 Silk panel from Noin-Ula.

97 Jar, *hu*. Ht. 36.5 cm. Nelson Gallery of Art and Atkins Museum, Kansas City, Mo.

98 The hunt among mountains. Relief on the shoulder of a pottery *hu*.

99 Watchtower. Ht. 120 cm. Royal Ontario Museum, Toronto.

100 Dog. Ht. 35.5 cm. From Changsha, Hunan. Center of Asian Art and Culture, The Avery Brundage Collection, San Francisco.

101 Tray with figures of musicians, dancers, acro-bats, and spectators. L. 67.5 cm. From a tomb at Tsinan, Shantung. People's Republic of China.

102 Stand for a lamp or 'coin-tree'. From a tomb at Nei-chiang, Szechwan. People's Republic of China.

103 Basin, Yüeh ware. Diam. 28.8 cm. Walker Art Center, Minneapolis, Minn.

MAP 6 China during the Three Kingdoms period.

104 After Ku K'ai-chih (c. 344–406). Illustration to *The Fairy of the Lo River*. Detail of a handscroll. Ht. 24 cm. Freer Gallery of Art, Washington, D.C.

105 Attributed to Ku K'ai-chih. The emperor with one of his concubines. Illustration to *The Admonitions of the Instructress*. Detail of a handscroll. Ht. 25 cm. British Museum, London.

106 Filial sons and virtuous women of antiquity. Panel from a wooden screen painted in lacquer. Ht. 81.5 cm. From a tomb dated 484 at Ta-t'ung, Shansi. People's Republic of China.

107 Hunting scene. Wall painting in the 'Tomb of the Wrestlers', T'ung-kou, Kirin.

108 The story of the filial Shun. Detail of an engraved stone slab from a sarcophagus. Ht. 61 cm. Nelson Gallery of Art and Atkins Museum, Kansas City, Mo.

MAP 7 The spread of Buddhism from India into central and eastern Asia.

109 Śākyamuni Buddha. Ht. 39.4 cm. Center of Asian Art and Culture, The Avery Brundage Collection, San Francisco.

110 Types of pagoda.

111 Twelve-sided pagoda of Sung-yüeh-ssu on Mount Sung, Honan.

112 Mai-chi-shan, Kansu. View from the southeast. Photo by Dominique Darbois.

113 Śākyamuni with attendant Buddha, perhaps Maitreya. Ht. 13.7 m. Cave XX, Yünkang, Shansi. Photo by the author, 1975.

114 Interior of Cave VII, Yünkang.

115 Buddha group, south wall of Pin-yang-tung, Lungmen.

116 The Wei Empress in procession with court ladies. Ht. 198 cm. Nelson Gallery of Art and Atkins Museum, Kansas City, Mo.

117 Stele illustrating the life of the Buddha and the teachings of the *Lotus Sūtra*. In Cave 133, Mai-chi-shan, Kansu. Photo by Dominique Darbois.

118 Śākyamuni and Prabhūtaratna. Ht. 26 cm. Musée Guimet, Paris.

119 The development of the Buddha image. After Mizuno.

120 *Bodhisattva*. Ht. 188 cm. University of Pennsylvania Museum, Philadelphia.

121 Minor deities and worshippers. Fragment of a

stone relief from Wan-fo-ssu, Ch'iung-lai, Szechwan. People's Republic of China.

122 Buddha preaching the law. Wall painting in Cave 249 (P 101), Tunhuang.

123 The Buddha incarnate in a golden gazelle (the *Rūrū Jātaka*). Wall painting in Cave 257 (P 110), Tunhuang. Photo by Dominique Darbois.

124 Landscape with fabulous beings, on lower part of ceiling of Cave 249 (P 101), Tunhuang. Photo by Dominique Darbois.

125 Chimera. L. 1.75 m. Nelson Gallery of Art and Atkins Museum, Kansas City, Mo.

126 Dragon. L. 19 cm. Fogg Museum of Art, Cambridge, Mass.

127 Hsi K'ang (223–262), one of 'Seven Sages of the Bamboo Grove'. Brick tomb relief, Nanking.

128 Horse. Ht. 24.1 cm. Said to be from a tomb near Loyang. Royal Ontario Museum, Toronto.

129 Vase. Ht. 23 cm. From a tomb of 575 at Anyang, Honan. People's Republic of China.

130 Flask. Ht. 19.5 cm. From a tomb of 575 at Anyang, Honan. People's Republic of China.

131 Water container in the form of a lion-dog, Yüeh ware. L. 12.1 cm. Center of Asian Art and Culture, The Avery Brundage Collection, San Francisco.

132 'Chicken ewer', Yüeh ware. Ht. 33 cm. Musée Guimet, Paris.

MAP 8 China in the T'ang Dynasty.

MAP 9 Ch'ang-an in the T'ang Dynasty.

133 Tumulus and processional way of tomb of Kao-tsung (died 683) and Wu Tse-t'ien (died 705), Ch'ien-hsien, Shensi. Photo by the author, 1973.

134 The main hall of Fu-kuang-ssu, Wu-t'ai-shan, Shansi. Redrawn by P. J. Darvall from *Ying-tsao hsüeh-she hui-k'an*.

135 The Western rigid truss and the Chinese beam-frame truss compared.

136 The development and decline of the bracket order.

137 Conjectural reconstruction of the Lin-te-tien of the Ta-ming Kung, Ch'ang-an. Drawn by T. A. Greeves.

138 Pagoda of Hsin-chiao-ssu, Ch'ang-an, Shensi.

139 Charger and his groom. L. 152 cm. University of Pennsylvania Museum, Philadelphia.

140 Vairocana Buddha flanked by Ānanda, Kāśyapa, and attendant *bodhisattvas*. Feng-hsien-ssu, Lungmen, Honan.

141 Standing Buddha, Udayāna type. Ht. 145 cm. From Hsiu-te Pagoda near Ch'ü-yang, Hopei. Victoria and Albert Museum, London.

142 Seated Buddha (head restored). Ht. 115 cm.

From Cave XXI, north wall, T'ien-lung-shan, Shansi. Fogg Art Museum, Cambridge, Mass.

143 The sage Vimalakīrti. Detail of a wall painting in Cave 103 (P 137 M), Tunhuang.

144 The paradise of Amitābha. Detail of a wall painting in the Kondō (Image Hall) of Hōryūji, Nara, Japan.

145 The young Śākyamuni cuts off his hair. Landscape in the painterly style. Detail of a banner painting. From Tunhuang. British Museum, London.

146 Pilgrims and travellers in a landscape. Landscape in the boneless style. Detail of wall painting in Cave 217 (P 70), Tunhuang.

147 Yen Li-pen (died 673): The Emperor Hsüan of the Ch'en Dynasty. Detail of a handscroll of thirteen emperors from Han to Sui. Ht. 51 cm. Museum of Fine Arts, Boston.

148 Female attendants. Detail of a wall painting in the tomb of Princess Yung-t'ai, Ch'ien-hsien, Shensi.

149 Attributed to Sung Hui-tsung (1101–1125). *Court Ladies Preparing Silk*. Detail of a handscroll after a T'ang Dynasty original. Ht. 37 cm. Museum of Fine Arts, Boston.

150 Attributed to Han Kan (active 740–760). *Night White*, a favourite horse of T'ang Ming Huang. Handscroll. Ht. 29.5 cm. Mrs. John D. Riddell, London.

151 Style of Wang Wei (?). *Riverside Under Snow*. Part of a handscroll(?). Formerly Manchu Household Collection.

152 Landscape in the linear style. Copy of wall painting in the tomb of I-te, Ch'ien-hsien, Shensi.

153 Covered jar with swing handle, decorated with parrots amid peonies. Ht. 24 cm. Excavated at Ho-chia-ts'un, Sian. People's Republic of China.

154 Octagonal wine cup. Ht. 6.5 cm. Excavated at Ho-chia-ts'un, Sian. People's Republic of China.

155 'Lion-and-grape' mirror. Diam. 24.1 cm. Mr. and Mrs. Myron S. Falk, New York.

156 Ewer with dancer and dragons in relief under a polychrome glaze. Ht. 24.2 cm. Royal Ontario Museum, Toronto.

157 Jar decorated with splashed polychrome glaze. Ht. 17.8 cm. Center of Asian Art and Culture, The Avery Brundage Collection, San Francisco.

158 Lobed bowl, Yüeh ware. Diam. 19 cm. Victoria and Albert Museum, London.

159 Vase, possibly Hsing ware. Ht. 23.5 cm. Center of Asian Art and Culture, The Avery Brundage Collection, San Francisco.

160 Jar, Huang-tao ware. Ht. 14.7 cm. The Barlow Collection, Sussex University, England.

161 Camel carrying a band of musicians. Ht. about 70 cm. From a tomb at Sian, Shensi. People's Republic of China.

162 Seated woman. Ht. about 25 cm. From a tomb at Loyang, Honan. People's Republic of China.

163 Tomb guardian trampling on a demon. Ht. 122 cm. Center of Asian Art and Culture, The Avery Brundage Collection, San Francisco.

MAP 10 China in the Sung Dynasty.

164 Winged lion in the style of the Warring States period. Ht. 21,5 cm. British Museum, London.

165 Seven-tiered bracket for a palace hall. Illustration from the Sung Dynasty architectural manual, *Ying-tsao fa-shih* (1925 edition).

166 Twelve-sided pagoda of Fu-kung-ssu, Ying-hsien, Shansi.

167 Interior of Lower Hua-yen-ssu, Ta-t'ung, Shansi. Photo by the author, 1975.

168 Lohan. Ht. 105 cm. From I-chou, Hopei. Metropolitan Museum of Art, New York.

169 Kuanyin. Ht. 225 cm. Nelson Gallery of Art and Atkins Museum, Kansas City, Mo.

170 Soul suffering the torments of hell. Stone relief sculpture on a cliff at Ta-tsu, Szechwan.

171 In the manner of Shih K'o (active mid-tenth century). *Two Minds in Harmony*. Part of a handscroll. Ht. 44 cm. National Museum, Tokyo.

172 Attributed to Ku Hung-chung (tenth century). *A Night Entertainment of Han Hsi-tsai*. Detail of a handscroll. Ht. 29 cm. Palace Museum, Peking.

173 Attributed to Li Lung-mien (c. 1040–1106). *Horse and Groom*. One of five tribute horses. Detail of a handscroll. Ht. 30.1 cm. Formerly Manchu Household Collection.

174 Attributed to Li Ch'eng (919–967). *Buddhist Temple in the Hills After Rain*. Hanging scroll. Ht. 112 cm. Nelson Gallery of Art and Atkins Museum, Kansas City, Mo.

175 Kuo Hsi (eleventh century), *Early Spring*. Hanging scroll dated equivalent to 1072. Ht. 158.3 cm. National Palace Museum, Taipei.

176 Fan K'uan (active late tenth to early eleventh century), *Travelling amid Mountains and Gorges*. Hanging scroll. Ht. 206.3 cm. National Palace Museum, Taipei.

177 Chang Tse-tuan (late eleventh to early twelfth century), *Life Along the River on the Eve of the Ch'ing-ming Festival*. Detail of a handscroll. Ht. 25.5 cm. Palace Museum, Peking.

178 Attributed to Tung Yüan (tenth century). *Scenery Along the Hsiao and Hsiang Rivers*. Detail of a handscroll. Palace Museum, Peking.

179 Attributed to Su Tung-p'o (1036–1101). *Bare Tree, Bamboo and Rocks*. Handscroll. Ht. 23.4 cm. Palace Museum, Peking.

180 Mi Yu-jen (1086–1165), *Misty Landscape*. Hanging scroll. Ht. 24.7 cm. Osaka Municipal Museum (former Abe Collection).

181 Sung Hui-tsung (reigned 1101–1125), *The Five-Colour Parakeet*. Hanging scroll. Ht. 53 cm. Museum of Fine Arts, Boston.

182 Attributed to Huang Chü-ts'ai (933–993). *Pheasant and Sparrows amid Rocks and Shrubs*. Hanging scroll. Ht. 99 cm. National Palace Museum, Taipei.

183 Attributed to Li T'ang (c. 1050–1130). *A Myriad Trees on Strange Peaks*. Fan. Ht. 24.7 cm. National Palace Museum, Taipei.

184 Attributed to Chao Po-chü (1120–1182). *Rocky Mountains Along a River in Autumn*. Detail of a handscroll. Ht. 57 cm. Palace Museum, Peking.

185 Ma Yüan (active 1190–1225), *On a Mountain Path in Spring*, with a poem by Yang Mei-tzu, consort of Ning-tsung. Album-leaf. Ht. 27.4 cm. National Palace Museum, Taipei.

186 Hsia Kuei (active 1200–1230), *Pure and Remote View of Hills and Streams*. Detail of a handscroll. Ht. 46.5 cm. National Palace Museum, Taipei.

187 Mu-ch'i (active mid-thirteenth century), *Evening Glow on a Fishing Village*, one of "Eight Views of the Hsiao and Hsiang Rivers." Detail of a handscroll. Ht. 33.2 cm. Nezu Art Museum, Tokyo.

188 Mu-ch'i, *The White-Robed Kuanyin*, flanked by crane and gibbons. Hanging scroll. Ht. 172 cm. Daitokuji, Kyoto.

189 Ch'en Jung (active 1235–1260), *The Nine Dragons*. Detail of a handscroll. Ht. 46 cm. Museum of Fine Arts, Boston.

190 Funerary pillow, Ting ware. Ht. 15.3 cm. Center of Asian Art and Culture, The Avery Brundage Collection, San Francisco.

191 Vase, *mei-p'ing*. Ht. 25.4 cm. Mrs. Alfred Clark, Fulmer, Buckinghamshire.

192 Bottle with copper-bound rim, Ju ware. Ht. 24.8 cm. Percival David Foundation of Chinese Art, London.

193 Pitcher. Ht. 22.9 cm. Center of Asian Art and Culture, The Avery Brundage Collection, San Francisco.

194 Jar, Chün ware. Ht. 12.5 cm. Victoria and Albert Museum, London.

195 Jar, Tz'u-chou ware. Ht. 20.5 cm. Center of Asian Art and Culture, The Avery Brundage Collection, San Francisco.

196 Vase, *mei-p'ing*, Tz'u-chou ware. Ht. 49.5 cm. From Hsiu-wu, Honan. Center of Asian Art and Culture, The Avery Brundage Collection, San Francisco.

197 Bowl, Tz'u-chou ware. Diam. 9 cm. Center of

Asian Art and Culture, The Avery Brundage Collection, San Francisco.

198 Traveller's flask. Ht. 37.5 cm. Private Collection, Japan.

MAP 11 Kilnsites in the Hangchow area.

199 Tea bowl, Fukien *temmoku* ware. Diam. 13 cm. Seligman Collection, Arts Council of Great Britain, London.

200 Tripod incense burner, southern *kuan* ware. Ht. 12.9 cm. National Palace Museum, Taipei.

201 Vase, Lung-ch'üan (*kinuta*) ware. Ht. 16.8 cm. National Palace Museum, Taipei.

202 Vase, *ch'ing-pai* or *ying-ch'ing* ware. Ht. 13 cm. Seligman Collection, Arts Council of Great Britain, London.

203 Incense burner, *liu-li* ware. Ht. 36 cm. Excavated in the remains of the Yüan capital Ta-tu (Peking). People's Republic of China.

204 Sketch map of Yüan Dynasty Ta-tu compared with Peking of Ming and Ch'ing.

205 Aerial view of the heart of Peking.

206 The Three Great Halls, San Ta Tien, of the Forbidden City, looking south. Drawn by T. A. Greeves.

207 Ch'ien Hsüan (c. 1235–1301), *Wang Hsi-chih Watching Geese*. Detail of a handscroll. Ht. 23.2 cm. The Metropolitan Museum of Art, New York.

208 Oracle bone script, *chia-ku-wen*. From Anyang. British Museum, London.

209 Seal script, *chuan-shu*. Rubbing from one of the 'Stone Drums'.

210 Clerical script, *li-shu*. Rubbing from a stone slab. After Driscoll and Toda.

211 Draft script, *ts'ao-shu*. Ch'en Shun (1483–1544), part of the inscription on his *Studies from Life*, 1538. Handscroll. National Palace Museum, Taipei.

212 Regular script, *k'ai-shu*. Emperor Hui-tsung (reigned 1101–1125), part of his *Poem on the Peony*, written in the 'thin gold' (*shou-chin*) style. Handscroll. National Palace Museum, Taipei.

213 Running script, *hsing-shu*. Chao Meng-fu (1254–1322), part of his *Pao-t'u Spring Poem*. Handscroll. National Palace Museum, Taipei.

214 Crazy draft script, *k'uang-ts'ao-shu*. Hsü Wei (1521–1593), poem. Handscroll. Wango H. C. Weng Collection, New York.

215 Chao Meng-fu (1254–1322), *The Autumn Colours on the Ch'iao and Hua Mountains*. Detail of a handscroll dated equivalent to 1295. Ht. 28.4 cm. National Palace Museum, Taipei.

216 Huang Kung-wang (1269–1354), *Living in the Fu-ch'un Mountains*. Detail of a handscroll dated equivalent to 1350. Ht. 33 cm. National Palace

Museum, Taipei.

217 Ni Tsan (1301–1374), *The Jung-hsi Studio*. Hanging scroll. Ht. 73.3 cm. National Palace Museum, Taipei.

218 Wang Meng (1308–1385), *Thatched Halls on Mount T'ai*. Hanging scroll. Ht. 111 cm.

219 Li K'an (active 1260–1310), *Ink Bamboo*. Detail of a handscroll. Nelson Gallery of Art and Atkins Museum, Kansas City, Mo.

220 Wu Chen (1280–1354), *Bamboo*. Album-leaf dated equivalent to 1350. Ht. 42.9 cm. National Palace Museum, Taipei.

221 Dish. Diam. 42.9 cm. Percival David Foundation of Chinese Art, London.

222 Vase and stand. Ht. 24.1 cm. Center of Asian Art and Culture, The Avery Brundage Collection, San Francisco.

223 Kuanyin. Ht. 67 cm. Excavated in the remains of the Yüan capital, Ta-tu (Peking). People's Republic of China.

224 Wine jar. Ht. 36 cm. Excavated at Pao-ting, Shensi. People's Republic of China.

225 Pair of vases dedicated to a temple in Kiangsi in 1351. Ht. 63 cm. Percival David Foundation of Chinese Art, London.

226 The Great Wall at Pa-ta-ling. Hedda Morrison.

227 The Liu-yüan Garden in Soochow.

MAP 12 Artistic centres of Southeast China.

228 *Pomegranates*. Ht. 35.3 cm. British Museum, London.

229 *Lotus Leaves and Root*. Ht. 25.8 cm. British Museum, London.

230 Lü Chi (late fifteenth to early sixteenth century), *Pair of Wild Geese on a Snowy Bank*. Hanging scroll. Ht. 185 cm. National Palace Museum, Taipei.

231 Shih-jui (mid-fifteenth century), *Landscape in the Blue and Green Style*. Detail of a handscroll. Ht. 25.5 cm. Cleveland Museum of Art, John L. Severance Fund.

232 Tai Chin (1388–1452), *Fishermen*. Detail of a handscroll. Ht. 46 cm. Freer Gallery of Art, Washington, D.C.

233 Shen Chou (1427–1509), *Landscape in the Manner of Ni Tsan*. Hanging scroll dated equivalent to 1484. Ht. 140 cm. Nelson Gallery of Art and Atkins Museum, Kansas City, Mo.

234 Shen Chou, *Returning Home from the Land of the Immortals*. Album-leaf mounted as a handscroll. Ht. 38.9 cm. Nelson Gallery of Art and Atkins Museum, Kansas City, Mo.

235 Wen Cheng-ming (1470–1559), *Cypress and Rock*. Handscroll dated equivalent to 1550. Ht. 26

cm. Nelson Gallery of Art and Atkins Museum, Kansas City, Mo.

236 T'ang Yin (1479–1523), *Gentleman Playing the Lute in a Landscape*. Detail of a handscroll. Ht. 27.3 cm. National Palace Museum, Taipei.

237 Ch'iu Ying (c. 1494–1552+), *Saying Farewell at Hsün-yang*. Detail of a handscroll. Ht. 34 cm. Nelson Gallery of Art and Atkins Museum, Kansas City, Mo.

238 Tung Ch'i-ch'ang (1555–1636), *Dwelling in the Ch'ing-pien Mountains*. Hanging scroll. Ht. 224 cm. Wango H. C. Weng Collection, New York.

239 Shao Mi (active 1620–1640). Leaf from an album of landscapes dated equivalent to 1638. Ht. 28.8 cm. Seattle Art Museum.

240 Ch'en Hung-shou (1599–1652), *Portrait of the Poet Po Chü-i*, in the manner of Li Lung-mien. Detail of a handscroll dated equivalent to 1649. Ht. 31.6 cm. Charles A. Drenowatz Collection, Zurich.

241 Wu Pin (c. 1568–1626), *Fantastic Landscape*. Hanging scroll dated equivalent to 1616. Ht. 250 cm. Hashimoto Collection, Takatsuki.

242 Yen-lo-wang (Yama). Ht. 83.8 cm. Royal Ontario Museum, Toronto.

243 *Magician Changing a Bamboo Walking-Stick into a Dragon*. K'o-ssu silk tapestry. National Palace Museum, Taipei.

244 Imperial dragon robe. Woven silk tapestry. Ht. 139.8 cm. Victoria and Albert Museum, London.

245 Cup stand. Diam. of bowl 6.5 cm. Mrs. John Riddell, London.

246 Rectangular dish. National Palace Museum, Taipei.

247 Incense burner. Diam. 19 cm. Freer Gallery of Art, Washington, D.C.

248 Wine vessel, *tsun*, in the form of a phoenix. Ht. 34.9 cm. National Palace Museum, Taipei.

249 Flask. Ht. 47.6 cm. National Palace Museum, Taipei.

250 Bowl. Diam. 15.5 cm. Percival David Foundation of Chinese Art, London.

251 Kraak ware dish and two *kendi* (drinking flasks), export ware. Diam. of dish 36.7 cm. Formerly University of Malaya Art Museum, Singapore.

252 'Monk's hat' jug. Ht. 20 cm. National Palace Museum, Taipei.

253 Kuanyin, Fukien Te-hua ware. Ht. 22 cm. University of Sussex, Trustees of the Barlow Collection.

254 Vase. Ht. 30.7 cm. British Museum, London.

255 'Fish jar'. Ht. 43.1 cm. Center of Asian Art and Culture, The Avery Brundage Collection, San Francisco.

256 Dish, 'Swatow' ware. Diam. 37.2 cm. Probably from Shih-ma, Fukien. Center of Asian Art and Culture, The Avery Brundage Collection, San Francisco.

257 Peking, the Forbidden City, looking north from the Wu-men to the T'ai-ho-men. A corner of the T'ai-ho-tien is visible beyond. Photo by Hedda Morrison.

258 Yüan-ming-yüan. Ruins of the Belvedere (Fang-wai-kuan), designed by Giuseppe Castiglione (Lang Shih-ning, 1688–1766). Photo by the author, 1975.

259 The *Po-hai* and the Summer Palace, Peking.

260 The Hall of Annual Prayers, *Ch'i-nien-tien*, in the Precinct of the Altar of Heaven, Peking.

261 Chiao Ping-chen (active c. 1670–1710), *Country Pursuits*. Detail of a hanging scroll. Mr. and Mrs. Allen D. Christensen Collection, Atherton, Calif.

262 Giuseppe Castiglione, *A Hundred Horses in a Landscape*. Detail of a handscroll. Ht. 94.5 cm. National Palace Museum, Taipei.

263 Yüan Chiang (early eighteenth century), *Gentlemen Conversing in a Landscape*. Hanging scroll. Ht. 213.5 cm. Center of Asian Art and Culture, The Avery Brundage Collection, San Francisco.

264 Hung-jen (1610–1664), *The Coming of Autumn*. Hanging scroll. Ht. 122 cm. Honolulu Academy of Arts.

265 Kung Hsien (1620–1689), *A Thousand Peaks and Myriad Ravines*. Hanging scroll. Ht. 62.3 cm. Charles A. Drenowatz Collection, Zurich.

266 Chu Ta (Pa-ta Shan-jen, 1626–c. 1705), *Landscape in the Manner of Tung Yüan*. Hanging scroll. Ht. 180 cm. Ostasiatiska Museet, Stockholm.

267 Chu Ta, *Two Birds*. Album-leaf. Ht. 31.8 cm. Sumitomo Collection, Oiso.

268 K'un-ts'un (Shih-ch'i, c. 1610–1693), *Autumn Landscape*. Handscroll dated equivalent to 1666. British Museum, London.

269 Shih-t'ao (Tao-chi, 1641–c. 1710), *The Peach Blossom Spring*, illustrating a story by T'ao Yüan-ming. Detail of a handscroll. Ht. 25 cm. Freer Gallery of Art, Washington, D.C.

270 Shih-t'ao, *A Man in a House Beneath a Cliff*. Album, leaf. Ht. 24.2 cm. C. C. Wang Collection, New York.

271 Wang Hui (1632–1717), *Landscape in the Manner of Fan K'uan*. Hanging scroll dated equivalent to 1695. Formerly Huang Pao-hsi Collection, Hong Kong.

272 Wang Yüan-ch'i (1642–1715), *Landscape in the Manner of Ni Tsan*. Hanging scroll. Ht. 82 cm. Dr. Franco Vannotti Collection, Lugano, Switzerland.

273 Yün Shou-p'ing (1633–1690), *Autumn Fragrance: Chrysanthemum and Convolvulus*. Ht. 32 cm. Dr. Franco Vannotti Collection, Lugano, Switzerland.

274 Wu Li (1632–1718), *White Clouds and Green Mountains*. Detail of a handscroll. Ht. 25.9 cm. National Palace Museum, Taipei.

275 Chin Nung (1687–1764), *Plum Blossoms*. Hanging scroll dated equivalent to 1761. Ht. 115.9 cm. Formerly Huang Pao-hsi Collection, Hong Kong.

276 Huang Shen (1687–1768+), *The Poet T'ao Yüan-ming Enjoys the Early Chrysanthemums*. Album-leaf. Ht. 28 cm. Stanford Museum of Art, Stanford, Calif.

277 Hua Yen (1682–1755+), *Birds, Tree and Rock*. Hanging scroll dated equivalent to 1745. Huang Pao-hsi Collection, Hong Kong.

278 Vase, *mei-p'ing*. Ht. 19.6 cm. Percival David Foundation of Chinese Art, London.

279 Bottle. Ht. 43.2 cm. Victoria and Albert Museum, London.

280 Teapot. Ht. 12.9 cm. Percival David Foundation of Chinese Art, London.

281 Bottle, copy of Ju ware. National Palace Museum, Taipei.

282 Double vase, *t'ao-p'ing*. Ht. 38.5 cm. National Palace Museum, Taipei.

283 Vase. Ht. 19 cm. The Mount Trust, England.

284 'Jesuit China' dish. Diam. 27.4 cm. British Museum, London.

285 Ch'en Ming-yüan (active 1573–1620), brush-rest, I-hsing ware. L. 10.8 cm. Nelson Gallery of Art and Atkins Museum, Kansas City, Mo.

286 Carp leaping out of the water. Ht. 16.7 cm. National Palace Museum, Taipei.

287 Taoist paradise. Panel of carved red lacquer inset with jade, lapis lazuli, and gilt metal. L. 110.2 cm. Victoria and Albert Museum, London.

288 Snuff bottle. Ht. (without stopper) 5.8 cm. Percival David Foundation of Chinese Art, London.

289 The Great Hall of the People, Peking, 1959.

290 Ivory carving. *Ch'ang O Flies to the Moon*. People's Republic of China.

291 Jen Po-nien (1840–1896), *Pine Tree and Mynah Birds*. Hanging scroll. Tan Tze Chor Collection, Singapore.

292 Wu Ch'ang-shih (1842–1927), *Lychee Nuts*. Hanging scroll. Ht. 91.4 cm. Mr. and Mrs. Allen D. Christensen Collection, Atherton, Calif.

293 Ch'i Pai-shih (1863–1957), *The Thing for Prolonging Life Is Wine!* Hanging scroll. Ht. 62.2 cm. Private Collection.

294 Chang Dai Chien (born 1899), *Ten Thousand Miles of the Yangtse*. Detail of a handscroll, showing the Min River at Kuan-hsien, Szechwan. Chang Ch'ün Collection, Taipei.

295 Hsü Pei-hung (Ju Péon, 1895–1953), *Magpies on an Old Tree*. Location unknown.

296 Li Hua (born 1907), *Refugees: A Contrast*. Woodcut.

297 Huang Yung-yü (contemporary), *Mountain Tribespeople*. Woodcut. Private Collection, Stanford, Calif.

298 Chao Wu-chi (Zao Wou-ki, born 1921), untitled. Ht. 152.4 cm. H. Harvard Arnason Collection, New York.

299 Lin Feng-mien (contemporary), *The Yangtse Gorges*. Ht. 51 cm. Private Collection, Stanford, Calif.

300 Tseng Yu-ho (born 1923), *Hawaiian Village*. Honolulu Academy of Arts, Honolulu.

301 Lü Shou-k'un (1919–1976), *Mountain*. Hanging scroll. Ht. 45.7 cm.

302 Li K'o-jan (born 1907), *Village in the Mountains*. Hanging scroll. Ht. 69.6 cm. Private Collection, Stanford.

303 Anonymous team of sculptors, *The Rent Collection Courtyard*. Detail of a life-size tableau in clay-plaster, in a former landlord's mansion at Ta-yi, Szechwan.

Index